Women, Drug Use, and HIV Infection

Women, Drug Use, and HIV Infection has been co-published simultaneously as *Women & Health*, Volume 27, Numbers 1/2 1998.

*Pre-publication
REVIEWS,
COMMENTARIES,
EVALUATIONS . . .*

"This is one of the largest and most convincing set of studies stressing the importance of HIV prevention efforts with substance abusing women. The findings support significant scientific and public policy implications for affected future generations."

Wendee M. Wechsberg, PhD
*Senior Research Psychologist
Substance Abuse Treatment Research
Research Triangle Institute*

More pre-publication
REVIEWS, COMMENTARIES, EVALUATIONS . . .

"**A** much-needed resource of critical information about the largest initiative to date designed to prevent HIV among drug users and their sexual partners. . . . Drs. Stevens, Tortu, and Coyle are to be commended for their efforts in bringing this material to the public's attention. . . .

Until a vaccine to prevent or cure HIV is developed, behavioral interventions are our only means available to reduce the spread of the disease. The publication of this book will aid immeasurably in achieving this goal."

Robert E. Booth, PhD
Associate Professor of Psychiatry, University of Colorado School of Medicine, Denver

The Haworth Medical Press
An Imprint of The Haworth Press, Inc.

Women, Drug Use, and HIV Infection

Women, Drug Use, and HIV Infection has been co-published simultaneously as *Women & Health*, Volume 27, Numbers 1/2 1998.

Women, Drug Use, and HIV Infection

Sally J. Stevens, PhD
Stephanie Tortu, PhD
Susan L. Coyle, PhD
Editors

The Haworth Medical Press
An Imprint of
The Haworth Press, Inc.
New York • London

Published by

The Haworth Medical Press, 10 Alice Street, Binghamton, NY 13904-1580 USA

The Haworth Medical Press is an imprint of The Haworth Press, Inc., 10 Alice Street, Binghamton, NY 13904-1580 USA.

Women, Drug Use, and HIV Infection has been co-published simultaneously as *Women & Health*, Volume 27, Numbers 1/2 1998.

The development, preparation, and publication of this work has been undertaken with great care. However, the publisher, employees, editors, and agents of The Haworth Press and all imprints of The Haworth Press, Inc., including The Haworth Medical Press and Pharmaceutical Products Press, are not responsible for any errors contained herein or for consequences that may ensue from use of materials or information contained in this work. Opinions expressed by the author(s) are not necessarily those of The Haworth Press, Inc.

The Haworth Press, Inc., 10 Alice Street, Binghamton, NY 13904-1580 USA

Cover design by Thomas J. Mayshock Jr.

Library of Congress Cataloging-in-Publication Data

Women, drug use, and HIV infection / Sally J. Stevens, Stephanie Tortu, Susan L. Coyle, editors.
 p. cm.
 "Has been co-published simultaneously as Women & health, Volume 27, Numbers 1/2, 1998."
 Includes bibliographical references and index.
 ISBN 1-7890-0351-1 (alk. paper) -- ISBN 0-7890-0527-1 (pbk. : alk. paper).
 1. AIDS (Disease) in women–Risk factors. 2. Women–Drug use. 3. Women–Health risk assessment. I. Stevens, Sally J. II. Tortu, Stephanie. III. Coyle, Susan L. IV. Women & health.
RA644.A25W655 1998
616.97'92'0082–dc21 98-17207
 CIP

Women, Drug Use, and HIV Infection

CONTENTS

SINGLE SITE DESCRIPTIONS

CONTEXTUAL VARIABLES IN WOMEN'S
HIV RISK BEHAVIORS

 ALL HAWORTH MEDICAL PRESS BOOKS
 AND JOURNALS ARE PRINTED
 ON CERTIFIED ACID-FREE PAPER

INDEXING & ABSTRACTING

Contributions to this publication are selectively indexed or abstracted in print, electronic, online, or CD-ROM version(s) of the reference tools and information services listed below. This list is current as of the copyright date of this publication. See the end of this section for additional notes.

- *Abstracts in Social Gerontology: Current Literature on Aging,* National Council on the Aging, Library, 409 Third Street SW, 2nd Floor, Washington, DC 20024

- *Academic Abstracts/CD-ROM,* EBSCO Publishing Editorial Department, P.O. Box 590, Ipswich, MA 01938-0590

- *Academic Search: database of 2,000 selected academic serials, updated monthly,* EBSCO Publishing, 83 Pine Street, Peabody, MA 01960

- *Behavioral Medicine Abstracts,* University of Washington Department of Social Work & Speech & Hearing Sciences, Box 354900, Seattle, WA 98195

- *Biology Digest,* Plexus Publishing Company, 143 Old Marlton Pike, Medford, NJ 08055-8750

- *c/o CAB International/CAB ACCESS . . . available in print, diskettes updated weekly, and on INTERNET. Providing full bibliographic listings, author affiliation, augmented keyword searching,* CAB International, P.O. Box 100, Wallingford Oxon OX10 8DE, United Kingdom

- *Child Development Abstracts & Bibliography,* University of Kansas, 213 Bailey Hall, Lawrence, KS 66045

- *CINAHL (Cumulative Index to Nursing & Allied Health Literature), in print, also on CD-ROM from CD PLUS, EBSCO, and SilverPlatter, and online from CDP Online (formerly BRS), Data-Star, and PaperChase.* (Support materials include Subject Heading List, Database Search Guide, and instructional video), CINAHL Information Systems, P.O. Box 871/1509 Wilson Terrace, Glendale, CA 91209-0871

- *CNPIEC Reference Guide: Chinese National Directory of Foreign Periodicals*, P.O. Box 88, Beijing, People's Republic of China

- *Combined Health Information Database (CHID),* National Institutes of Health, 3 Information Way, Bethesda, MD 20892-3580

- *Contemporary Women's Issues,* Responsive Databases Services, 23611 Chagrin Blvd., Suite 320, Beachwood, OH 44122

(continued)

- *Criminal Justice Abstracts,* Willow Tree Press, 15 Washington Street, 4th Floor, Newark, NJ 07102

- *Criminology, Penology and Police Science Abstracts,* Kugler Publications, P.O. Box 11188, 1001 GD Amsterdam, The Netherlands

- *Current Contents see: Institute for Scientific Information*

- *Excerpta Medica/Secondary Publishing Division,* Elsevier Science Inc., Secondary Publishing Division, 655 Avenue of the Americas, New York, NY 10010

- *Family Studies Database (online and CD/ROM),* National Information Services Corporation, 306 East Baltimore Pike, 2nd Floor, Media, PA 19063

- *Feminist Periodicals: A Current Listing of Contents,* Women's Studies Librarian-at-Large, 728 State Street, 430 Memorial Library, Madison, WI 53706

- *General Science Index,* The H.W. Wilson Company, 950 University Avenue, Bronx, NY 10452

- *General Science Source: comprehensive abstracts of nearly 200 general science periodicals, updated monthly,* EBSCO Publishing, 83 Pine Street, Peabody, MA 01960

- *Health Management Information Service (HELMIS),* Nuffield Institute for Health, 71-75 Clarendon Road, Leeds LS2 9PL, England

- *Health Source: Indexing & Abstracting of 160 selected health related journals, updated monthly,* EBSCO Publishing, 83 Pine Street, Peabody, MA 01960

- *Health Source Plus: expanded version of "Health Source" to be released shortly,* EBSCO Publishing, 83 Pine Street, Peabody, MA 01960

- *HealthSTAR,* National Library of Medicine, 8600 Rockville Pike, Bethesda, MD 20894

- *Higher Education Abstracts,* Claremont Graduate University, 231 East Tenth Street, Claremont, CA 91711

- *Hospital and Health Administration Index,* American Hospital Association, One North Franklin, Chicago, IL 60606

- *IBZ International Bibliography of Periodical Literature,* Zeller Verlag GmbH & Co., P.O.B. 1949, d-49009, Osnabruck, Germany

- *Index to Periodical Articles Related to Law,* University of Texas, 727 East 26th Street, Austin, TX 78705

- *Industrial Hygiene Digest,* Industrial Health Foundation, Inc., 34 Penn Circle West, Pittsburgh, PA 15206

(continued)

- *Institute for Scientific Information*, 3501 Market Street, Philadelphia, PA 19104-3302 (USA). Coverage in:
 a) Social Science Citation Index (SSCI): print, online, CD-ROM
 b) Research Alerts (current awareness service)
 c) Social SciSearch (magnetic tape)
 d) Current Contents/Social & Behavioral Sciences (weekly current awareness service)
- *INTERNET ACCESS (& additional networks) Bulletin Board for Libraries ("BUBL") coverage of information resources on INTERNET, JANET, and other networks.*
 - <URL:http://bubl.ac.uk/>
 - The new locations will be found under <URL:http://bubl.ac.uk/link/>.
 - Any existing BUBL users who have problems finding information on the new service should contact the BUBL help line by sending e-mail to <bubl@bubl.ac.uk>.
 The Andersonian Library, Curran Building, 101 St. James Road, Glasgow G4 0NS, Scotland
- *MasterFILE: updated database from EBSCO Publishing,* EBSCO Publishing, 83 Pine Street, Peabody, MA 01960
- *Medication Use STudies (MUST) DATABASE*, The University of Mississippi, School of Pharmacy, University, MS 38677
- *Mental Health Abstracts (online through DIALOG),* IFI/Plenum Data Company, 3202 Kirkwood Highway, Wilmington, DE 19808
- *NIAAA Alcohol and Alcohol Problems Science Database (ETOH),* National Institute on Alcohol Abuse and Alcoholism, 1400 Eye Street NW, Suite 200, Washington, DC 20005
- *ONS Nursing Scan in Oncology-NAACOG's Women's Health Nursing Scan,* NURSECOM, Inc., 1211 Locust Street, Philadelphia, PA 19107
- *Papillomavirus Report,* Leeds Medical Information, Worsley Medical & Dental Building, University of Leeds, Leeds LS2 9JT, United Kingdom
- *Periodical Abstracts, Research I (general & basic reference indexing & abstracting data-base from University Microfilms International (UMI), 300 North Zeeb Road, P.O. Box 1346, Ann Arbor, MI 48106-1346),* UMI Data Courier, P.O. Box 32770, Louisville, KY 40232-2770
- *Periodical Abstracts, Research II (broad coverage indexing & abstracting data-base from University Microfilms International (UMI), 300 North Zeeb Road, P.O. Box 1346, Ann Arbor, MI 48106-1346),* UMI Data Courier, P.O. Box 32770, Louisville, KY 40232-2770

(continued)

- *Periodical Abstracts Select (abstracting & indexing service covering most frequently requested journals in general reference, plus journals requested in libraries serving undergraduate programs, available from University Microfilms International (UMI), 300 North Zeeb Road, P.O. Box 1346, Ann Arbor, MI 48106-1346),* UMI Data Courier, Attn: Library Services, Box 34660, Louisville, KY 40232

- *POPLINE,* National Library of Medicine, 8600 Rockville Pike, Bethesda, MD 20894

- *Population Index,* Princeton University Office Population, 21 Prospect Avenue, Princeton, NJ 08544-2091

- *Psychological Abstracts (PsycINFO),* American Psychological Association, P.O. Box 91600, Washington, DC 20090-1600

- *Public Affairs Information Bulletin (PAIS),* Public Affairs Information Service, Inc., 521 West 43rd Street, New York, NY 10036-4396

- *Referativnyi Zhurnal (Abstracts Journal of the All-Russian Institute of Scientific and Technical Information),* 20 Usievich Street, Moscow 125219, Russia

- *Sage Family Studies Abstracts (SFSA),* Sage Publications, Inc., 2455 Teller Road, Newbury Park, CA 91320

- *Social Planning/Policy & Development Abstracts (SOPODA),* Sociological Abstracts, Inc., P.O. Box 22206, San Diego, CA 92192-0206

- *Social Science Citation Index . . . see: Institute for Scientific Information*

- *Social Science Source: coverage of 400 journals in the social sciences area; updated monthly,* EBSCO Publishing, 83 Pine Street, P.O. Box 2250, Peabody, MA 01960-7250

- *Social Sciences Index (from Volume 1 & continuing),* The H.W. Wilson Company, 950 University Avenue, Bronx, NY 10452

- *Social Work Abstracts,* National Association of Social Workers, 750 First Street NW, 8th Floor, Washington, DC 20002

- *SOMED (social medicine) Database,* Landes Institut fur Den Offentlichen Gesundheitsdienst NRW, Postfach 20 10 12, D-33548 Bielefeld, Germany

- *Studies on Women Abstracts,* Carfax Publishing Company, P.O. Box 25, Abingdon, Oxon OX14 3UE, United Kingdom

(continued)

- **Women "R" CD/ROM,** Softline Information Inc, 20 Summer Street, Stamford, CT 06901. A new full text Windows Database on CD/ROM. Presents full depth coverage of the wide range of subjects that impact and reflect the lives of women. Can be reached at 1 (800) 524-7922, www.slinfo.com, or e-mail: hoch@slinfo.com, Softline Information, Inc., 20 Summer Street Stamford, CT 06901

- **Women Studies Abstracts,** Rush Publishing Company, P.O. Box 1, Rush, NY 14543

- **Women's Studies Index (indexed comprehensively),** G.K. Hall & Co., P.O. Box 159, Thorndike, ME 04986

SPECIAL BIBLIOGRAPHIC NOTES

related to special journal issues (separates)
and indexing/abstracting

☐ indexing/abstracting services in this list will also cover material in any "separate" that is co-published simultaneously with Haworth's special thematic journal issue or DocuSerial. Indexing/abstracting usually covers material at the article/chapter level.

☐ monographic co-editions are intended for either non-subscribers or libraries which intend to purchase a second copy for their circulating collections.

☐ monographic co-editions are reported to all jobbers/wholesalers/approval plans. The source journal is listed as the "series" to assist the prevention of duplicate purchasing in the same manner utilized for books-in-series.

☐ to facilitate user/access services all indexing/abstracting services are encouraged to utilize the co-indexing entry note indicated at the bottom of the first page of each article/chapter/contribution.

☐ this is intended to assist a library user of any reference tool (whether print, electronic, online, or CD-ROM) to locate the monographic version if the library has purchased this version but not a subscription to the source journal.

☐ individual articles/chapters in any Haworth publication are also available through the Haworth Document Delivery Service (HDDS).

ABOUT THE EDITORS

Sally J. Stevens, PhD, is Research Associate Professor at the Southwest Institute for Research on Women at the University of Arizona. She has worked in the field of addiction studies and HIV prevention as both a clinician and a researcher. Dr. Stevens has been the Principal Investigator of several federally funded research grants, including HIV prevention for drug users and their sexual partners: homelessness and substance abuse treatment: and substance abuse treatment for addicted women and their children.

Stephanie Tortu, PhD, is Principal Investigator at the National Development and Research Institutes in New York City, where her work focuses on women drug users at risk for HIV infection and the evaluation of AIDS interventions. She joined the Institutes in 1988, after three years as Assistant Professor at Cornell University Medical College. Dr. Tortu is currently conducting a study on the social context of AIDS risk among women in East Harlem. She also serves on the Board of Directors of the Bronx-Harlem Needle Exchange.

Susan L. Coyle, PhD, is Health Scientist Administrator in the Community Research Branch of the National Institute on Drug Abuse (NIDA). She administers an extramural research portfolio of HIV and violence epidemiology and prevention among drug users, with specialties in intervention evaluation research and network analysis. Women and adolescents are populations of particular interest. Prior to joining NIDA, Dr. Coyle served as Study Director to the National Research Council Panel on the Evaluation of AIDS Interventions.

OVERVIEW

Women's Drug Use and HIV Risk: Findings from NIDA's Cooperative Agreement for Community-Based Outreach/Intervention Research Program

Susan L. Coyle, PhD

This volume brings together empirical findings from a multisite program of research on HIV infection among out-of-treatment drug users, sponsored by the National Institute on Drug Abuse (NIDA). The papers highlight a number of factors related to HIV infection among women who inject drugs and/or smoke crack cocaine, or who are the sex partners of individuals who use these drugs. Bringing their risk factors to light is both timely and critical at a point in the epidemic in which women's vulnerability to HIV disease is becoming increasingly apparent. Worldwide, women account for 42 percent of the adults living with HIV/AIDS, but women's

[Haworth co-indexing entry note]: "Women's Drug Use and HIV Risk: Findings from NIDA's Cooperative Agreement for Community-Based Outreach/Intervention Research Program." Coyle, Susan L. Co-published simultaneously in *Women & Health* (The Haworth Medical Press, an imprint of The Haworth Press, Inc.) Vol. 27, No. 1/2, 1998, pp. 1-18; and: *Women, Drug Use, and HIV Infection* (ed: Sally J. Stevens, Stephanie Tortu, and Susan L. Coyle) The Haworth Medical Press, an imprint of The Haworth Press, Inc., 1998, pp. 1-18. Single or multiple copies of this article are available for a fee from The Haworth Document Delivery Service [1-800-342-9678, 9:00 a.m. - 5:00 p.m. (EST). E-mail address: getinfo@haworthpressinc.com].

acquisition of the virus has begun to grow more rapidly than it has for men (United Nations, 1996). In the United States, over 78,000 cumulative cases of AIDS were reported in women and female adolescents by mid-1996 (Centers for Disease Control, 1996). Drug use plays a major role in the spread of this disease: 46 percent of women's AIDS cases have been directly attributed to injection drug use–itself a public health concern–and another 18 percent attributed to women's heterosexual contacts with injection drug users.[1] It should also be noted that 70 to 80 percent of AIDS cases ascribed to heterosexual contact in the U.S. have been in women, most of them in young, minority, indigent women who use crack cocaine and who trade sex for crack, other drugs, or money (Holmberg, 1996).

As part of the U.S. National Institutes of Health, NIDA has a particular interest in the twin public health problems of drug use and HIV infection. NIDA is one of the foremost Federal sponsors of behavioral epidemiology and social science research on AIDS risk and prevention, and it currently allocates about one third of its research dollars to study the nature, extent, and patterns of drug use/abuse and HIV-related behaviors and to study the efficacy and effectiveness of interventions designed to reduce HIV risk behaviors and avert incident infections. Both of these goals are met in the multisite research program featured in this volume, the Cooperative Agreement for AIDS Community-Based Outreach/Intervention Research Program.

The "Cooperative Agreement," as well as its predecessor research program (the National AIDS Demonstration Research, or "NADR" program), were designed to monitor HIV risk behaviors and seroprevalence levels in out-of-treatment drug users. To this end, investigators in each program have collected serological and behavioral data from men and women of all race/ethnic groups since 1987. Currently women make up nearly 30 percent of research participants. The data show that while HIV rates are similar in male and female IDUs, women face some unique risk situations relative to men, including greater use of crack cocaine and more extensive sex exchange transactions (Tortu, Goldstein et al., this volume, provide a valuable exploration of these gender-related risks), and of course many women face potential transmission of the virus to their infants.

Before describing women's HIV risks, however, it is first important to discuss the purposes and strategies of community-based outreach/HIV intervention research in order to give the reader an understanding of the context and parameters of much of the research reported in this volume. The discussion will begin with a brief look at the NADR program and will be followed by more detailed background information on the Cooperative

Agreement program. For a condensed comparison of the two research initiatives, see Tables 1a and 1b.

NADR: THE NATIONAL AIDS DEMONSTRATION RESEARCH PROGRAM

Under NADR, NIDA supported a network of 29 sites to deliver outreach-based HIV interventions to not-in-treatment drug users and their sex partners, collect baseline and follow-up reports of HIV risk behaviors, and

TABLE 1a. Selected Characteristics of NIDA's NADR and Cooperative Agreement Programs

Feature	NADR	Cooperative Agreement
Sites	29 in U.S. and Puerto Rico–	23 in U.S., Puerto Rico, and Brazil–
	• Boston MA	17 with 6 months follow-up schedule:
	• Chicago IL	
	• Cincinnati OH	• Anchorage AK
	• Cleveland OH	• Collier County FL
	• Dallas TX	• Dayton/Columbus OH
	• Dayton/Columbus OH	• Denver CO
	• Hartford CT	• Detroit MI
	• Honolulu HI	• Flagstaff AZ
	• Houston TX	• Hartford CT
	• Jersey City NJ	• Houston TX
	• Long Beach CA	• Long Beach CA
	• Miami FL	• Miami FL
	• Minneapolis/St. Paul MN	• New Orleans LA
	• Newark NJ	• New York (Harlem) NY
	• New Haven CT	• Oakland CA
	• New Orleans LA	• Philadelphia PA
	• New York (Brooklyn) NY	• Portland OR
	• New York (Harlem) NY	• San Juan (Rio Piedras) PR
	• Paterson NJ	• Tucson AZ
	• Philadelphia PA	
	• Pittsburgh PA	6 with 3 months follow-up schedule:
	• Portland OR	
	• San Juan (Rio Piedras) PR	• Durham County NC
	• San Antonio TX	• Lexington KY
	• San Francisco CA (2 sites)	• Rio de Janeiro BRAZIL
	• Seattle WA	• San Antonio TX
	• Tucson AZ	• St. Louis MO
	• Washington DC	• Washington DC

TABLE 1b. Selected Characteristics of NIDA's NADR and Cooperative Agreement Programs

Feature	NADR	Cooperative Agreement
Eligibility Criteria	• No gender quotas • Injected drugs last 6 months and • Out of treatment last 30 days, or • Had sexual contact with IDU in last 6 months, and • Did not inject drugs last 6 mos.	• Minimum 30% women recruits • 18 years of age or older, and • Injected drugs last 30 days, or • Smoked crack cocaine in the last 48 hours, and • Out of treatment last 30 days
Enrollment	• Between 1988-1990, enrolled 11,569 women and 32,700 men	• Between 1/92-12/95, enrolled 7,054 women and 16,440 men
Standard Data Collection Instruments	• AIDS Initial Assessment/AIA • AIDS Follow-up Assessment/ AFA	• Risk Behavior Assessment/RBA • Risk Behavior Follow-up Assessment/RBFA • Client Contact Form • Client Eligibility and Assignment Form • Client Participation Summary • HIV Coding Document
Study Design Features	• Street outreach: education, bleach & condom distribution, recruitment • Random assignment to interventions (typically) • Elementary intervention of HIV counseling (1 or 2 sessions) • Enhanced intervention as either an add-on or alternative to elementary intervention • 6-month follow-up	• Street outreach: education, bleach & condom distribution, recruitment • Random assignment to interventions (always) • Standard intervention of HIV pre- & posttest counseling and antibody testing (2 sessions) • Enhanced intervention as an add-on to standard intervention • 6 month follow-up at 17 sites • 3 month follow-up at 6 sites

build a national database of records for over 36,000 IDUs and more than 8,000 sex partners. Certain cross-site research commonalities were built into NADR, such as target audience, goals, reliance on community outreach, and standardized pre- and posttest data collection. Sites were allowed, however, to tailor HIV intervention activities in accordance with community needs and preferred theoretical models of behavior change. In general, outreach workers spent time in the streets and other public places providing AIDS education along with kits of hygiene materials (bleach, condoms) that people could use to reduce their risk of viral transmission. Outreach workers also encouraged IDUs and sex partners to participate in

structured HIV interventions, which typically involved basic AIDS counseling or an enhanced program of social support to facilitate behavior change. Intervention messages varied but were aimed at instilling a repertoire of behaviors to avert HIV transmission, such as cessation of injection drug use, drug treatment, use of sterile injection equipment, condom use, and avoidance of sex partners who inject drugs. HIV antibody testing was frequently offered.

Table 2 provides a brief demographic profile of female participants in the demonstration program. Among women, blacks constituted over half of NADR's sample of IDUs and sex partners.[2] Whites made up the second largest group of female IDUs, and Hispanics were the second largest group of female sex partners. Table 2 also shows that the women participants in NADR were at substantial risk for HIV. Indeed, 14 percent of the women who were tested for HIV in the program were seropositive at the time of enrollment.[3] Among injecting drug users the rate was 17.8 percent, considerably higher than the 5.5 percent rate among female sex partners. Sex risk exposure was evident as well, with women IDUs being 1 1/2 times more likely than women sex partners to have exchanged sex for money or drugs in the last 30 days (31.4 percent vs. 20.3 percent). Sexually active women in NADR reported a mean of 26.3 unprotected vaginal sex contacts in the last month, 10.5 unprotected oral sex contacts, and 1.5 unprotected anal sex contacts. (The high number of risky vaginal sex acts reported in NADR relative to those reported in the Cooperative Agreement may be partly attributable to site differences and/or differences in data collection methodologies. NADR included proportionately more large cities; moreover, its post-intervention questionnaire asked subjects about behaviors in the last 6 months, whereas Cooperative Agreement subjects were asked about behaviors in the last 30 days. Note: NADR's data were transformed to 30-day rates for comparison purposes here.)

Although most NADR sites implemented a randomized field trial, many of the published findings have relied on one-group pretest-posttest analysis of all participants, without comparison to a control condition. The studies have reported positive behavior changes between intake and the six-month follow-up, such as reductions in injection frequency (Andersen, Smereck & Braunstein, 1993; Camacho, Williams, Vogtsberger & Simpson, 1995; Colon, Robles, Freeman & Matos, 1993; Deren, Davis, Beardsley, Tortu & Clatts, 1995; Friedman et al., 1992; Neaigus et al., 1990; Siegal, Falck, Carlson & Wang, 1995; Simpson et al., 1994; Stephens, Feucht & Roman, 1991; Wechsberg, Cavanaugh & Dunteman, 1994) and increases in condom use (Andersen et al., 1993; Colon et al., 1993; Deren et al., 1995; Friedman et al., 1992; Neaigus et al., 1990).[4] With respect to women, Deren, Davis,

Tortu, Beardsley and Ahluwalia (1995) found that female IDUs reported significant post-intervention risk reductions in injection frequency, renting/borrowing "works" and other injection paraphernalia, and unprotected heterosexual intercourse (interestingly, the greatest reductions in sex risk occurred among women IDUs who were pregnant at baseline or became pregnant by the time of follow-up). Finally, Rhodes, Wolitski and Thornton-Johnson (1992) found that, following the intervention, a significant proportion of female sex partners (68 percent) began to always use condoms with their IDU sex partners. Given such promising ends, NIDA next launched the Cooperative Agreement program.

TABLE 2. Selected Demographic and HIV Risk Characteristics of Women in the NADR Database

	Total Women (n = 11,569)		IDU Women (n = 7,907) (68.3%)		Female Sex Partners (n = 3,662) (31.7%)	
Mean age	32.0 years		32.8 years		30.5 years	
Ethnicity	n	(%)	n	(%)	n	(%)
Black	6,315	(54.6%)	4,055	(51.3%)	2,260	(61.7%)
White	2,724	(23.6%)	2,166	(27.4%)	558	(15.2%)
Hispanic	2,104	(18.2%)	1,427	(18.0%)	677	(18.5%)
Mexican American	988	(8.5%)	522	(6.6%)	466	(12.7%)
Puerto Rican	1,020	(8.8%)	843	(10.7%)	177	(4.8%)
Other Hispanic	96	(0.8%)	62	(0.8%)	34	(0.9%)
Other[a]	426	(3.7%)	259	(3.2%)	167	(4.6%)
History of IDU[b]	8,579	(74.3%)	7,865	(99.5%)	714	(19.6%)
Mean unprotected sex acts in last 30 days [s.d.][c]						
Vaginal	26.3 [42.4]		25.3 [42.6]		28.4 [41.8]	
Oral	10.5 [27.9]		11.2 [28.9]		9.1 [25.5]	
Anal	1.5 [10.0]		1.6 [10.6]		1.3 [8.4]	
Exchanged sex for money or drugs in last 30 days[b]	3,218	(27.9%)	2,477	(31.4%)	741	(20.3%)
Tested for HIV	5,435	(47.0%)	3,751	(47.4%)	1,684	(46.0%)
HIV positive	759	(14.0%)	666	(17.8%)	93	(5.5%)

[a]Includes Native American/Alaskan, Asian/Pacific Islander, and unknown/refused.
[b]Missing values excluded when calculating percentages.
[c]Among those who were sexually active.

THE COOPERATIVE AGREEMENT
FOR AIDS COMMUNITY-BASED OUTREACH/INTERVENTION
RESEARCH PROGRAM

To facilitate collaboration among investigators, as well as to strengthen the basis for evaluating program effects, NIDA inaugurated its Cooperative Agreement for AIDS Community-Based Outreach/Intervention Research Program in 1990. While government scientists shaped the broad contours of the program, much of the responsibility for developing the study was in the hands of the Steering Committee, which was composed of principal investigators from the 23 grantee sites and NIDA. Several subcommittees assisted in formulating the policies, procedures, and research strategies, which in turn were brought to the Steering Committee for final decision making.[5] Subcommittees were tasked, for example, to develop guidelines and policy with respect to:

- Monitoring and Client Eligibility,
- The Standard Intervention,
- Data Management,
- Data Reporting and Analysis,

- Publications Policy,
- Supplemental Research,
- Qualitative Research, and
- Women's Issues.

Cross-Site Research Implementation Issues

Through the Steering Committee and its subcommittees, investigators worked together to devise standardized research protocols and data collection instruments for use across all sites (all instruments were available in English, Spanish, and Portuguese). Six data collection forms were developed whose use was required across sites. Two of the forms, the Risk Behavior Assessment (RBA) and the Risk Behavior Follow-up Assessment (RBFA), were administered by trained interviewers to collect self-reported behavioral data at intake into the study and at the post-intervention follow-up. In brief, these instruments elicited self-reports about demographics and living arrangements; drug use history (including treatment history and current drug use); sex history and current sexual activity; attitudes and exposure to HIV testing and AIDS prevention; and arrest and work histories. The other four instruments collected process level data on the implementation of the program and included: (1) the Client Contact Form, which was completed by outreach workers and used to track the number of outreach contacts and services provided to any given research participant; (2) the Client Eligibility and Assignment Form, which was completed by project staff at intake into the study and used to double-check outreach contacts, verify study eligibility and drug use, and monitor

the assignment of participants to the experimental (enhanced) or control (standard) intervention; (3) the Client Participation Summary, which recorded the number of planned and unplanned intervention sessions attended between intake and conclusion of the study and which was finally completed by project staff after the client's follow-up interview (or nine months post-intake if the client did not return for follow-up); and (4) the HIV Coding Document, which was used to record the results of the client's antibody blood test(s) and to document whether the client returned to the site to learn his or her test results (thus, this form collected client-linked serological data as well as information on intervention implementation).[6] Other standardized research/intervention protocols included prototype plans for sampling, specific duration and content of outreach contacts, a two-session HIV counseling and testing intervention, and a number of substudies that so far have involved as few as two and as many as 18 of the Cooperative Agreement sites.

There has been a dynamic aspect to the research involved in the Cooperative Agreement program, in part because of variability in the timing of grant awards. The 23 grants were made between 1990 and 1994, each for a period of five years. As a result of this staggered schedule, some investigators have completed their research while others will continue to operate through June 1999. In addition, flexibility in the research protocol has been necessary to accommodate changing knowledge and conditions in HIV risk profiles (such as a perceived upswing in sex-for-crack exchanges), available technologies (such as the introduction of the female condom), and research strategies (such as recalculating time intervals to measure intervention effects). For example, as shown in Table 1a, the first 17 sites funded in the Cooperative Agreement program chose to follow up participants after six months, whereas the last six sites decided on a three-month follow-up period.

Sampling

Target populations for inclusion in the Cooperative Agreement program were injection drug users (IDUs) and crack cocaine users (CCUs). In recruiting participants, Cooperative Agreement sites adhered to a "targeted sampling" strategy developed by Watters and Biernacki (1989). Targeted sampling aspires to adduce the best possible sampling frames for street-based, hidden and fluctuating populations by mapping geographic areas of local drug use activity and HIV infection. Investigators periodically updated and plotted into the maps a number of quantitative and qualitative indicators of these public health problems, such as data on drug and prostitution arrest records, emergency room episodes, drug treatment

records, census tract information, STD data, and other epidemiological records. Such quantitatively indicated drug use activity was confirmed by ethnographic observations of the community and interviews with key local informants.

With these maps as guides, each site used street-based outreach to provide education and services and to recruit about 35 drug users each month into the intervention project. Unlike NADR, this second generation research program did not include a criterion for recruiting sex partners, but instead sought to involve a greater proportion of female drug users than had been reached in the predecessor program, especially as it had become apparent that women were more involved than men in the crack use drug scene. To this end, sites were required to have at least 30 percent of their drug user samples be women (in NADR, about 25 percent of the drug users were women). Moreover, the first 17 sites were allowed to have CCUs constitute up to 30 percent of their sample, but the six later-funded sites enlarged the proportion of crack users to 40 percent, which thereby increased their chances of recruiting women. Finally, the Women's Issues Subcommittee moved to bring female sex partners of drug users into the Cooperative Agreement research program by developing a special multi-site study on women that was conducted at three sites (Tucson AZ, Collier County FL, and Portland OR).

Experimental Design

Figure 1 displays the multi-track research design that the Steering Committee adopted to randomize assignment and provide HIV risk reduction interventions. Participants were randomly assigned at the individual or community level to receive either the Cooperative Agreement's multisite "standard intervention" of outreach and HIV counseling/testing or an enhanced, site-specific intervention.[7] The latter involved an experimental HIV intervention, the results of which could be compared with the standard. An excellent example of this type of evaluation can be found in the article by McCoy, McCoy and Lai in this volume, who found that Miami's enhanced gender- and culture-specific intervention was more effective than the Cooperative Agreement standard in helping black women reduce their drug use and increase their condom use. Note that each site's enhancement acted as an add-on to the standard; thus, all participants received the standard intervention, and about half also received an enhanced intervention.

The Standard Intervention

As discussed in the paper by Stevens, Estrada and Estrada (this volume), the standard intervention by itself appears to be an effective way to

FIGURE 1. Cooperative Agreement Study Protocol

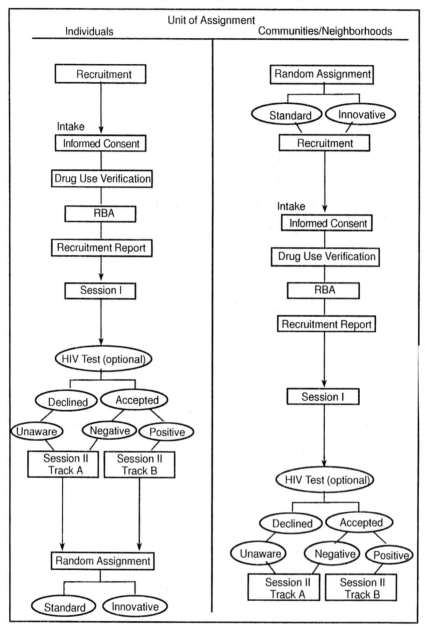

access and intervene with hard-to-reach drug using populations. The standard intervention was a multicomponent HIV risk reduction strategy involving street outreach in combination with HIV testing and counseling. Its key components are discussed below.

Outreach. During the initial stage of the intervention, outreach workers indigenous to the community delivered a set of standardized services on the streets: i.e., condom and bleach distribution, distribution of HIV-related literature, and referrals to HIV prevention agencies and drug treatment facilities, if available. They also described the NIDA-sponsored study to potential recruits. Outreach workers continued to provide the street-level services to drug users regardless of whether they entered the project, but they stopped actively trying to recruit individuals as research participants after five attempts. (Outreach workers used the Client Contact Form to track the number of times they interacted with potential clients on the street.)

Intake. The next stage of the intervention process took place in an intervention site, such as a clinic, van, storefront, or other office facility, which afforded the kind of privacy not available to drug users on the street. Eligibility criteria required that research participants were 18 years of age or older, injected drugs in the last 30 days or smoked crack cocaine in the last 48 hours, and were out of drug treatment in the last 30 days. Drug use was verified on the street by observation or in the intervention site by physical inspection of fresh needle marks ("tracks") and/or urine toxicology. Informed consent was also elicited at the intervention site.

Another part of intake involved epidemiological data collection. The Risk Behavior Assessment questionnaire was administered privately, face-to-face, following informed consent.[8] (The Risk Behavior Follow-up Assessment questionnaire was administered approximately six months thereafter.) The Client Eligibility and Assignment Form and the Client Participation Summary were also initiated at intake but, of course, were completed over the course of the intervention to monitor recruitment and delivery of services to program participants.

Pretest Counseling and HIV Testing. Theory-based risk reduction education and pretest counseling for HIV testing were provided during a 20- to 30-minute, one-on-one session in which a trained counselor-educator (not the interviewer) discussed the specifics of HIV risk reduction with the client. The content of the counseling and education session was based on fundamental principles about human behavior related to problem recognition, inducement to change, appropriate knowledge and skills, and removal of barriers and/or provision of materials needed to make change feasible (Janz & Becker, 1984; Sutton, 1982; Bandura, 1977). Basic in-

formation about HIV disease and infection was first discussed, followed by personalized, hierarchical risk reduction strategies for high-risk drug and sex behaviors. Needle cleaning and condom use were rehearsed at least twice, and bleach kits and condoms were provided. Finally, if the participant agreed, a phlebotomist drew blood by venous or finger-stick method for HIV antibody testing.[9] The HIV Coding Document was initiated to record the blood draw.

Posttest Counseling. Finally, a second HIV education and counseling session was held a few weeks after the pretest counseling (optimally within two weeks, but no more than six weeks later). This session took place either as "track A" or "track B," with track A providing counseling for persons whose HIV test results were negative, and track B providing posttest counseling for persons whose antibody results were positive (individuals who declined the blood test were also assigned to track A, which in effect became a booster session for their pretest counseling). The meaning of HIV test results was discussed at the posttest session, and risk reduction strategies/materials from the pretest session were reviewed. Results of the blood test were recorded on the HIV Coding Document and entered into the national database.

Data on Women's Drug Use and HIV Status

Between January 1992 and December 1995, Cooperative Agreement projects collected data from 14,197 IDUs and 9,297 CCUs (in this case, people who injected drugs *and* smoked crack were classified as IDUs). Women constituted 24 percent of the IDUs and 36 percent of the crack-only users. As shown in Table 3, women thus far recruited in the Cooperative Agreement program were older than those participating in NADR, with a mean overall age of 34.4 years. The mean age for IDU women was approximately 36 years, compared to 32.8 years in NADR, which suggests that the female IDU recruits in the Cooperative Agreement program may be part of the same birth cohort as those participating in the earlier program. In addition, more than three quarters of the female recruits in the Cooperative Agreement program reported using crack cocaine–some smoking crack to the exclusion of injection drug use, others involved in both kinds of drug use. The majority of non-crack using IDUs were white women. Among IDUs who also smoked crack, black women constituted the largest group. Black women were also the largest group of crack-only users.

Table 3 also shows the sex risk profile of women in the Cooperative Agreement program. Relative to NADR women, this profile suggests a lower risk for HIV infection through unprotected sexual intercourse. Proportionately fewer women in the second generation program tested posi-

TABLE 3. Selected Demographic and HIV Risk Characteristics of Women in the Cooperative Agreement

	Total Women (n = 7,054)	IDU Women (n = 1,517) (21.5%)	IDU + Crack Using Women (n = 2,021) (28.7%)	Crack Using Women (n = 3,516) (49.8%)
Mean age	34.4 years	36.2 years	35.8 years	32.9 years
Ethnicity	n (%)	n (%)	n (%)	n (%)
Black	4,151(58.8%)	426(28.1%)	1,139(56.4%)	2,586(73.6%)
White	1,254(17.8%)	556(36.7%)	408(20.2%)	290 (8.3%)
Hispanic	1,303(18.5%)	440(29.0%)	371(18.4%)	491(14.0%)
Mexican Am.	534 (7.6%)	259(17.1%)	143 (7.1%)	132 (3.8%)
Puerto Rican	665 (9.4%)	146 (9.6%)	194 (9.6%)	324 (9.2%)
Other Hisp.	104 (1.5%)	35 (2.3%)	34 (1.7%)	35 (1.0%)
Other[a]	347 (4.9%)	95 (6.3%)	103 (5.1%)	149 (4.2%)
History of IDU[b]	3,925(72.1%)	1,517(100.0%)	2,021(100.0%)	387(20.3%)
Mean unprotected sex acts in last 30 days [s.d.][c]				
Vaginal	9.7 [16.5]	10.0 [13.9]	10.2 [16.3]	9.2 [17.5]
Oral	14.7 [27.8]	15.0 [27.3]	16.4 [28.1]	13.4 [27.9]
Anal	2.7 [4.3]	1.8 [2.0]	3.6 [5.4]	2.5 [4.1]
Exchanged sex for money or drugs in last 30 days[b]	2,031(35.6%)	240(21.9%)	669(40.9%)	1,122(37.7%)
Tested for HIV	5,817(82.5%)	1,212(79.9%)	1,661(82.2%)	2,943(83.7%)
HIV positive	621(10.7%)	113 (9.3%)	221(13.3%)	287 (9.8%)

[a] *Includes Native American/Alaskan, Asian/Pacific Islander, and unknown/refused.*
[b] *Missing values excluded when calculating percentages.*
[c] *Among those who were sexually active.*

tive for HIV antibodies (10.7 percent) than they did in NADR (14.0 percent). With respect to IDUs, 9.3 percent of Cooperative Agreement women were seropositive at baseline, compared with 17.8 percent in NADR. Although fewer unprotected sex contacts in the second program may play a role in the lower rates, the rates themselves should be interpreted cautiously given the differences in program sites as well as differences in the proportions of women being tested. Relative to the Cooperative Agreement, proportionately more sites in NADR were in cities where the virus was reported early in the epidemic. Moreover, although proportionately fewer women in NADR were tested for HIV than in the Cooperative Agreement (47 percent vs. 83 percent), it is possible that those who

refused testing in the second program did so because they already knew they were HIV-positive. Unfortunately, we do not have the data to explore this possibility more fully.

The Cooperative Agreement program does, however, provide data about women CCUs, who were not eligible for inclusion in the NADR program. In the Cooperative Agreement, HIV seroprevalence among "crack-only" using women was 9.8 percent, and among women who smoked crack as well as injected drugs it was 13.3 percent. The higher crack-related rates relative to IDU rates may be due to CCUs' more extensive practice of sex exchange (noted earlier by Edlin et al., 1994, and others), which occurred 70 percent more often than it did among injection-only drug users (see Table 3).

As mentioned earlier, six sites that were funded later than the others had the option of modifying the Cooperative Agreement research protocol for a smaller multisite study that will probably include a greater proportion of women than the earlier design. These six sites adjusted their sampling quotas so that up to 40 percent of their recruits would be noninjection crack users. Given the larger number of crack smokers at many of these six sites, they also modified the standardized counseling sessions to place more emphasis on the reduction of sex-related HIV risks and to bypass the needle cleaning rehearsals if subjects reported no history of injection drug use. Finally, they appended new items to the behavioral data collection forms to capture more historical background information on drug use and sex practices, including use of the female condom.

Another expansion of data collection on women was made by the Women's Issues Subcommittee to the Cooperative Agreement Steering Committee, whose members collaborated to develop two standardized instruments for a small substudy. The Women's Supplement Questionnaire and Women's Supplement Follow-up Questionnaire were created to collect data on female drug users' perceived norms of sexual behavior and drug use; social support; access to economic and other resources; sexual decision making; attitudes toward men; and histories of sexual and physical abuse. Investigators in Tucson, Portland, and Collier County also used these instruments to collect similar data from female sex partners of drug users. A paper in this volume by He, McCoy, Stevens and Stark discusses the substudy's findings on the sex risk practices of female sex partners of drug users as they are related to physical and sexual abuse.

In terms of intervention effects, results from the Cooperative Agreement research program have only begun to be analyzed and published. While many of the sites have completed data collection, others are still in the process of gathering data, and thus their findings are often still preliminary.

Two of the 13 papers in this volume focus on program effects on women's risk and protective behaviors; the others present epidemiological data on women's HIV risk. In the section *HIV Risk Behavior Change of Female Drug Users,* two papers discuss women's ability to change their HIV risk behaviors. Both papers investigate the effects of HIV interventions on women's HIV-related sex practices–one at the site level and the other at the national level. *Single Site Descriptions* describes two geographically different Cooperative Agreement sites: Hartford CT, and Anchorage AK. The similarities and differences in the women enrolled at each site are notable, as is the type of research conducted by each team of investigators. *Contextual Variables in Women's HIV Risk Behaviors* includes four articles that focus on factors at the community, interpersonal, and personal level that affect women's risk taking–community size, living arrangements, violence in sex partner relationships, and beliefs about condom use. One paper on male-female differences in risks for HIV and other sexually transmitted diseases makes up the next section, *Gender Differences in HIV Risk Behavior and Health Status of Drug Users.* One of these gender differences involves exchanging sex for drugs or money, a phenomenon which is also the focus of the following section, *A Unique Population of Women at Risk.* The latter presents two papers showing how sex exchange plays a critical role in drug using women's risk for HIV.

Clearly, much has been learned about women's drug use and HIV risks, such as women's greater involvement in cocaine use and in sex exchange relative to men. While this in itself marks progress, the accumulating knowledge base must be used productively and creatively if we are to avert new disease infection among women. The high number of new HIV infections occurring in women drug users, their sex partners, and their children makes it incumbent upon us to continue to develop, adapt, and implement risk reduction interventions that are responsive and effective if lives are to be spared.

NOTES

1. In comparison, 22 percent of AIDS cases in men were related to injection drug use, and 1 percent stemmed from heterosexual contact with IDUs (CDC, 1996).

2. Racial/ethnic terminology is sensitive to historical changes in preferences. Although "African American" is generally preferred at this time, the term "black" is used here to comport with the item on the survey questionnaire used to classify respondents. "Black" is also inclusive of non-American citizens (e.g., Caribbean or African nationals) who participated in the program.

3. Fewer than half (47 percent) were tested, which may have biased the prevalence rates reported here.

4. Some investigators did use the randomized trial to test the hypothesis that more intensive sessions would produce a greater amount of behavior change than basic sessions would. For example, Siegal and colleagues (1995) found that IDUs assigned to an enhanced intervention were more likely to use new needles than IDUs in a basic program; regardless of intervention assignment, however, 16 percent of IDUs in both groups initiated the practice of always cleaning syringes before injection. Colon, Sahai, Robles and Matos (1995) found similar results. Additionally, Stephens, Simpson, Coyle and McCoy (1993) observed that increased exposure time in an intervention (rather than intervention assignment *per se*) was a significant predictor in inducing or maintaining low levels of injection frequency and reducing risky needle practices.

5. In addition to the subcommittees, a number of workgroups were also formed on an *ad hoc* basis to address short-term or late-breaking issues.

6. All client-related data are protected as confidential under the authority of the Public Health Service Act.

7. As seen in Figure 1, if a site chose to assign individuals (or networks), randomization occurred following the completion of the second HIV counseling session. If sites chose to assign communities (neighborhoods, census tracts), randomization occurred prior to outreach and recruitment.

8. Psychometric tests of the RBA have shown the instrument to be both reliable and valid (Needle et al., 1995; Weatherby et al., 1994).

9. At year end 1995, about 82 percent of participants had elected to be tested for HIV at intake into the study (testing was offered again at follow-up to individuals who tested seronegative or did not get tested at baseline).

REFERENCES

Andersen, M.D., Smereck, G.A.D., & Braunstein, M.S. (1993). LIGHT model: An effective intervention model to change high-risk AIDS behaviors among hard-to-reach urban drug users. *American Journal of Drug & Alcohol Abuse, 19,* 309-325.

Bandura, A. (1977). *Social Learning Theory.* Englewood Cliffs, NJ: Prentice-Hall.

Camacho, L.M., Williams, M.L., Vogtsberger, K.N., & Simpson, D.D. (1995). Cognitive readiness of drug injectors to reduce AIDS risks. *American Journal on Addictions, 4,* 49-55.

Centers for Disease Control and Prevention. (1996). *HIV/AIDS Surveillance Report,* Midyear edition, *8*(1).

Colon, H.M., Robles, R.R., Freeman, D., & Matos, T. (1993) Effects of HIV risk reduction education program among injection drug users in Puerto Rico. *Puerto Rico Health Sciences Journal, 12,* 27-34.

Colon, H.M., Sahai, H., Robles, R.R., & Matos, T.D. (1995). Effects of a community outreach program in HIV risk behaviors among injection drug users in San Juan, Puerto Rico: An analysis of trends. *AIDS Education and Prevention, 7,* 195-205.

Deren, S., Davis, W.R., Beardsley, M., Tortu, S., & Clatts, M. (1995). Outcomes of a risk reduction intervention with high risk populations: The Harlem AIDS project, *AIDS Education and Prevention, 7,* 379-390.

Deren, S., Davis, W.R., Tortu, S., Beardsley, M., & Ahluwalia, I. (1995). Women at high risk for HIV: Pregnancy and risk behaviors. *Journal of Drug Issues, 25,* 57-71.

Edlin, B.R., Irwin, K.L., Faruque, S., McCoy, C.B., Word, C., Serrano, Y., Inciardi, J.A., Bowser, B.P., Schilling, R.F., Holmberg, S.D., & the Multicenter Crack Cocaine and HIV Infection Study Team (1994). Intersecting epidemics– Crack cocaine use and HIV infection among inner-city youth. *The New England Journal of Medicine, 331*(21), 1422-1427.

Friedman, S.R., Neaigus, A., Des Jarlais, D.C., Sotheran, J.L., Woods, J., Sufian, M., Stepherson, B., & Sterk, C. (1992). Social interventions against AIDS among injecting drug users. *British Journal of Addiction, 87,* 393-404.

Holmberg, S. (1996). The estimated prevalence and incidence of HIV in 96 large US metropolitan areas. *American Journal of Public Health, 86,* 642-654.

Janz, N.K., & Becker, M.H. (1984). The health belief model: A decade later. *Health Education Quarterly, 11,* 1-47.

Neaigus, A., Sufian, M., Friedman, S.R., Goldsmith, D.S., Stepherson, B., Mota, P., Pascal, J., & Des Jarlais, D.C. (1990). Effects of outreach intervention on risk reduction among intravenous drug users. *AIDS Education and Prevention, 2,* 253-271.

Needle, R., Fisher, D.G., Weatherby, N., Chitwood, D., Brown, B.S., Cesari, H., Booth, R., Williams, M.L., Watters, J., Andersen, M., & Braunstein, M. (1995). Reliability of self-reported HIV risk behaviors of drug users. *Psychology of Addictive Behaviors, 9,* 242-250.

Rhodes, F., Wolitski, R.J., & Thornton-Johnson, S. (1992). An experiential program to reduce AIDS risk among female sex partners of injection-drug users. *Health and Social Work, 17,* 261-272.

Siegal, H.A., Falck, R.S., Carlson, R.G., & Wang, J. (1995). Reducing HIV needle risk behaviors among injection-drug users in the midwest: An evaluation of the efficacy of standard and enhanced interventions. *AIDS Education and Prevention, 7,* 308-319.

Simpson, D.D., Camacho, L.M., Vogtsberger, K.N., Williams, M.L., Stephens, R.C., Jones, A., & Watson, D. (1994). Reducing AIDS risks through community outreach interventions for drug injectors. *Psychology of Addictive Behaviors, 8,* 86-101.

Stephens, R.C., Feucht, T.E., & Roman, S.W. (1991). Effects of an intervention program on AIDS-related drug and needle behavior among intravenous drug users. *American Journal of Public Health, 81,* 568-571.

Stephens, R.C., Simpson, D.D., Coyle, S.L., McCoy, C.B. & the National AIDS Research Consortium (1993). Comparative effectiveness of NADR interventions. In B.S. Brown & G.M. Beschner (Eds.), *Handbook on Risk of AIDS: Injection Drug Users and Sexual Partners* (pp. 519-556). Westport, CT: Greenwood Press.

Sutton, S.R. (1982). Fear-arousing communications: A critical examination of theory and research. In J.R. Eiser (Ed.), *Social Psychology and Behavioral Medicine*. New York: John Wiley & Sons.

United Nations (1996). *UNAIDS and WHO: The HIV/AIDS Situation in Mid 1996*. Fact Sheet, July.

Watters, J., & Biernacki, P. (1989). Targeted sampling: Options for the study of hidden populations. *Social Problems, 36,* 416-430.

Weatherby, N.L., Needle, R., Cesari, H., Booth, R., McCoy, C. B., Watters, J.K., Williams, M.L., & Chitwood, D.D. (1994). Validity of self-reported drug use among injection drug users and crack cocaine users recruited through street outreach. *Evaluation and Program Planning, 17,* 347-355.

Wechsberg, W.M., Cavanaugh, E.R., & Dunteman, G.H. (1994). Changing needle practices in community outreach and methadone treatment. *Evaluation and Program Planning, 17*(4):371-379.

Women Drug Users and HIV Prevention: Overview of Findings and Research Needs

Sally J. Stevens, PhD
Stephanie Tortu, PhD
Susan L. Coyle, PhD

The selected concerns and research findings presented in this special collection on drug involved women and HIV are numerous and complex. Descriptions of the drug use patterns, HIV seroprevalence levels, drug and sex risk behaviors, as well as the contextual variables that play an important part in the lives of women at risk for HIV, differ across the various cities in which the Cooperative Agreement sites are located. The variables that impact women's HIV risk-taking behavior include those at the individual level and relationship level as well as those at the broader social environmental level. Variables at the individual level include, for example, women's perception of risk. Research conducted in Connecticut by Singer et al. (this volume) demonstrates that women who perceived themselves to be at low risk actually engaged in greater HIV risk behavior. Also, those

Sally Stevens is Associate Research Professor, Southwest Institute for Research on Women, University of Arizona, Tucson, AZ. Stephanie Tortu is Principal Investigator, National Development and Research Institutes, Inc., NY. Susan L. Coyle is Health Scientist Administrator, Community Research Branch, National Institute on Drug Abuse, Washington, DC.

This research was funded by the National Institute on Drug Abuse, Community Research Branch.

[Haworth co-indexing entry note]: "Women Drug Users and HIV Prevention: Overview of Findings and Research Needs." Stevens, Sally J., Stephanie Tortu, and Susan L. Coyle. Co-published simultaneously in *Women & Health* (The Haworth Medical Press, an imprint of The Haworth Press, Inc.) Vol. 27, No. 1/2, 1998, pp. 19-23; and: *Women, Drug Use, and HIV Infection* (ed: Sally J. Stevens, Stephanie Tortu, and Susan L. Coyle) The Haworth Medical Press, an imprint of The Haworth Press, Inc., 1998, pp. 19-23. Single or multiple copies of this article are available for a fee from The Haworth Document Delivery Service [1-800-342-9678, 9:00 a.m. - 5:00 p.m. (EST). E-mail address: getinfo@haworthpressinc.com].

who perceived themselves at low risk were more socially isolated. Research on women's living arrangements conducted by Metsch et al. (this volume) shows that women who live alone engage in greater risk behaviors on some needle risks (i.e., using a reused needle, injecting in a shooting gallery), and report higher levels on some sexual risks (i.e., exchanging sex for drugs, exchanging sex for money).

Variables that impact women's HIV risk behaviors include the type of relationship in which women are involved. Research reported by Fenaughty et al. (this volume) found that when Alaskan Native women engaged in sex with white men, condoms were used significantly less often than in those reported by other pairings. In a study conducted in Long Beach, California and New York City, Wood et al. (this volume) found that among women, cognitive factors (i.e., condom beliefs and intentions) as well as behaviors associated with condom use varied depending upon whether their sex partner was a main or paying partner. Additionally, research reported by He et al. (this volume) indicates that women who have experienced abuse or threat of abuse (including rape) in their intimate relationships report higher levels of sex risk behaviors. Moreover, women who reported having been sexually molested prior to the age of 13 years also reported higher levels of some sex risk behaviors.

Broader social environmental variables including cultural norms have been found to impact women's HIV risk behavior. In Kentucky, preliminary data presented by Cattarello et al. (this volume) indicates that HIV risks of women differ depending on the size and type of city in which they live. When comparing two cities with high seroprevalence in different states (Miami, FL and New York), Tortu, McCoy et al. (this volume) found several differences in sociodemographic characteristics and drug use between women enrolled in these respective Cooperative Agreement sites.

While numerous factors have been shown to affect women's HIV risk-taking behavior, drug use and risk behaviors have also been shown to differ between men and women. Tortu, Goldstein et al. (this volume) examined gender differences in New York. Women reported using crack more frequently, while men more frequently reported using crack *and* injection drugs. With regard to sex risks, women reported having more sex partners. Thus, while men may be exposed more frequently to risk from injection, the sources of women's risk include both their own sex and drug behaviors as well as indirectly related risks stemming from the male's injection behavior.

In spite of the fact that women enrolled in the Cooperative Agreement reported high levels of a variety of sex and drug risk behaviors, research

presented by Weeks et al. (this volume) indicates that women are concerned about becoming infected with HIV. The women interviewed in this study reported using numerous approaches to address multiple HIV risks, often using creative efforts to avoid becoming infected. Additionally, as presented by Stevens et al. (this volume), women are responsive to HIV interventions and are capable of reducing both sex and drug risk behaviors. Six-month post intervention follow-up data on the national sample indicated significant reduction in risk by women who participated in the Cooperative Agreement standard intervention. Moreover, culture- and gender-specific enhanced interventions, as tested in Miami by McCoy et al. (this volume), indicate that greater reductions in risk can be achieved by interventions that are targeted to specific risk populations.

While a number of women have participated in community-based HIV outreach and intervention programs such as the ones described in this volume, we recognize that recruitment and retention strategies for HIV prevention have often been designed for "average" drug users, which, in the short history of drug abuse research, has meant for men. With increasing and disproportionate numbers of women acquiring HIV disease, we need to widen our focus on HIV risk and protective behaviors, including risk-taking contexts which may be specific to women. This means encouraging not only gender-sensitive recruitment strategies for women but also encouraging basic and applied HIV behavioral and social research aimed at understanding and preventing HIV infection in women whose drug and sex practices put them at high risk (i.e., IDUs, CCUs, injecting and non-injecting sexual partners of male and/or female IDUs, and women who trade sex for drugs, money, or subsistence).

To respond to such needs, NIDA recently released a program announcement "Women's HIV Risk and Protective Behaviors." This announcement addresses women's multiple sources and levels of HIV risk stemming from drug and sexual practices. As the research in this volume and elsewhere has shown, drug-dependent women not only engage in injection-related risks, but they are more likely than men to engage in high-risk sex; indeed women IDUs are more likely than men to acquire HIV sexually (Ickovics & Rodin, 1992; Haverkos, 1993). Moreover, violence in the lives of women has been associated with HIV risk behaviors (see He et al., this volume) and more research is needed on the strength and the direction of linkages between violence and women's HIV-related drug and sex risk taking as well as women's ability to adopt risk reduction strategies. Some women face not only interpersonal subordination but structural second-class status as well, such as having fewer drug treatment slots or economic opportunities relative to men, which in turn affects

women's risk taking when it comes to sharing drugs or drug paraphernalia and negotiating sexual practices. Risk reduction on an individual level must be complemented by major structural change if the epidemic is to be effectively addressed for women. In addition, there are issues relating specifically to women's sexuality such as pregnancy, child bearing, and contraceptive practices that are not routinely investigated within the context of HIV/AIDS research. Such issues warrant greater attention in terms of how these conditions might affect risk behavior maintenance and/or adoption of protective behaviors.

Finally, research is needed on interventions tailored to gender-specific HIV risks and protective factors, whether at the level of the individual, the couple, the group, or the larger social environment. At the individual level, gender-sensitive intervention strategies may address women's needs for skills building, appropriate prevention messages and messengers, and access to woman-controlled technologies (such as the female condom or microbicides). At the partnership or relationship level, women may need help with negotiation and communication skills, or in dealing with coercion or violence. In addition, more attention needs to be paid to the role of the male drug injector in heterosexual transmission of HIV, as there has been a tendency to place the responsibility of condom use on women. In settings where condom use by men has been mandated (i.e., brothels in Nevada and Thailand), there has been some success in preventing transmission of HIV and other sexually transmitted diseases (Albert et al., 1995; Rojanapithayakorn, 1994). Normative change with respect to safer injection practices might be effected by intervening at the level of the drug using network, and structural change may be needed to open up community treatment slots or make community risk reduction projects, such as syringe exchanges, more accessible to women.

Of course, women are not a homogenous group. As the papers in this volume have documented, there are numerous intergroup differences in risk profiles, sexual relationships, life situations, perceptions of risk, access to resources, and structural settings. Further research is needed on such matters as racial/ethnic diversity, differences between women who have heterosexual contacts only and those who have bisexual contacts, differences between women sex exchangers and non-exchangers, and comparisons between women from different age groups. Understanding differences as well as similarities among women will be critically important if we hope to effectively reduce the multiple sources of women's HIV risk.

REFERENCES

Albert, A.E., Warner, D.L., Hatcher, R.A., Trussell, J. & Bennett, C. (1995). Condom use among female commercial sex workers in Nevada's legal brothels. *Am J Public Health, 85*(11):1514-1520.

Haverkos, H.W. (1993). Reported cases of AIDS: An update. *New England Journal of Medicine, 329*(7):511.

Ickovics, J. & Rodin, J. (1992). Women and AIDS in the United States: Epidemiology, natural history and mediating mechanism. *Health Psychology, 11,* 1-16.

Rojanapithayakorn, W. (1994). *100% condom-use initiative in Thailand: An update.* Presented at the Ad Hoc Technical Advisory Meeting on HIV Prevention Research. Geneva: May.

HIV RISK BEHAVIOR CHANGE
OF FEMALE DRUG USERS

HIV Sex and Drug Risk Behavior
and Behavior Change
in a National Sample of Injection Drug
and Crack Cocaine Using Women

Sally J. Stevens, PhD
Antonio L. Estrada, PhD
Barbara D. Estrada, MS

SUMMARY. This paper describes HIV sex and drug risk behavior and behavior change of injection drug and crack cocaine using women enrolled in a national multi-site Cooperative Agreement pro-

Sally J. Stevens and Barbara D. Estrada are affiliated with Southwest Institute for Research on Women, University of Arizona. Antonio L. Estrada is affiliated with Mexican American Studies, University of Arizona.

This research was supported by the National Institute on Drug Abuse, Community Research Branch.

[Haworth co-indexing entry note]: "HIV Sex and Drug Risk Behavior and Behavior Change in a National Sample of Injection Drug and Crack Cocaine Using Women." Stevens, Sally J., Antonio L. Estrada, and Barbara D. Estrada. Co-published simultaneously in *Women & Health* (The Haworth Medical Press, an imprint of The Haworth Press, Inc.) Vol. 27, No. 1/2, 1998, pp. 25-48; and: *Women, Drug Use, and HIV Infection* (ed: Sally J. Stevens, Stephanie Tortu, and Susan L. Coyle) The Haworth Medical Press, an imprint of The Haworth Press, Inc., 1998, pp. 25-48. Single or multiple copies of this article are available for a fee from The Haworth Document Delivery Service [1-800-342-9678, 9:00 a.m. - 5:00 p.m. (EST). E-mail address: getinfo@haworthpressinc.com].

gram. Baseline data on the 1,403 women who were randomly assigned to a two session intervention that was standardized across sites indicate that sex and drug risk behavior for becoming infected with HIV was considerable. Six-month post intervention follow-up data for the same sample of women show that significant reductions in sex and drug risk behavior were observed for the entire sample of women for the risk variables under study. Significant reductions were also demonstrated for various sub-groups of women enrolled in the study on most of the sex and drug risk variables. Given these findings, it appears that the standard intervention was effective in assisting drug using women reduce their behaviors that put them at risk of becoming infected with HIV. Further research is needed on the development and evaluation of HIV interventions that target specific risk behaviors and various HIV risk behavior profiles of women. *[Article copies available for a fee from The Haworth Document Delivery Service: 1-800-342-9678. E-mail address: getinfo@haworthpressinc.com]*

INTRODUCTION

From a historical perspective the human immunodeficiency virus (HIV) epidemic is still young. In spite of its youth this epidemic has had a dramatic impact on the lives of individuals, families and communities around the world. In the United States (US), HIV was originally identified in homosexual men. Recent trends, however, indicate that HIV has increasingly affected women. In 1981-1982, women constituted 4% of AIDS cases reported in the U.S. By December 1995, they comprised 14% of all AIDS cases ever reported in the U.S. (Amaro, 1995), and 19% of all the cases diagnosed in 1995 (Centers for Disease Control and Prevention [CDC], 1995). With these recent increases women now constitute one of the fastest growing populations becoming infected with HIV. Many of the women becoming infected report sex and/or drug behaviors that put them at risk for HIV infection.

Sex Related HIV Risks

Studies with drug using women who are not in drug treatment indicate high levels of sex risk behaviors that are related to the transmission of HIV (Dwyer, Richardson, Ross, Wodak & Miller, 1994; Inciardi, 1994; McCoy & Inciardi, 1993). Sex risk behaviors include behaviors such as the number of sex partners (Stevens, Estrada, Polk & Erickson, 1994), unprotected sex (Booth, Watters & Chitwood, 1993; Catania et al., 1992; Tortu, Beardsley, Deren & Davis, 1994), trading sex for money or drugs (Tortu et al.,

1994; Wechsberg, Dennis & Stevens, 1996), and sex with an injection drug user (Ramos, 1995; Wortley, Chu & Berkelman, 1997). Additionally, the presence of a sexually transmitted disease (STD) has been positively associated with risk of HIV infection (Laga, Manoka, Kivuvu, Malele & Piot, 1993; Seidlin, Vogler, Lee, Lee & Dubin, 1993).

Unfortunately, the number of women who become infected with AIDS as a result of having sex with an infected man is likely to continue for a number of reasons. First, there are still more infected men than women, thus increasing the relative probability that within heterosexual relationships a woman would have an infected man as a sexual partner. When considering women who have developed AIDS as a result of heterosexual intercourse, 40% reported that their sexual partner was a bisexual man. Moreover, data from men who identify themselves as homosexual suggest that more than a quarter of these men had recently engaged in sex with a woman (Chu, Peterman, Doll, Buehler & Curran, 1992). Secondly, women are more likely to be infected by a man than a man is likely to be infected by a woman (Padian, Shiboski & Jewell, 1990) because of the relative efficiency of the virus transmitting from male to female. Finally, many women report being unable to control condom use or even sexual activity, including when they have sex and what kind of sex they have (Gama & Ruiz, 1994; Inciardi, Lockwood & Pottieger, 1993). Women who fear that their sexual partner may become angry or violent often report feeling pressured to acquiesce to their partner's demand for unsafe sex (Stuntzner-Gibson, 1991). Consequently, protection against AIDS for some women is out of their control.

Drug Related HIV Risks

Drug related HIV risk behaviors consist of behaviors that are both directly and indirectly related to drug use. Risk behaviors that are directly related to drug use include behaviors such as the frequency of injection (Blattner, Biggar, Wiess, Melbye & Goedert, 1985; Des Jarlais & Friedman, 1987), and the sharing of contaminated needles and other equipment used for the preparation and injection of drugs (Des Jarlais, Friedman & Woods, 1990; Koester, 1994). Risk behaviors that are indirectly related to drug use include the use of noninjection drugs. Many of the drugs used by women, particularly crack cocaine, have been found to influence sexual behavior and functioning including a reduction of inhibition and a propensity toward risky sexual behavior (i.e., multiple sexual partners, unprotected sex) that is associated with HIV infection (Bowser, 1989; Fullilove, Fullilove, Bowser & Gross, 1990; Inciardi, 1994; Inciardi, Lockwood & Pottieger, 1993; Trapido, Lewis & Comerford, 1990). Additionally, drug

use with or during sex may impede decision making regarding condom use or impede coordination skills for putting on and/or removing a condom (Stevens, Ruiz, Romero & Gama, 1995). Furthermore, women who have sex with male IDUs are at risk for becoming infected with HIV not only from injection related risk but from sexual risks as well (Erickson, Estrada & Stevens, 1990; Stevens, Gama, Polk & Estrada, 1995; Tortu et al., 1994).

Studies on gender differences in drug related HIV risk behaviors often indicate that drug using women report higher levels of risk than men. Female IDUs report sharing needles more frequently than men (Dwyer et al., 1994; Wechsberg, Dennis & Ying, 1995) and report having more sexual partners who were IDUs (Dwyer et al., 1994). Women who are dependent upon men for drugs and injection drug equipment often inject *after* the man in a drug injection episode (Su et al., 1996). Furthermore, crack cocaine using women often report having unprotected sex in exchange for crack cocaine (De Groff & Stevens, 1992). While both men and women who engage in sex for crack report having numerous sex partners, women often report significantly more sexual partners than men (Inciardi, 1995).

Considering the dramatic increase in the number of women who are developing AIDS through sex and/or drug related HIV risk behavior, it is important that these behaviors are identified and appropriate and effective risk reduction interventions are developed. It is with this purpose that this paper is written. This paper describes HIV sex and drug risk behavior and behavior change of injection drug (IDUs) and crack cocaine (CCUs) using women from 21 of the National Institute on Drug Abuse (NIDA) Cooperative Agreement sites. Three main questions are examined. First, what are the demographic characteristics and the HIV sex and drug risk behaviors of the women who participated in the study? Second, are HIV risk behaviors different for women who report having only one sex partner (single sex partners) from those who report multiple sexual partners, or, between women who are IDUs and women who are CCUs? And third, did reduction of HIV sex and drug risk behavior occur between the initial interview and the six-month follow-up interview? If significant reduction in risk behavior was reported, for whom did this occur?

METHOD

This study was funded by the National Institute on Drug Abuse, Community Research Branch (NIDA/CRB). Data for this paper includes data sent to the national database (December, 1995) from 21 Cooperative

Agreement sites. Potential subjects who met entrance criteria were given a baseline questionnaire: the Risk Behavior Assessment (RBA) which addressed both HIV sex and drug risk behaviors (see Coyle, this volume). After the interview subjects participated in an HIV prevention education session that included HIV counseling and testing. Two weeks later the subjects returned for their HIV test results and were then randomly assigned to either a "Standard" or to an "Enhanced" intervention. Standard subjects were told that they were finished with the intervention, given advice or help with social service agency referrals and asked to return in six months for their Risk Behavior Follow-up Assessment (RBFA) interview. Subjects assigned to the Enhanced intervention were asked to participate in additional intervention activities. The Enhanced intervention varied between sites, each site designing their own intervention based on various theoretical models of behavior change. The Standard intervention was developed by a team of Cooperative Agreement investigators and was used by all of the participating sites.

SAMPLE

All women included in the study were either IDUs and/or CCUs. Recent drug use was verified by observation of recent needle track marks (for IDUs) and/or positive urinalysis results for heroin or cocaine. A total of 1,403 women from the 21 Cooperative Agreement sites who were assigned to the Standard intervention completed both the RBA and RBFA. Because only the Standard intervention was consistent across sites, data from only those who were assigned to the Standard and who had both an RBA and an RBFA were included in the analysis.

RESULTS

The first question that this study addressed concerns the baseline demographic and HIV sex and drug risk behaviors of the women who participated in the study. Table 1 describes the demographic characteristics of the 1,403 women. The three main ethnic groups included women who were Black (55.1%), White (20.0%) and Hispanic (18.4%). Most of the women (84.2%) were between the ages of 25 and 44 years. Only 20.6% were legally married or considered themselves married by common-law. Most of the women either lived in their own house or apartment (46.9%), or in someone else's house or apartment. Over half of the women (55.3%) had a minimum of a high school education or equivalent.

TABLE 1. Demographic Characteristics

Characteristics	n	%
Race/Ethnicity:		
Black	773	55.1
White	281	20.0
Hispanic	258	18.4
Native American	80	5.7
Asian/Pacific Is.	2	0.1
Other	9	0.6
Age:		
18-24	91	6.5
25-34	550	39.2
35-44	631	45.0
> 45	131	9.3
Marital Status:		
Single	553	39.5
Separated	186	13.3
Divorced	168	12.0
Common-Law	165	11.8
Opp sex partner	133	9.5
Married	123	8.8
Widowed	56	4.0
Same sex partner	17	1.2
Living arrangement:		
Own house or appt.	657	46.9
Someone else's house/appt.	589	42.0
Hotel	50	3.6
Shelter/welfare house	50	3.6
Streets	41	2.9
R & B; halfway house	19	1.4
Other	17	1.2
Education:		
< 8th grade	98	7.0
9th grade to < high school	529	37.7
High school graduate	318	22.7
GED	134	9.6
Trade/technical school	51	3.6
Some college	210	15.0
College grad.	62	4.4

Table 2 describes the HIV sex and drug risk behaviors reported. At baseline, 17.9% of the women reported that they did not have sex in the previous 30 days. Over half (54.1%) reported having one sex partner and 28.0% reported having more than one sex partner. Approximately one-

TABLE 2. Baseline HIV Sex and Drug Risk Variables: Total Sample (Past 30 Days)

Risk Behavior	n	%
Number of sex partners		
None	250	17.9
One	756	54.1
> One	392	28.0
Number of IDU sex partners		
None	909	65.7
≥ One	475	34.3
Drug use with/during sex		
Alcohol	496	35.5
Marijuana	205	14.7
Cocaine	153	10.9
Heroin	263	18.8
Speedball	105	7.5
Number of times had sex		
None	252	18.0
One to ten	572	40.9
Eleven to 30	324	23.3
> 30	249	17.8
Number of times had unprotected sex		
None	353	25.4
One to ten	549	39.4
Eleven to 30	293	21.1
> 30	197	14.1
Proportion of unprotected sex		
Never (.00)	364	25.9
≤ .50	118	8.5
.51-.99	148	10.5
Always (1.00)	773	55.1
Ever have an STD		
Yes	1108	79.0
No	295	21.0

TABLE 2 (continued)

Risk Behavior	n	%
Number of times injected		
None	659	47.1
1-60	439	31.3
> 60	302	21.6
Number of times used bleach to clean needles		
Never	126	39.7
≤ half the time	38	12.0
> half the time	41	13.0
Always	112	35.3
Number of times used used works		
None	1071	76.8
One to 10	176	12.6
> 10	148	10.6
Number of times used crack		
None	351	25.4
One to 30	632	45.7
31 to 90	192	13.9
> 90	208	15.0
Number of days used crack		
None	323	23.0
One to 15	527	37.6
16 to 30	552	39.4

third (34.3%) reported having had sex with an IDU. The most frequent drug used with or during sex was alcohol which was reported by 35.5% of the women. The majority of the women (64.2%) had sex one to 30 times during the past 30 days; and about equal percentages reported not having sex (18.0%)[1] and having sex over 30 times (17.8%). A quarter of the women (25.4%) reported never having unprotected sex. However, when omitting the 18.0% who did not have sex, the percentage drops to 8.9%. The proportion of sex that was always unprotected was 55.1%. Again, this percentage would increase if those who did not have sex were removed

1. This percentage (18.0%) differs from the percentage (17.9%) who reported not having a sex partner during the previous 30 days because the total number of respondents to each respective question differed.

from the calculation. With regard to STDs, 79.0% of the women reported having some type of STD sometime in their lifetime.

All of the women in the study had either used injection drugs or crack cocaine in the previous 30 days. Over half (52.9%) reported injecting drugs. Of those who did inject, 40.8% injected more than 60 times in the previous 30 days. For those who reported using needles that had been used by someone else, only 35.3% always used bleach to clean needles prior to injecting. Approximately one quarter (23.2%) of those who injected drugs reported using works that they knew had been used by someone else.

Almost three quarters (74.6%) of the women reported using crack cocaine in the previous 30 days, and 39.4% reported using crack at least 16 days out of the past 30.

A second question posed is whether baseline HIV risk behaviors were different between (1) single versus multiple sexual partners and (2) IDUs versus CCUs. To address this question, women assigned to the Standard intervention who had completed an RBA and an RBFA were first divided into two groups.

A two-part analysis using eight sex risk variables and five drug risk variables compared women who reported having one sex partner with those who reported having multiple sexual partners during the 30 days prior to the RBA. One of the drug related variables is actually a protective behavior, i.e., the proportion of times using bleach to clean needles. The intervention is intended to increase this behavior while decreasing all the other specified variables. Again, data from only the women who were randomly assigned to the Standard intervention and who had both an RBA and RBFA were included. Results, reported in Table 3, indicate that women who had multiple sexual partners demonstrated greater risk than those with one sexual partner on seven of the eight sex risk variables including: the number of sex partners; number of IDU sex partners; number of times used any drug before or during sex; number of times exchanged sex for money or drugs; number of times had sex; the number of times had unprotected sex; and the number of STDs in lifetime ($p \leq .021$). Women who had a single sex partner reported greater risk on one sex risk variable: the proportion of unprotected sex ($p < .000$). With regard to the five drug risk variables, women with multiple sex partners reported greater risk on two variables: the number of times used crack and the number of days used crack ($p < .000$).

A second, two-part analysis using the same eight sex risk variables compared female IDUs with female CCUs. Women who reported injection drug use only (n = 440; 31.4%) and women who reported both injection drug use and crack cocaine use (n = 297; 21.2%) were classified as IDUs.

TABLE 3. Baseline HIV Sex and Drug Risks: Single vs. Multiple Sexual Partners (Past 30 Days)

Risk Behavior	Single Sex Partners			Multiple Sex Partners			Significance Level
	M	SD	N	M	SD	N	
Number of sex partners	1.00	.00	756	15.82	46.18	392	***.000
Number of IDU sex partners	.45	.50	751	.88	3.57	380	*.021
Number of times used any drug before/during sex	10.26	16.03	755	30.05	70.86	389	***.000
Number of times exchanged sex for money/drugs	.27	1.92	751	25.38	72.13	387	***.000
Number of times had sex	19.99	16.71	756	41.40	81.97	387	***.000
Number of times had unprotected sex	19.42	15.30	751	24.40	45.13	387	***.000
The proportion of unprotected sex	.87	.31	756	.68	.36	392	***.000
Number of STDs (ever)	3.98	7.16	736	5.70	9.18	370	**.002
Number of times injected	38.00	2.59	755	47.12	4.84	391	.097
Proportion of times used bleach to clean needles	.48	.46	164	.41	.45	98	.233
Proportion of times used used works	.21	.36	401	.25	.39	185	.189
Number of times used crack	39.68	84.77	749	83.18	131.96	383	***.000
Number of days used crack	11.43	11.60	756	17.71	12.01	391	***.000

* p = < .05
** p = < .01
*** p = < .001

Women who reported only crack cocaine use (n = 664; 47.4%) were classified as CCUs. Results, presented on Table 4, indicate that female IDUs exhibited significantly greater sexual risks on three variables: the number of IDU sex partners (p < .000); the number of times used any drug before or during any sex (p = .010); and the number of STDs in lifetime (p = .012).

The third question posed in this study concerned whether reduction in sexual behavior occurred for those women who participated in the two session Standard intervention. Five sets of RBA-RBFA risk behavior paired t-tests were conducted. The five analyses looked at whether significant behavior change occurred for: (1) the total sample of women; (2) women with a single sex partner; (3) women with multiple sex partners; (4) female CCUs; and (5) female IDUs. The same seven "past 30 days" timeframe sex risk variables and the five drug risk variables were analyzed. Data from these analyses indicated that significant HIV risk reduction occurred. When the data for the total sample of women was analyzed (presented in Table 5), significant reductions in sex and drug risks between RBA and RBFA were obtained on all of the risk variables examined (p < .028).

Table 6 presents behavior change data for all of the women who reported having a single sex partner at baseline. Significant reductions on five of the seven sex risk variables were obtained. These included: the number of IDU sex partners; the number of times used any drugs before or during sex; the number of times had sex; the number of times had unprotected sex; and the proportion of unprotected sex. As expected, significant reductions were not observed for the two variables for which the women reported relatively low risk on the RBA: the number of sex partners and the number of times exchanged sex for money or drugs. With regard to the five drug risk variables, significant reductions in risks were reached on all five variables (p ≤ .023).

Table 7 describes the paired RBA-RBFA data for the women reporting multiple sex partners. Results of the analysis showed significant sex and drug risk reductions on all of the risk variables analyzed (p ≤ .019).

Sex and drug risk behavior change was analyzed by the type of drug use that the women reported. Table 8 describes behavior change data for women reporting injection drug use. Significant sex risk reduction was demonstrated on all of the seven sex risk variables (p ≤ .013). With regard to the three drug related variables appropriate to IDUs, significant changes were made for all three variables: the number of times injected (p = .000); the number of times used bleach to clean needles (p = .001); and the number of times used works known to be used by others (p = .000).

Table 9 presents behavior change data for those reporting crack cocaine

TABLE 4. Baseline HIV Sex Risks: IDU vs. CCUs (Past 30 Days)

Risk Behavior	IDUs			Non-IDUs			Significance Level
	M	SD	N	M	SD	N	
Number of sex partners	5.22	22.08	737	4.72	28.65	658	.395
Number of IDU sex partners	.75	2.57	734	.19	.55	647	***.000
Number of times used any drug before/during sex	16.06	48.00	738	11.88	30.46	657	*.010
Number of times exchanged sex for money/drugs	7.82	41.32	732	6.67	38.02	652	.321
Number of times had sex	21.91	53.07	740	19.03	40.97	654	.146
Number of times had unprotected sex	15.91	26.50	737	14.18	31.41	652	.313
The proportion of unprotected sex	.67	.44	741	.65	.44	659	.960
Number of STDs (ever)	4.79	8.78	710	3.88	7.03	636	*.012

* p = < .05
*** p = < .001

36

TABLE 5. Sex and Drug Risk Behavior Change for Total Sample (Past 30 Days)

Risk Behavior	RBA		RBFA			Significance Level
	M	SD	M	SD	N	
Number of sex partners	4.98	25.38	3.13	26.26	1395	**.004
Number of IDU sex partners	.49	1.93	.28	1.02	1368	***.000
Number of times used any drug before/during sex	14.02	40.81	7.91	29.96	1387	***.000
Number of times exchanged sex for money/drugs	7.25	39.79	4.19	49.29	1383	**.028
Number of times had sex	20.30	47.21	14.33	27.71	1383	***.000
Number of times had unprotected sex	15.11	29.04	10.74	21.16	1372	***.000
The proportion of unprotected sex	.66	.44	.51	.47	1403	***.000
Number of times injected	42.74	80.22	25.11	64.59	1368	***.000
Proportion of times used bleach to clean needles	.36	.43	.51	.45	114	**.001
Proportion of times used used works	.20	.34	.13	.30	484	***.000
Number of times used crack	51.83	101.70	29.38	73.94	1373	***.000
Number of days used crack	13.21	12.07	8.08	10.86	1399	***.000

** p = < .01
*** p = < .001

TABLE 6. Sex and Drug Risk Behavior Change for Women Reporting a Single Sex Partner (Past 30 Days)

Risk Behavior	RBA		RBFA			Significance Level
	M	SD	M	SD	N	
Number of sex partners	1.00	.00	1.15	3.81	754	.289
Number of IDU sex partners	.45	.50	.32	1.19	743	**.002
Number of times used any drug before/during sex	10.16	15.90	6.01	14.92	747	***.000
Number of times exchanged sex for money/drugs	.26	1.92	.68	6.84	751	.103
Number of times had sex	16.71	20.01	13.75	24.95	752	***.002
Number of times had unprotected sex	15.30	19.47	11.21	20.65	743	***.000
The proportion of unprotected sex	.87	.31	.60	.47	756	***.000
Number of times injected	38.46	71.26	19.74	49.28	737	***.000
Proportion of times used bleach to clean needles	.42	.44	.57	.44	55	*.023
Proportion of times used works	.20	.35	.14	.32	256	**.007
Number of times used crack	39.81	84.99	22.00	55.32	744	***.000
Number of days used crack	11.43	11.60	7.21	10.38	756	***.000

* p = < .05
** p = < .01
*** p = < .001

TABLE 7. Sex and Drug Risk Behavior Change for Women Reporting Multiple Sexual Partners (Past 30 Days)

Risk Behavior	RBA		RBFA			Significance Level
	M	SD	M	SD	N	
Number of sex partners	15.85	46.24	8.71	48.92	391	**.002
Number of IDU sex partners	.88	3.60	.35	.97	373	**.005
Number of times used any drug before/during sex	30.15	71.12	15.30	51.68	386	**.000
Number of times exchanged sex for money/drugs	25.44	72.49	13.74	92.58	383	*.019
Number of times had sex	40.90	81.52	22.10	35.97	378	***.000
Number of times had unprotected sex	24.78	45.68	14.65	24.35	376	***.000
The proportion of unprotected sex	.68	.36	.54	.45	392	***.000
Number of times injected	47.95	96.63	31.48	80.28	382	***.000
Proportion of times used bleach to clean needles	.24	.37	.53	.46	40	**.000
Proportion of times used works	.25	.38	.16	.31	122	***.005
Number of times used crack	82.22	130.78	46.88	105.05	382	***.000
Number of days used crack	17.72	11.99	10.60	11.80	389	***.000

* p = < .05
** p = < .01
*** p = < .001

39

TABLE 8. Sex and Drug Risk Behavior Change for Female IDUs (Past 30 Days)

Risk Behavior	RBA		RBFA			Significance Level
	M	SD	M	SD	N	
Number of sex partners	5.23	22.11	2.75	19.60	735	***.000
Number of IDU sex partners	.75	2.58	.42	1.30	727	**.002
Number of times used any drug before/during sex	15.99	48.10	8.58	26.89	733	**.000
Number of times exchanged sex for money/drugs	7.81	41.37	3.76	35.88	730	*.013
Number of times had sex	21.99	53.27	14.65	28.61	734	***.000
Number of times had unprotected sex	15.99	26.63	11.26	22.53	727	***.000
The proportion of unprotected sex	.67	.44	.49	.48	741	***.000
Number of times injected	79.93	95.49	46.34	82.49	728	***.000
Proportion of times used bleach to clean needles	.36	.43	.52	.45	112	**.001
Proportion of times used used works	.19	.34	.13	.30	478	***.000

* p = < .05
** p = < .01
*** p = < .001

40

TABLE 9. Sex and Drug Risk Behavior Change for Female CCUs (Past 30 Days)

Risk Behavior	RBA		RBFA				Significance Level
	M	SD	M	SD	N		
Number of sex partners	4.73	28.67	3.58	32.17	657		.313
Number of IDU sex partners	.19	.55	.12	.52	638		*.010
Number of times used any drug before/during sex	11.88	30.60	7.19	33.14	651		***.000
Number of times exchanged sex for money/drugs	6.60	38.04	4.70	61.05	650		.410
Number of times had sex	18.41	39.27	14.02	26.73	646		**.009
Number of times had unprotected sex	14.17	31.60	10.20	19.54	642		**.002
The proportion of unprotected sex	.65	.44	.54	.47	659		***.000
Number of times used crack	76.34	117.94	38.31	84.26	651		***.000
Number of days used crack	18.13	10.60	10.28	11.06	663		***.000

* p = < .05
** p = < .01
*** p = < .001

use. Significant sex risk reduction occurred on five of the seven sex risk variables: the number of IDU sex partners ($p = .010$); the number of times used any drug before or during sex ($p < .000$); the number of times had sex ($p = .009$); the number of times had unprotected sex ($p = .002$); and the proportion of unprotected sex ($p < .000$). With regard to the two drug risk variables appropriate to CCUs, significant reductions were obtained for both variables: the number of times used crack, and the number of days used crack ($p < .000$).

DISCUSSION

This initial view of the data allows for a number of conclusions, and illuminates other research questions that need to be examined. The initial description of the population suggests that women who participated in this study came from varying backgrounds and life situations. Women from several ethnic/racial backgrounds and of varying ages, educational levels, marital status and current living situations were represented. By nature of the study, however, all subjects were either IDUs, CCUs or both IDUs and CCUs. HIV sex and drug risk behavior was certainly evident indicating that women who use injection drugs and crack cocaine are an appropriate and important group to target for HIV prevention interventions.

Data presented on Table 3 shows that, in general, women who have multiple sex partners report higher levels of sex risks than those with one sex partner. Women with multiple sex partners have sex more frequently, including more unprotected sex. They also have more sex partners, including more sex partners who are IDUs. Women with multiple sex partners also report more lifetime instances of having an STD. While drugs and sex are often intertwined for both groups of women, those with multiple sex partners report more instances of drug use with or during sex and more instances of trading sex for money or drugs. While HIV risks associated with injection drug use were similar for both groups, crack cocaine use was significantly greater for those with multiple sex partners.

Implications from this data for the design of appropriate interventions are numerous. For example, interventions for both women who have single sex partners and those with multiple sex partners should focus on how sex and drugs are intertwined. Discussion of how the effects of drugs may hinder their ability to make good decisions and impede their ability to properly use a condom or clean a needle should occur. Articulation of situations in which sex and drugs occur together, how they can better prepare themselves in advance for these situations, or how to avoid the situation may be helpful. Preparation for a situation in which sex and

drugs occur together may include obtaining condoms in advance (making sure that the condoms are made of latex and are within the expiration date) and practicing, under the influence of drugs, how to correctly put on and take off a male condom, or, insert and remove a female condom. If avoidance of the sex and drugs situation is desired, interventionists may want to focus on identifying when and where these interactions take place as well as identifying alternative activities (NA meetings) and social support (a non-drug using friend/relative) that may provide social support. Encouragement to select alternative activities and develop social support prior to the onset of a situation in which sex and drugs occur may be helpful.

While addressing the interplay between sex and drugs is appropriate for both women with single sex partners and those with multiple sex partners, intervention programs may want to emphasize particular risks that are elevated for each subgroup. For example, the exchanging of sex for money or drugs is a topic that may need to be addressed in more depth with those who have multiple sex partners. Additionally, interventionists may want to emphasize how the presence of an STD facilitates HIV transmission. Given the number of sex partners and frequency of sex reported by women with multiple sex partners, regular gynecological exams should be recommended. When working with women who have single sex partners, interventionists may want to note the efficiency of male to female sexual transmission of HIV, and the risk having sex with an IDU (even in monogamous relationships) because of the indirectly related injection drug risk.

Data from the comparison of sexual risk behaviors of female IDUs with female CCUs (presented in Table 4) indicates that these groups have near equal risk levels on several of the sex risk variables. However, because female IDUs have significantly more IDU partners, intervention programs targeting female IDUs may want to emphasize the risk of becoming infected through heterosexual intercourse with an infected partner who may have became infected through risk associated with injection drug use. Additionally, because female IDUs reported a significantly higher frequency of having other STDs, intervention programs should focus on how the presence of other STDs may increase their susceptibility of becoming infected with HIV.

Data presented in Table 5 shows that the women enrolled in the NIDA Cooperative Agreement program reported making substantial and significant reductions in their sex and drug risk behaviors. Various subgroups of women enrolled in the program also reduced their risks. As shown in Table 6, women who had one sex partner made significant reductions in their sex and drug risk behaviors. The two variables that did not reach significance in reduction of risk included: (1) number of sex partners, and

(2) number of times exchanged sex for money or drugs. However, because the level of risk for those two variables at baseline was relatively low, significant reductions were not expected. Table 7 shows that women with multiple sexual partners reported significant behavior change on all of the sex and appropriate drug risk variables, and Table 8 shows that women who were IDUs also reported significant behavior change on all of the sex and appropriate drug risk variables.

Table 9 indicates that women who use crack cocaine are also capable of making positive behavior changes, but have some trouble making significant change in some sex activity. Behavior change for CCUs was evidenced on five of the seven sex risk variables and on both of the appropriate drug risk variables. The two variables for which reduction of sexual risk was not evidenced included the number of sex partners, and the number of times exchanged sex for money and drugs. Baseline data indicates relatively high levels of risks on these variables indicating: (1) that these behaviors occur frequently and may be particularly difficult for female CCUs to change, and (2) perhaps the Cooperative Agreement Standard intervention did not adequately address these risk behaviors. As noted by Coyle (this volume) the more recently funded final six Cooperative Agreement sites have already altered the Standard intervention placing more emphasis on HIV sexual risks associated with crack cocaine use. While it is too early to analyze the effect of this intervention change, it is clear from the data presented here that prevention programs targeting female CCUs need to intensify intervention strategies aimed at reducing the number of sexual partners and the trading of sex for money and drugs. Previously mentioned intervention strategies such as identification of environmental triggers to sexual risk taking (i.e., particular crack houses, friends' apartments, bars), identification of alternative activities (i.e., NA meetings, children's activities) and positive social support (i.e., church group, non-drug using friend or relative) may assist women who use crack cocaine in reducing these sex risk behaviors.

While recognizing the positive results of this study, there are a number of limitations that deserve discussion. First, the women enrolled in the Cooperative Agreement program were recruited through street outreach; consequently, the generalizability of the results are limited to this population. Second, the outcome data described in this paper was obtained from women who completed both an RBA and RBFA. Further analysis should be conducted to describe differences in demographic characteristics (i.e., younger versus older) and risk behaviors (i.e., those who exchange sex for money and drugs and those who do not exchange) of women who completed both an RBA and RBFA with those who only completed an RBA.

Third, while the Standard intervention was developed to be consistent across sites, some minor site specific differences did exist (see Coyle, this volume). Finally, further analysis is needed to look at the effectiveness of the Standard intervention for other subgroups of women (i.e., Hispanic/ non-Hispanic; prostitutes/non-prostitutes) as well as differences in risk behavior change between those who participated in the Standard versus Enhanced interventions.

In summary, NIDA's Cooperative Agreement program was effective in reaching and engaging high-risk female IDUs and CCUs in an HIV prevention program. The data reveals high levels of HIV risk indicating that this population of women are in need of HIV prevention programs. Overall, sex and drug risk behavior change was evidenced for the variables under study for the total population, and for most variables for different subgroups of women. These results indicate that the Cooperative Agreement Standard intervention is a strong, generic intervention for a diverse group of women at risk. However, given the different levels and types of sex and drug risks reported by different groups of women, perhaps the next challenge is to develop specific interventions that target different risk behaviors for the many profiles of women at risk for AIDS. Perhaps additional HIV risk reduction can then be obtained.

REFERENCES

Amaro, H. (1995). Love, sex and power. Considering women's realities in HIV prevention. *American Psychologist, 50*(6), 437-447.

Blattner, W.A., Biggar, R.J., Wiess, S.H., Melbye, M., & Goedert, J.J. (1985). Epidemiology of human T-lymphotropic virus type III and the risk of acquired immunodeficiency syndrome. *Annals of Internal Medicine, 103*, 665-670.

Booth, R.E., Watters, J.K., & Chitwood, D.D. (1993). HIV risk-related sex behaviors among injection drug users, crack smokers, and injection drug users who smoke crack. *American Journal of Public Health, 83*(8), 1144-1148.

Bowser, B.P. (1989). Crack and AIDS: An ethnographic impression. *Journal of the National Medical Association, 81,* 538-540.

Catania, J.A., Coates, T.J., Kegeles, S., Thompson-Fullilove, M., Peterson, J., Marin, B., Siegal, D., & Hulley, S. (1992). Condom use in multi-ethnic neighborhoods of San Francisco. The population-based AMEN (AIDS in multi-ethnic neighborhoods) study. *American Journal of Public Health, 82*(2), 284-287.

Centers for Disease Control and Prevention (1995, June). *HIV/AIDS Surveillance Report,* Atlanta: Author.

Centers for Disease Control and Prevention (1995). *HIV/AIDS Surveillance Report, 7* (2), Atlanta: Author.

Chu, S.Y., Peterman, T.A., Doll, L.S., Buehler, J.W., & Curran, J.W. (1992). AIDS in bisexual men in the United States: Epidemiology and transmission to women. *American Journal of Public Health, 82,* 220-224.

De Groff, A. & Stevens, S.J. (1992). *HIV and crack cocaine use: Issues in prevention strategies: Final report.* Submitted to the Arizona Department of Health Services. Tucson, AZ: Tucson AIDS Project.

Des Jarlais, D.C., Friedman, S.R., & Woods, J.S. (1990). Intravenous drug users and AIDS. In D.G. Ostrow (Ed.), *Behavioral Aspects of AIDS.* New York: Plenum Medical Book Company.

Des Jarlais, D.C. & Friedman, S.R. (1987). HIV infection among intravenous drug users: Epidemiology and risk reduction. *AIDS, 1* (1), 67-76.

Dwyer, R., Richardson, D., Ross, M.W., Wodak, A., Miller, M.E., & Gold, J. (1994). A comparison of HIV risk between women and men who inject drugs. *AIDS Education and Prevention, 6*(5), 379-389.

Erickson, J.R., Estrada, A.L., & Stevens, S.J. (1990, November). *Risk for AIDS among female sexual partners of IVDUs.* Paper presented at the 118th Annual Meeting of The American Public Health Association, NY.

Fullilove, R.E., Fullilove, M.T., Bowser, B.P., & Gross, S.A. (1990). Risk of sexually transmitted diseases among black adolescent crack users in Oakland and San Francisco, California. *Journal of the American Medical Association, 263,* 851-855.

Gama, D. & Ruiz, D. (1994). *Perceptions of women's control of sexual encounters and condom use.* Unpublished report.

Inciardi, J.A. (1994). HIV/AIDS risks among male, heterosexual non-injecting drug users. In *NIDA Research Monograph Series: The Context of HIV Risks Among Drug Users and Their Sexual Partners.* Rockville, MD.

Inciardi, J.A. (1995). Crack, crack house sex, and HIV risk. *Archives of Sexual Behavior, 24*(3), 249-269.

Inciardi, J.A., Lockwood, D., & Pottieger, A.E. (1993). *Women and Crack-Cocaine.* New York: Macmillan Publishing Company.

Koester, S.K. (1994). Copping, running, and paraphernalia laws: Contextual variables and needle risk behavior among injection drug users in Denver. *Human Organization, 53*(3), 287-295.

Laga, M., Manoka, A., Kivuvu, M., Malele, B., & Piot, P. (1993). Nonulcerative sexually transmitted diseases as risk factors for HIV-1 transmission in women: Results from a cohort study. *AIDS, 7,* 95-102.

McCoy, H.V. & Inciardi, J.A. (1993). Women and AIDS: Social determinates of sex-related activities. *Women & Health, 20*(1), 69-86.

Padian, N.S., Shiboski, S.S., & Jewell, N. (1990). *The relative efficiency of female-to-male HIV sexual transmission.* Proceedings of the Sixth International Conference on AIDS, June 20-24; San Francisco, CA.

Ramos, R. (1995). *Componeros–female sex partners of injection drug users: HIV/AIDS infection in the U.S. Mexico border.* Unpublished manuscript, U.S. Mexican Border Health Association, El Paso, TX.

Seidlin, M., Vogler, M., Lee, E., Lee, Y.S., & Dubin, N. (1993). Heterosexual transmission of HIV in a cohort of couples in New York City. *AIDS, 7,* 1247-1254.

Stevens, S.J., Estrada, A.L., Polk, B., & Erickson, J.R. (1994, September). *Women and HIV: Sexual risk behaviors and behavior change of injection drug and crack cocaine using women.* Paper presented at the Second Science Symposium on Drug Abuse, Sexual Risk, and AIDS: Prevention Research 1995-2000, Flagstaff, AZ.

Stevens, S.J., Gama, D., Polk, B., & Estrada, A.L. (1995, June). *Women at risk: Sexual transmission of HIV.* Paper presented at the NIDA Satellite Conference on AIDS and Drug Abuse, Scottsdale, AZ.

Stevens, S.J., Ruiz, D., Romero, O., & Gama, D. (1995, February). *HIV prevention and education: Street outreach for special populations: The crack addicted and intravenous drug users.* Presented at the National Update on AIDS, San Francisco, CA.

Stuntzner-Gibson, D. (1991). Women and HIV disease: An emergency social crisis. *Social Work, 36,* 22-27.

Su, S.S., Pach, A., Hoffman, A., Pierce, T.G., Ingels, J.S., Unfred, C., & Gray, F. (1996). *Drug injector risk networks and HIV transmission: A prospective study.* Unpublished report to the National Institute on Drug Abuse.

Tortu, S., Beardsley, M., Deren, S., & Davis, W.R. (1994). The risk of HIV infection in a national sample of women with injection drug-using partners. *American Journal of Public Health, 84*(8), 1243-1249.

Trapido, E.J., Lewis, N., & Comerford, M. (1990). HIV-1 and AIDS in Belle Glade, Florida. *American Behavioral Scientist, 33,* 451-464.

Wechsberg, W.M., Dennis, M.L., & Stevens, S.J. (1996). *AIDS outreach/intervention for risk reduction among women substance abusers: Trends, outcomes, and future implications.* Presented at the XII International AIDS Conference, Vancouver, WA.

Wechsberg, W.M., Dennis, M.L., & Ying, Z. (1995, November). *Women and men injectors: Differences and trends in their drug use patterns and HIV risk.* Presented at the meeting of the American Public Health Association, San Diego.

Wortley, P.M., Chu, S.Y., & Berkelman (1997). Epidemiology of HIV/AIDS in women and the impact of the expanded 1993 CDC surveillance definition of AIDS. In D. Cotton & D.H. Watts (Eds.), *The Medical Management of AIDS in Women.* New York: Wiley-Liss, Inc.

ACKNOWLEDGMENTS

We would like to acknowledge our appreciation to the Principal Investigators at the 21 NIDA/CRB sites that permitted use of data from their site:

Dennis G. Fisher, PhD	Anchorage, AK
Robert Trotter, PhD	Flagstaff, AZ
Sally J. Stevens, PhD	Tucson, AZ
Fen Rhodes, PhD	Long Beach, CA
John Watters, PhD Ricky Bluthenthal, MA	San Francisco, CA
Robert Booth, PhD	Denver, CO
Merrill C. Singer, PhD	Hartford, CT
Jeffrey Hoffman	District of Columbia (Washington)
Clyde B. McCoy, PhD	Miami, FL
Carl G. Leukefeld	Lexington, KY
Vernon Shorty, PhD	New Orleans, LA
Marcia Anderson, PhD	Detroit, MI
Linda B. Cottler, PhD	St. Louis, MO
Sherry Deren, PhD	New York, NY
Wendee Wechsberg, PhD	Durham/Wake Counties, NC
Harvey A. Siegal, PhD	Columbus/Dayton, OH
Michael Stark, PhD	Portland, OR
Lynne C. Kotranski, PhD	Philadelphia, PA
Rafaela R. Robles, EdD	Rio Piedas, PR
Isaac Montoya, PhD	Houston, TX
David Desmond, MSW	San Antonio, TX

This research was supported by the National Institute on Drug Abuse, Community Research Branch.

Effectiveness of HIV Interventions Among Women Drug Users

H. Virginia McCoy, PhD
Clyde B. McCoy, PhD
Shenghan Lai, PhD

SUMMARY. A prospective cohort study was conducted among chronic injecting and crack cocaine drug using women. The hypothesis tested was that participation in a standard-plus-innovative intervention was more likely to produce behavior change than participation in a standard intervention. Standardized intervention protocols and corresponding instruments were designed. Data were collected on drug and sex risk behaviors at baseline and six-month follow-up intervals. The level of behavioral change in two intervention arms—standard and a standard-plus-innovative intervention—was measured by composite sex risk and drug risk scores using the generalized estimating equation approach. The results show that on four risk measures the enhanced intervention was significantly associated with

H. Virginia McCoy is affiliated with Florida International University and University of Miami Comprehensive Drug Research Center. Clyde B. McCoy and Shenghan Lai are affiliated with University of Miami Comprehensive Drug Research Center.

This research was supported by the National Institute on Drug Abuse (NIDA) grant UO1DA06910.

Staff members who were instrumental in the implementation of this study include Norman Weatherby, PhD, Sam Comerford, BS, Carolyn McKay, MHSA and Sally Dodds, PhD, and those who assisted with the preparation of the paper include Ronald Correa, MS, Eugene Komaroff, PhD, and Sarah Messiah, BS.

[Haworth co-indexing entry note]: "Effectiveness of HIV Interventions Among Women Drug Users." McCoy, H. Virginia, Clyde B. McCoy, and Shenghan Lai. Co-published simultaneously in *Women & Health* (The Haworth Medical Press, an imprint of The Haworth Press, Inc.) Vol. 27, No. 1/2, 1998, pp. 49-66; and: *Women, Drug Use, and HIV Infection* (ed: Sally J. Stevens, Stephanie Tortu, and Susan L. Coyle) The Haworth Medical Press, an imprint of The Haworth Press, Inc., 1998, pp. 49-66. Single or multiple copies of this article are available for a fee from The Haworth Document Delivery Service [1-800-342-9678, 9:00 a.m. - 5:00 p.m. (EST). E-mail address: getinfo@haworthpressinc.com].

49

positive change in both drug use and sexual behavior: less frequent drug use, less drug use during sex, and more frequent condom use during particular frequencies for specific types of sexual activities. Public health interventions are effective when targeting specific risk behaviors through interventions tailored to prevent HIV and reduce risk behaviors among specific cultural and gender groups. *[Article copies available for a fee from The Haworth Document Delivery Service: 1-800-342-9678. E-mail address: getinfo@haworthpressinc.com]*

INTRODUCTION

Evaluation studies on the nature and extent of interventions to reduce HIV risk behaviors can make an important contribution to slowing the AIDS epidemic in the population. The extent to which different strategies enhance the efficacy of prevention programs for changing behaviors for particular gender and cultural groups is examined in this report.

Acquired Immune Deficiency Syndrome (AIDS) has become a significant health concern for women. The number of AIDS cases among females has increased from 3 percent in 1981 to 18 percent of all reported cases in 1995 (CDC, 1995). Moreover, the disease disproportionately affects black women as they represent over 50 percent of all female cases of AIDS. In addition, over one third of all national cases of AIDS reported in 1995 were associated with drug use. Although men who have sex with men continue to account for the largest proportion of AIDS cases, the AIDS epidemic is now increasing more rapidly among injecting drug users and the increase in AIDS cases resulting from heterosexual transmission also is reflected in the increase of cases reported among women (CDC, 1995).

The association between the injection of drugs and the seroprevalence of HIV is reflected in the increased proportion of AIDS cases among persons who reported injecting drug use from 17 percent during 1981-1987 to 27 percent during 1993-October 1995 (CDC, 1995). Crack, the smokable form of cocaine, also has a significant association with acquiring AIDS. Increasing evidence suggests that the current epidemics of HIV/AIDS intersect with an epidemic of illicit drug use and high rates of unprotected sexual activity (Edlin et al., 1994). For example, crack-users in New York, Miami and Denver have been found to exhibit higher rates of HIV infection than non-crack-users (Edlin et al., 1994; McCoy et al., 1996; Booth, Koester, & Pinto, 1995) and injection drug users who smoked crack were 50 percent more likely to be HIV positive than were other injection drug users (DiClemente, Work, & Coleman, 1991). More-

over, studies have found that crack-smokers, particularly those who also injected drugs, are at an increased risk for HIV infection by practicing high-risk sexual behaviors such as exchanging sex for money or drugs, having sex with injecting drug users and drug use before and/or after sex (Booth, Watters, & Chitwood, 1992).

Although some HIV prevention education strategies have been effective in the reduction of some risk behaviors, consistent and long-term changes require a variety of well-planned, targeted, multidimensional, and interdisciplinary strategies that are sustained with repeat exposures (Oakley, Fullerton, & Holland, 1995; Rugg, 1990). Reductions of drug using behaviors require different strategies than those concerned with sexual risk behaviors (Stephens, Simpson, Coyle, & McCoy, 1993). For example, cocaine abusers have shown higher levels of sexual HIV risk behaviors (Des Jarlais, Friedman, & Casriel, 1990), distinctive treatment needs (Dolan, Black, Malow, & Penk, 1992) and different characteristic patterns of psychopathology (Malow, West, Pena, & Lott, 1991) when compared to other addict populations. At the same time, African-Americans are disproportionately represented among AIDS cases in the United States compared to other ethnic groups as they account for the majority of cases among injection drug users, women and children. This overrepresentation underscores the importance of cultural and racial factors that can significantly affect treatment response (Miller, Turner, & Moses, 1990; Sorensen, 1990). Strategies for both populations require incorporating different approaches to affect skills, norms, beliefs, social networks, and social support (Moore, Harrison, & Doll, 1994).

Several existing studies have demonstrated a reduction in HIV risk behavior and suggest that chronic drug users are capable of behavior change relative to HIV risk reduction behaviors following an HIV/AIDS risk reduction intervention (McCoy, McCoy, Hockman, & Anderson, 1995; Siegal, Falck, Carlson, & Wang, 1995; McCoy, Rivers, & Khoury, 1993; Stephens et al., 1993; McCusker, Stoddard, Zapka et al., 1992; Des Jarlais, Friedman, Choopanya et al., 1992; Chitwood et al., 1991). However, it is important to examine the intervention research design as well as the risk factors of the targeted population to determine the specific variables that can be attributed to the behavior change and successful outcomes relative to HIV/AIDS risk behavior (Booth & Watters, 1994).

A number of studies have incorporated a pre-post test design to produce successful behavior change related to high-risk sexual behavior and drug abuse behavior. Relative to high-risk sexual behaviors, an intervention program targeting runaway adolescents found that after an educational intervention, subjects were using condoms more consistently, and prac-

ticed high-risk sexual behavior less often (Rotheram-Borus, Koopman, Haignere, & Davies, 1991). In another study, black adolescent males displayed increased AIDS knowledge, less favorable attitudes to risky sex, and lower intentions to engage in such behaviors after receiving the AIDS Risk Reduction program (Jemmott, Jemmott, & Fong, 1992).

Pre-post test designs have also been successful with drug abuse behavior. For example, in an early assessment of a media campaign intended to heighten awareness about AIDS, combined with local interventions by doctors, community workers and others, heroin addicts in treatment were interviewed prior to intervention and six months later; and substantial reductions were reported in HIV risk behaviors between interviews (Robertson, Skidmore, & Roberts, 1988). A similar study involving methadone maintenance clients examined the effects of an HIV pre-post-testing and individual counseling on behavior change. At the six-month post-assessment, risk behaviors had declined among 39 percent of those located (Martin, Serpelloni, Galvan et al., 1990). Several other studies have also found evidence of behavior change from pre-test to post-test among IDUs (Sorensen et al., 1994; Anderson, Smereck, & Braunstein, 1993; Booth & Wiebel, 1992; Calsyn, Saxon, Wells, & Greenberg, 1992).

The National Institute on Drug Abuse (NIDA) funded a number of sites through the National AIDS Demonstration and Research (NADR) program which developed interventions to increase behavior change which were demonstrated to be successful among IDUs. For example, Watters (1987) reported significant increases in needle hygiene and decreases in needle sharing among San Franciscan drug injectors following an intervention of outreach and bleach distribution with instructional brochures. Chitwood et al. (1991) reported findings in IDUs in Miami and found pre-post decreases in frequency of injection, needle sharing, and shooting gallery use after participation in a NADR intervention of AIDS education and bleach/condom skills demonstrations. Furthermore, another NADR study in Cleveland found significant pre-post increases in condom use and decreases in sharing drug paraphernalia, using heroin and cocaine, and having sex with IDUs following exposure to an intervention that included basic AIDS education and a "hands-on" demonstration of bleach and condoms (Stephens, Feucht, & Roman, 1991). In addition, several other NADR studies also have supported positive behavior change utilizing pre-post designs with supporting interventions whose findings include less frequent drug injection, proper needle cleaning and fewer reports of needle sharing (Kroliczak, 1991; Siegal et al., 1991; Reinhart & Rosenthal, 1991).

This paper reports the results of a study among chronic injecting and

crack cocaine drug using men and women which tested the hypothesis that participation in a standard-plus-innovative intervention was more likely to produce behavior change than participation in a standard intervention. The study design incorporated both pre- and post-intervention measures and the incorporation of two theoretically-based interventions designed to reduce HIV/AIDS risk behaviors to be compared for their relative effectiveness with populations of African-American women in Miami, Florida in the Miami CARES program (Miami CARES [Community AIDS Research and Evaluation Studies]). A parallel study of African American men was reported previously (McCoy et al., 1996).

METHODS

NIDA Standard Intervention

A standardized intervention protocol was developed by grantees participating in the NIDA Cooperative Agreement (see Coyle, this volume). The protocol was similar to a NIDA-developed counseling and educational model which was, in turn, based on theories of behavior change, including Social Influence Theory, Health Belief Model, Fear Arousal Theory, and Social Learning Theory (Coyle, 1993). Briefly, it consisted of two education and counseling sessions encompassing HIV and antibody screening. The first session featured pre-test counseling, demonstrations of safe condom use, demonstrations of safe needle cleaning with bleach, and referrals to social and health services. The second session consisted of post-test counseling, medical treatment advice for seropositive participants, referrals, and provision of condoms and needle hygiene kits.

Miami CARES Innovative Intervention (Standard-Plus-Innovative)

In addition to receiving the identical standard intervention as described above, participants assigned to the standard-plus-innovative intervention received an additional intervention. The overall goals of the innovative intervention were to (1) assist participants in initiating risk reduction behaviors for both acquiring and transmitting HIV; (2) assist participants in maintaining HIV risk reduction behaviors once they have been initiated and (3) identifying personalized social and psychological factors to assist in the conversion of HIV prevention information and skills into behavioral action. The intervention was conducted in a small group session convened in a centralized assessment center.

Theory

The intervention was guided by an integrated model, following components from several outstanding behavior change theories and models. The model postulated that baseline behaviors and demographic characteristics provide the historical setting and environment in which prevention programs intervene in an attempt to change intentions and behavior. An individual's environment determines the types and value (importance) of interactions and influences of associates which may contribute to the social norms surrounding sexual behavior (based loosely on a structural interpretation of concepts in the Theory of Reasoned Action [subjective and community norms] and Social Learning Theory [observational learning]) (Fishbein, M. & Middlestadt, S., 1989; Bandura, 1977). Efficacy beliefs (Bandura, 1977, 1989) include self-efficacy, which governs the confidence with which an individual approaches adopting new behaviors or stopping old behaviors, and response efficacy, which determines one's belief that effective preventive action can be taken. Barriers and facilitators, contributed by the Health Belief Model (Kirscht & Joseph 1989), determine access, hindrances, and supports necessary to change behaviors. Each of these theoretical concepts had been found to be efficacious in previous research (Rhodes & Humfleet, 1993; Kelly, 1995; Catania, Kegeles, & Coates, 1990; Fishbein & Middlestadt, 1989).

Intervention Content

Content was based upon themes of domestic responsibilities and supportive behaviors among women. Strategies consisted of a review of basic HIV information, discussion of female and male anatomy (using models); condom consumerism and condom use; condom use and needle cleaning demonstrations; development of a personalized risk reduction strategy, which was a commitment or contract to attempt sex and drug behavior changes appropriate to their personal situations.

The content of the innovative interventions considerered gender-oriented sociocultural influences on individual development; contradictory cultural norms in the African-American and white society; and responsible sexual decision making (Mucherera & Pate, 1989; Scales & Beckstein, 1982). The content also provided an awareness of the need for cooperation in protecting others against HIV. Moreover, the women's intervention featured themes of domestic (household) responsibilities and women's role in maintaining relationships. The men's intervention featured a sports theme. While not all men and women conform to traditional, culturally-

based gender roles, the themes attempted to place risk reduction information into familiar contexts.

To place the content and themes into the intervention context, the Rules of the AIDS Game (for men) is comparable to the Recipe for AIDS Safety (for women). Selecting a particular sport and dish, the interventionist drew analogies to AIDS and HIV. "The menu [goal] is not to get HIV if you don't have it, and not to give it to someone else if you do. The menu [goal] in the AIDS Recipe [Game] is to avoid getting HIV from your sex or drug-using partners (keeping HIV out of your body) and to avoid giving it to your sex or drug-using partners, or unborn child (keeping HIV from getting in someone else's body). What spoils the dish is HIV. [Your opponent is HIV.] It's not a needle, it's not a man [woman]. It's a virus. Learn how it can spoil the dish so you can serve a healthy meal. [Learn its moves to play a better game of defense.]" (Dodds & McCoy 1993).

The central focus of the intervention was the development of a personalized risk reduction strategy which targeted the health beliefs (perceived susceptibility, severity, and benefits), facilitators (supports), barriers, and cues necessary to achieve change in targeted behaviors. The group format facilitated a collaborative alliance with the interventionist and modeled the skills helpful in obtaining social support.

Other Intervention Elements

1. Provision of accurate, detailed knowledge about risk (basic medical and virological characteristics of HIV infection, transmission mechanisms and rationale for each transmission route, male and female anatomy [using anatomical models], behavioral risk continuum);
2. Preparation for coping with potential stressors related to HIV and risk behavior change (e.g., threat of illness and death, low self-esteem about one's ability to control drug use or sexual impulses long enough to engage in protective behaviors, inadequate interpersonal negotiation skills, conflict in perceived gender role behavior, perception of being different than one's drug-using peers, loss of perceived personal freedom) by (a) reconceptualizing the threat of HIV as a problem that can be solved; (b) assuring that advance planning can provide adequate time for protection; (c) assuring that the future holds hope for even better alternatives to prevent HIV; (d) rehearsing and cue-ing for situational stress reduction; and (e) providing support for lapses and setbacks in behavior as being normal in change efforts;

3. Assertiveness training and rehearsal of specific words and phrases to both initiate risk reduced behavior and resist coercive pressures to engage in unsafe behaviors.

Procedures

Current drug users participated in a prospective cohort study, following a modified interrupted time series design for female participants (Wholey, Hatry, & Newcomer 1994), comparing a nationally developed standard HIV prevention protocol to a locally derived theoretically-designed intervention program. The Miami, FL, urban sample selected only African American males and females, following a targeted sampling strategy. Indigenous outreach workers located, screened and recruited eligible participants, who were at least 18 years old, had used injected cocaine or heroin or used crack cocaine in the previous 30 days, and had not been in drug treatment 30 days prior to intake.

Clients were first informed of the general purpose of the study—to study drug use, sexual behavior, and health—and the strict confidentiality of all results. Self-reports of sociodemographic characteristics and drug-and sex-related risk behaviors were collected using the Risk Behavior Assessment questionnaire (RBA) and Risk Behavior Follow-up Assessment questionnaire (RBFA) which were administered by experienced interviewers; both instruments have been found reliable and valid (Weatherby et al., 1994; Fisher et al., 1993). Administration of the RBA required 30-60 minutes and was implemented prior to participation in HIV pre-test counseling or any intervention.

After administration of the RBA and HIV pre-test counseling, subjects were asked to voluntarily receive an HIV test. All subjects were informed of study criteria before the urine sample, interviews, and blood sample were collected. An HIV pre-test counseling session was conducted following the NIDA standard intervention model.

After each participant was tested for HIV antibodies and scheduled to return within 42 days for HIV post-test counseling, women were assigned to the standard and innovative intervention protocols. Since the innovative intervention was administered after the standard was delivered, both subjects and providers of the standard intervention were blinded to group assignment.

The sample size of 541 female drug users includes those who participated in the standard or innovative interventions and received a follow-up evaluation six, twelve, or eighteen months following the intervention. An 80% follow-up rate was achieved; however, there were no significant

differences in risk behaviors (crack use frequency, injection risks, or times had heterosexual sex without a condom) of participants not followed.

Analysis

The Generalized Estimating Equation (GEE) approach was used to assess the efficacy of the two interventions; that is, whether the enhanced intervention was significantly associated with positive (better) behavioral changes. The GEE approach is a general method for fitting mathematical models to data involving repeated response measurements on the same subject. The responses may be either discrete or continuous. This method accounts for intra-subject correlation, often treated as nuisance parameters among repeated measurements on the same subject. Different subjects can have different numbers of repeated measurements.

Drug use and sexual risk behaviors were quantified by creating composite variables for drug use frequency, condom use frequency, and taking drugs during sex; for example, drug use measured as the number of days using crack, cocaine, heroin, and speedball was combined to form number of days using drugs. In order to measure the changes in both drug and sex behaviors over time, some cutpoints for frequencies of drug use and sexual risks were made and a categorical variable was created. For example, for *drug use*, the number of days using any drug less than 10 days in the last 30 days quantified drug use behavior. *Drug use during sex* was measured as using drugs during sex less than 30 times in the last 30 days; *condom use* was measured as use during mouth-penis or anus-penis sex more than 95% of occasions in the last 30 days; *condom use and drug use* was measured as using condoms during vaginal-penis or mouth-penis or anus-penis sex more than 50 percent of occasions and using any drugs less than 15 days in the last 30 days.

RESULTS

The demographic characteristics of the standard and innovative participants are shown in Table 1 which indicates that, in addition to race and gender (African-American females), both groups were relatively similar in other characteristics at baseline. There were no significant differences between standard and innovative groups on marital status, education, or living arrangement. About half of each group was single, one fourth married, and one fourth separated, divorced, or widowed. Slightly more than half of each group had not graduated high school; the innovative group

TABLE 1. Demographic Characteristics by Intervention Assignment (N = 541)

Characteristics	Standard	Innovative	p-value
Age			.008
< 24	7.0	2.4	
25-34	50.8	47.6	
35-44	37.6	38.1	
45+	4.6	11.9	
Marital Status			.792
Single	50.1	46.8	
Married (or common-law)	24.6	27.0	
Separated, divorced, widowed	25.3	26.2	
Education			.116
< High school grad; has some technical training	58.6	56.3	
High school grad or GED	27.2	34.9	
Some college or more	14.2	8.7	
Residence Type			.001
Own or someone else's house	77.3	92.9	
Hotel/rooming house/shelter	8.7	2.4	
Street/jail/other	14.0	4.8	
Living Arrangement			.082
Live alone	18.1	13.5	
Live with spouse or sex partner	17.1	11.1	
Live with other family, children, adults	64.8	75.4	

was more likely to be a high school graduate and the standard group was more likely to have some college education. Very small proportions of each group lived alone or with a spouse (or sex partner).

Significant differences between standard and innovative groups were noted on age and residence type. Small variations in age occur in the youngest and oldest age groups, indicating that the standard group was somewhat more likely to be in the youngest age category and the innovative more likely to be in the oldest age category. More than three fourths of each group lived in their own or someone else's house; very small proportions lived in other types of residences.

The results of the GEE analyses comparing the two intervention arms are presented in Table 2 and indicate that on four behaviors the enhanced

TABLE 2. Drug and Sexual Behaviors (Last 30 Days) Correlated with Intervention Assignment

Behaviors	Odds	95% C.I.	p-value
Drug Use[1]			
Standard	1.00		
Innovative	1.59	(1.06, 2.38)	0.026
Drug Use During Sex[2]			
Standard	1.00		
Innovative	4.08	(0.98, 16.96)	0.05
Condom Use[3]			
Standard	1.00		
Innovative	1.52	(1.08, 2.12)	0.015
Condom Use and Drug Use[4]			
Standard	1.00		
Innovative	1.05	(1.05, 2.19)	0.028

[1]Drug Use (dependent variable: if using any drugs was less than 10 days in the last 30 days, then drug use was coded as 1, otherwise it was coded as zero)

[2]Drug Use During Sex (dependent variable: if using any drugs during sex less than 30 times in the last 30 days, drug use during sex was coded as 1, otherwise it was coded as zero)

[3]Condom Use (dependent variable: if condom use during mouth-penis or anus-penis sex more than 95 percent of occasions in the last 30 days, condom use was coded as 1, otherwise it was coded as zero)

[4]Condom Use and Drug Use (dependent variable: if condom use during vaginal-penis or mouth-penis or anus-penis sex more than 50 percent of occasions and using any drugs less than 15 days in the last 30 days, condom use was coded as 1, otherwise it was coded as zero)

intervention was significantly associated with positive change in both drug use and sexual behavior. The results for *drug use* show that compared to women in the standard intervention, women in the enhanced intervention were 1.6 times (Odds Ratio) more likely to have less drug use (crack, cocaine, speedball, heroin) (less than 10 days). The results for *drug use during sex* show that the innovative intervention participants were 4 times

more likely to take drugs during sex less than 30 times in the last 30 days. The results show that *condom use* during mouth-penis or anus-penis sex among innovative intervention participants was 1.5 times more likely to be more than 95% of occasions in the last 30 days. A composite of *drug and sexual risks* (combined) is created for the final variable: condom use during vaginal-penis, mouth-penis, or anus-penis sex more than 50% of occasions *and* using any drug less than 15 days in the last 30 days. The results produced significant differences (p = .028) between the innovative relative to the standard, but of less relative risk than using the separate variables of drug use and sexual risk.

DISCUSSION

Interventions were designed using prominent theoretical concepts which had been found efficacious in other studies in reducing HIV risk behaviors. The study tested the hypothesis that participation in a standard-plus-innovative intervention would produce more positive behavior changes than participation in a standard intervention alone. African-American women participated in group sessions in which HIV prevention content was encompassed in gender- and culture-specific lessons and analogies. The risk behavior changes in which significant differences were found between standard and innovative interventions included drug use of less than 10 days, drug use during sex of less than 30 times, and condom use during 95% or more of occasions for specific types of sexual activities. These findings for African-American women support the study hypothesis with a number of caveats.

First, the innovative intervention appeared to be more efficacious than the standard for participants with less risky behaviors, for example, drug use of less than 10 days and drug use during sex of less than 30 times in the last 30 days. While both drug and sexual behaviors changed for the better over time on a number of risk behaviors (not shown), differences between standard and innovative were limited to a few behaviors. The specificity of frequencies of behaviors might suggest that precise targeting of behaviors for intervention participation might be required, as is suggested by a number of theories, such as the Theory of Reasoned Action and Theory of Planned Behavior (Fishbein & Middlestadt, 1989; Ajzen, 1991).

In addition to the need to specifically target behaviors, these interventions were delivered to groups of women using gender-specific and cultural-specific themes and strategies consistent with the sociocultural context of the lives of the participants. In particular, gender-specific strategies

responded to the unique needs of women and provided them with better chances of making positive life adjustments. It used life experience examples and analogies that participants currently faced in the context of their lives, providing a means to respond to their concerns about AIDS and drugs in familiar contexts.

The findings on condom use must also be viewed in the context that women may not have control over the use of condoms; therefore, the increase in condom use may reflect women's negotiation skills or men's willingness to use condoms.

Another limitation of the study is that it is unknown whether the results for this sample of cocaine and heroin injectors, cocaine snorters, and crack smokers, would generalize to other populations. It is also unknown whether interventions targeted to a specific type of drug user would affect behavior change outcomes; although it has been shown that such studies affect crack cocaine users positively (McCoy et al., in press).

In the absence of a proven vaccine, efforts must be directed at changing high-risk behaviors in order to curb the AIDS epidemic. Future research must identify prevention programs for drug users that employ the most effective and proven strategies for changing behaviors. When theoretical models guide the designs of interventions they will be more likely to produce behavior change. Without a theoretical framework or model-based approach, the reasons some individuals have changed and other individuals have not changed are unknown (Zimmerman & Olson, 1994). As a result, the most effective methods for changing behaviors are unknown. Precise identification of components and strategies are necessary for appropriate replication of effective programs (Chaisson, Osmond, Moss, Feldman, & Bernacki, 1987; DiClemente & Peterson, 1994). For example, some studies provide only a limited picture of individual beliefs and practices simply because the operational definitions of the constructs have varied from study to study (Gielen, Faden, O'Campo, Kass, & Anderson, 1994). In some cases, only partial tests of the model are undertaken (Harrison et al., 1991; Cochran & Peplau, 1991) and correlations with behavioral outcomes are not available (Oakley, Fullerton, & Holland, 1995; Booth & Watters, 1994; Harrison et al., 1991; Hayes, Sharp, & Miner, 1989).

Interventions also require the integration of theoretical principles combined with contextual and sociocultural variables, such as gender and culture (Auerbach, Wypijewska, & Brodie, 1994). Prevention programs have been predominately male-oriented and have neglected issues of racial, cultural, class, and gender differences (Weeks, Schensul, Williams, Singer, & Grier, 1995). Only recently have they begun to address

populations of women of various ethnic and racial backgrounds who are at risk. For example, the development of effective sexual risk reduction programs for women depends in part on the extent to which appeals for "safer sex" practices are culturally relevant and derived from a sound understanding of the beliefs and needs of the target population (Gielen et al., 1994).

In conclusion, these results have implications for the design of future HIV prevention interventions for drug using women. First, the results suggest that targeting specific behaviors, perhaps even specific frequencies of behaviors, may be important in achieving behavior change. Second, the study further confirms our conviction that intervention sessions can more adequately focus behavior change information when targeting particular racial/ethnic groups. Third, interventions which are designed using theoretical foundations provide greater continuity and consistency with an accumulating base of knowledge upon which to extend improved interventions and, therefore, show greater promise of efficacy.

REFERENCES

Ajzen, I. (1991). The theory of planned behavior. *Organization Behavior and Human Decision Processes, 50,* 179-211.

Anderson, M. D., Smereck, G. A., & Braunstein, M. S. (1993). LIGHT model: An effective intervention model to change high-risk AIDS behavior among hard-to-reach urban drug users. *American Journal of Drug and Alcohol Abuse, 19,* 309-325.

Auerbach, J. D., Wypijewska, C., & Brodie, H. K. H. (1994). *AIDS and behavior: An integrated approach.* Washington, DC: National Academy Press.

Bandura, A. (1977). Self-efficacy. *Psychological Review, 84,* 191-215.

Bandura, A. (1989). Perceived self-efficacy in the exercise of control over AIDS infection. In V. M. Mays, G. W. Albee, & S. F. Schneider (Eds.), *Primary prevention of AIDS.* Newbury Park, CA: Sage.

Booth, R.E., Koester, S. K., & Pinto, F. (1995). Gender differences in sex-risk behaviors, economic livelihood, and self-concept among drug injectors and crack smokers. *American Journal on Addictions, 4,* 313-322.

Booth, R. E., & Watters, J. K. (1994). How effective are risk-reduction interventions targeting injecting drug users? *AIDS, 8,* 1515-1524.

Booth, R. E., Watters, J. K., & Chitwood, D. D. (1993). HIV risk-related sex behaviors among injection drug users, crack smokers, and injection drug users who smoke crack. *American Journal of Public Health, 83*(8), 1144-1148.

Booth, R. E., & Wiebel, W. W. (1992). The effectiveness of reducing needle-related risks for HIV through indigenous outreach to injection drug users. *American Journal of Addictions, 1,* 277-288.

Calsyn, D. A., Saxon, A. J., Wells, E .A., & Greenberg, D. M. (1992). Longitudinal sexual behavior changes in injecting drug users. *AIDS, 6,* 1207-1211.

Catania, J. A., Kegeles, S. M., & Coates, T. J. (1990). Towards an understanding of risk behavior: An AIDS risk reduction model (ARRM). *Health Education Quarterly, 17,* 53-72.

Centers for Disease Control. (1995). First 500,000 AIDS cases-United States, 1995. *Morbidity and Mortality Weekly Report, 44*(46), 849-853.

Chaisson, R. E., Osmond, D., Moss, A. R., Feldman, H.W., & Bernacki, P. (1987). HIV, bleach, and needle sharing [letter]. *Lancet,* i, 1430.

Chitwood, D. D., Inciardi, J. A., McBride, D. C., McCoy, C. B., McCoy, H. V., & Trapido, E. (1991). *A community approach to AIDS intervention.* New York: Greenwood Press.

Cochran, S. D., & Peplau, L. A. (1991). Sexual risk reduction behaviors among young heterosexual adults. *Social Science and Medicine, 33*(1), 25-36.

Coyle, S. L. (1993). *The NIDA HIV counseling and education intervention model: Intervention manual.* Rockville, MD: National Institute on Drug Abuse (NIH Pub. No. 93-3508).

Des Jarlais, D. C., Friedman, S. R., & Casriel, C. (1990). Target groups for preventing AIDS among intravenous drug users; 2. "hard data" studies. *Journal of Consult Clinical Psychology, 58,* 50-56.

Des Jarlais, D. C., Friedman, S. R., Choopanya, K., Vanichseni, S., & Ward, T. P. (1992). International epidemiology of HIV and AIDS among injecting drug users. *AIDS, 6,* 1053-68.

DiClemente, R. J., & Peterson, J. L. (1994). Changing HIV/AIDS risk behaviors: The role of behavioral interventions. In R. J. DiClemente & J. L. Peterson (Eds), *Preventing AIDS: Theories and methods of behavioral interventions.* New York: Plenum Press.

DiClemente, R.J., Work, & Coleman. (1991, November). *Crack cocaine use associated with increased drug risk behaviors and seroprevalence among a street population of drug users in San Francisco.* Paper presented at the 119th Annual Meeting of the American Public Health Association, Atlanta, GA.

Dolan, M. P., Black, J. L., Malow, R. M., & Penk, W. (1992). Clinical differences among opioid and speedball users in treatment. *Psychology of Addictive Behaviors, 5,* 78-84.

Edlin, B. R., Irwin, K., Faruque, S., McCoy, C. B., Word, C., Serrano, Y., Inciardi, J. A., Bowser, B. P., Schilling, R., Holmberg, S. D. and Multicenter Crack Cocaine and HIV Infection Study Team. (1994). Intersecting epidemics: Crack cocaine use and HIV infection in inner-city young adults. *New England Journal of Medicine, 33*(21), 1422-1427.

Fishbein, M., & Middlestadt, S. (1989). Using the theory of reasoned action as a framework for understanding and changing AIDS related behaviors. In V. M. Mays, G. W. Albee, & S. F. Schneider (Eds.), *Primary Prevention of AIDS.* Newbury Park, CA: Sage.

Fisher, D., Needle, R., Weatherby, N., Brown, B., Booth, R., & Williams, M. (1993, June). *Reliability of Drug User Self-Report 1993.* Presented as a poster session at the IXth International Conference on AIDS, Berlin, Germany.

Gielen, A. C., Faden, R. R., O'Campo, P., Kass, N., & Anderson, J. (1994). Women's protective sexual behaviors: A test of the health belief model. *AIDS Education and Prevention, 6*(1), 1-11.

Harrison, D. F., Wambach, K. G., Byers, J. B., Imershein, A. W., Levine, P., Maddox, K., Quadagno, D. M., & Fordyce, M. L. (1991). AIDS knowledge and risk behaviors among culturally diverse women. *AIDS Education and Prevention, 3*(2), 79-89.

Hayes, C. E., Sharp, E. S., & Miner, K. R. (1989). Knowledge, attitudes, and beliefs of HIV seronegative women about AIDS. *Journal of Nursing and Midwifery, 34*(5), 291-295.

Jemmott, J. D., Jemmott, L. S., & Fong, G. T. (1992). Reductions in HIV risk-associated sexual behaviors among black male adolescents: Effects of an AIDS prevention intervention. *American Journal of Public Health, 82,* 372-377.

Kelly, J. A. (1995). *Changing HIV risk behavior: Practical strategies.* New York: The Guilford Press.

Kirscht, J., & Joseph, J. (1989). The Health Belief Model. In V. M. Mays, G. W. Albee, & S. F. Schneider (Eds.), *Primary prevention of AIDS.* Newbury Park, CA: Sage.

Kroliczak, A. (1991). Preliminary findings regarding AIDS intervention among hispanics in the Southwest United States. In National Institute on Drug Abuse (Ed.), *Community-based AIDS prevention: Studies of intravenous drug users and their sexual partners.* Washington, DC: US Government Printing Office.

Malow, R., West, J., Pena, J., & Lott, W. (1991). Affective disorders and adjustment problems in cocaine and opioid addicts. *Psychology of Addictive Behaviors, 6,* 4-11.

Martin, G. S., Serpelloni, G., Galva, U., Rizzetto, A., Gomma, M., Morgante, S., & Rezza, G. (1990). Behavior change in injecting drug users: Evaluation of an HIV/AIDS programme. *AIDS Care, 2,* 275-279.

McCoy, C. B., McCoy, H. V., Hockman, E., & Anderson, M. D. (1995, November). *Effectiveness of HIV risk reduction interventions in a national multisite randomized community trial.* Submitted for publication.

McCoy, C. B., Metsch, L. R., Inciardi, J. A., Anwyl, R. S., Wingerd, J., & Bletzer, K. (1996). Sex, drugs, and the spread of HIV/AIDS in Belle Glade, Florida. *Medical Anthropology Quarterly, 10*(1), 1-11.

McCoy, C. B., Rivers, J. E., & Khoury, E. L. (1993). An emerging public health model for reducing AIDS-related risk behavior among injecting drug users and their sexual partners. *Drugs & Society, 7*(3/4), 143-159.

McCoy, C. B., Weatherby, N. L., Metsch, L. R., McCoy, H. V., Rivers, J. E., & Correa, R. (in press). Effectiveness of HIV interventions among crack users. *Drugs & Society.*

McCusker, J., Stoddard, A. M., Zapka, J. G., Morrison, C. S., Zorn, M., & Lewis, B. F. (1992). AIDS education for drug abusers: Evaluation of short-term effectiveness. *American Journal of Public Health, 82,* 533-540.

Miller, H. G., Turner, C. F., & Moses, L. E. (1990). *AIDS: The second decade.* Washington, DC: National Academy Press.

Moore, J. S., Harrison, J. S., & Doll, L. S. (1994). Interventions for sexually active, heterosexual women in the United States. In D. J. DiClemente & J. L. Peterson (Eds.), *Preventing AIDS: Theories and methods of behavioral interventions.* New York: Plenum Press.

Mucherera, K., & Pate, D. (1989). Cultural sensitivity and work with African-American men in reproductive health care. *Men's Reproductive Health, 3*(2), 3-6.

Oakley, A., Fullerton, D., & Holland, J. (1995). Behavioral interventions for HIV/AIDS prevention. *AIDS, 9,* 479-486.

Reinhart, G. R., & Rosenthal, A. M. (1991). Preliminary findings: Changes in drug use, needle use, and sexual behavior among intravenous drug users. In National Institute on Drug Abuse (Ed.), *Community-based AIDS prevention: Studies of intravenous drug users and their sexual partners.* Washington, DC: US Government Printing Office.

Rhodes, F., & Humfleet, G. L. (1993). Using goal-oriented counseling and peer support to reduce HIV/AIDS risk among drug users not in treatment. *Drugs & Society, 7,* 185-204.

Robertson, J. R., Skidmore, C. A., & Roberts, J. K. (1988). HIV infection in intravenous drug users: A follow-up study indicating changes in risk taking behavior. *British Journal of Addictions, 83,* 387-396.

Rotheram-Borus, M. J., Koopman, C., Haignere, C., & Davies, M. (1991). Reducing HIV sexual risk behaviors among runaway adolescents. *Journal of the American Medical Association, 266,* 1237-1241.

Rugg, D. (1990, Summer). AIDS prevention: A public health psychology perspective. *New Directions for Program Evaluation, 46,* 7-22.

Scales, P., & Beckstein, D. (1982). From macho to mutuality: Helping young men to make effective decisions about sex, contraception, and pregnancy. In Stuart & Wells (Eds.), *Pregnancy in adolescence: Needs, problems, and management.* Van Nostrand Reinhold.

Siegal, H. A., Falck, R. S., Carlson, R. G., & Wang, J. (1995). Reducing HIV needle risk behaviors among injection-drug users in the Midwest: An evaluation of the efficacy of standard and enhanced interventions. *AIDS Education and Prevention, 7*(4), 308-319.

Siegal, H. A., Carlson, G., Falck, R., Li, L., Forney, M. A., Rapp, R. C., Baumgartner, K., Myers, W., & Nelson, M. (1991). HIV infection and risk behaviors among intravenous drug users in low seroprevalence areas in the Midwest. *American Journal of Public Health, 81,* 1642-1644.

Sorensen, J. L., London, J., Heitzmann, C., Gibson, D. R., Morales, E. S., Dumontet, R., & Acree, M. (1994). Psychoeducational group approach: HIV risk reduction in drug users. *AIDS Education and Prevention, 6*(2), 95-112.

Sorensen, J. L. (1990). Preventing AIDS: Prospects for change in white intravenous drug users. In C. O. G. Luekefeld, R. J. Battjes, & Z. Amsel (Eds.), *AIDS and the intravenous drug user: Future directions for community based prevention research.* Monograph Series No. 93, pp. 83-107. Rockville, MD: National Institute on Drug Abuse.

Stephens, R. C., Simpson, D. D., Coyle, S. L., McCoy, C. B., & The National AIDS Research Consortium. (1993). Comparative effectiveness of NADR interventions. In B. J. Brown & G. Beschner (Eds.), *Handbook on AIDS and the injection drug user.* Westport: Greenwood Press.

Stephens, R. C., Feucht, T. E., & Roman, S. W. (1991). Effects of an intervention program AIDS-related drug and needle behavior among intravenous drug users. *American Journal of Public Health, 81*(5), 568-571.

Watters, J. K. (1987). A street-based outreach model of AIDS prevention for intravenous drug users; preliminary evaluation. *Contemporary Drug Problems, 14*(3), 411-423.

Weatherby, N. L., Needle, R., Cesari, H., Booth, R. E., McCoy, C. B., Watters, J. K., Williams, M. L., & Chitwood, D. D. (1994). Validity of self-reported drug use among injection drug users and crack cocaine users recruited through street outreach. *Evaluation and Program Planning, 17*(4), 347-354.

Weeks, M. R., Schensul, J. J., Williams, S. S., Singer, M., & Grier, M. (1995). AIDS prevention for African-American and Latina women: Building culturally and gender appropriate intervention. *AIDS Education and Prevention, 7*(3), 251-263.

Wholey, J. S., Hatry, H. P., & Newcomer, K. E. (1994). *Handbook of practical program evaluation.* San Francisco: Jossey-Bass Publishers.

Zeger, S. L., Liang, K-Y, & Albert, P. (1988). *Biometrics, 44*, 1049-1060.

Zimmerman, R. S., & Olson, K. (1994). AIDS-related risk behavior and behavior change in a sexually active, heterosexual sample: A test of three models of prevention. *AIDS Education and Prevention, 6*(3), 189-205.

AIDS Risk Perception
Among Women Drug Users
in Hartford, CT

Merrill Singer, PhD
Hanteng Dai, MD
Margaret R. Weeks, PhD
Dorca Malave

SUMMARY. This paper reports the findings of a study of congruence between AIDS risk perception and risk behavior in a sample of outreach-recruited out-of-treatment injection and non-injection crack cocaine using women in Hartford, CT. While rates of drug- and sex-related AIDS risk were high in this sample, perception of risk

Merrill Singer is Associate Director and Chief of Research, Hispanic Health Council, 175 Main Street, Hartford, CT 06106. Hanteng Dai is a research fellow at the Hispanic Health Council. Margaret R. Weeks is Associate Director, Institute for Community Research, Hartford, CT. Dorca Malave is a member of the research support staff, Hispanic Health Council, Hartford, CT.

This study was funded by a grant from the National Institute on Drug Abuse.

[Haworth co-indexing entry note]: "AIDS Risk Perception Among Women Drug Users in Hartford, CT." Singer, Merrill et al. Co-published simultaneously in *Women & Health* (The Haworth Medical Press, an imprint of The Haworth Press, Inc.) Vol. 27, No. 1/2, 1998, pp. 67-85; and: *Women, Drug Use, and HIV Infection* (ed: Sally J. Stevens, Stephanie Tortu, and Susan L. Coyle) The Haworth Medical Press, an imprint of The Haworth Press, Inc., 1998, pp. 67-85. Single or multiple copies of this article are available for a fee from The Haworth Document Delivery Service [1-800-342-9678, 9:00 a.m. - 5:00 p.m. (EST). E-mail address: getinfo@haworthpressinc.com].

was low among many of the respondents. Variation in risk perception reflects sociodemographic differences in the sample, with those women who were most socially isolated exhibiting the greatest incongruence between personal risk and risk perception. Women who have had contact with health or social service programs were the most likely to report reductions in risk behavior. *[Article copies available for a fee from The Haworth Document Delivery Service: 1-800-342-9678. E-mail address: getinfo@haworthpressinc.com]*

AIDS was mistakenly seen as an exclusive disease of men, in particular, gay men, during the first years of the epidemic in the U.S. In spite of a growing caseload of women with HIV disease and diagnosed AIDS, recognition of AIDS as a threat to women's health remained quite limited. As Richardson (1989:1) notes,

> despite the widespread attention AIDS has received from the media . . . many Americans don't really expect AIDS to affect them. If they think about it at all it is as . . . a disease that happens to "other kinds" of people . . . This is an attitude especially likely to be true of women.

Indeed, as Richardson (1994:42) has more recently observed,

> until a few years ago a common response to attempts to discuss the topic of women and AIDS was "Do women get AIDS?," the assumption being that women were at little or no risk.

Early failure to see women–and for many women to see themselves–as being at risk for AIDS was a significant barrier to effective AIDS prevention, including the development of prevention models that were targeted and sensitive to the special needs and life situations of women. Existing research suggests that for individuals to initiate, or be motivated to initiate, behavior change to avoid disease, they must first perceive the disease as a personal risk and one that is of a fairly serious nature. Consequently, the prevailing psychological theories of disease prevention, including the health belief model (Janz and Becker, 1984), reasoned action theory (Ajzen and Fishbein, 1986), social learning theory (Bandura, 1977), and the stages of change model (Prochaska and DiClemente, 1983), all assert that perception of high personal risk is a necessary (if insufficient) component of risk avoidance. With reference to the issues at hand in this paper, if a woman does not believe that a disease like AIDS affects women, or that for some reason she personally can be infected, it is unlikely that she will adopt preventive strategies, even when they are readily available and easy

to use (which, because of unequal gender relations, is not actually true in the case of AIDS) (Gillies and Carballo, 1990; Prohaska et al., 1990; Catania, Kegeles, and Coates, 1990; Weeks et al., 1995). As a result, infection may spread as prevention initiatives are misdirected, ignored or marginally supported (Doyal, 1994).

Data on AIDS rates suggest that this is precisely what may have occurred among many women. The extent of infection among women, especially in some regions of the U.S. (e.g., the Northeast), has soared (Ellerbrock et al., 1991; Amaro, 1993) as has the rate of drug use among women (Ettore, 1992). While during 1981, women constituted 3 percent of new AIDS cases in the U.S., by 1993 they made up almost 16 percent of the annual incidence rate (Sobo, 1995). Currently, the incidence of new AIDS cases is rising four times faster among women than among men (Centers for Disease Control and Prevention, 1993). Some sub-groups of women, especially African Americans and Latinas and those who use drugs, have especially high rates of AIDS (Shayne and Kaplan, 1991; Singer, 1994). A survey of female admissions to the New York City jail system, for example, found that half (49.6 percent) of those who were injection drug users (IDUs) were seropositive for HIV compared to a quarter (25.6 percent) of the total admission sample (Magura et al., 1993). Although there are significantly more male than female IDUs, in a national study of this population (n = 26,260) coordinated by the National Institute on Drug Abuse (NIDA), rates of HIV infection were no higher among men than women (18.7 percent and 17.8 percent respectively) (LaBrie et al., 1993). According to the Centers for Disease Control and Prevention (1991:358), "the largest proportionate increases [of diagnosed and reported AIDS cases from 1989 to 1990] occurred among women, blacks and Hispanics . . . and persons exposed to HIV through heterosexual contact," while injection drug use remained the most prevalent route of infection among women.

Despite greater general awareness during the second decade of the epidemic that AIDS does not discriminate by gender (except that women, ironically, may be at greater risk because of seminal ejaculation during intercourse) and that many women have been infected with HIV disease and died of AIDS, not all women, even women who regularly engage in behaviors widely known to be associated with high rates of infection, readily perceive they are at risk. The purpose of this paper is to report findings from a study in Hartford, CT of AIDS risk and risk perception among a group of inner city women who are actively involved in street drug use. Factors associated with higher and lower levels of congruence between perceived AIDS risk and reported risk behaviors were found to

have significant implications for targeting AIDS prevention efforts. While we agree with the argument of Crisp et al. (1993:73) that AIDS policy and prevention "should aim to change unsafe injecting and sexual behaviors directly, rather than attempting to achieve changes indirectly by changing risk perception," our findings show that examining the implications of risk perception remains an important arena of prevention research.

AIDS RISK PERCEPTION

Perceived risk exists at two levels. As Snyder and Rouse (1992:144) indicate:

> Perceived *personal risk* is an individual's vulnerability or fear, and perceived *social risk* includes beliefs that a problem exists at the neighborhood, city, state, or national level. Beliefs about personal and societal risk appear to be distinct across a range of social and natural risks . . .

Concern with increasing the appropriateness of perceived personal susceptibility (to ensure that people are neither unduly panicked nor ignoring real danger) has been central to public health efforts for several decades (Rosenstock, 1960). Risk perception was adopted as a potentially important area of research for AIDS prevention based on the belief that "[p]rograms that do not attend to variations in risk perception are less likely to be successful in motivating individuals to act" (Turner, Miller and Moses, 1989:272).

One direction of research has involved assessing exaggerated AIDS risk perception that could lead to problematic behaviors (e.g., discrimination against people with AIDS, avoidance of health care settings because of fear of infection) (Gerbert, Maguire and Sumser, 1991; Mondragón, Kirkman-Liff and Schneller, 1991). Of greater pertinence to our research has been a series of studies that assess personal perception of risk in relationship to sociodemographic, attitudinal, or behavioral issues. Commonly in this body of literature, self-reported evaluation of personal risk has been tied to the study of formal AIDS knowledge (usually involving the administration of true/false pen-and-paper tests), based on the assumption that higher levels of knowledge should lead to higher levels of perceived vulnerability (among those who are indeed more vulnerable), and that the latter, in turn, should contribute to receptivity to risk reduction

education and behavior change. Studies among several different populations of the relationship of knowledge to perceived risk have shown a direct correlation: higher levels of AIDS knowledge are linked to higher levels of perceived risk and greater accuracy of personal risk assessment (DiClemente et al., 1988; Mickler, 1993; Stevenson, Gay and Josar, 1995). This finding has led to an emphasis in AIDS prevention on ensuring that people learn precise information about their personal level of risk as part of the effort to reduce the frequency of risk behavior (Mickler, 1993).

The association between perceived risk and protective behavior change has been found to be more ambiguous, however: greater knowledge and perceived risk commonly do not closely predict risk avoidance. For example, in a recent national study in the U.S. (cited in Turner, Miller and Moses, 1989), 65 percent of heterosexual women who reported having multiple sex partners (nine or more during the last year) were found to have never purchased condoms. Almost 60 percent of study participants assessed their personal risk of AIDS on the lowest rung of a risk scale. Similarly, a study of gay men in The Netherlands found that the majority of individuals (70 percent) who had unprotected anal intercourse were aware of the potential risk, and this was especially true (95.6 percent) of those men who reported anal intercourse with casual partners (Bosga et al., 1995).

Among drug-involved populations, similar patterns have been noted. In a study of 137 female (mostly drug-using) sex partners of male IDUs in California, Corby and co-workers (1991) found a reasonably high awareness of AIDS susceptibility. This did not translate, however, into lowered sexual risk. Almost all of the women in the study (94.9 percent) reported engaging in unprotected vaginal intercourse during the previous six months. In a study of over a hundred IDUs, Magura et al. (1989) did not find a relationship between self-reported use of previously used needles and perceived risk for AIDS. Similarly, Crisp et al. (1993) found that risk perception was unrelated to either drug use or sexual risk behavior among 1,245 IDUs in Sydney, Australia. However, in a California study of women drug injectors, Huang, Watters, and Case (1988) found perceived susceptibility to HIV to be a predictor of condom use, while Kline and Strickler (1993:319), in a study of women in drug treatment, concluded that "women who have injected drugs within the past 4 weeks seem to recognize that this behavior puts them at risk for HIV; in fact, it may be that concern about AIDS is what motivated them to enter drug treatment in the first place."

These studies suggest the importance of further clarification of the relationship between AIDS risk perception and risk behavior among active drug users if we are to be able to "maximize message specificity, population

reach, and impact" in AIDS prevention (Snyder and Rouse, 1992:156; Becker and Joseph, 1988). Is perception of risk independent of behavior change? Is awareness of risk higher in some subgroups of drug users than others? What might account for these differences? These are the questions addressed in the remainder of this paper.

METHODS

Data for this paper were collected in Project Cope II (the Community Outreach Prevention Effort), a NIDA funded Cooperative Agreement study in Hartford, CT of AIDS risk and risk prevention among outreach-recruited, street drug users. Hartford was one of 23 Cooperative Agreement sites in the U.S., Puerto Rico, and Brazil. Located in close proximity to New York City, Hartford has both a large number of injection drug users (relative to its population) and a comparatively high rate of HIV infection in this population. Estimates are that there are 8,000-12,000 IDUs in the city (which has a total population of under 140,000). The Division of HIV Services of the federal Health Resources and Services Administration estimates that over 3,000 people in the Hartford metropolitan area are infected with HIV, 58% through injection drug use (Eichler, 1996). Several testing studies in Hartford have found HIV seropositive rates between 30-45 percent among IDUs (with rates of infection being higher among female IDUs) (Singer et al., 1992). The smoking of powder-cocaine (free-basing) and crack-cocaine also are common in Hartford, especially among female drug users. Smoking of cocaine has been linked with sex for drugs/money exchanges in local research (Singer, 1995).

We included all female participants (a total of 208) in Project COPE II in the analysis presented in this paper. All of these participants met the NIDA eligibility criteria (see Coyle, this volume). All of the data presented in this paper were collected using the Risk Behavior Assessment Questionnaire (RBA), the standard intake instrument for NIDA's Cooperative Agreement projects. The perception of AIDS risk was mainly collected by asking the question: "Which statement best describes your chance of getting AIDS? Would you say you have: No chance = 0 percent; Some chance = 25 percent; A half chance = 50 percent; A high chance = 75 percent; A sure chance = 100 percent; Not applicable/not available (has AIDS); Don't know/unsure; and Refused?" These answers were coded as 0-8, respectively. In order to simplify the analysis for this paper, outcomes for this variable were recoded to: "No chance = 0; Half and less chance = 1; and More than half chance = 2."

Data were analyzed using SPSS for Windows version 6.1. Bivariate

measures of association between perceived chance of getting AIDS and possible contributing variables were examined. Chi-square tests and two-tailed t-tests were used to determine significance.

RESPONDENTS

As seen in Table 1, among the 208 participants, the age range was between 20-61 years, with a mean age of 34 years. About half (49 percent) were Hispanic (all Hispanics were Puerto Rican); 39 percent were African

TABLE 1. Sociodemographic Profile of Participants by Ethnicity

	African-American	White & others	Puerto Rican	Total
Participants (n =)	81	24	103	208
Mean age (years)	36	35	32	34
Education (%)				
Less than High School	48.2	45.9	68.0	57.7
GED or HS	34.6	20.8	22.3	26.9
Trade/Tech. Training	13.6	29.2	9.7	13.5
Some College	3.7	4.2	0	1.9
Marital Status (%)				
Single (never married)	53.1	29.2	41.7	44.7
Married/Common Law	23.5	45.9	39.8	34.2
Separated/Divorced/Widowed	23.5	25	18.4	21.2
Income				
< 500	51.9	37.5	56.3	52.4
500-999	39.5	29.2	31.1	34.1
1,000-1,999	7.4	16.7	6.8	8.2
> = 2,000	1.2	16.7	5.8	5.3
Employment				
Unemployed, looking for job	45.7	41.7	25.2	35.1
Unemployed, not looking for job	25.9	16.7	33.0	28.4
Full-time job	0.0	0.0	0.0	0.0
Part-time job	2.5	0.0	0.0	1.0
Homemaker	7.4	8.3	25.2	16.3
Disabled	17.3	20.8	13.6	15.9
Other	1.2	12.5	3.0	3.4

American; and 12 percent were white (non-Hispanic) or Asian/Pacific Islander. More than half of the women (57.7 percent) had less than high school education, with 26.9 percent, 13.5 percent, and 1.9 percent having GED or high school, trade/technical training, or some college, respectively. Nearly half (44.7 percent) were single and never married. Among the others, only 6.7 percent were formally married, 27.3 percent were living with a partner or in a common law marriage, and 21.2 percent were separated, divorced or widowed. About half (49 percent) of the women lived with adults other than their spouses or opposite-sex partners. More than half (52 percent) lived with children under 18 years old. Nearly a third of the women (31 percent) considered themselves to be homeless.

Overwhelmingly, the participants were extremely poor. Most (52.4 percent) reported that they made less than $500 in the 30 days prior to participating in the study, 34.1 percent made $500-999, and 8.2 percent made $1,000-1,999. Only 5.3 percent made more than $2,000 a month. As for their sources of income, only 5.3 percent of the women had paid employment and none of these had a full-time job. An additional 11.5 percent engaged in the legal sale or trading of goods on the street. Among the women who were not working but were well enough to do so, the majority indicated they were trying to find employment. Most (73.6 percent) of the women received support from some form of public assistance. Another 12.5 percent received social security, disability, unemployment or workmen's compensation. A small percentage of the women received alimony or child support (3.4 percent), or unemployment compensation (1.9 percent). Additionally, more than one third (37.5 percent) received some money from spouses/partners, family members, or friends. Finally, many of the women reported that they engaged in various illegal activities as sources of income. One in five (20.7 percent) derived some income from prostitution. Another 15.9 percent participated in illegal activities, such as drug dealing, stealing, robbery or shoplifting, as a means of raising money to support themselves and their drug addiction.

In sum, the women in our sample were extremely poor, lacked jobs and had low levels of education, and primarily were Puerto Rican or African American. A comparison of sociodemographic characteristics by ethnicity found that whites had more education ($p = .008$), more income ($p = .01$), and were more likely to be married (either formally or in a common-law arrangement) or to live with partners ($p = 0.03$) than either African Americans or Puerto Ricans. The latter had the lowest level of education and income and were the least likely to be married or to be living with a partner. These findings reflect general sociodemographic patterns found in Hartford in prior research (Singer et al., 1990; Singer et al., 1992).

Overall, the sample was composed of heavy drug users. As seen in Table 2, the majority of the women had used alcohol, marijuana, crack-cocaine, powder-cocaine, heroin, and speedball (a combination of heroin and cocaine). While heroin was the most frequently used drug, less than 2 percent of the women used only one drug, while more than 90 percent regularly used more than three drugs and some of the women reported that they used nine different drugs. The mean number of illicit drugs used (i.e., not including alcohol) was five. The mean age of their first drug use was 16. Generally, the women began using alcohol and marijuana during their teenage years, added the use of powder-cocaine and heroin in their early twenties, and began using crack-cocaine and speedball in their mid-twenties. The majority of the women had injected all three of the drugs/drug combinations that are the most commonly injected drugs in Hartford: powder-cocaine, heroin and speedball, with heroin being the most frequently injected substance (approximately three times per day on average).

In terms of sexual preference, the majority of the women (89.4 percent) considered themselves to be heterosexual, while 4.3 percent and 5.3 percent respectively reported that they were lesbian or bisexual. The women engaged in significant levels of risky sexual behavior. As seen in Table 3, among the 150 women (73.1 percent) who had at least one sexual partner during the last 30 days, more than one-third (36.6 percent) had sex (vaginal, oral, or anal) with more than one person; 7.8 percent had sex with 10 or more people. The mean number of sexual partners during the last 30 days was four, with a range between 1 and 76. About a quarter of the women had sex 10 or more times during the last month and a similar

TABLE 2. Profile of Participant Drug Use Patterns

	Alcohol	Marijuana /Hashish	Crack	Powder Cocaine	Heroin	Speedball
Ever used drugs (% of participants)	93	89	69	90	87	71
Age of first use (mean)	16	16	25	22	22	24
Days used drug in last 30 days (mean)	10	4	11	8	22	12
Times injected in last 30 days (mean)				59	92	81

TABLE 3. Profile of Sexual Behavior During the Last 30 Days

Number of partners	Number of participants	%		Number of days had sex	Number of participants	%
0	55	26.4		0	55	26.4
1	95	45.7		1	17	8.2
2	20	9.6		2	10	4.8
3-9	19	9.1		3-9	51	24.4
10-19	9	4.4		10-19	34	16.4
20+	7	3.4		20+	39	18.8
Not sure	3	1.4		Not sure	2	1.0
Total	208	100.0		Total	208	100.0

percent did not have sex during this period. Most of the women's sex partners were male. Ten of the women reported having one female sex partner during the last month.

In addition to having multiple sex partners, 31 percent of the women reported that at least one of their sex partners was likely to have been a drug injector (not including very casual or new partners about whom they were unsure). Moreover, the women reported using a variety of drugs in conjunction with sex during the previous 30-day period. More than half (57 percent) used heroin, one-third (33 percent) used alcohol, one-fourth (25 percent) used crack, another one-fourth (23 percent) used speedball, one-fifth (19 percent) used powder cocaine, and one-seventh (13 percent) used marijuana during sexual activities.

Many of the women in the sample reported having ever exchanged sex for drugs (30 percent) or money (46 percent). Over the last 30-day period, 15 percent indicated that they had exchanged sex for drugs, while 23 percent had exchanged sex for money. The primary drugs involved in sex for drug exchanges were heroin and cocaine.

Most of the women in this study rarely used safer sex practices, although protective efforts varied depending on their partner. Those women who reported having sex with other women never used barrier methods. The few women (2.4 percent) who reported having both male and female partners never used barrier methods except during vaginal intercourse with men (41 percent). Women who only had sex with male partners used barriers/condoms only 7 percent of the time during cunnilingus, 38 percent of the time during fellatio, 12.5 percent of the time during anal intercourse, and 13 percent of the time during vaginal intercourse.

Women in the sample commonly reported having had sexually trans-

mitted and other infectious diseases of various kinds. Based on having been told by a physician of their diagnosis, rates of infection were as follows: gonorrhea 29.6 percent, syphilis 13.5 percent, hepatitis B 19.5 percent, yeast infection 43.1 percent, chlamydia 11.1 percent, trichomonas 11.1 percent, genital herpes 4.3 percent, and genital warts 2.9 percent. Some of the women reported multiple or repeated infections: e.g., eight women had been diagnosed with yeast infections more than 15 times, and one woman reported 42 such incidents.

About one-third (33 percent) of the women reported that they had been tested for HIV infection at least once. Another third (34 percent) had been tested two or three times and 15 percent had been tested more than three times. About a fifth of the women (18 percent), however, had never been tested. Even among those who had been tested for HIV, 17 percent reported that they had not gone back to the test site to receive their test results the last time they were tested.

Thirty-seven of the women (17.8 percent) had been diagnosed with HIV infection prior to their involvement in Project COPE II. Three of the women had been diagnosed with AIDS or AIDS-related complex. If we take into account the following facts: (1) some women had never been tested, (2) some did not return to get their test results, (3) some women might be in denial concerning their HIV status, and (4) some women might have been in the "window" period at the point of testing (i.e., too soon after infection for the production of measurable levels of HIV antibodies), then the rate of HIV in the sample may be even higher.

RESULTS

The vast majority of the women (93.3 percent) responded to our interview question regarding self-perceived AIDS risk. Most of those who declined to respond had already been diagnosed with AIDS or a related HIV condition. As seen in Table 4, 16.8 percent thought they had no chance of getting AIDS, 36.5 percent perceived that they had only a 25 percent chance, 15.9 percent reported they had a 50 percent chance, 17.3 percent indicated a 75 percent chance, and 6.7 percent were certain they would get AIDS (100 percent chance). In other words, despite high rates of drug and sex-related AIDS risk, over half (54 percent) of the women believed that they had only a 25 percent or less chance of contracting AIDS, while only one-fourth perceived more than a 50 percent chance that this would occur.

Significant subpopulation differences have been found in prior studies of the congruence between personal risk assessment and risk behaviors

TABLE 4. Perceived Chance of Getting AIDS by Ethnicity

Perceived Chance	African-American (%)	White & Asian/ Pacific Islanders (%)	Puerto Rican (%)	Total (%)
No (0%) chance	12.5	4.2	23.3	16.8
Some (25%) chance	38.8	25.0	37.9	36.5
Half (50%) chance	15.0	25.0	14.6	15.9
High (75%) chance	18.8	37.5	11.7	17.3
Sure (100%) chance	7.5	8.3	5.8	6.7
Have AIDS already	2.5	0.0	1.0	1.4
Not sure/don't know	5.0	0.0	5.8	5.3
Total	100.0	100.0	100.0	100.0

(Sandfort et al., 1991). A closer examination of the patterning of risk perception in our sample shows that greater congruence between actual behavior and perceived AIDS risk increased with age, greater education, and higher income. Women who were IDUs also had a higher level of perceived risk than those who were non-injecting crack smokers.

Ethnicity was closely related to perceived vulnerability. Whites perceived higher personal chances (p = 0.02) of contracting AIDS than either African Americans or Puerto Ricans. Of the 111 women who reported they had a 25 percent or less chance of getting AIDS, 55 percent were Puerto Rican. Additionally, 56 percent of these women had less than a high school education, and only 9 percent were married. Sixty percent with low perceived susceptibility made less than $500 a year and 93 percent reported incomes less than $1000 a year. Fifty percent of these women were non-IDU cocaine users and 20 percent had never had an HIV test before.

Of the 35 women who reported that they had no chance of getting AIDS, Puerto Ricans accounted for 63 percent. Most of the other women in this category were African American. Also among these women, the proportion with less than a high school level of education was 63 percent; 79 percent were single, separated, divorced or widowed; 66 percent made less than $500 and all of them made less than $1000 in the past year; 57 percent were non-IDU cocaine users; and 24 percent never had an HIV test. Among these women, 43 percent were primary Spanish-speakers. English-speakers made up 67 percent of those who reported a 25 percent perceived chance of getting AIDS compared to 54 percent of those who perceived they had no chance of getting AIDS.

Importantly, if a woman had ever been diagnosed with an STD or hepatitis, her perception of personal AIDS risk increased. In particular,

prior diagnosis with hepatitis B, gonorrhea or trichomonas was significantly associated (p < 0.05) with a higher level of perceived chance of getting AIDS.

All of the women, who during the 30 days prior to being enrolled in Project COPE II had received AIDS prevention education, sterile needles or other prevention materials from one of the city's AIDS prevention programs, or who had received a referral to a drug treatment program, reported a higher level of perceived personal vulnerability than those who had not received these services (although not at a statistically significant level). Of greatest significance in our findings was the fact that women who perceived higher levels of personal AIDS risk were more likely to report they had reduced the frequency of risk behavior. Significantly (p < 0.05) more of the women who reported they had greater than a 50 percent chance of getting AIDS cut back their needle sharing and use of previously used needles, reduced the number of sex partners they had, used condoms or other latex protection more often, and made other risk reduction changes in their sexual practices during the prior 30 days. Using bleach to sterilize their needles also increased among these women, although not at a rate that achieved statistical significance.

DISCUSSION

Although our prior research found that IDUs and other drug users in the city of Hartford generally are aware of HIV/AIDS, its lethality, symptoms, and routes of transmission, the findings from the present study of 208 drug-involved women indicate that over half believed they have less than a 25 percent to no chance of getting AIDS. Given their active involvement in high-risk behaviors, the low level of perceived risk in this population is notable and not without potential consequence for their likelihood of contracting AIDS.

Finding a high level of incongruence between perceived AIDS risk and risky behavior appears to confirm a common pattern in the AIDS epidemic: the tendency to see the disease as a condition that primarily affects other people, people who are different from oneself (Kinsey, 1994; Schoenborn, Marsh and Hardy, 1994). This attitude has been widely reported among those who believe that AIDS in the U.S. is limited almost exclusively to gay men, drug users, and the sex partners of drug users (Blake and Arkin, 1988). As Snyder and Rouse (1992:145) state, "Many people believe that they are not at risk since they are heterosexual, date 'nice' people, and are not promiscuous." This tendency is not unique to the AIDS epidemic but rather reflects a broader pattern of susceptibility denial and the downplay-

ing of risk in the face of a threatening disease or other misfortune. Researchers have coined various terms, including "unrealistic optimism," "unique invulnerability," "illusion of uniqueness," and "self-serving bias," to label this phenomenon (Larwood, 1978; Perloff and Fetzer, 1986; Snyder, 1978; Weinstein, 1987). As Mickler (1993:45) observes, "although people may be fairly accurate in appraising the chances that others will experience misfortune, they tend to underestimate their own chances of negative outcomes . . . " Some groups, like adolescents, have been found to be particularly likely to hold such attitudes (Burger and Burns, 1988). In the case of the AIDS epidemic, denial may be significantly enhanced by societal stigmatization both of the disease and the kinds of people who commonly are believed to be primarily affected by it (Clatts and Mutchler, 1989; Warwick, Aggleton and Homans, 1988). As a result, even individuals who regularly engage in the highest-risk behaviors for the transmission of HIV can retain a personal sense of invulnerability.

Importantly, presumption of low-to-no risk is not evenly divided among women in our sample. A number of factors predict high or low-risk perception. Puerto Rican women were significantly ($p = 0.02$) more likely to believe that they were at low or no risk for AIDS than were whites and African Americans. Additionally, compared to those who at least felt they were at some risk for contracting AIDS (25 percent chance of developing the disease), those who perceived they were not susceptible were more likely: (1) to be monolingual Spanish-speakers; (2) to have lower levels of education; (3) not to be in a marital relationship; (4) to have lower annual income; (5) to be unemployed; (6) to be non-injection cocaine users rather than IDUs; and (7) to never have had an HIV test. In other words, female drug users who were more isolated (culturally, lingually, socially, economically, and educationally) were most likely to misperceive their level of AIDS risk. This key finding underlines the need for targeted education specifically designed to overcome isolation and to reach and engage this population, a group that could be referred to as *doubly victimized* (by discrimination based on their gender and ethnicity, on the one hand, and by their intense social isolation, on the other) (Friedman, Des Jarlais and Sterk, 1990). Indeed, the argument could be made that underestimating AIDS risk is a means people use to express their sense of powerlessness to protect themselves from infection.

As we have argued elsewhere (Singer and Weeks, 1996), there is a growing need for customized AIDS prevention targeted to a range of special subpopulations at highest risk for infection or who form natural social groups with common risk pathways. These natural groupings may not be the traditional exposure categories but may be smaller, more

homogeneous collectivities within broader transmission categories or be composed of individuals who crosscut the boundaries of commonly identified exposure categories. Prevention efforts for these groups must be highly sensitive to the sociocultural contexts of their lives including contextual and social structural factors that promote "risk taking" behavior or prevent access to AIDS information and services (Connors, 1992). As Ward (1993:427) comments, "Risk taking implies autonomy in the world," and for this reason "given the power differentials in contemporary society it may be sensible to think of HIV in poor women as vertical transmission instead of horizontal transmission." In the present study, social isolation appears to delineate a natural social group of women in critical need of targeted AIDS prevention. Isolation in this instance is a social product, a consequence of overt and covert discrimination based on ethnic, gender, and class differences from the dominant population (Singer et al., 1990).

When this normally isolated group is reached and successfully involved in the public health and social service system (e.g., through culture and gender sensitive street outreach or user-friendly needle exchange programs), our findings show that their perception of AIDS risk goes up significantly. Thus, women in our sample who had been diagnosed with an STD were much more likely to believe they were at high risk of AIDS ($p < 0.0001$). Similarly, women who reported they had received AIDS prevention information and materials or been referred for services were more likely to perceive themselves at high risk than those women who had not received this information or referral, despite similarities in reported risk behaviors of the two groups.

Significantly ($p < 0.05$), and contrary to several other studies, women in our sample who perceived they were at high risk of AIDS were more likely to lower their frequency of risk behaviors, including both the use of previously used and potentially infected needles ($p < 0.00001$) and having sex without a condom ($p = 0.003$), than were women who believed they were at low risk for AIDS. Although the present study has a number of limitations, including the lack of a truly random sample of women drug users and reliance on cross-sectional data, our findings suggest the importance of further investigating the link between risk perception and behavior change to lower risk. Involving hard-to-reach, highly at-risk groups in existing health and social programs can make an important contribution to heightened awareness of personal risk and subsequent risk reduction.

REFERENCES

Ajzen, I. and Fishbein, M. (1986). *Understanding Attitudes and Predicting Behavior.* Englewood Cliffs, NJ: Prentice Hall.

Amaro, H. (1993). Reproductive choice in the age of AIDS: Policy and counseling issues. In C. Squire (Ed.), *Women and AIDS,* pp. 20-41. London: Sage.

Bandura, A. (1977). Self-efficacy: Toward a unifying theory of behavioral change. *Psychological Review,* 84: 191-215.

Becker, M. and Joseph, I. (1988). AIDS and behavioral change to reduce risk: A Review. *American Journal of Public Health,* 78(4): 394-410.

Blake, S. and Arkin, E. (1988). A summary of national public opinion surveys on AIDS: 1983 through 1986. *AIDS Information Monitor.* Washington, DC: American Red Cross.

Bosga, M., de Wit, J., de Vroome, E., Houweling, H., Schop, W., and Sandfort, T. (1995). Differences in perception of risk for HIV infection with steady and non-steady partners among homosexual men. *AIDS Education and Prevention,* 72(2): 103-115.

Burger, J. and Burns, L. (1988). The illusion of unique invulnerability and use of effective contraception. *Personality and Social Psychology Bulletin,* 14: 264-270.

Cantania, J., Kegeles, S., and Coates, T. (1990). Toward an understanding of risk behavior: An AIDS risk reduction model (AARM). *Health Education Quarterly,* 17(1): 53-72.

Centers for Disease Control and Prevention. (1991). Update: Acquired Immunodeficiency Syndrome–United States, 1981-1990. *Morbidity and Mortality Weekly Report,* 40, 358-369.

Centers for Disease Control and Prevention. (1993). Update: Acquired Immunodeficiency Syndrome–United States, 1992. *Morbidity and Mortality Weekly Report,* 42, 547-557.

Clatts, M. and Mutchler, K. (1989). AIDS and the dangerous other: Metaphors of sex and deviance in the representation of disease. *Medical Anthropology,* 10: 105-114.

Connors, M. (1992). Risk perception, risk taking and risk management among intravenous drug users: Implications for AIDS prevention. *Social Science and Medicine,* 34(6): 591-601.

Corby, N., Wolitski, R., Thorton-Johnson, S., and Tanner, W. (1991). AIDS knowledge, perception of risk, and behaviors among female sex partners of injection drug users. *AIDS Education and Prevention,* 3(4): 353-366.

Crisp, B., Barber, J., Ross, M., Wodak, A., Gold, J., and Miller, M. (1993). Injection drug users and HIV/AIDS: Risk behaviors and risk perception. *Drug and Alcohol Dependence,* 33: 73-80.

DiClemente, R., Boyer, C., and Morales, E. (1988). Minorities and AIDS: Knowledge, attitudes and misconceptions among Black and Latino adolescents. *American Journal of Public Health,* 7(1): 55-57.

Doyal, L. (1994). HIV and AIDS: Putting women on the global agenda. In L. Doyal, J. Naidoo and T. Wilton (Eds.), *AIDS: Setting a Feminist Agenda,* pp. 11-29. London: Taylor and Francis, LTD.

Eichler, A. (1996). Letter to Hartford Title 1 Recipients, Division of HIV Services, Bureau of Health Resources Development, Health Resources and Services Administration.

Ellerbrock, T., Bush, T., Chamberland, M., and Oxtobny, M. (1991). Epidemiology of women with AIDS in the United States, 1981 through 1991. *Journal of the American Medical Association,* 265(22): 1971-1975.

Ettore, E. (1992). *Women and Substance Abuse.* New Brunswick, NJ: Rutgers University Press.

Friedman, S., Des Jarlais, D., and Sterk, C. (1990). AIDS and the social relations of intravenous drug users. *The Milbank Quarterly,* 68(Sup. 1): 85-110.

Gerbert, B., Maguire, B., and Sumser, J. (1991). Public perception of risk of AIDS in health care settings. *AIDS Education and Prevention,* 3(4): 322-327.

Gillies, P. and Carballo, M. (1990). Adult perception of risk, risk behavior and HIV/AIDS: A focus for intervention and research. *AIDS,* 4: 943-951.

Huang, K., Watters, John, and Case, P. (1988). Health beliefs and self-efficacy: Predictors of safer needle use and safer sex among intravenous drug users. Paper presented at the Annual Meeting of the American Public Health Association, Boston.

Janz, N. and Becker, M.H. (1984). The health belief model: A decade later. *Health Education Quarterly,* 11: 1-47.

Kinsey, K. (1994). 'But I know my man' : HIV/AIDS risk appraisals and heuristical reasoning patterns in childbearing women. *Holistic Nurse Practitioner,* 8(2): 79-88.

Kline, A. and Strickler, J. (1993). Perception of risk for AIDS among women in drug treatment. *Health Psychology,* 12(4): 313-323.

LaBrie, R., McAuliffe, W., Nemeth-Coslett, R., and Wilberschied, L. (1993). The prevalence of HIV infection in a national sample of injection drug users. In B. Brown and B. Beschner (Eds.), *Handbook on Risk of AIDS,* pp. 16-37. Westport, CT: Greenwood Press.

Larwood, L. (1978). Swine-flu: A field study of self-serving bias. *Journal of Applied Social Psychology,* 18: 283-289.

Magura, S., Grossman, J., Lipton, D., Siddiqi, Q., Shapiro, J., Marion, I., and Amann, K. (1989). Determinants of needle sharing among intravenous drug users. *American Journal of Public Health,* 79(4): 459-462.

Magura, S., Kang, S-Y., Shapiro, J., and O'Day, J. (1993). HIV risk among women injecting drug users who are in jail. *Addiction,* 88: 1351-1360.

Mickler, S. (1993). Perceptions of vulnerability: Impact of AIDS-preventive behavior among college adolescents. *AIDS Education and Prevention,* 5(1): 43-53.

Mondragón, D., Kirkman-Liff, B., and Schneller, E. (1991). Hostility to people with AIDS: Risk perception and demographic factors. *Social Science and Medicine,* 32(10): 1137-1142.

Perloff, L. and Fetzer, B. (1986). Self-other judgements and perceived vulnerability to victimization. *Journal of Personality and Social Psychology*, 50: 502-510.

Prochaska, J. and DiClemente, C. (1983). Stages and processes of self-change in smoking: Toward an integrative model of change. *Journal of Consulting and Clinical Psychology*, 5: 390-395.

Prohaska, T., Albrecht, G., Levy, J., Sugrue, N., and Kim, J. (1990). Determinants of self-perceived risk for AIDS. *Journal of Health and Social Behavior*, 31: 384-394.

Richardson, D. (1989). *Women and AIDS*. New York: Routledge.

Richardson, D. (1994). AIDS: Issues for feminism in the UK. In L. Doyal, J. Naidoo and T. Wilton (Eds.), *AIDS: Setting a Feminist Agenda*, pp. 42-57. London: Taylor and Francis, LTD.

Rosenstock, I. (1960). What research in motivation suggests for public health. *American Journal of Public Health*, 50: 295-302.

Sandfort, T., Van Zessen, G., Van Griensven, G., Sraver, C., and Tielman, R. (1991). Risk-bearing sexual behavior and risk awareness in three distinct samples of the Dutch population. Paper presented at the 7th International Conference on AIDS, Florence, Italy.

Schoenborn, C., Marsh, S., and Hardy, A. (1994). AIDS knowledge and attitudes for 1992: Data from the National Health Interview Survey. *Advance Data from Vital and Health Statistics* No. 243. Hyattsville, MD: National Center for Health Statistics.

Shayne, V. and Kaplan, B. (1991). Double victims: Poor women and AIDS. *Women & Health*, 17(1): 21-37.

Singer, M. (1994). AIDS and the health crisis of the U.S. urban poor: The perspective of critical medical anthropology. *Social Science and Medicine*, 39(7): 931-948.

Singer, M., Jia, Z., Schensul, J., Weeks, M., and Page, J.B. (1992). AIDS and the iv drug user: The local context in prevention efforts. *Medical Anthropology*, 14: 285-306.

Singer, M., Flores, C., Davison, D., Burke, G., Castillo, Z., Scalon, K., and Rivera, M. (1990). SIDA: The economic, social, and cultural context of AIDS among Latinos. *Medical Anthropology Quarterly*, 4: 73-117.

Singer, M. and Weeks, M. (1996). Preventing AIDS in communities of color: Anthropology and social prevention. *Human Organization* (in press).

Snyder, C. (1978). The 'illusion' of uniqueness. *Humanistic Psychology*, 18: 33-41.

Snyder, L. and Rouse, R. (1992). Targeting the audience for AIDS messages by actual and perceived risk. *AIDS Education and Prevention*, 4(2): 160-171.

Sobo, E. (1995). *Choosing Unsafe Sex: AIDS-Risk Denial among Disadvantaged Women*. Philadelphia: University of Pennsylvania Press.

Stevenson, H., Gay, K., and Josar, L. (1995). Culturally sensitive AIDS education and perceived AIDS risk knowledge: Reaching the 'know-it-all' teenager. *AIDS Education and Prevention*, 7(2): 134-144.

Turner, C., Miller, H., and Moses, L. (1989). *AIDS: Sexual Behaviors and Intravenous Drug Use*. Washington, DC: National Academy Press.

Ward, M. (1993). A different disease: AIDS and health care for women in poverty. *Culture, Medicine, and Psychiatry,* 17(4): 413-430.

Warwick, I., Aggleton, P., and Homans, H. (1988). Constructing commonsense–young people's beliefs about AIDS. *Sociology of Health and Illness,* 10: 213-223.

Watters, J. and Biernacki, P. (1989). Targeted sampling: Options for the study of hidden populations. *Social Problems,* 36(4): 416-430.

Weeks, M., Schensul, J., Williams, S., Singer, M., and Grier, M. (1995). AIDS prevention for African-American and Latina women: Building culturally and gender-appropriate intervention. *AIDS Education and Prevention,* 7(3): 251-263.

Weinstein, N. (1987). Unrealistic optimism about susceptibility to health problems: Conclusions from a community-wide sample. *Journal of Behavioral Medicine,* 10: 481-500.

Sex Partners of Alaskan Drug Users: HIV Transmission Between White Men and Alaska Native Women

Andrea M. Fenaughty, PhD
Dennis G. Fisher, PhD
Henry H. Cagle, BS

SUMMARY. This study describes patterns of sexual behavior and condom use in a sample of 1125 Black, White, and Alaska Native drug users. Data are self-reports of recent sexual behavior, including descriptions of (up to) the five most recent sex partners. This provided information on 1116 sex partner pairs, of which at least one

Andrea M. Fenaughty, Dennis G. Fisher, and Henry H. Cagle are affiliated with the Department of Psychology, University of Alaska, Anchorage.

This research was funded by grant U01 DA07290 from the National Institute on Drug Abuse. Support for Dr. Fenaughty was provided in part by Individual National Research Service Award F32 DA05599 from the National Institute on Drug Abuse.

We would like to acknowledge Patricia J. Queen and the entire staff of the Drug Abuse Research Field Station, University of Alaska Anchorage, for their unique contributions to this project. We are especially grateful to the men and women who agreed to share their stories with us.

An earlier version of this paper was presented at the Tenth Annual International Conference on AIDS in Yokohama, Japan, August, 1994.

Address correspondence to Andrea M. Fenaughty, Department of Psychology–IVDU Grant, University of Alaska, Anchorage, 3211 Providence Drive, Anchorage, AK 99577. Electronic mail may be sent via internet to ANAMF1@UAA.ALASKA.EDU.

[Haworth co-indexing entry note]: "Sex Partners of Alaskan Drug Users: HIV Transmission Between White Men and Alaska Native Women." Fenaughty, Andrea M., Dennis G. Fisher, and Henry H. Cagle. Co-published simultaneously in *Women & Health* (The Haworth Medical Press, an imprint of The Haworth Press, Inc.) Vol. 27, No. 1/2, 1998, pp. 87-103; and: *Women, Drug Use, and HIV Infection* (ed: Sally J. Stevens, Stephanie Tortu, and Susan L. Coyle) The Haworth Medical Press, an imprint of The Haworth Press, Inc., 1998, pp. 87-103. Single or multiple copies of this article are available for a fee from The Haworth Document Delivery Service [1-800-342-9678, 9:00 a.m. - 5:00 p.m. (EST). E-mail address: getinfo@haworthpressinc.com].

87

partner was a drug user. Sex partner pairs involving a White man and an Alaska Native woman were frequently reported. Level of condom use within these pairs was significantly lower than within all other pairs. The implications of a potential vector of HIV transmission from White, drug using men to Alaska Native women are discussed. *[Article copies available for a fee from The Haworth Document Delivery Service: 1-800-342-9678. E-mail address: getinfo@haworthpressinc.com]*

A VECTOR OF HIV TRANSMISSION BETWEEN WHITE MEN AND ALASKA NATIVE WOMEN?

Drug use continues to play a substantial role in the spread of HIV and AIDS. The AIDS epidemic is increasing most rapidly among injection drug users (IDUs) and those who have had heterosexual sexual contact with a person at high risk of HIV infection, often an IDU (CDC, 1995a). IDUs are at increased risk of HIV infection due to the sharing of injection equipment (Chitwood et al., 1995; Lamothe et al., 1993; Marmor et al., 1987). IDUs engage in sexual behaviors, such as having multiple sexual partners and rarely using condoms (Baker, Kochan, Dixon, Wodak, & Heather, 1994; Feucht, Stephens, & Roman, 1990; Kim, Marmor, Dubin, & Wolfe, 1993; Lewis & Watters, 1994; Wells, Calsyn, Saxon, & Greenberg, 1993), both of which have been associated with increased risk of HIV infection (Lamothe et al., 1993). Use of crack cocaine has been associated with sexual behaviors known to put one at risk for HIV and other sexually transmitted diseases (DeHovitz et al., 1994; Ellerbrock, Harrington, Bush, Schoenfisch, Oxtoby, & Witte, 1995; Fullilove, Fullilove, Bowser, & Gross, 1990; Hudgins, McCusker, & Stoddard, 1995; Inciardi, 1995; McCoy & Inciardi, 1993; Ratner, 1993; Schultz, Zweig, Singh, & Htoo, 1989). HIV seropositivity has been associated with the use of cocaine in both its smokable (Booth, Watters, & Chitwood, 1993; Chaisson, Stoneburner, Hildebrandt, Ewing, Telzak, & Jaffe, 1991; Edlin et al., 1994; Ellerbrock et al., 1992) and injectable forms (Amsel, Battjes, & Pickens, 1990; Chaisson et al., 1989).

Unprotected sex provides a route of virus transmission from drug users to their sex partners (Klee, Faugier, Hayes, Boulton, & Morris, 1990). There is generally a higher proportion of men than women among IDUs (Des Jarlais, Chamberland, Yancovitz, Weinberg, & Friedman, 1984). Due in part to this imbalance, male IDUs are more likely than female IDUs to have non-IDU sexual partners (Brown & Primm, 1988; Des Jarlais et al., 1987; Murphy, 1988). As a consequence, female sex partners of IDUs are one of the fastest growing groups of people with AIDS in the United States (CDC, 1995a).

In US AIDS cases among women, 51% of the 23,633 heterosexually transmitted cases are attributable to sex with an IDU (CDC, 1995b). An additional 29% of heterosexually transmitted cases are officially attributed to sex with an HIV-infected person whose risk was unspecified. Some proportion of these cases may actually be attributable to sex with an HIV-infected non-IDU or IDU whose sex partner was unaware of their injection drug use. Furthermore, among women, 66% of AIDS cases initially classified with no identifiable risk were later determined to be attributable to heterosexual contact with an infected person (CDC, 1994).

Although relatively little is known about the HIV risk behaviors of American Indians/Alaska Natives (AI/AN), the research that exists suggests that this group may also be at increased risk of HIV infection (Conway et al., 1992; Conway, Hooper, & St. Louis, 1989; Estrada, Erickson, Stevens, & Fernandez, 1990; Fisher & Booker, 1990; Rowell, 1990). HIV infection has risk factors in common with sexually transmitted diseases (STDs) such as gonorrhea and syphilis and with hepatitis B, three diseases which have been found disproportionately in AI/AN (Buehler, Stroup, Klaucke, & Berkelman, 1989; Toomey, Oberschelp, & Greenspan, 1989). Metler, Conway, and Stehr-Green (1991) reported that from 1989 to 1990 there was a greater increase in diagnosed AIDS cases among AI/AN than among any other racial/ethnic group.

If increased risk of HIV infection is associated with (a) being a female sex partner of a drug user, and (b) being an AI/AN, then AI/AN women who are sex partners of drug users may be at especially high risk of HIV infection. Fisher, Cagle and Wilson (1993) found that among a sample of drug users in Anchorage, Alaska, the Alaska Native women had the highest percentage of IDU sex partners. Correspondingly, recent epidemiological data indicate that the percentage of heterosexually transmitted female AIDS cases attributable to sex with an IDU is higher among AI/AN women (60%) than among women of any other racial/ethnic group (Hispanics, 55%; Blacks, 48%; Whites, 45%; Asian/Pacific Islanders, 29%; CDC, 1995b).[1]

The purpose of this study was to examine the association between sex partner ethnicity and high-risk sexual behavior, specifically failure to use condoms. These exploratory analyses were guided by the following research questions:

1. In a sample of primarily White, Black, and AI/AN drug users, what are the patterns of sexual behavior as they relate to the ethnicity of both partners?
2. Is condom use related to ethnicity? This is a two-part question: (a) Are men or women of one ethnic group any more or less likely to

use condoms in general? Here we were particularly interested in the comparison of AI/AN women to all other groups, and (b) Do men or women of any ethnic group use condoms differentially, depending on the ethnicity of their sex partners?

METHODS

Unique data analytic methods and subsamples of the Anchorage cohort of drug users were used to address each of the research questions outlined previously. The overall sample from which these subsamples (described below) were drawn consisted of the 1125 drug users who reported engaging in sexual activity in the 30 days prior to interview. This overall sample was 66% male, 41% White, 32% Black, 21% AI/AN, and had a median age of 33 years. (Because only 15% of those classified as AI/AN self-identified as American Indian, Alaska Native will be used hereinafter to refer to this ethnic category.) The majority (64%) of the sample reported having had only one sex partner in the last month; the highest reported number of sex partners was 300.

In order to describe patterns of sexual behavior by the ethnicity of both partners (Question #1), we considered the respondent as the unit of analysis. The Risk Behavior Assessment (RBA) provided data (gender and ethnicity) on the respondent; a separate instrument provided data on the sex partner(s) of each respondent. The Sex Partner Matrix (SPM), a supplementary questionnaire used by several other Cooperative Agreement grantees, was used to assess the following information for up to five sex partners in the last 30 days: (a) gender, ethnicity, age, and drug use of sex partner, (b) types of sexual activity (vaginal, anal, and/or oral sex) and condom use for each, and (c) whether drugs or money were exchanged for the sex. The data on sex partner gender and ethnicity from the SPM were included in a cluster analysis. Cluster analysis is a tool used to identify groups of individuals who respond similarly on one set of variables, and then examine differences among the groups, or clusters, on another set of variables (Aldenderfer & Blashfield, 1984). Accordingly, cluster analysis was used to identify clusters of drug users with similar patterns of sex partners (by gender and ethnicity). Only sex partners who had vaginal sex with the respondent were considered. These clusters were then described in terms of the gender and ethnicity of the respondent. Due to restrictions dictated by the cluster analysis software, the cluster analysis was run on a randomly selected sample of 550.

The question of whether gender and ethnicity are related to condom use, regardless of sex partner characteristics (Question #2a), was answered

by examining the percent of all vaginal sex reported by our respondents for which condoms were used. Because this analysis was expected to have little power (due to a small expected effect size), two restrictions were made on the sample in an effort to reduce error variance: (a) only the most commonly reported type of sexual activity (i.e., vaginal sex) was considered, and (b) only the most common ethnic groups (i.e., White, Black, and Alaska Native) were included ($n = 1013$). Again, the unit of analysis was the respondent, and all variables came from the RBA. A 2 (gender) \times 3 (ethnicity) factorial analysis of variance was run with percent of vaginal sex involving condoms as the dependent variable. Because of previous analyses on the same cohort indicating that Alaska Native women are at particularly high risk for various behavior-related diseases (Orr, Fenaughty, & Fisher, 1995; Paschane, Cagle, Fenaughty, & Fisher, in press), a specific contrast comparing Alaska Native women to all other groups was included in the ANOVA.

To address the more specific question of whether condom use varies, not just with the ethnicity and gender of one of the partners, but with certain combinations of sex partner ethnicities (Question #2b), we considered the pair of individuals involved in a sexual encounter, rather than one or the other of those individuals, as the unit of analysis. To get this kind of data, we once again relied on data from both the RBA and the SPM. We started with a dataset comprised of every sex partner description in the SPM, added to it the gender and ethnicity of the respondent who described those sex partners, then removed the following low frequency pairs: (a) pairs who engaged in only oral or anal sex, (b) pairs who were comprised of same-sex individuals, and (c) pairs in which either partner was of an ethnicity other than Black, White or Alaska Native. It was expected that the inclusion of these low frequency pairs would have markedly increased the error variance. The resulting dataset ($n = 1116$) contained information on the gender and ethnicity of both partners, whether condoms were used during each encounter, and whether drugs or money were exchanged for sex. Rather than considering the ethnicities of the sex partners comprising each pair as two separate variables (and looking for an interaction), we created one variable with nine possible values: sex partner pair consisting of a Black man and a Black (1), White (2), or Alaska Native (3) woman; a White man and a Black (4), White (5), or Alaska Native (6) woman; an Alaska Native man and a Black (7), White (8), or Alaska Native (9) woman. Condom use was dichotomized to indicate whether condoms had been used to any extent within each pair. A chi-square test of homogeneity of proportions was used to test the null hypothesis that the proportion of sexual encounters involving condom use was the same across all nine

categories of sex partner ethnicity combinations. Clustan (Wishart, 1987) was used to perform the cluster analyses; for all other analyses, the SAS system was used (SAS Institute, 1989).

RESULTS

Who Has Sex with Whom?

A series of hierarchical agglomerative cluster analyses were run separately on random halves (n's = 366) of the SPM sample (n = 732), using all possible combinations of two methods (complete linkage, Johnson, 1967; and Ward's method, Ward, 1963) and two measures (Euclidean distance and correlation). Visual inspection of the resulting dendrograms and degree of agreement (i.e., size of the adjusted Rand statistic; Fisher & Hoffman, 1988; Hubert & Arabie, 1985) among the various cluster solutions indicated that the six-cluster solution using complete linkage and correlation had the most robust structure. After combining the two halves of the dataset and randomly selecting a subsample of 550, a final hierarchical agglomerative cluster analysis with complete linkage and correlation was performed, and the six-cluster solution was selected. Figure 1 shows the mean number of sex partners of each ethnicity and gender for each cluster. The six clusters represent those individuals having sex with primarily Black, White, or Alaska Native women, or Black, White, or Alaska Native men. To gain a complete picture of the patterns of sexual behavior among this sample of drug users, we examined the characteristics of the men and women who made up each of the six clusters. Cluster 1, those who have sex primarily with Black women, is made up largely of Black (79%) men. Of those having sex with White women primarily (Cluster 2), most were White (57%) men. Cluster 3, or those having sex mainly with Alaska Native women, were either White (44%), Alaska Native (27%), or Black (26%) men. Cluster 4, those who have sex with Black men, is split between Black (40%), Alaska Native (27%), and White (25%) women. The majority of those reporting having White male sex partners (Cluster 5) are themselves a largely White (58%) female group. Finally, the cluster of individuals who report having sex with Alaska Native men (Cluster 6) is made up of mostly Alaska Native (53%) women.

Who Uses Condoms Least?

Figure 2 shows the mean values on percent of vaginal sex for which condoms were used, by gender and ethnicity of the respondent. The 2 (gen-

FIGURE 1. Mean number of sex partners of each gender and ethnicity, by cluster (*n* = 550).

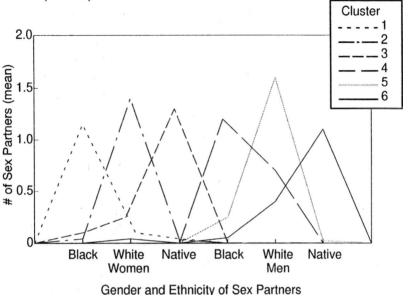

der) × 3 (ethnicity) ANOVA yielded a significant overall model, $F(5, 1007)$ = 2.82, $p < .05$. The results of the contrast indicated that Alaska Native women reported less condom use for vaginal sex ($M = .13$) than all other groups (M's ranging from .18 to .28; $F(1,1007) = 5.15$, $p < .05$). No other effects were significant within this model, nor were there any significant effects of gender or ethnicity in models of anal or oral sex.

Does Condom Use Depend on Sex Partner Characteristics?

Table 1 presents the proportion of sexual encounters that involved condoms, as a function of the ethnicity of both sex partners. A comparison of the *n*'s in this table reveals that the most frequent sex partner pair in the sample was one involving a White man and a White woman ($n = 304$). This is hardly surprising given that Whites comprise the largest ethnic group in the Anchorage sample. What is interesting, however, is that the third most common sex partner pair is comprised of a White man and an Alaska Native woman ($n = 162$).

A chi-square test of the homogeneity of proportions was run, examining the proportion of sexual encounters involving condoms for each of the nine

FIGURE 2. Percent of vaginal sex in the prior 30 days for which condoms were used, by gender and ethnicity of respondent (*n* = 1013).

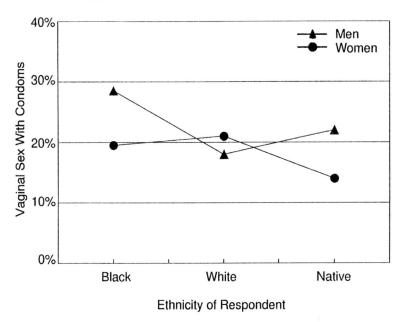

Ethnicity of Respondent

sex partner pairs. This analysis indicated that the proportion of sexual encounters in which condoms were used differed significantly as a function of the ethnicity of the sex partners, $\chi^2(8, n = 1116) = 24.21, p < .01$. As Table 1 shows, sexual encounters between White men and Alaska Native women involve the least amount of condom use (25%).[2] An examination of the rightmost column and the middle row of this table shows that condom use within a White male/Alaska Native female pair was lower than in other pairs involving either an Alaska Native woman or a White man.

Having determined that Alaska Native women's low rate of condom use was specific to sex with White men, we sought to uncover any factors that might explain this phenomenon. Previous analyses of condom use within this sample suggest that the strongest predictor of condom use is that one partner receives drugs or money in exchange for the sex; women or men who trade sex for drugs or money are more likely than others to use condoms (Fenaughty, Fisher, & MacKinnon, 1994; Fenaughty, Fisher, MacKinnon, Wilson, & Cagle, 1993). If the low White male/Alaska Native female condom use was associated with trading sex for money or

TABLE 1. Percent of Sexual Encounters (*n* = 1116) Involving Condoms, by Sex Partner Ethnicity

	Female Partner Ethnicity		
Male Partner Ethnicity	Black	White	AK Native
Black			
%	40	47	41
n	*165*	*145*	*115*
White			
%	52	40	25
n	*46*	*304*	*162*
AK Native			
%	67	40	40
n	*9*	*53*	*117*

Note: Percentages represent the percentage of all sexual encounters (vaginal sex only) involving sex partners of the specified racial/ethnic groups for which condoms were used. The *n*'s represent the total number of sex partner pairs of the specified racial/ethnic group combination.

drugs, we would expect correspondingly low proportions of sex involving exchange of drugs or money within these pairs relative to other pairs. Table 2 presents the proportions of sexual encounters that involved the exchange of drugs or money, as a function of the ethnicity of both sex partners. Although not identical to that found in Table 1, the pattern of proportions in Table 2 is somewhat consistent with the hypothesis that low levels of condom use among White male/Alaska Native female pairs is associated with the exchange of sex for drugs or money. For example, the trade of sex for drugs is relatively uncommon among White male/Alaska Native female pairs (within which condom use is lowest), but frequently occurs among Black male/White female pairs (within which condom use is higher). Because relatively small proportions of sexual encounters within any of the sex partner pairs involved the exchange of money, interpretation of those data is less clear.

DISCUSSION

The results of the cluster analysis, coupled with an examination of the frequencies of the various sex partner pairs, suggest that, in this sample,

TABLE 2. Percent of Sexual Encounters (*n* = 1116) Involving Trade for Drugs or Money, by Sex Partner Ethnicity

Male Partner Ethnicity	Female Partner Ethnicity		
	Black	White	AK Native
Black			
% trade for drugs for sex	14	23	19
% trade for money for sex	6	6	5
n	*165*	*145*	*115*
White			
% trade for drugs for sex	13	7	4
% trade for money for sex	26	10	6
n	*46*	*304*	*162*
AK Native			
% trade for drugs	33	19	6
% trade for money	0	13	3
n	*9*	*53*	*117*

Note: Percentages represent the percentage of all sexual encounters (vaginal sex only) involving sex partners of the specified ethnic groups for which drugs or money were exchanged. The *n*'s represent the total number of sex partner pairs of the specified ethnic group combination who engaged in vaginal sex.

sex partners tend to be of the same ethnic group, with one notable exception: Alaska Native women with White male sex partners. This is important given the findings that (a) Alaska Native female drug users report less condom use than men or women of other ethnicities, and (b) this low level of condom use seems to be specific to sex with White men (and conversely, that White men use condoms less with Alaska Native women than with any other sex partners). The findings based on the sex partner pair data need to be qualified, as all descriptions of sex partner pairs came from only one member of each pair. Ideally, one would like to be able to assess the validity of reports of sexual behavior by interviewing both partners. Financial cost, time restraints, likelihood of successful recruitment of all sex partners, and ethical considerations (i.e., divulging drug use of study participants) preclude the conduct of such a study. There is, however, no reason to believe that the fact that sex partner descriptions came from study participants would account for the observed pattern of findings.

It is unclear why there is exceptionally low condom use among pairs of

White men and Alaska Native women. It is possible that condom use is higher within other sex partner pairs because those pairs are more likely to include a sex worker, who is more likely than a non-sex worker to insist on condom use (Robertson & Plant, 1988). Although there is some similarity between the patterns of condom use and the exchange of sex for money or drugs in relation to sex partner ethnicity, this hypothesis was not thoroughly tested in the present study. Relatively small proportions of the two critical sex partner pairs (i.e., White male/Alaska Native female and White male/White female) had engaged in the exchange of sex for drugs or money, limiting the conclusions that can be drawn regarding the associations among sex partner ethnicity, condom use, and the trade of sex for drugs or money. Future research should include systematic testing of this hypothesis.

Had there been evidence that Alaska Native women use condoms less regardless of partner ethnicity, it might have been an indication that HIV prevention messages were not being delivered to or understood by Alaska Native women. This explanation makes little sense, however, given that levels of condom use among Alaska Native women and either Black or Alaska Native men are consistent with those for all other sex partner pairs.

Another possible explanation for the pattern of condom use found in this study lies in the differences in power and gender roles between men and women in general, and White men and Alaska Native women specifically. Here, power refers not just to differences in socioeconomic status (there is actually no gender difference in monthly income within the current sample) but to differences in communication and conflict resolution styles: Men are more likely than women to rely on physical persuasion (Maccoby, 1988). Gender roles may dictate that women should avoid confrontation, especially during a sexual encounter (Fullilove et al., 1990). Unfortunately, safe sex negotiation may require women to break out of traditional roles, often coming into direct conflict with men (Campbell, 1990; Miller, 1986). The fear that this conflict may result in some form of abuse may prevent women from demanding or even suggesting that their partner use a condom (Amaro, 1995). Indeed, Amaro and Gornemann (1992) found that an overwhelming number of female focus group participants indicated that power and gender roles were key barriers to HIV risk reduction in their own lives. It is possible that negotiation of condom use is especially difficult within White male/Alaska Native female relationships, in which gender role expectations may be especially strong. Future research of a qualitative nature may be best-suited to investigate the roles of perceived power, fear of abuse, and gender role expectations in the sexual decision-making process.

The implications of these findings extend into the domains of both epidemiology and prevention. From an epidemiological perspective, the pattern of sexual behavior found in this sample of drug users suggests a possible bridge of HIV transmission between White male drug users and Alaska Native women. In the current sample, White men are more likely than any other group to be IDUs (Fisher, Fenaughty, & Paschane, 1995). Earlier research using this cohort demonstrated that Alaska Native women compared to all other groups have a higher proportion of sex partners who are needle users (Fisher, Cagle, & Wilson, 1993). In Alaska, 10% of reported AIDS cases are classified with the risk category "Injection drug user"; another 6% are classified as "Men who have sex with men and injection drug user" (Alaska Division of Public Health, 1995). Although Alaska is still considered a low HIV seroprevalence area (CDC, 1995a), an Alaskan's risk of becoming infected with HIV increases when that person engages in unprotected sex, especially with an IDU. The extent to which this specific pattern of events occurs (i.e., an Alaska Native woman having unprotected sex with a White IDU) is unknown. It is also unclear what, if any, effect Alaska's unique mobility patterns might have on such a disease transfer. Many Alaska Native men and women currently living in Anchorage frequently visit the remote villages where their family members and friends live (Fisher, Cagle, & Wilson, 1993). In a study of the HIV seroprevalence among AI/AN at Indian Health Service sites nationwide (including nine in Alaska), similar HIV infection rates were found in women from rural and urban areas, suggesting diffusion of the HIV epidemic to rural AI/AN (Conway et al., 1992). Thus, a bridge of transmission from White male drug users to Alaska Native women might extend beyond the limits of Anchorage into rural Alaska.

Having identified a potential bridge of disease transmission, we must address the issue of prevention. Clearly, one goal of a prevention program should be to increase the use of condoms across all groups. On average, condoms were used for only 20 to 30% of sexual encounters reported in this study. A second goal, however, should be to bring condom use within White male/Alaska Native female pairs at least up to the level found in other pairs of sexual partners. One obvious suggestion is to target White male drug users and their Alaska Native female sex partners even more intensely for HIV risk reduction interventions. Unfortunately, because we have so little understanding of why condoms are so rarely used within these couples, there is no reason to expect that such interventions would be successful. In an era of scarce prevention dollars, it is even more imperative to design programs based on both theory and empirical research. One area of research that might prove useful in the development of interven-

tions is the identification of subtypes of individuals who may have very different reasons for not using condoms. For example, while one group of female drug users may not use condoms out of fear of physical retaliation from an abusive partner, another group may be too embarrassed to talk with their partner about condoms, let alone go to a pharmacy and purchase condoms. A single intervention is unlikely to be equally effective with these two different types of women. As suggested by the success of the client-treatment matching strategy within the area of drug abuse treatment, tailoring interventions to fit particular individuals' circumstances and motivations may lead to more positive, long-lasting behavior change. In addition, qualitative research methods may be most appropriate for uncovering the circumstances surrounding the relative lack of condom use found within White male/Alaska Native female couples.

NOTES

1. Z test for the difference between two proportions was significant only for the comparison of Asian/Pacific Islanders to Alaska Natives, perhaps due to very unequal cell sizes.
2. The cellchi2 option (SAS Institute Inc.,1989) within the chi-square procedure indicated that the lower than expected condom use for White male/Alaska Native female pairs contributed greatly to the overall chi-square.

REFERENCES

Adlenderfer, M., & Blashfield, R. K. (1984). *Cluster analysis.* Sage University Paper series on Quantitative Applications in the Social Sciences, 07-044. Newbury Park, CA: Sage Publications.

Alaska Division of Public Health (1995, July). *Epidemiology Bulletin, No. 17.* Alaska Division of Public Health, Section of Epidemiology.

Amaro, H. (1995). Love, sex, and power. *American Psychologist, 50,* 437-447.

Amaro, H., & Gornemann, I. (1992). *HIV/AIDS related knowledge, attitudes, beliefs, and behaviors among Hispanics: Report of findings and recommendations.* Boston: Boston University School of Public Health and Northeast AIDS Consortium.

Amsel, Z., Battjes, R., & Pickens, R. (1990, June). *Cocaine use and HIV risk among intravenous opiate addicts.* Poster presented at the Sixth International Conference on AIDS, San Francisco.

Baker, A., Kochan, N., Dixon, J., Wodak, A., & Heather, N. (1994). Drug use and HIV risk-taking behavior among injecting drug users not currently in treatment in Sydney, Australia. *Drug and Alcohol Dependence, 34,* 155-160.

Booth, R. E., Watters, J. K., & Chitwood, D. D. (1993). HIV risk-related sex behaviors among injection drugs users, crack smokers, and injection drug users who smoke crack. *American Journal of Public Health, 83,* 1144-1148.

Brown, L. S., & Primm, B. J. (1988). Sexual contacts of intravenous drug abusers: Implications for the next spread of the AIDS epidemic. *Journal of the National Medical Association, 80,* 651-656.

Buehler, T. M., Stroup, D. F., Klaucke, D. N., & Berkelman, R. L. (1989). The reporting of race and ethnicity in the National Notifiable Diseases Surveillance System. *Public Health Reports, 104,* 457-465.

Campbell, C. A. (1990). Women and AIDS. *Social Science and Medicine, 30,* 407-415.

CDC. (1994.) Heterosexually acquired AIDS–United States, 1993. *Morbidity & Mortality Weekly Report, 43,* 155-160.

CDC. (1995a). First 500,000 AIDS cases–United States, 1995. *Morbidity & Mortality Weekly Report, 44,* 849-853.

CDC. (1995b). *HIV/AIDS Surveillance Report, 7.*

Chaisson, R. E., Bacchetti, P., Osmond, D., Brodie, B., Sande, M. A., & Moss, A. R. (1989). Cocaine use and HIV infection in intravenous drug users in San Francisco. *Journal of the American Medical Association, 261,* 561-585.

Chaisson, M. A., Stoneburner, R. L., Hildebrandt, D. S., Ewing, W. E., Telzak, E. E., & Jaffe, H. W. (1991). Heterosexual transmission of HIV-1 associated with the use of smokable freebase cocaine (crack). *AIDS, 5,* 1121-1126.

Chitwood, D. D., Griffin, D. K., Comerford, M., Page, J. B., Lai, S., & McCoy, C. B. (1995). Risk factors for HIV-1 seroconversion among injection drug users: A case-control study. *American Journal of Public Health, 85,* 1538-1542.

Cohen, J. B. (1991). Why women partners of drug users will continue to be at high risk for HIV infection. *Journal of Addictive Diseases, 10,* 99-110.

Conway, G. A., Ambrose, T. J., Chase, E., Hooper, E. Y., Helgerson, S. D., Johannes, P., Epstien, M. R., McRae, B. A., Munn, V. P., Keevama, L., Raymond, S. A., Schable, C. A., Satten, G. A., Petersen, L. R., & Dondero, T. J. (1992). HIV infection in American Indians and Alaska Natives: Surveys in the Indian Health Service. *Journal of Acquired Immune Deficiency Syndromes, 5,* 803-809.

Conway, G. A., Hooper, E. Y., & St. Louis, M. E. (1989, June 4-9). Risk of AIDS and HIV infection in American Indians and Alaska Natives. *International AIDS Conference, 5,* 123 (abstract no. W.A.P.23).

DeHovitz, J. A., Kelly, P., Feldman, J., Sierra, M. F., Clarke, L., Bromberg, J., Wan, J. Y., Vermund, S. H., & Landesman, S. (1994). Sexually transmitted diseases, sexual behavior, and cocaine use in inner-city women. *American Journal of Epidemiology, 140,* 1125-1134.

Des Jarlais, D. C., Chamberland, M. E., Yancovitz, S. R., Weinberg, P., & Friedman, S. R. (1984). Heterosexual partners: A large risk group for AIDS. *Lancet, 2,* 1346-1347.

Des Jarlais, D. C., Wish, E., Friedman, S. R., Stoneburner, R., Yancovitz, S. R., Mildvan, D., El-Sadr, W., Brady, E., & Cuadrado, M. (1987). Intravenous drug use and the heterosexual transmission of the human immunodeficiency virus. *New York State Journal of Medicine, 87,* 283-286.

Edlin, B. R., Irwin, K. L., Farque, S., McCoy, C. B., Word, C., Serrano, Y., Inciardi, J. A., Bowser, B. P., Schilling, R. F., Holberg, S. D., & the Multicenter Crack

Cocaine and HIV Infection Study Team. (1994). Intersecting epidemics–Crack cocaine use and HIV infection among inner-city young adults. *New England Journal of Medicine, 331,* 1422-1427.

Ellerbrock, T. V., Harrington, P. E., Bush, T. J., Schoenfisch, S. A., Oxtoby, M. J., & Witte, J. J. (1995). Risk of human immunodeficiency virus infection among pregnant crack cocaine users in a rural community. *Obstetrics & Gynecology, 86,* 400-404.

Ellerbrock, T. V., Lieb, S., Harrington, P. E., Bush, T. J., Schoenfisch, S. A., Oxtoby, M. J., Howell, J. T., Rogers, M. F., & Witte, J. J. (1992). Heterosexually transmitted human immunodeficiency virus infection among pregnant women in a rural Florida community. *New England Journal of Medicine, 327,* 1704-1709.

Estrada, A. L., Erickson, J. R., Stevens, S. S., & Fernandez, M. (1990, June 22). HIV risk behaviors among Native American IVDU's. *International AIDS Conference, 2,* 270 (abstract no. F.C.757).

Fenaughty, A. M., Fisher, D. G., & MacKinnon, D. (1994). Predictors of condom use among Alaska Native, White, and Black drug users in Alaska. *Arctic Medical Research, 53* (Suppl. 2), 704-711.

Fenaughty, A., Fisher, D., MacKinnon, D., Wilson, P. J., & Cagle, H. H. (1993, October). Predicting condom use by drug users [Abstract]. *Proceedings of the 121st Annual Meeting of the American Public Health Association,* San Francisco, 144.

Feucht, T. E., Stephans, R. C., & Roman, S. W. (1990). The sexual behavior of intravenous drug users: Assessing the risk of sexual transmission of HIV. *Journal of Drug Issues, 20,* 195-213.

Fisher, D. G., & Booker, J. M. (1990). Drug abuse in Alaska: Myths versus reality. *Psychology of Addictive Behaviors, 4,* 2-5.

Fisher, D. G., Cagle, H. H., & Wilson, P. J. (1993). Drug use and HIV risk in Alaska Natives. *Drugs & Society, 7* (3/4), 107-117.

Fisher, D. G., Fenaughty, A. M., & Paschane, D. M. (1995). Alaska Native drug users: Results of a five-year study. *Abstracts of the 123rd Annual Meeting & Exhibition of the American Public Health Association,* San Diego, CA (2005-112).

Fisher, D. G., & Hoffman, P. (1988). The adjusted Rand statistic: A SAS macro. *Psychometrika, 53,* 417-523.

Fullilove, R. E., Fullilove, M. T., Bowser, B. P., & Gross, S. A. (1990). Risk of sexually transmitted disease among Black adolescent crack users in Oakland and San Francisco, California. *Journal of the American Medical Association, 263,* 851-855.

Hubert, L., & Arabie, P. (1985). Comparing partitions. *Journal of Classification, 2,* 193-218.

Hudgins, R., McCusker, J., & Stoddard, A. (1995). Cocaine use and risky injection and sexual behaviors. *Drug and Alcohol Dependence, 37,* 7-14.

Inciardi, J. (1995). Crack, crack house sex, and HIV risk. *Archives of Sexual Behavior, 24,* 249-269.

Johnson, S. (1968). Hierarchical clustering schemes. *Psychometrika, 38,* 241-254.

Kim, M. Y., Marmor, M., Dubin, N., & Wolfe, H. (1993). HIV risk-related sexual behaviors among heterosexuals in New York City: Associations with race, sex, and intravenous drug use. *AIDS, 7,* 409-414.

Klee, H., Faugier, J., Hayes, C., Boulton, T., & Morris, J. (1990). Sexual partners of injecting drug users: The risk of HIV infection. *British Journal of Addiction, 85,* 413-418.

Lamothe, F., Bruneau, J., Coates, R., Rankin, J. G., Soto, J., Arshinoff, R., Brabant, M., Vincelette, J., & Fauvel, M. (1993). Seroprevalence of and risk factors for HIV-1 infection in injection drug users in Montreal and Toronto: A collaborative study. *Canadian Medical Association Journal, 149,* 945-951.

Lewis, D. K., & Watters, J. K. (1994). Sexual behavior and sexual identity in male injection drug users. *Journal of Acquired Immune Deficiency Syndromes, 7,* 190-198.

Maccoby, E. E. (1988). Gender as a social category. *Developmental Psychology, 24,* 755-765.

Marmor, M., Des Jarlais, D. C., Cohen, H., Friedman, S. R., Beatrice, S. T., Dubin, N., El-Sadr, W., Mildvan, D., Yancovitz, S., Mathur, U., & Holzman, R. (1987). Risk factors for infection with human immunodeficiency virus among intravenous drug abusers in New York City. *AIDS, 1,* 39-44.

McCoy, H. V., & Inciardi, J. A. (1993). Women and AIDS: Social determinants of sex-related activities. *Women & Health, 1,* 69-86.

Metler, R., Conway, G. A., & Stehr-Green, J. (1991). AIDS surveillance among American Indians and Alaska Natives. *American Journal of Public Health, 81,* 1469-1471.

Miller, J. B. (1986). *Toward a new psychology of women.* Boston: Beacon Press.

Murphy (1988). Heterosexual contacts of intravenous drug abusers: Implications for the next spread of the AIDS epidemic. *Advances in Alcohol & Substance Abuse, 7,* 89-97.

Orr, S. M., Fenaughty, A. M., & Fisher, D. G. (1995). Predictors of Chlamydia trachomatis infection in Alaskan drug users. *Abstracts of the 123rd Annual Meeting & Exhibition of the American Public Health Association,* San Diego, CA (3004-291).

Paschane, D. M., Cagle, H. H., Fenaughty, A. M., & Fisher, D. G. (1998). Gender differences in risk factors for gonorrhea among Alaskan drug users. *Drugs & Society, 13* (1/2).

Ratner, M. S. (Ed.). (1993). *Crack pipe as pimp: An ethnographic investigation of sex-for-crack exchanges.* New York: Lexington Books.

Robertson, J. A., & Plant, M. A. (1988). Alcohol, sex and risks of HIV infection. *Drug and Alcohol Dependence, 22,* 75-78.

Rowell, R. (1990). Warning signs: Intravenous drug abuse among American Indians/Alaskan Natives. *Drugs & Society, 5*(1/2), 21-35.

SAS Institiute Inc. (1989). *SAS/STAT User's guide, Version 6, Fourth Edition, Volumes 1 & 2.* Cary, NC: SAS Institute Inc.

Schultz, S., Zweig, M., Singh, T., & Htoo, M. (1989). Congenital syphilis–New York City, 1986-1988. *Morbidity & Mortality Weekly Report, 38,* 825-829.

Toomey, K. E., Oberschelp, A. G., & Greenspan, J. R. (1989). Sexually transmitted diseases and Native Americans: Trends in reported gonorrhea and syphilis morbidity, 1984-1988. *Public Health Reports, 104,* 566-572.

Ward, J. (1963). Hierarchical grouping to optimize an objective function. *Journal of the American Statistical Association, 58,* 236-244.

Wells, E. A., Calsyn, D. A., Saxon, A. J., & Greenberg, D. M. (1993). Using drugs to facilitate sexual behavior is associated with sexual variety among injection drug users. *Journal of Nervous and Mental Disease, 181,* 626-631.

Wishart, D. (1987). *Clustan user manual (Fourth edition).* Edinburgh: Program Library Unit, Edinburgh University.

CONTEXTUAL VARIABLES IN WOMEN'S HIV RISK BEHAVIORS

A Comparison of HIV Risk Behaviors Among Women Drug Users from Two Cities in a Rural State: Recommendations for Targeted Prevention

Anne M. Cattarello, PhD
Carl G. Leukefeld, DSW
Susan Woolley, MS
Jon Parker, MSW

Anne M. Cattarello is Assistant Professor of Sociology, University of Wisconsin-Eau Claire, Eau Claire, WI 54702. Carl G. Leukefeld is Professor of Psychiatry and Director of the Multi-disciplinary Research Center on Drug and Alcohol Abuse, University of Kentucky, Lexington, KY 40506. Susan Woolley is with Volunteers of America and is Project Coordinator in Louisville, 933 Goss Avenue, Louisville, KY 40217. Jon Parker is with the Community Action Council and is Project Director in Lexington, 200 W. 2nd Street, Lexington, KY 40508.

The authors would like to thank the following people for their dedicated work on the P.E.A.K. project: Patrick McKiernan, Bud Cavanaugh, Joe Cantrill, Betty Peyton, Richard R. Clayton, Clyde B. McCoy, Shannon Beaven, and Melissa Huffman.

[Haworth co-indexing entry note]: "A Comparison of HIV Risk Behaviors Among Women Drug Users from Two Cities in a Rural State: Recommendations for Targeted Prevention." Cattarello, Anne M. et al. Co-published simultaneously in *Women & Health* (The Haworth Medical Press, an imprint of The Haworth Press, Inc.) Vol. 27, No. 1/2, 1998, pp. 105-122; and: *Women, Drug Use, and HIV Infection* (ed: Sally J. Stevens, Stephanie Tortu, and Susan L. Coyle) The Haworth Medical Press, an imprint of The Haworth Press, Inc., 1998, pp. 105-122. Single or multiple copies of this article are available for a fee from The Haworth Document Delivery Service [1-800-342-9678, 9:00 a.m. - 5:00 p.m. (EST). E-mail address: getinfo@haworthpressinc.com].

SUMMARY. Most HIV prevention programs for women target individual risk behaviors while the influence of larger contextual factors, such as city of residence, are often neglected. This preliminary study compares women drug users from two different cities in the largely rural state of Kentucky on HIV risk behaviors. The women are from Lexington, a medium sized metropolitan area, and from Louisville, a large metropolitan area. Comparisons between the women from the two cities indicate that there are many similarities in their risk behaviors, but also some important differences. The women from Lexington (the smaller city), are more likely to be at risk for becoming infected with HIV due to their drug use, while the women from Louisville (the larger city) are more likely to be at risk because of their sex exchange practices and economic situation. The implications for prevention are discussed. *[Article copies available for a fee from The Haworth Document Delivery Service: 1-800-342-9678. E-mail address: getinfo@haworthpressinc.com]*

While some progress has been made in addressing the unique concerns of women in relation to HIV, basic research and prevention efforts tailored specifically to women are lacking (Amaro, 1995; DeCarlo, 1995). Both the macro and the micro level influences on behavior that place women at risk for becoming infected with HIV need to be further explored and understood. In this study we take a macro level approach and explore the relationship between city of residence and the risk of contracting HIV. Specifically, we compare women from two diverse cities in Kentucky (KY) on involvement in HIV risk behaviors.

HIV/AIDS AND CITY OF RESIDENCE

The incidence and prevalence of social and public health problems varies by geographic location, with such patterns remaining consistent over time despite population turnover. This suggests that these problems are engendered by the characteristics of the area rather than by the individuals that reside in them (Shaw & McKay, 1969). Oftentimes, research funding and the allocation of resources to deal with social and health problems, including HIV/AIDS, is determined by population size.

It has been consistently documented over time that the AIDS epidemic in the United States (US) is disproportionately concentrated in large metropolitan areas. AIDS incidence rates are two to three times higher in metropolitan areas with a population greater than 500,000 than in metropolitan areas with a population between 50,000 and 500,000 (CDC,

1995b). In 1994 and 1995 about 10% of persons with AIDS were residents of small metropolitan areas and about 6% were residents of nonmetropolitan areas (CDC, 1995b). Therefore, approximately 84% of AIDS cases occurred in large metropolitan areas. For the July, 1994 through June, 1995 reporting period, the rates of AIDS cases were 39.1 (per 100,000) in larger metropolitan areas compared to 16.5 in smaller metropolitan areas (CDC, 1995b). By the end of June, 1995 the cumulative total of reported AIDS cases in large metropolitan areas was 403,626 and 46,042 for small metropolitan areas (CDC, 1995b).

The differences in the incidence and prevalence of AIDS according to city size comes as no surprise. Because relatively more people are infected with HIV/AIDs in large cities, it is more likely that an individual will have HIV sex or needle risk contact with an infected person and, thus, become infected themselves. In addition, in large cities there are relatively more people engaging in risky behaviors and/or who have risk factors associated with contracting HIV. For example, infection with a sexually transmitted disease (STD) increases one's chance of becoming infected with HIV (CDC, 1995a), and, as with AIDS, the incidence and prevalence of STDs is typically higher in large cities than in smaller cities. Also, drug injection and sex risks associated with crack use are behaviors that substantially increase a person's risk for becoming infected with HIV (McCoy & Inciardi, 1995). Drug injecting and crack use also tend to be concentrated in large cities. Drug injection is linked to HIV through the sharing of contaminated works, and the use of crack through its effects of increasing sexual activity and reducing inhibitions which can lead to engaging in unsafe sex (CDC, 1995c). Crack use has also been associated with exchanging sex for money and/or drugs and these behaviors also put one at high risk for contracting HIV (Edlin et al., 1994; Inciardi, Lockwood & Pottieger, 1993; Watson, Kail & Ray 1993). Given the greater concentration of HIV/AIDs in large metropolitan areas, it is these areas that have received most of the federal and state funding for HIV prevention, services and research. Consequently, research findings with regards to HIV risk behaviors and behavior change are often based on studies conducted in large metropolitan areas. Although HIV/AIDS may be concentrated in larger cities it is certainly not confined there. As mentioned previously, in 1994 and 1995, 10% of AIDS cases were reported in smaller metropolitan areas. The AIDS epidemic, including the demographics of those infected, infection route and risk behaviors may be different in small metropolitan areas. Since risk behaviors have been found to vary within large metropolitan areas (Watters, 1989), it is plausible to expect differences between large and smaller cities.

Population size is only one characteristic by which cities may be differentiated and, hence, constitutes only one macro level factor that may influence variation in HIV/AIDS infection rates among cities. In all likelihood a number of city characteristics in addition to or in conjunction with population size, such as socioeconomic status and drug availability, also influence the clustering of people who engage in risk behaviors in large cities.

Since most HIV/AIDS prevention programming targets individuals (Watters, 1989), most prevention efforts focus on informing individuals about the risk behaviors associated with becoming infected with HIV/AIDS (i.e., unprotected sex, sharing needles) and on protecting themselves. Although unprotected sex with an infected partner can lead to HIV infection regardless of the city in which a person resides, knowledge of differences in HIV risk behaviors according to city could lead to more informed and more effective prevention efforts. If the type and frequency of participation in risk behaviors differ according to city of residence, prevention messages should be tailored to the population at hand (Gordon, 1989). The CDC calls attention to this with the statement "(h)ealth officials must account for local variations in population characteristics and behaviors that may affect the risk for HIV transmission" (CDC, 1994, p. 975). Watters (1989, p. 10) also notes that HIV prevention policies "if they are to be effective in restraining the spread of HIV–must be sensitive to local conditions which can and do vary widely."

Previous Research

Although limited attention has been devoted specifically to comparing HIV risk behaviors according to city of residence, results of two previous studies suggest that HIV risk behaviors do vary by city. Siegal et al. (1994) compared subjects from four different size cities in Ohio on 23 variables, a number of which represented HIV risk behaviors. Of these 23 comparisons, responses differed significantly according to city on 16 of the items. These items included crack use, injection of cocaine and/or heroin, injection of other opiates, injection at a shooting gallery, and safer needle practices. In a study conducted by Forney, Inciardi and Lockwood (1992), the researchers focused upon the differences in drug use, sexual practices, and AIDS knowledge among women who were current regular users of crack cocaine and who had exchanged sex for money or drugs during the 30 days prior to recruitment. This urban/rural study compared the behaviors of urban women from Miami and rural women from southeast Georgia. While, overall, the women were more similar than dissimilar in their drug use and sexual practices, important significant differences were noted. The urban

women reported having significantly more sex partners than the rural women (66 in the past 30 days versus 23) and significantly more days in which they exchanged sex for money or drugs (19 days in the past 30 days versus 15.4). These results suggest that participation in some risk behaviors does vary according to city of residence.

THE CURRENT STUDY

City Comparisons

This study was conducted in Lexington, KY (located in Fayette county) and in Louisville, KY (located in Jefferson county). Because descriptive data is compiled at the county level, county data is used to describe various characteristics of each city.[1] In Table 1 the population size, racial composition, and economic characteristics of the two cities/counties are presented using data from the 1990 census. Lexington/Fayette county is a medium-sized metropolitan area with a population of 225,366 and Louisville/Jefferson county is almost three times as large with a population of 664,937. The racial composition of the two cities is similar and parallels national figures, although Louisville has a slightly higher percentage of African Americans

TABLE 1. City/County Characteristics, 1990 Census Data

	Fayette County (Lexington)	Jefferson County (Louisville)
City/County Characteristics		
Total Population	225,366	664,937
Percent White	84%	82%
Percent African American	13	17
Percent Other Race	2	1
Median Household Income	$28,056.00	$27,092.00
Percent of Persons with Income Below the Poverty Level	14%	14%
Percent Unemployed	4	6

than Lexington (17% compared to 13%). The economic characteristics of the two communities are also alike. The median household income in Lexington is slightly over $28,000.00 annually while for Louisville it is about $1,000.00 less. Both cities have approximately 14% of persons living below the poverty level, but Louisville has a higher percentage of the unemployed civilian labor force (6%) compared to Lexington (4%).

In Table 2 the cities are compared on numbers and rates for selected infectious diseases (i.e., AIDS, STDs, and Tuberculosis < TB >). These data are from 1995.[2] Regarding AIDS, Kentucky is a low seroprevalence state with AIDS cases occurring at a rate of 8.1 (per 100,000) between July 1994 and June 1995 (CDC, 1995b). The cumulative total of AIDS cases for the state is 1,684 (CDC, 1995b). Forty-eight of these cases occurred among women. As

TABLE 2. 1995 Numbers and Rates (per 100,000 Inhabitants) for Infectious Diseases[1]

	Fayette County (Lexington)	Jefferson County (Louisville)
Cumulative AIDS Cases (December, 1995)		
Number	250	693
Percent of Kentucky's Total (i.e., 1684)	15%	41%
Sexually Transmitted Diseases		
Gonorrhea		
Number	406	2,542
Rate	170.0	377.8
Syphilis		
Number	119	273
Rate	49.8	40.6
Chlamydia		
Number	856	1,618
Rate	358.3	240.4
Tuberculosis		
Number	27	72
Rate	11.3	10.7

[1]Source: Kentucky Department of Health Services (1996), phone inquiry.

the data in Table 2 indicates, a much higher percentage of the state's AIDS cases occurred in Louisville (41%) compared with Lexington (15%).

In terms of STDs, although the rate of infection with Gonorrhea is substantially higher in Louisville (377.8) compared to Lexington (170.0), the rates for Syphilis and, in particular, Chlamydia are higher in Lexington. The 1995 rate for Syphilis is about 50 per 100,000 in Lexington while in Louisville it is about 41. In Lexington, Chlamydia occurred at a rate of 358.3, while in Louisville the rate was much lower at 240.4. The rate of TB infection is slightly higher in Lexington compared to Louisville (11.3 versus 10.7).

Table 3 shows 1994 data on drug related deaths and arrest data for the index crimes, drugs, and prostitution.[3] Drug related deaths occurred at a slightly higher rate in Lexington than in Louisville (5.9 versus 4.3). Arrests for the index crimes combined and for violent crimes separately also occurred at a higher rate in Lexington than in Louisville. For example, 864.2 per 100,000 inhabitants were arrested for violent crimes in Lexington, compared to 533.0 in Louisville. Additionally, drug arrests occurred at a higher rate in Lexington than in Louisville (900.7 compared to 819.1). In contrast, the arrest rate for property crimes is slightly higher in Louisville than in Lexington.[4] Furthermore, arrests for prostitution occurred at a much higher rate in Louisville than in Lexington (72.8 versus 13.0).

To summarize, the population of Louisville (the larger city) accounts for a much higher percentage of Kentucky's AIDS cases, has a higher rate of Gonorrhea infection, and a higher arrest rate for prostitution than the population of Lexington. However, contrary to expectations, most of the comparisons indicate that Lexington (the smaller city) is more problematic in terms of most of the factors examined. Lexington has higher rates of Syphilis, Chlamydia, and Tuberculosis than Louisville. The rates for drug related deaths, for drug arrests, and for two out of three indicators of crime are also higher in Lexington than in Louisville. Although Louisville evidenced higher rates on some factors associated with HIV infection (i.e., AIDS cases and prostitution arrests), the results of the city comparisons underscore the importance of acknowledging the comparatively high levels of HIV related factors of the women living in a smaller city and consequently the need for specialized prevention efforts.

METHODOLOGY

The Kentucky Cooperative Agreement

The University of Kentucky has contracted with the *Community Action Council,* in Lexington, and with *Volunteers of America,* in Louisville, for

TABLE 3. 1994 Numbers and Rates (per 100,000 Inhabitants) for Drug Related Deaths, Index Crime Arrests, Drug Arrests, and Prostitution Arrests

	Fayette County (Lexington)	Jefferson County (Louisville)
Drug Related Deaths[1]		
Number	14	29
Rate	5.9	4.3
Index Crime Arrests[2]		
Total		
Number	4,726	11,812
Rate	1986.4	1758.1
Violent		
Number	2,056	3,581
Rate	864.2	533.0
Property		
Number	2,670	8,231
Rate	1122.2	1225.1
Drug Arrests[2]		
Number	2,143	5,503
Rate	900.7	819.1
Prostitution and Commercialized Vice Arrests[2]		
Number	31	489
Rate	13.0	72.8

[1]Source: Kentucky Vital Statistics, Health Data Branch (1996), phone inquiry.
[2]Source: Crime in Kentucky, Commonwealth of Kentucky Crime Report (1994).

outreach and data collection. The University maintains a close working relationship with both contractors, ensuring that Cooperative Agreement protocols are maintained. The study sites in Lexington and Louisville are similar. Both sites are located in or close to the downtown area, in a section of the city that drug users live in or frequent. One difference between the two study sites is that in Lexington, subjects are driven to the health department for HIV testing, while in Louisville, the interventionist walks clients next door to a homeless health facility. However, in spite of this difference, the proportion of clients who are tested for HIV is similar for the two sites.

The Sample

Data on 135 women are used to explore differences in demographic composition, HIV risk behaviors, and infection with STDs according to city of residence. Ninety-one of the women are from Lexington, and 44 of the women are from Louisville. The women who comprise the sample for this study were recruited between December, 1993 and November, 1995 and interviewed following the Cooperative Agreement protocol (see Coyle, this volume).

Variable Measurement and Analyses

Data for the study were collected from the women using the Risk Behavior Assessment (RBA) (see Coyle, this volume). The data were analyzed by comparing the Lexington and Louisville women on relevant demographic characteristics, drug use, drug related risk behaviors, incidents of STDs, sexual practices, and sex related risk behaviors. It should be noted that the sexual practices data are from women who report engaging in sexual activity within the previous 30 days.[5] The vast majority of women recruited into this study from both Lexington and Louisville report that they are heterosexual. Comparisons between women in the two cities were not made for anal intercourse since very few women (N = 7) reported this behavior. A difference in proportions test is used when the data are presented in terms of percentages, while t-tests are used to analyze the differences in the mean levels of risk behaviors according to city.

RESULTS

Demographics

Table 4 presents the demographic characteristics of the women from Lexington and Louisville who participated in the study. For the majority of the comparisons, the women from the two cities are similar demographically. For example, the majority of women from both cities are African American (77% in Lexington and 82% in Louisville). The mean age of the women in Lexington is 33 years while in Louisville the mean age is 34 years. A large percent of women from both cities did not complete high school (44% in Lexington and 39% in Louisville). Although a larger percentage of women from Lexington report being unemployed (68% versus 59%), this difference also was not statistically significant.

TABLE 4. Demographic Characteristics for All Women and for Lexington and Louisville Women Separately (percentages)

	Total	Lexington	Louisville	SIG
Total N	135	91	44	
Race				
African American	78.5%	76.9%	81.8%	
White	19.3	20.9	15.9	
Other	2.2	2.2	2.3	
Mean Age	33	33	34	
Education				
< High School	42.2	44.0	38.6	
High School Grad or GED	29.7	24.3	38.6	
Some Trade to College Grad	28.2	30.8	22.7	
Marital Status				
Never Married	45.2	44.0	47.7	
Married/Living Together	21.4	26.4	11.4	*
Separated/ Widowed/Divorced	33.4	29.7	40.9	
Living Place				
Own House/Apt.	43.7	49.5	31.8	**
Another's House/ Apt.	47.4	42.9	56.8	
Shelter/Street	7.4	6.6	9.1	
Percent Homeless	32.6	24.2	50.0	*
Percent Unemployed	65.2	68.2	59.1	
Income of < $500 in Last 30 Days	64.4	58.2	77.3	*

* = $p < .05$
** = $p < .10$

Significant differences on demographic characteristics were found for marital status, living place, and income. Although the majority of women from both cities have either never been married or are separated, divorced, or widowed, a significantly higher percentage of women from Lexington (26%) reported being either married or living with a sexual partner compared to women from Louisville (11%). Also, and perhaps concomitantly, a significantly higher percentage of women from Lexington reported living in their own house or apartment (50% versus 32%). A significantly larger percentage of women from Louisville reported having an income of less than $500.00 in the last 30 days (77% versus 58%) as well as a significantly larger percentage who perceived themselves to be homeless (50% versus 24%).

To summarize the results of the demographic comparisons, the majority of women in both samples are relatively young, African American adults with similar educational attainment. Significant differences are apparent, however, in that a higher percentage of women from Lexington (the smaller city) reported either being married or living with a sexual partner and living in their own dwelling, while a higher percentage of women from Louisville (the larger city) were homeless and were relatively more economically disadvantaged.

Drug Related Risk

Table 5 displays data on alcohol and drug use (marijuana, crack, and cocaine injection) reported by the women from both Lexington and Louisville.[6] Data on the use of the other substances asked about in the RBA such as heroin and speedball are not presented as only a small number of women from both cities reported current use of them. The vast majority of women from both cities reported current use of alcohol and crack and about two-thirds of the women reported current use of marijuana. Close to one-third of the women from Lexington reported injecting cocaine in the past 30 days compared to about 16% of women from Louisville.

A statistically significant difference between the women from the two cities was found for the mean number of times used alcohol in the past 30 days. On the average, women from Lexington consumed about 93 full drinks of alcohol in the past month compared to approximately 46 by women from Louisville. Although the other comparisons on mean number of times used drugs are not statistically significant, women from Lexington have used all substances more times than the women from Louisville. For example, women from Lexington reported using crack about 168 times in the past month compared to 121 times for women in Louisville. In addition, Lexington women injected cocaine an average of 31 times in the

past 30 days compared to Louisville women who reported injecting co-caine 17 times in the past 30 days.

Limited data on injection of *any* drug in the past 30 days are shown in Table 6.[7] While significant differences between the women from the two cities in terms of the percent injecting any drug and the percent using works that had previously been used were not detected, a higher percent-age of women from Lexington reported injecting any drug (28.6% versus 20.4%) and using works that had previously been used (46.2% versus 44.4%).

Summarizing drug use and drug related HIV risks, although only the comparison on mean number of times used alcohol was found to be signif-

TABLE 5. Drug Related Risk

	Lexington	Louisville	SIG
Percent Reporting Current Use of:			
Alcohol	74.7%	86.4%	
Marijuana	60.4	61.4	
Crack	95.6	95.5	
Cocaine (Injected)	27.5	15.9	
Mean Number of Times Used:			
Alcohol	93.39	46.33	*
Marijuana	21.49	19.52	
Crack	167.64	121.39	
Cocaine (Injected)	30.72	16.57	

* = p < .05

TABLE 6. Injecting Practices

	Lexington	Louisville	SIG
Percent Injecting any Drug	28.6%	20.4%	
Percent Using Used Works	46.2	44.4	

icantly different between the women from the two cities, there is a trend for women from Lexington (the smaller city) to engage in higher levels of alcohol and drug use, and drug related risk behaviors than women from Louisville (the larger city).

Sex Related Risk

HIV sex related risk data, including history of STDs, sexual practices, and exchange practices for the women from the two cities are compared in Table 7. The three most frequently reported STDs include Gonorrhea, Chlamydia and Syphilis. Gonorrhea was the most frequently reported STD with 45% of the women from Lexington having been infected at some point in their lives compared to 43% of women from Louisville. Chlamydia was the second most often occurring STD, again with a slightly higher percentage of women from Lexington reporting infection (19%) compared to women from Louisville (16%). Syphilis was reported third most often with 11.0% of Lexington women and 11.4% of Louisville women reporting having had Syphilis at some point in their lifetime.

The data on sexual practices for the previous 30 days shows that the women from Lexington had significantly more drug injecting partners (.57 versus .06) and significantly more vaginal sex (14.61 versus 8.36) than women from Louisville. Contrary to this, when looking at data on exchange practices, significantly more women from Louisville had given sex for money at some point in their lives (57% versus 41%). Although the remaining comparisons were not statistically significant, there is a trend for women from Louisville to be more at risk for contracting HIV because of their exchange practices.

Summarizing the sex related HIV risk data, these risks differed for the women from the two cities. While women from Lexington (the smaller city) were at risk more frequently because of the number of times they had sex and the number of partners who were injectors, women from Louisville (the larger city) were more at risk for contracting HIV due to their sex exchange practices.

DISCUSSION

Before discussing the implications of this research, it is important to note that the results of this study are preliminary. These are the first Cooperative Agreement data on women from Kentucky and the sample size is relatively small. As the number of women recruited into the study

increases, it is possible that the same trends will produce significant differences, or, different patterns of risk behaviors according to city of residence might emerge. In addition, subjects for this study were not randomly selected from each of their respective cities and, therefore, the results should not be considered representative of women drug users in each of the cities.

Similar to the conclusions reached by Forney et al. (1992) in their

TABLE 7. Sex Related Risk

	Lexington	Louisville	SIG
STD Infection			
Gonorrhea	45.1%	43.2%	
Chlamydia	18.7	15.9	
Syphilis	11.0	11.4	
Sexual Practices			
# of Days Had Sex	9.43	9.89	
# of Different Male Partners	2.49	2.72	
# of Drug Injecting Partners	0.57	0.06	*
# of Times Had Vaginal Sex	14.61	8.36	*
# of Times Had Unprotected Vaginal Sex	10.72	6.36	
Exchanging Practices (percentages)			
Ever Gave Sex for Drugs	38.5%	43.2%	
Gave Sex for Drugs in Last 30 Days	37.1	52.6	
Ever Gave Sex for Money	40.7	56.8	*
Gave Sex for Money in Last 30 Days	56.7	52.0	

* = p < .05

comparison of urban/rural women on HIV risk behaviors, the results of this study show the women from Lexington (the smaller city) and Louisville (the larger city) to be alike in a number of ways. In terms of demographic characteristics, the women from both cities are predominately African American, have similar educational backgrounds, and have never been married, although a substantial percentage in both groups reported being either separated, divorced, or widowed. STD infection among both samples is also similar, with Gonorrhea being the STD that most women report having had. In addition, the number of days had sex and the average number of sex partners were similar for the women from both cities.

One of the most striking differences between the women concerns their alcohol use, in particular, but also their use of crack. Women from Lexington (the smaller city) reported using alcohol significantly more times in the past month than women from Louisville (the larger city). Also, women from Lexington reported using crack more times than women from Louisville. Other important differences between the women from the two cities involve economic influences and sex exchange practices. Economically, the women from Louisville are more disadvantaged than the women from Lexington. A significantly higher percentage of the women from Louisville reported an income under $500.00 during the past 30 days and more women from Louisville perceived themselves to be homeless. Interestingly, a significantly higher percentage of women from Louisville had exchanged sex for money in their lifetime and a higher percentage (although non-significant) of women from Louisville had also exchanged sex for drugs in the past 30 days, and, sex for drugs in their lifetime.

Implications for Prevention

Some important differences in risk behaviors between women from the two cities suggest that, for some risk factors, different types of prevention messages may need to be emphasized in different types of cities. For example, the findings of this study indicate that reducing levels of drug, and particularly alcohol, use and providing education about how drug and alcohol use may cause disinhibition in HIV protective behaviors should constitute a primary area of focus in Lexington. In addition, those who use drugs or drink heavily may be less inclined to adhere to HIV prevention messages. For HIV prevention instruction on needle cleaning and safe sex practices to be effective, it may be necessary to address the behavior of heavy alcohol use first, or at least simultaneously with other risk behaviors. Furthermore, because women in Lexington reported significantly more sex partners who are injection drug users, prevention messages should emphasize the risk of becoming infected with HIV from one's partner's injection practices.

In contrast, the findings of this study suggest that if HIV prevention is to be effective in Louisville, interventionists should focus on women's economic situations and their exchange practices. The lack of stability engendered by economic destitution may impact negatively on women's abilities to practice HIV risk reduction. Economically deprived women may be concerned more with issues related to daily survival (i.e., housing, food) rather than those related to HIV, whose effects may take years to notice (Kline, Kline & Oken, 1992). In addition, there is a strong connection between exchanging sex for money and/or drugs and involvement in HIV risk behaviors (see Edlin et al., 1994; Inciardi et al., 1993; Watson et al., 1993). For those women who exchange sex for money and/or drugs, if alternatives to this behavior are not available or cannot be created, emphasis must be placed on educating these women about how to practice safe sex in these risky situations. Moreover, "they need interventions that provide motivation and the ability to apply the knowledge they have accumulated and practice the necessary precautions" (Watson et al., 1993, p. 10).

Suggestions for Future Research

Future analyses of these data will focus on the relationship between city of residence, drug use patterns and levels of use, the exchange of sex for money and/or drugs, and involvement in other HIV risk behaviors. The injection and needle cleaning practices among Lexington and Louisville women will also be examined as more women injectors are recruited into the study.

More research is needed on the relationship between city of residence and HIV risk behaviors among women before prevention interventions based on city differences can be developed. Future studies should include a number of different cities. Research on assessing the influence of specific city characteristics, as well as individual level factors on HIV risk behaviors, is needed in order to begin to sort out the complex relationships among these factors. The results of this study indicate that this is a viable avenue for further research and one that could have potentially important implications for the prevention of HIV infection among women.

NOTES

1. Lexington/Fayette county is a merged city county government and, hence, the city and county population are one and the same. Some sources consider the city of Louisville as separate from Jefferson county. For example, the Uniform Crime Reports present data according to city and cite Louisville as having a popu-

lation of 276,307. We argue that it is most appropriate to consider the county population when discussing Louisville as it is widely recognized as a much larger city than Lexington.

2. The rates in this table are computed based on the counties' population in 1995. For Lexington/Fayette county this figure was 238,885 and for Louisville/Jefferson county the number was 672,918.

3. The rates in this table are based on the counties' population in 1994. For Lexington/Fayette county this number was 237,922 and for Louisville/Jefferson county it was 671,872.

4. Data on crimes known to the police parallel arrest data. When the city/county of Lexington is compared with only the city of Louisville, Lexington consistently ranks above Louisville in terms of reported crime, both violent and property (see Uniform Crime Reports from the years 1991-1994).

5. When sexual practice data are analyzed, the sample size in Lexington is reduced to 77, with 9 of the women being excluded because they have not had sex in the past 30 days. The sample size is reduced to 36 in Louisville, with 5 women being excluded because they have not had sex.

6. The number of times used is defined differently according to the drug and is as follows: Alcohol–the number of 8 ounce drinks consumed; Marijuana–number of joints smoked; Crack–number of highs obtained; Cocaine–number of times injected.

7. Cocaine is the drug most often injected in Lexington and Louisville. Of the 26 women who have injected in Lexington, 25 report injecting cocaine and of the 9 women who have injected in Louisville, 7 have injected cocaine.

REFERENCES

Amaro, H. (1995). Love, sex, and power: Considering women's realities in HIV prevention. *American Psychologist, 50*(6), 437-447.

Centers for Disease Control and Prevention (1995a). Update: AIDS among women–United States, 1994. *Journal of the American Medical Association, 273*(10), 767-768.

Centers for Disease Control and Prevention (1995b). HIV/AIDS Surveillance Report, 7(1). U.S. Department of Health and Human Services.

Centers for Disease Control and Prevention (1995c). Facts about drug use and HIV/AIDS. U.S. Department of Health and Human Services.

Centers for Disease Control and Prevention (1994). Heterosexually acquired AIDS–United States, 1993. *Journal of the American Medical Association, 271*(13), 975-976.

Centers for Disease Control and Prevention (1992). HIV, heterosexual transmission, and women. *Journal of the American Medical Association, 268*(4), 520-521.

Commonwealth of Kentucky Crime Report (1994). *Crime in Kentucky*. Frankfort, KY: Kentucky State Police.

DeCarlo, P. (1995). *What Are Women's HIV Prevention Needs?* San Francisco: University of California.

Edlin, B.R., Irwin, K.L., Faruque, S., McCoy, C.B., Word, C., Serrano, Y., Inciardi, J.A., Bowser, B.P., Schilling, R.F., & Holmberg, S.D. (1994). Intersecting epidemics–crack cocaine use and HIV infection among inner-city young adults. *The New England Journal of Medicine,* November 24th, 1422-1427.

Forney, M.A., Inciardi, J.A., & Lockwood, D. (1992). Exchanging sex for crack-cocaine: A comparison of women from rural and urban communities. *Journal of Community Health, 17*(2), 73-85.

Gordon, R.S. (1989). An operational classification of disease prevention. *Public Health Reports, 98,* 107-109.

Inciardi, J.A., Lockwood, D., & Pottieger, A.E. (1993). *Women and Crack-Cocaine,* New York: Macmillan Publishing Company.

Kline, A., Kline, E., & Oken, E. (1992). Minority women and sexual choice in the age of AIDS. *Social Science and Medicine, 34,* 447-457.

McCoy, C.B. & Inciardi, J.A. (1995). *Sex, Drugs, and the Continuing Spread of AIDS.* Los Angeles: Roxbury Publishing Company.

Shaw, C.R. & McKay, H.B. (1969). *Juvenile Delinquency and Urban Areas.* Chicago: University of Chicago Press.

Siegal, H.A., Carlson, R.G., Wang, J., Falck, R.S., Stephens, R.C., & Nelson, E.D. (1994). Injection drug users in the midwest: An epidemiologic comparison of drug use patterns in four cities. *Journal of Psychoactive Drugs, 26*(3), 265-275.

U.S. Department of Justice, Federal Bureau of Investigation (1991-1994). *Crime in the United States.* Washington, DC: USGPO.

Watson, D.D., Kail, B., & Ray, S. (1993). Sex for money and drugs. In Brown, B.S., Beschner, G.M. & National AIDS Research Consortium (Eds.). *Handbook on Risk of AIDS: Injection Drug Users and Sexual Partners.* Westport, CT: Greenwood Press.

Watters, J.K. (1989). Observations on the importance of social context in HIV transmission among intravenous drug users. *The Journal of Drug Issues, 19*(1), 9-26.

Social Influences:
Living Arrangements
of Drug Using Women
at Risk for HIV Infection

Lisa R. Metsch, PhD
Clyde B. McCoy, PhD
H. Virginia McCoy, PhD
James Shultz, PhD
James Inciardi, PhD
Harlan Wolfe, MSW
Ronald Correa, MS

Lisa R. Metsch, Clyde B. McCoy, James Shultz, Harlan Wolfe, and Ronald Correa are affiliated with the Comprehensive Drug Research Center and Department of Epidemiology and Public Health, University of Miami, 1400 N.W. 10th Avenue, Suite 1108, Miami, FL 33136. H. Virginia McCoy is affiliated with the Department of Public Health, Florida International University, ACI 394, 3000 N.E. 145th Street, North Miami, FL 33181. James Inciardi is affiliated with the Center for Drug and Alcohol Studies, University of Delaware, 77 E. Main Street, Newark, DE 19716.

This research was supported by the National Institute on Drug Abuse, Research Project Research Grant Cooperative Agreement # DA06910-05.

The authors would like to acknowledge editors Dr. Stephanie Tortu and Dr. Susan Coyle for their helpful comments and critique. We would also like to acknowledge the research assistance of Sonia Rivas and Heather McAnany.

Address correspondence to Lisa R. Metsch, Comprehensive Drug Research Center, 1400 N.W. 10th Avenue, Suite 1108, Miami, FL 33136.

[Haworth co-indexing entry note]: "Social Influences: Living Arrangements of Drug Using Women at Risk for HIV Infection." Metsch, Lisa R. et al. Co-published simultaneously in *Women & Health* (The Haworth Medical Press, an imprint of The Haworth Press, Inc.) Vol. 27, No. 1/2, 1998, pp. 123-136; and: *Women, Drug Use, and HIV Infection* (ed: Sally J. Stevens, Stephanie Tortu, and Susan L. Coyle) The Haworth Medical Press, an imprint of The Haworth Press, Inc., 1998, pp. 123-136. Single or multiple copies of this article are available for a fee from The Haworth Document Delivery Service [1-800-342-9678, 9:00 a.m. - 5:00 p.m. (EST). E-mail address: getinfo@haworthpressinc.com].

SUMMARY. The purpose of this study was to explore the associations among living arrangements, HIV seroprevalence, and HIV risk and protective factors among 1,322 drug users participating in the University of Miami CARES (Community AIDS Research and Evaluation Studies) HIV intervention program. Living arrangements may be associated with HIV prevention behaviors; however, these influences can be either protective or destructive and therefore merit further examination. Statistical analyses indicated differences in the living arrangements of women compared with men, and significant associations were noted among women's living arrangements, HIV seroprevalence, risk behaviors and protective behaviors. The data from this study suggest that future HIV prevention research should investigate not only high-risk individuals, but persons with whom they interact often, especially those with whom they live or with whom they have sex. The next phase of HIV and drug interventions should be attentive to the incorporation of social context and social influences, paying particular attention to understudied populations such as high-risk women. *[Article copies available for a fee from The Haworth Document Delivery Service: 1-800-342-9678. E-mail address: getinfo@haworthpressinc.com]*

INTRODUCTION

HIV/AIDS in Miami, Florida: Focus on Women

In 1995, Miami/Dade County, Florida ranked fourth among United States metropolitan areas in annual incidence rate of AIDS cases (CDC, 1996). Despite ranking 23rd in population among urban areas, Miami ranked third in cumulative female adult/adolescent AIDS cases reported since 1981, and second in female AIDS cases reported in the most recent year, 1995 (Dawn Gnesda, CDC, personal communication, March 1996). For one-in-three (33%) AIDS cases diagnosed in Miami women, the HIV exposure category was injection drug use; for another one-in-three (32%) the HIV risk was heterosexual transmission (Florida HRS, 1996).

Women drug users frequently engage in drug-sharing and sexual practices that put them at risk for HIV infection (Fullilove, Fullilove, Bowser, & Gross, 1990; Rolfs, Goldberg, & Sharrar, 1990; McCoy & Miles, 1992; Inciardi, Lockwood, & Pottieger, 1993; Edlin, Irwin, Faruque, McCoy, Word, Serrano, Inciardi, Bowser, Schilling, & Holmberg, 1994; Metsch, McCoy, & Weatherby, 1996). Women drug users often exist within social networks whose members share drug injection equipment, visit high-risk locales such as shooting galleries and have multiple sexual liaisons; conse-

quently, these women experience high rates of HIV infection (Chaisson, Stoneburner, Hildebrandt, Ewing, Telzak, & Jaffe, 1991; Barnard, 1993; Astemborski, Vlahov, Warren, Solomon, & Nelson, 1994; Freeman, Rodriguez, & French, 1994; McCoy, Metsch, Page, McBride, & Comerford, in press). Exchanging sex-for-drugs and exchanging sex-for-money have been commonly documented among female IDUs and crack cocaine smokers (Fullilove et al., 1990; Chaisson et al., 1991; Inciardi et al., 1993; Ratner, 1993; McCoy, Miles, & Inciardi, 1995). Sexual exchange is associated with increased rates of HIV seropositivity and fuels the AIDS epidemic in this population (Des Jarlais, Wish, Friedman, Stoneburner, Yancoitz, Mildvan, El-Sadar, Brady, & Cuadrado, 1987; Chu, Buehler & Berkleman, 1990; Ellerbrock, Lieb, & Harrington, 1992; Booth, Watters, & Chitwood, 1993; Forbes, 1993; Tortu, Beardsley, Deren, & Davis, 1994; McBride, Mutch, Kilcher, Inciardi, & McCoy, 1996; Metsch et al., 1996; Shultz, McCoy, Metsch, Chitwood, Weatherby, & Correa, in press).

This study focuses primarily on the associations among living arrangements, HIV seroprevalence, and HIV risk and protective factors among drug-using women participating in the University of Miami CARES (Community AIDS Research and Evaluation Studies) HIV intervention program. It is our thesis that living arrangements may be associated with HIV prevention behaviors; however, these influences can be either risk-potentiating or protective, prompting the need for further study and explication. While the extant literature on living arrangements is sparse, recent studies highlight the importance of examining social influences on risk and protective factors, including living arrangements (Robles, Colon, Matos, Reyes, Marrero, & Lopez, 1993; Deren, Beardsley, Tortu, Davis, & Clatts, 1993; Zapka, Stoddard, & McCusker, 1993; Lockwood, Pottieger, & Inciardi, 1996; Metsch, McCoy, McCoy, Shultz, Lai, Weatherby, McAnany, Correa, & Anwyl, 1995a). Within this context, this paper describes (1) differences in living arrangements between men and women in relation to HIV serostatus; (2) interrelationships among living arrangement indicators and drug-and-sexual-risk and protective behaviors; and (3) implications of study findings for the development of future studies and intervention strategies.

METHODS

Study Population

Data for these analyses were drawn from the Miami site of the National Institute on Drug Abuse's Cooperative Agreement Program for AIDS

outreach/intervention research study which targets both high-risk out-of-treatment IDUs and crack smokers. Recruitment of study participants was initiated in 1992. Indigenous outreach workers located, screened, and recruited eligible participants who were required to be at least 18 years of age, not in drug treatment 30 days prior to initial recruitment, and had self-reported the use of drugs 30 days prior to recruitment.

Data Collection

Data were collected using a nationally standardized, validated instrument, the Risk Behavior Assessment (RBA), developed by the National Institute on Drug Abuse's Cooperative Agreement (Weatherby, Needle, Cesari, Booth, McCoy, Watters, Williams, & Chitwood, 1994; Chitwood, Inciardi, McBride, McCoy, McCoy, & Trapido, 1991). The interview lasted 30 to 60 minutes and consisted of questions related to demographics, living conditions, lifetime and 30-day prevalence of alcohol use, lifetime and 30-day prevalence of drug abuse, age of onset of alcohol or other drug use, sexual history for the 30 days preceding the interview, history of sexually transmitted diseases (STDs), exchanging behaviors (including sex-for-drugs, sex-for-money) and use of alcohol or other drugs during sexual activity. The RBA instrument was administered by interviewers who were well trained and experienced in conducting face-to-face interviews with drug users. Respondents were encouraged to participate through a $15 stipend for their time and assurances of anonymity and confidentiality through a Confidentiality Certificate issued by the National Institute on Drug Abuse. HIV testing accompanied by pre-test and post-test counseling was conducted on-site by certified phlebotomists and trained counselors.

Data Analysis

The present analysis includes 1,322 drug users, 533 women and 789 men. We assessed the relationship between operationalized variables of living arrangements and HIV risk and protective factors. Chi square tests for differences in proportions among living arrangement categories were conducted for risk and protective behavior variables. These data were summarized in four sections: (1) gender comparisons for living arrangements and HIV serostatus; (2) living arrangements and drug behaviors among women; (3) living arrangements and IDU risks among women; and (4) living arrangements and sexual behaviors among women. Each section includes a table for which total Ns and proportion of persons engaging in risk behaviors are reported by living arrangement categories.

Definition of Living Arrangements

For the present analysis, two types of living arrangements were studied: housing status and persons lived with. Housing status was defined as either housed or homeless (including persons living on the street or shelters). Persons lived with was defined as living alone, living with a sex partner, or not living with a sex partner.

RESULTS

Gender Differences in Demographics, Living Arrangements and HIV Serostatus

While most of the sample consisted of blacks[1] between the ages of 25 and 44 who had not progressed educationally beyond a high school degree, women were more likely to be black (p < .01), younger (p < .005), and less educated (p < .005). Significant differences were found for the proportions of respondents within each of the categories of living arrangement variables in comparisons between men (n = 789) and women (n = 533) (p < .005). Women were less likely to live alone and more likely to live with a sex partner, as compared with men (p < .005). Women were more likely to be housed, while men were much more likely to be homeless (p < .005).

The prevalence of HIV by gender and living arrangements (Table 1) for respondents in this study reveals that the overall HIV seropositivity was significantly higher for women (34.7%) than for men (22.8%) (p < .005). Among the categories of living arrangement variables, the highest rates of HIV seropositivity were found for women living alone (45.1%) and for homeless women (47.0%). Furthermore, among categories of living arrangement variables, being homeless was associated with the *highest* HIV infection rate posted for women (47.0%), but the *lowest* seropositivity rate for men (20.3%).

Living Arrangements and Drug Behaviors Among Women

Frequency of self-reported drug use during the 30-day period preceding the baseline interview is summarized in Table 2. In this table, both the

1. Black Americans were the target group for the Miami CARES Cooperative Agreement intervention study.

TABLE 1. Demographic and Living Arrangement Characteristics and Sero-status of 1322 Drug Using Men and Women

	Men (789)	Women (533)	Men HIV+ 22.8% (180)	Women HIV+ 34.7%*** (185)
Race/Ethnicity				
Black (Not Hispanic)	90.4	94.9**	23.8	36.2
White (Not Hispanic)	4.6	3.2	11.1	5.9
Hispanic	4.4	1.3	17.1	0.0
Other	0.6	0.6	0.0	33.3
Age				
18-24	3.4	7.3***	25.9	33.3
25-34	38.7	51.2	17.7	34.1
35-44	47.8	35.8	26.0	36.6
45+	10.1	5.6	26.3	30.0
Education				
< HS	36.8	55.2***	25.9	38.1
HS/GED	40.6	29.3	22.5	30.1
> HS	22.7	15.6	18.4	31.3
Housing Status				
Housed	63.1	87.6***	24.3	33.0
Homeless	36.9	12.4	20.3	47.0
Persons Lived With				
Alone	40.8	17.1***	22.4	45.1
Sex Partner	15.0	29.5	26.3	28.7
Not With Sex Partner	44.2	53.5	22.1	34.7

** p < .01
*** p < .005

proportion of women who reported using drugs ten or more times in the last 30 days as well as the median times used in the past 30 days are reported. Use of multiple substances (polydrug use) was commonly observed among women in this study. Women who lived with a sex partner were significantly more likely to report using alcohol more than ten times in the last 30 days, as compared to women who lived alone or who did not live with a sex partner (65.6% vs. 50.5% vs. 56.5%, p < .05). Homeless women, as compared to their housed counterparts, reported higher median number of episodes of alcohol use in 30 days (90 vs. 60), crack use (122.5 vs. 105), and cocaine use (90 vs. 40).

TABLE 2. Living Arrangements and Drug Use Patterns of Women. Times Used Drugs in Previous 30-Day Period (N = 533)

	N	ALCOHOL > 10 Times		CRACK > 10 Times		COCAINE > 10 Times		HEROIN > 10 Times		SPEEDBALL > 10 Times	
		%	Med	%	Med	%	Med	%	Med	%	Med
Housing Status											
Housed	467	59.3	60.0	89.7	105.0	10.9	40.0	3.0	60.0	3.0	90.0
Homeless	66	50.0	90.0	93.9	122.5	7.6	90.0	4.5	60.0	4.5	90.0
Persons Lived With											
Alone	91	50.5*	69.0	94.5	99.0	9.9	60.0	4.4	60.0	5.5	120.0
Sex Partner	157	65.6	60.0	87.3	100.0	9.6	40.0	4.5	60.0	3.2	88.0
Not With Sex Partner	285	56.5	75.0	90.5	120.0	11.2	50.0	2.1	30.0	2.5	90.0

* p < .05

Living Arrangements and IDU Risks Among Women

Drug risks related to injection drug use (IDU) are shown in Table 3. Injection behaviors differed by women living in various arrangements as women who lived alone, as compared to women who lived with others, were significantly more likely to report: (1) using a reused needle/syringe (63.6% vs. 18.8% and 17.6%, p < .05; (2) giving used works to others (72.7% vs. 18.8% and 17.6%, p < .01); and (3) injecting in a shooting gallery (27.3% vs. 6.3% and 0%, p < .05).

Living Arrangements and Sexual Behaviors Among Women

The following sexual risk behaviors were analyzed in relation to living arrangement categories: having more than one sexual partner, having an IDU sexual partner, having vaginal sex without a condom, exchanging sex for drugs and exchanging sex for money (see Table 4). Only heterosexual relationships and vaginal sexual intercourse were included in this analysis because of sample limitations for other types of sexual relations, such as anal sex.

In general, living arrangements and sexual risk behaviors were significantly associated. Non-use of condoms during vaginal sex was more commonly reported by women who lived with sex partners, as compared with women who lived alone and women who did not live with sex partners (87.2% vs. 58.8% and 63.6%, p < .005). Also, exchanging sex-for-drugs

TABLE 3. Living Arrangement Characteristics and IDU Risk of Drug Using Women (N = 44)

	N	Used Reused Needle %	Used Shooting Gallery %	Gave Used Works to Others %
Housing Status				
Housed	35	25.7	5.7	25.7
Homeless	9	44.4	22.2	55.6
Persons Living With				
Alone	11	63.6*	27.3*	72.7**
Sex Partner	16	18.8	6.3	18.8
Not With Sex Partner	17	17.6	0.0	17.6

* p < .05
** p < .01

TABLE 4. Living Arrangements Characteristics and Sexual Risk of Drug Using Women

	More Than One Sex Partner		Vaginal Sex without Condom		Sex for Drugs		Sex for Money		IDU Partner	
	N	%	N	%	N	%	N	%	N	%
Housing Status										
Housed	230	54.4	291	71.0	222	52.4	302	71.2	25	6.0*
Homeless	30	56.6	35	66.0	30	54.5	40	72.7	7	13.5
Persons Lived With										
Alone	44	62.0	40	58.8***	41	56.9*	56	77.8*	6	9.1
Sex Partner	75	49.0	129	87.2	67	43.8	98	64.1	10	6.7
Not With Sex Partner	141	56.0	157	63.6	144	56.7	188	74.0	16	6.4

* p < .05
*** p < .005

and sex-for-money were significantly associated with living arrangements: women who lived with sex partners were less likely to engage in these high-risk behaviors (p < .05). Few women reported having an IDU sexual partner; yet homeless women were more likely to report having an IDU sexual partner than their non-homeless counterparts (13.5% vs. 6.0%, p < .05).

DISCUSSION

This study has some limitations. First, these data were cross-sectional and thus are limited with regard to any inferences of causality (Kelsey, Thompson, & Evans, 1986). Second, measures of living arrangements were limited in this data set as the Cooperative Agreement was not intended to study the effects of living arrangements on HIV risk behaviors. Nevertheless, this study represents one of the first descriptive explorations of living arrangements among drug using women at risk for HIV infection. Our findings indicate that differences exist in the living arrangements of women compared with men. These data also indicate that women's living arrangements are associated with HIV seroprevalence and risk and protective behaviors.

First, women in this study had very high HIV seroprevalence rates as previously reported (Metsch et al., 1995a); and these high rates were observed across all categories of living arrangements. HIV infection rates were 45.1% for women living alone and 47.0% for homeless women.

Second, compared with male drug users in this study, women drug users were less likely to live alone, less likely to be homeless and more likely to live with a sex partner. These findings suggest the possibility of designing innovative interventions for women and their live-in mates. For example, it may be possible to design couple-focused interventions which would maximize the supportive function of the couple's relationship (Metsch, Rivers, Miller, Bohs, McCoy, Morrow, Bandstra, Jackson, & Gissen, 1995).

Third, although based on small numbers, risky injection drug use, including the use of shooting galleries and sharing reused paraphernalia, was more prevalent among women who lived alone. Women who live alone may shoot up with other companions or in shooting galleries because they do not have a live-in IDU partner.

Fourth, women who lived with their sexual partners appeared to be at the highest risk for heterosexual transmission of HIV because they did not report consistent condom use during vaginal sex. This is not surprising because previous research has indicated that relatively few persons use

condoms with steady or exclusive partners. For example, among 158 sexually active, out-of-treatment heterosexual IDU men and women in a Philadelphia-based study, only 20% of those having intercourse with spouses used condoms, compared with 59% of subjects whose sexual contacts were with casual or commercial partners (Watkins, Metzger, Woody, & McLellan, 1993). Similarly, Hooykass and colleagues (1989) in Amsterdam found that women with private partners used condoms far less frequently than women with commercial sex partners.

CONCLUSION

These findings provided a preliminary look at the role of social influences and social environments in defining and shaping individuals' risk behaviors and practices. There is an increasing recognition of the value of extending our understanding of HIV infection to include research on the relationship of social context to individual risk behaviors. Living arrangements, one aspect of social context, were shown to be associated with risk behaviors and HIV status. Systematic research should explore other social influences in order to develop interventions which focus on the role of social context.

The findings presented here have several implications for the development of multi-level interventions focused on couples, groups or social networks. The data from this study suggest that outreach and training efforts might not only target high-risk individuals, but also persons with whom they interact often, especially those with whom they live or with whom they have sex. For example, outreach and interventions which target women as well as their sexual partners could attempt to address the relevant "relationship" issues (e.g., violence, women's fears of retribution for assertiveness, and the power dynamics between men and women) which appear to impact on drug use and HIV risk behaviors (Amaro, 1995).

REFERENCES

Amaro, H. (1995). Love, sex, and power: Considering women's realities in HIV prevention. *American Psychologist, 50*(6), 437-447.

Astemborski, J., Vlahov, D., Warren, D., Solomon, L., & Nelson, K.E. (1994). The trading of sex for drugs or money and HIV seropositivity among female intravenous drug users. *American Journal of Public Health, 84*(3), 382-387.

Barnard, M.A. (1993). Needle sharing in context: Patterns of sharing among men and women injectors and HIV risks. *Addiction, 88*(6), 805-812.

Booth, R.E., Waters, J.K., & Chitwood, D.D. (1993). HIV risk related sex behaviors among injection drug users, crack smokers, and injection drug users who smoke crack. *American Journal of Public Health*, 83(8), 1144-1148.

Centers for Disease Control (1996). *HIV/AIDS Surveillance Report: Year End Edition*. Washington, DC: Centers for Disease Control.

Chaisson, J.A., Stoneburner, R.L., Hildebrandt, D.S., Ewing, W.E., Telzak, E.E., & Jaffe, H.W. (1991). Heterosexual transmission of HIV-1 associated with the use of smokable freebase cocaine (crack). *AIDS*, 5(9), 1121-1126.

Chitwood, D.D., Inciardi, J.A., McBride, D.C., McCoy, C.B., McCoy, H.V., & Trapido, E. (1991). *A Community Approach to AIDS Intervention: Exploring the Miami Outreach Project for Injecting Drug Users and Other High Risk Groups* (pp. 89-90). Westport, CT: Greenwood Press.

Chu, S.Y., Buehler, J.W., & Berkelman, R.L. (1990). Impact of the human immunodeficiency virus epidemic on mortality in women of reproductive age. *Critical Care Nurse*, 10 (8), 43.

Deren, S., Beardsley, M., Tortu, S., Davis, R., & Clatts, M. (1993). Behavior change strategies for women at high risk for HIV. *Drugs & Society*, 7(3/4), 119-128.

Des Jarlais, D.C., Wish, E., Friedman, S.R., Stoneburner, R., Yancoitz, S.R., Mildvan, D., El-Sadar, W., Brady, E., & Cuadrado, M. (1987). Intravenous drug use and the heterosexual transmission of the human immunodeficiency virus. *New York State Journal of Medicine*, 87(5), 283-6.

Edlin, B., Irwin, K.L., Faruque, S., McCoy, C.B., Word, C., Serrano, Y., Inciardi, J.A., Bowser, B.P., Schilling, R.F., Holmberg, S.D., & The Multicenter Crack Cocaine and HIV Infection Study Team. (1994). Intersecting epidemics–Crack cocaine use and HIV infection among inner-city young adults. *New England Journal of Medicine*, 331, 1422-1427.

Ellerbrock, T.V., Lieb, S., & Harrington, P.E. (1992). Heterosexually transmitted human immunodeficiency virus infection among pregnant women in a rural Florida community. *New England Journal of Medicine*, 327(24), 1704-1709.

Florida Health and Rehabilitative Services. (1996). HIV/STD/TB Monthly Report, July, 1995. State of Florida Department of Health and Rehabilitative Services.

Forbes, A. (1993). Crack cocaine and HIV: How national drug addiction treatment deficits fan the pandemic flames. *AIDS and Public Policy*, 8, 44-52.

Freeman, R.C., Rodriguez, G.M., & French, J.F. (1994). A comparison of male and female intravenous drug users' risk behaviors for HIV infection. *American Journal of Drug and Alcohol Abuse*, 20(2), 129-157.

Fullilove, R.E., Fullilove, M.T., Bowser, B.P., & Gross, S.A. (1990). Risk of sexually transmitted disease among black adolescent crack users in Oakland and San Francisco, California. *Journal of the American Medical Association*, 26, 851-855.

Hooykaas, C., van der Pligt, J., van Doornum, G.J., van der Linden, M.M., & Coutinho, R.A. (1989). Heterosexual at risk for HIV: Differences between

private and commercial partners in sexual behavior and condom use. *AIDS*, 3, 525-532.

Inciardi, J.A., Lockwood, D., & Pottieger, A. (1993). *Women and Crack-Cocaine.* New York: Macmillan.

Kelsey, J.L., Thompson, W.D., & Evans, A.S. (1986). *Methods in Observational Epidemiology.* New York: Oxford University Press Inc.

McBride, D.C., Mutch, P.B., Kilcher, C., Inciardi, J.A., & McCoy, H.V. (1996). Barriers to treatment access for women in non-urban areas. In D. Chitwood, J.A. Inciardi, & J.E. Rivers (Eds.), *The American Pipe Dream: Crack Use in the Inner City* (pp. 115-128). New York: Harcourt Brace College Publishers.

McCoy, C.B., Metsch, L.R., Page, J.B., McBride, D.C., & Comerford, S.T. (in press). Injecting drug users' attitudes towards intervention and its potential for reducing the transmission of HIV. *Medical Anthropology.*

McCoy, H.V. & Miles, C. (1992). A gender comparison of health status among users of crack cocaine. *Journal of Psychoactive Drugs,* 24(4), 389-397.

McCoy, H.V., Miles, C., & Inciardi, J.A. (1995). Survival sex: Inner city women and crack cocaine. In J.A. Inciardi & K. McElrath (Eds.), *The American Drug Scene: An Anthology.* Los Angeles: Roxbury Publishing.

Metsch, L.R., McCoy, H.V, & Weatherby, N.L. (1996). Women and crack cocaine. In D. Chitwood, J.A. Inciardi, & J.E. Rivers (Eds.), *The American Pipe Dream: Crack Use in the Inner City* (pp. 71-88). New York: Harcourt Brace College Publishers.

Metsch, L.R., McCoy, C.B., McCoy, H.V., Shultz, J., Lai, S., Weatherby, N.L., McAnany, H., Correa, R., & Anwyl, R. (1995a). HIV-related risk factors among homeless women in Miami, Florida. *Journal of Psychoactive Drugs,* 27(4), 435-446.

Metsch, L.R., Rivers, J.E., Miller, M., Bohs, R., McCoy, C.B., Morrow, C.J., Bandstra, E.S., Jackson, V., & Gissen, M. (1995b). Implementation of a family-centered treatment program for substance-abusing women and their children: Barriers and resolutions. *Journal of Psychoactive Drugs,* 27(1), 73-83.

Ratner, M.S. (1993). *Crack Pipe as Pimp.* Lexington: Lexington Press.

Robles, R.R., Colon, H.M., Matos, T.D., Reyes, J.C., Marrero, C.A., & Lopez, C.M. (1993). Risk factors and HIV infection among three different cultural groups of injection drug users. In B.S. Brown & G.M. Beschner (Eds.), *Handbook on Risk of AIDS: Injection Drug Users and Sexual Partners.* Westport, CT: Greenwoood Press.

Rolfs, R.T., Goldberg, M., & Sharrar, R.G. (1990). Risk factors for syphilis: Cocaine use and prostitution. *American Journal of Public Health,* 80, 853-857.

Shultz, J.M., McCoy, C.B., Metsch, L.R., Chitwood, D.D., Weatherby, N.L., & Correa, R. (1996). HIV risk behaviors among street homeless, offstreet homeless, and non-homeless male substance abusers in Miami/Dade County, Florida. *International Journal of the Addictions,* in press.

Tortu, S., Beardsley, M., Deren, S., & Davis, W.R. (1994). The risk of HIV infection in a national sample of women with injection drug-using partners. *American Journal of Public Health,* 84(8), 1243-1249.

Watkins, K.E., Metzger, D., Woody, G., & McLellan (1993). Determinants of condom use among intravenous drug users. *AIDS,* 3, 525-532.

Weatherby, N.L., Needle, R., Cesari, H., Booth, R., McCoy, C.B., Watters, J.K., Williams, M., & Chitwood, D.D. (1994). Validity of self-reported drug use among injection drug users and crack cocaine users recruited through street outreach. *Evaluation and Program Planning,* 17, 347-355.

Zapka, J.G., Stoddard, A.M., & McCusker, J. (1993). Social network, support and influence: Relationships with drug use and protective AIDS behavior. *AIDS Education and Prevention,* 5(4), 352-366.

Differences in Condom Behaviors and Beliefs Among Female Drug Users Recruited from Two Cities

Michele M. Wood, MA
Stephanie Tortu, PhD
Fen Rhodes, PhD
Sherry Deren, PhD

SUMMARY. This paper examines predictors of condom cognitions and condom use for vaginal sex within women's main and paying partnerships. The sample consisted of active injection drug and crack-using women recruited from two cities with disparate HIV rates. A total of 338 drug-using women who reported vaginal sex with a main and/or paying partner in the prior 30 days were recruited for this study. Recruitment site was a significant predictor for several of the variables examined, for both main and paying partners. Ethnicity and prior HIV test result were also significant predictors, but only for main sex partners. Findings support previous research and suggest that the factors which predict condom beliefs, intention, and

Michele M. Wood and Fen Rhodes are affiliated with California State University, Long Beach, CA. Stephanie Tortu and Sherry Deren are affiliated with the National Development & Research Institutes, New York, NY.

This research was supported by grants from the Community Research Branch of the National Institute on Drug Abuse (U01-DA07286, U01-DA07474).

Address correspondence to Michele Wood, CSULB Center for Behavioral Research & Services, 920 Pacific Avenue, Long Beach, CA 90813 (mwm6@ wonder.em.cdc.gov [internet]).

behaviors are different for main versus paying partners. Interventions designed to increase condom use must recognize that cognitive factors associated with condom use may vary by partner type, ethnicity, and recruitment site, particularly when important contextual variables, such as local seroprevalence, vary. *[Article copies available for a fee from The Haworth Document Delivery Service: 1-800-342-9678. E-mail address: getinfo@haworthpressinc.com]*

INTRODUCTION

With each passing year, women are gaining larger representation in this country's AIDS epidemic. Minority women are at disproportionately high risk, with African American and Latina women comprising three-quarters (75.2%) of the adult and adolescent female cases of AIDS reported (Centers for Disease Control and Prevention [CDC], 1995). As of December, 1995, exposure to HIV among adult and adolescent women with AIDS was accounted for primarily by injection drug use (47%) and heterosexual transmission (37%) (CDC, 1995). Many intervention efficacy studies have demonstrated substantial reductions in HIV risk among injection drug users (IDUs) through the adoption of safer injection practices, including reduced drug use, decreased needle sharing, and decreased use of borrowed needles (Stephens, Simpson, Coyle, McCoy, & NARC, 1993). However, interventions have been less successful in reducing HIV sexual risks (National Institute on Drug Abuse [NIDA], 1994; Stephens et al., 1993).

Recent research has suggested the importance of cognitive factors in mediating the use of condoms. Such factors include beliefs about using condoms, intention to use condoms, and self-efficacy regarding condom use. Beliefs and attitudes about using condoms have been shown to be related to condom use in several studies (Norris & Ford, 1994; Friedman et al., 1994; Sibthorpe, Fleming, Tesselaar, & Gould, 1991; Jemmott & Jemmott, 1991; Schilling, El-Bassel, Gilbert, & Schinke, 1991), and positive beliefs and attitudes towards condoms have been associated with greater intention to use condoms (Corby, Jamner, & Wolitski, 1996; Jemmott & Jemmott, 1991). In addition to cognitive factors, frequency of condom use has also been linked to both stage of change and intention to use condoms (Rhodes & Malotte, in press). Likewise, women with higher levels of self-efficacy with respect to condom use have been found to be more likely to practice safer sex with their partners than those with lower self-efficacy (Rhodes & Malotte, in press).

Demographic and contextual factors may also influence condom behaviors and beliefs among drug-using women. One important demographic

variable is race/ethnicity. Differences in condom beliefs based upon racial or ethnic-group membership have been established in several instances (Wyatt, 1994; Gomez & Marin, 1993; Farmer, Lindenbaum, & Good, 1993). In one such study, African Americans more frequently reported having angry reactions during the process of condom negotiation, which may be related to different cognitions about the use of condoms (Johnson et al., 1994). Perceptions of HIV risk have been found to vary by racial or ethnic group, and may be associated with beliefs about condom use. For example, African American women, and also men, were found to have higher levels of perceived risk for HIV exposure than were Whites (Johnson et al., 1994), and Latina women may not perceive having unprotected sex as a potential risk factor for HIV infection (Gomez & Marin, 1993). Another important factor that has been shown to predict condom use, among both men and women, is HIV serostatus (Watkins, Metzger, Woody, & McLellan, 1993), with seropositive individuals being more likely to use condoms.

A contextual factor that may influence condom behaviors and beliefs is local community HIV seroprevalence. Awareness of community rates of HIV infection may impact perceived risk or vulnerability, which, in turn, may influence condom behaviors and related cognitive factors. In communities with high rates of HIV seroprevalence, having a steady sex partner may be viewed as an important means of protection from heterosexual transmission. One study found that individuals in high seroprevalence communities who had steady sex partners often did not perceive themselves to be at risk for HIV infection (Seidlin, Vogler, Lee, Lee, & Dubin, 1993).

The use of crack cocaine is another factor that has been found to be related to sex behaviors and condom use. The common practice of financially supporting drug habits by having sex in exchange for drugs with numerous partners, usually without using a condom, has been established among crack-using women (Institute of Medicine, 1994). Previous research, both ethnographic and survey-based, has linked the use of crack cocaine to participation in high-frequency, high-risk sex with numerous and often anonymous partners, as well as higher rates of HIV infection (Booth, Watters, & Chitwood, 1993; Edlin et al., 1994; Inciardi, 1993; Lindsay, Peterson, Boring, Gramling, Wilin, & Klein, 1992; Longshore, Anglin, Annon, & Hsieh, 1993; McCoy & Inciardi, 1993; Ratner, 1993; Wallace, Steinbert, & Weiner, 1992; Weatherby et al., 1992). One such investigation (Booth et al., 1993) found that crack smokers, in comparison to drug injectors who did not smoke crack, reported having a greater number of sex partners and a greater number of unprotected sex acts, were more likely to have exchanged sex for money and/or drugs, and reported using drugs more often before or during sex. They also found that crack-using IDUs were more likely to have

sex partners who are drug injectors, compared with those who do not use crack. This research suggests that use of crack cocaine may be an additional, important predictor of condom behaviors and beliefs.

The exchange of sex for money or drugs may also be associated with beliefs about condoms and their actual use. Several studies of female drug users have found that women who exchange sex for money or drugs are more likely to use condoms with their paying partners than with their main partners (Corby & Wolitski, 1992; Corby, Wolitski, Rhodes, O'Reilly, & CDC Demonstrations Projects, 1993; Corby, Wolitski, Thornton-Johnson, & Tanner, 1991; Rhodes et al., 1990; Weiss et al., 1993). Motivation on the part of such women for engaging in unprotected sex with their main partners has been attributed to a desire to communicate and experience a greater level of intimacy with these partners as compared with paying partners (Dorfman, Derish, & Cohen, 1992). It may be that women who exchange sex for money or drugs have more negative attitudes and beliefs about using condoms with their main partners, and they may engage in unprotected vaginal sex with main partners more frequently than do their non-trading counterparts.

The purpose of the present study was to compare condom beliefs, self-efficacy, intentions, and condom use among injection drug and crack cocaine using women recruited from two U.S. cities with dissimilar HIV seroprevalence rates and racial/ethnic compositions. It was hypothesized that recruitment site would be a significant mediator of condom behaviors and cognitions. Specifically, women recruited from the high prevalence site would report different attitudes about condoms, greater self-efficacy for condom use, greater intention to use condoms, and greater frequency of condom use for vaginal sex with both main and paying sex partners, than women recruited from the lower prevalence site. In addition, racial/ethnic background, current crack use, prior HIV test results, and sex trader status were also expected to be significant predictors of condom beliefs, intentions, and use.

METHOD

Participants

A total of 539 out-of-treatment injection drug and/or crack cocaine using women were recruited to participate in an ongoing HIV risk intervention program for active drug users through street outreach in two NIDA Cooperative Agreement sites with disparate HIV seroprevalence rates. Recent drug use was confirmed by urine test and/or visible track

marks. A total of 390 women (72%) reported having engaged in vaginal sex during the past 30 days, and 338 (63%) had done so with a main and/or paying sex partner. Of these women, only 13 identified themselves as belonging to an ethnic group other than African American, Latina, or White, and were therefore excluded from the analyses. Thus, 325 were considered eligible for the present study.

Forty percent of the women were recruited at a high prevalence site, East Harlem, New York City, and 60% were recruited at a low prevalence site, Long Beach, California. More than three-quarters (84%) reported having a main or steady sex partner, and 34% reported having one or more paying partners during the past 30 days. All study participants were offered an HIV test in conjunction with their participation in the study; 83% agreed to be tested.

A third (33%) of the women recruited in East Harlem who received an HIV test were seropositive; 5% of those recruited in Long Beach were seropositive. Eighty percent of the women sampled reported that during the past year they had typically injected illicit drugs and/or smoked crack cocaine at least twice daily. Half of the women (50%) were current drug injectors; a somewhat larger percentage of women (59%) reported that they had ever injected drugs. The majority (83%) had used crack in the past 30 days. Nearly all of the women (93%) said that they had smoked crack at some time in their lives. The majority of women were African American (51%), 26% were Latina, 23% were White. Latinas recruited in East Harlem were primarily Puerto Rican (94%), while those recruited in Long Beach were predominantly Mexican American (89%). The median age was 35, with a range of 21 to 59 years. Thirty-nine percent of the women described themselves as homeless, although only 8% were living on the street at time of recruitment. Almost half of the participants (48%) had not completed high school. In terms of regular employment, only 8% of the women sampled indicated that they currently had full- or part-time jobs. The median number of lifetime arrests for these women was two. Participant demographic differences by site are presented in Table 1.

Measures

Two instruments, the Risk Behavior Assessment and the Behaviors and Beliefs Questionnaire, were employed to assess condom use behaviors, attitudes and beliefs, and to obtain demographic data, including information about prior HIV testing.

Risk Behavior Assessment (RBA). The instrument includes items regarding drug use, needle use, sharing and disinfection of injection equipment, condom use, and the exchange of sex for money or drugs. In addi-

TABLE 1. Selected Demographic and Drug Use Characteristics for Participants Recruited in East Harlem vs. Long Beach

Characteristic (Total N = 325)	East Harlem No.	(%)	Long Beach No.	(%)	p*
Sex Exchange Status					.08
(Past 30 Days)					
Exchange	36	(27.9)	73	(37.4)	
No Exchange	93	(72.1)	122	(62.6)	
Race/Ethnicity					.00
African American	69	(53.5)	97	(49.5)	
Latina	49	(38.0)	35	(17.9)	
White	11	(8.5)	64	(32.7)	
Latina Sub-Group					.00
Puerto Rican	44	(93.6)	0	(0.0)	
Mexican American	0	(0.0)	31	(88.6)	
Other	3	(6.4)	4	(11.4)	
Consider Self Homeless?					.78
Yes	51	(39.8)	75	(38.3)	
No	77	(60.2)	121	(61.7)	
Living on the Streets?					.10
Yes	6	(4.7)	19	(9.7)	
No	123	(95.3)	177	(90.3)	
Most Recent Prior HIV Result					.00
Positive	18	(14.1)	1	(0.5)	
Negative	72	(56.3)	131	(66.8)	
Never Tested/					
Don't Know	38	(29.7)	64	(32.7)	
Tested for HIV at Intake					.00
Yes	80	(62.0)	190	(96.9)	
No	49	(38.0)	6	(3.1)	.00
Result of HIV Test					
Positive	26	(32.9)	9	(4.7)	
Negative	53	(67.1)	181	(95.3)	
Age Category					.02
21-29	35	(27.1)	31	(15.8)	
30-39	70	(54.3)	109	(55.6)	
40+	24	(18.6)	56	(28.6)	

TABLE 1 (continued)

Characteristic (Total N = 325)	East Harlem No.	(%)	Long Beach No.	(%)	p*
High School Graduate or Equivalent?					.02
No	72	(55.8)	83	(42.6)	
Yes	57	(44.2)	112	(57.4)	
Employment					.00
Part- or Full-Time Work	3	(2.3)	22	(11.8)	
Unemployed	121	(94.5)	132	(70.6)	
Retired, Disabled	4	(3.1)	33	(17.6)	
Crack Use (Past 30 Days)					.02
Yes	115	(89.1)	156	(79.6)	
No	14	(10.9)	40	(20.4)	
Injection Drug Use (Past 30 Days)					.00
Yes	41	(31.8)	120	(61.2)	
No	88	(68.2)	76	(38.8)	
Frequency of Illicit Drug Use (Past Year)					.00
Fewer than 2 Times/Day	13	(10.1)	51	(26.0)	
2 or More Times/Day	116	(89.9)	145	(74.0)	

* Chi-square test.
Note: Two of the women recruited in East Harlem who self-identified as Latina declined to state their Latina ethnic subgroup, and one of the women recruited in East Harlem tested indeterminate.

tion, the questionnaire also documents participant drug treatment experiences, HIV testing history, health status, and basic demographics.

Behaviors and Beliefs Questionnaire (BBQ). The BBQ is a questionnaire that was developed by the principal investigator of the Long Beach Cooperative Agreement site (Dr. Fen Rhodes) in collaboration with other Cooperative Agreement investigators. The instrument assesses beliefs, self-efficacy, intentions, and behaviors pertaining to strategies for reducing drug-related and sexual HIV risk. Beliefs associated with the adoption of target behaviors are assessed on a scale from (1) "agree very much" to (5) "disagree very much." Perceived self-efficacy for performing target behaviors is measured on a 10-point scale from (1) "absolutely sure I cannot" to (10) "absolutely sure I can." Personal intentions are expressed on a scale from (1) "very sure I will" to (4) "very sure I won't." Current

behavioral performance is measured on a five-point scale from (1) "every time" to (5) "never," representing respondents' degree of present compliance in performing each specified target behavior. As in the RBA, a 30-day frame of reference is employed for behavior recall. Eight behaviors are measured in the BBQ, including the target behaviors examined in the present study, always using condoms for vaginal sex with main and paying sex partners. Separate versions of the BBQ were developed for men and women; the version of the BBQ for female respondents was utilized in this investigation.

PROCEDURE

Recruitment and Measurement. Women who were interviewed as part of the present study were recruited from the two sites using a targeted sampling plan employing geographic, gender, ethnicity, and drug use (injection versus crack) quotas. Informed consent was obtained at the time of recruitment, after which participants were urine tested for opiates and cocaine and screened for recent track marks to confirm their eligibility. The RBA and BBQ were individually administered by trained interviewers and took approximately one hour to complete. Following completion of the questionnaires, subjects were paid fifteen dollars for their time and were offered HIV antibody testing.

Data Analysis. To determine site differences with respect to participant demographics, contingency table analysis (chi-square) was used for selected categorical variables.

The influence of recruitment site (East Harlem/Long Beach) on condom use beliefs, self-efficacy, intentions, and behaviors for vaginal sex within main and paying partnerships was assessed using multivariate logistic regression analyses. Four variables were included as covariates in the analyses: ethnicity (African American/White/Latina), crack user status (crack user/nonuser), most recent HIV test result (positive/negative/never tested or never received result), and sex exchange status (exchange/no exchange).

Factor analysis was performed on nine items representing beliefs about the use of condoms for vaginal sex with main and paying partners. Principal components analysis yielded two distinct factors which represented "Cause Harm to Relationship" and "Provide Disease Protection" for using condoms with both types of sex partners. Factor scores for both belief components were calculated by summing the ratings of those items having relatively pure loadings on each factor. For main partners, five such items were associated with the first factor, and three were associated

with the second. For paying partners, four items were associated with the first factor, and two were associated with the second. Factor scores were then dichotomized using a median split. The individual items comprising each factor are included in Tables 2 and 3. All other rating scales were also dichotomized according to the median split. Statistical analyses were conducted using a standard statistical software package (SPSS, 1992).

RESULTS

Site Differences

As shown in Table 1, women recruited in East Harlem were different from women recruited in Long Beach in many ways. Women in East Harlem were more likely to be HIV positive and more likely to use drugs at least twice a day than women recruited in Long Beach. They were also

TABLE 2. Belief Components: Getting Main Partner to Always Use Condoms for Vaginal Sex

Factor and Items	Factor Loading	Mean Response
Harm Relationship		
1. Would decrease your partner's sexual pleasure	.88	2.2
2. Would decrease your sexual pleasure	.84	2.6
3. Would make sex less intimate	.84	2.3
4. Would make your partner angry	.77	2.4
5. Would be a lot of trouble	.71	2.9
Disease Protection		
1. Would make you feel safer from AIDS and other diseases	.90	1.6
2. Would make your partner feel safer from AIDS and other diseases	.84	1.9
3. Would make you feel like a responsible person	.80	1.8

1 = Agree Very Much, 5 = Disagree Very Much

TABLE 3. Belief Components: Getting Paying Partners to Always Use Condoms for Vaginal Sex

Factor and Items	Factor Loading	Mean Response
Harm Relationship		
1. Would decrease your partner's sexual pleasure	.82	3.1
2. Would make sex less intimate	.81	3.4
3. Would decrease your sexual pleasure	.77	3.6
4. Would make your partner angry	.65	3.2
Disease Protection		
1. Would make you feel like a responsible person	.78	1.3
2. Would make you feel safer from AIDS and other diseases	.75	1.2

1 = Agree Very Much, 5 = Disagree Very Much

less likely to have a high school degree or equivalent. Although the large majority of women in both groups were unemployed, women in Long Beach were more likely to have a full- or part-time job. In addition, the East Harlem sample included greater proportions of younger women and Latina women, while the Long Beach sample included greater proportions of women who had exchanged sex for money and/or drugs and women who had injected drugs. No difference was found in prevalence of home-lessness.

Beliefs

Condom Use Would Harm Relationship. Results for the logistic regression analyses predicting the belief that using a condom for vaginal sex with main and paying partners would negatively impact the relationship are shown in Table 4. For main partners, site, ethnicity, and prior HIV result were significant predictors. Women recruited in East Harlem were more likely than those recruited in Long Beach, White women were more likely than African American women, and both women who had tested HIV negative and those who had never been tested or who had never received their test result were more likely than those who had tested HIV positive, to believe that using a condom would negatively impact their

TABLE 4. Logistic Regression Analysis for Beliefs Regarding Condom Use with Main and Paying Partners for Vaginal Sex (Harm Relationship)

	Main Partner (n = 270)			Paying Partners (n = 108)		
Variable	% Agree*	Adjusted Odds Ratio	95% C. I.	% Agree	Adjusted Odds Ratio	95% C. I.
Site						
Long Beach	40.1	reference		47.9	reference	
East Harlem	66.1	4.34 (p = .000)	2.39-7.85	47.2	1.09 (p = .856)	0.44-2.68
Ethnicity						
African Amer.	42.8	reference		43.9	reference	
White	58.5	3.24 (p = .001)	1.61-6.49	52.0	1.79 (p = .273)	0.63-5.10
Latina	58.8	1.75 (p = .089)	0.92-3.35	51.9	1.63 (p = .320)	0.62-4.29
Current Crack Use						
Yes	51.1	reference		47.5	reference	
No	48.0	1.43 (p = .309)	0.72-2.87	50.0	1.01 (p = .987)	0.22-4.73
Prior HIV Result						
Positive	37.5	reference		40.0	reference	
Negative	49.1	3.33 (p = .038)	1.07-10.40	43.8	1.12 (p = .907)	0.16-8.09
Never Tested/DK	55.7	4.88 (p = .009)	1.49-15.94	60.0	2.51 (p = .375)	0.33-19.23
Sex-Trader Status						
Nontrader	51.4	reference				
Trader	46.4	0.93 (p = .823)	0.49-1.77			

*Percentages represent univariate frequencies based on the median split.

relationship with their main sex partner. For paying partners, none of the variables were significant predictors of the belief that using condoms would harm their relationships with paying partners.

Condom Use Would Provide Disease Protection. Results from the regression analyses predicting the belief that using a condom for vaginal sex with main and paying partners would provide disease protection are included in Table 5. Again, for main partners, site and ethnicity were significant predictors. Women recruited in East Harlem were more likely than women recruited in Long Beach, and African American women were more likely than White women, to believe that using a condom for vaginal sex with their main partner would provide protection from AIDS and other sexually transmitted diseases. For paying partners, site was also significant; women in Long Beach were more likely than those in East Harlem to believe that using condoms for vaginal sex with paying partners would provide disease protection.

While sex exchange status was not a statistically significant predictor of this belief, women who exchanged sex for money and/or drugs were somewhat more likely than non-exchangers to believe that using condoms with main partners would provide disease protection. The adjusted odds ratio for sex exchange status was 1.77 ($p = .088$).

Self-Efficacy

For predicting higher self-efficacy for condom use, regression results are shown in Table 6. For main partners, race/ethnicity was the only variable that successfully predicted self-efficacy; African American women were more likely than White women to have high self-efficacy for using condoms with their main partners. None of the variables significantly predicted self-efficacy for using condoms with paying partners.

Intention

Results of the regression analyses predicting greater intention to use condoms for vaginal sex with main and paying partners are shown in Table 7. For main partners, race/ethnicity and prior HIV result were the only significant predictors. African American women were more likely than both White and Latina women to report their intention to use a condom the next time they have vaginal sex with their main partner. Likewise, women who had tested HIV positive were more likely than both women who had tested negative and those who had never been tested or did not receive their results to report their intention to use a condom the next time they have

TABLE 5. Logistic Regression Analysis for Beliefs Regarding Condom Use with Main and Paying Partners for Vaginal Sex (Provide Disease Protection)

Variable	Main Partner (n = 270)			Paying Partners (n = 108)		
	% Agree*	Adjusted Odds Ratio	95% C. I.	% Agree	Adjusted Odds Ratio	95% C. I.
Site						
Long Beach	34.6	reference		86.3	reference	
East Harlem	70.6	4.03 (p = .000)	2.25-7.21	66.7	0.32 (p = .044)	0.10-0.97
Ethnicity						
African Amer.	55.8	reference		73.7	reference	
White	29.2	0.47 (p = .033)	0.23-0.94	88.0	2.32 (p = .290)	0.49-11.04
Latina	54.4	0.74 (p = .364)	0.39-1.42	85.2	2.65 (p = .149)	0.71-9.92
Current Crack Use						
Yes	52.0	reference		80.2	reference	
No	36.0	1.24 (p = .567)	0.60-2.55	75.0	3.82 (p = .172)	0.56-26.26
Prior HIV Result						
Positive	81.3	reference		40.0	reference	
Negative	49.1	0.51 (p = .338)	0.13-2.01	83.6	4.04 (p = .186)	0.51-31.89
Never Tested/DK	43.2	0.36 (p = .147)	0.09-1.44	76.7	3.12 (p = .298)	0.37-26.49
Sex Exchange Status						
No Exchange	47.7	reference				
Exchange	55.4	1.77 (p = .088)	0.92-3.40			

*Percentages represent univariate frequencies based on the median split.

149

TABLE 6. Logistic Regression Analysis of Self-Efficacy for Condom Use with Main and Paying Partners (Vaginal Sex)

Variable	Main Partner (n = 267)			Paying Partners (n = 108)		
	% Higher Self-Efficacy*	Adjusted Odds Ratio	95% C. I.	% Higher Self-Efficacy	Adjusted Odds Ratio	95% C. I.
Site						
Long Beach	55.0	reference		50.7	reference	
East Harlem	59.3	0.96 (p = .898)	0.55-1.68	63.9	1.51 (p = .370)	0.61-3.73
Race/Ethnicity						
African Amer.	63.8	reference		49.1	reference	
White	42.9	0.38 (p = .004)	0.20-0.74	60.0	1.97 (p = .207)	0.69-5.64
Latina	55.2	0.63 (p = .144)	0.34-1.17	63.0	1.62 (p = .332)	0.61-4.28
Current Crack Use						
Yes	55.7	reference		55.4	reference	
No	61.2	0.57 (p = .110)	0.28-1.14	50.0	1.34 (p = .710)	0.29-6.21
Prior HIV Result						
Positive	75.0	reference		80.0	reference	
Negative	54.9	0.42 (p = .170)	0.12-1.44	53.4	0.34 (p = .373)	0.03-3.59
Never Tested/DK	56.8	0.42 (p = .174)	0.12-1.47	53.3	0.39 (p = .438)	0.04-4.24
Sex Exchange Status						
No Exchange	57.3	reference				
Exchange	55.4	1.02 (p = .961)	0.55-1.89			

*Percentages represent univariate frequencies based on the median split.

TABLE 7. Logistic Regression Analysis of Intention to Use Condoms with Main and Paying Partners (Vaginal Sex)

Variable	Main Partner (n = 270)			Paying Partners (n = 107)		
	% With Intention*	Adjusted Odds Ratio	95% C. I.	% With Intention	Adjusted Odds Ratio	95% C. I.
Site						
Long Beach	38.9	reference		80.6	reference	
East Harlem	35.8	0.63 (*p* = .124)	0.35-1.13	58.3	0.26 (*p* = .008)	0.10-0.70
Race/Ethnicity						
African Amer.	47.1	reference		66.1	reference	
White	27.7	0.41 (*p* = .013)	0.21-0.83	84.0	2.56 (*p* = .171)	0.67-9.90
Latina	27.9	0.43 (*p* = .014)	0.22-0.84	77.8	2.14 (*p* = .192)	0.68-6.72
Current Crack Use						
Yes	39.4	reference		73.0	reference	
No	30.0	1.06 (*p* = .873)	0.51-2.18	75.0	2.17 (*p* = .406)	0.35-13.55
Prior HIV Result						
Positive	75.0	reference		80.0	reference	
Negative	35.9	0.14 (*p* = .002)	0.04-0.50	73.6	0.26 (*p* = .261)	0.02-2.74
Never Tested/DK	34.1	0.12 (*p* = .001)	0.03-0.44	70.0	0.28 (*p* = .301)	0.02-3.14
Sex Exchange Status						
No Exchange	36.4	reference				
Exchange	42.9	1.28 (*p* = .446)	0.68-2.41			

*Percentages represent univariate frequencies based on the median split.

151

vaginal sex with their main partner. For paying partners, recruitment site significantly predicted intention; women in Long Beach were more likely than those in East Harlem to have greater intention to use a condom the next time they have vaginal sex with a paying partner.

Behavior

For predicting frequency of condom use during the past 30 days, results of regression analyses are shown in Table 8. In the analysis predicting condom use with main partners, site, race/ethnicity, and prior HIV result were significant predictors. The odds for women recruited in East Harlem were twice as great as for those recruited in Long Beach, and the odds for African American women were twice as great as for Latina women to have used condoms for vaginal sex with their main partners during the past 30 days. Women who tested HIV positive were more likely to use condoms than both those who had tested negative and those who had never been tested or who never received their test results. None of the variables predicted condom use with paying partners.

Confounding of Site/Latina Sub-Group

The definition of "Latina" was confounded by recruitment site; all of the Puerto Rican women were recruited in East Harlem, and all of the Mexican women were recruited in Long Beach. (A small number of women from other countries of origin were also recruited at each site.) To determine the influence of this confound on the analyses conducted, chi-square tests were performed on all dependent variables for Mexican women versus Puerto Rican women. While there were no differences on self-efficacy, intentions and condom use, three beliefs were found to differ significantly by Latina ethnic identification. Puerto Rican women were more likely to believe that using condoms for vaginal sex with their main partner would harm their relationship ($p = .012$) and also would provide protection from diseases ($p = .002$); Mexican women were more likely to believe that using condoms with paying partners would provide disease protection ($p = .03$). Two sets of multiple logistic regression analyses were then performed by using each of the three beliefs as dependent variables. In the first set, the independent variables included those listed in Table 4, with Latina representing *only* Mexican women. In the second set, the independent variables included those listed in Table 4, with Latina representing *only* Puerto Rican women. No differences were found between the outcomes of these separate analyses and the original analyses in which all Latina ethnic subpopulations were grouped together.

TABLE 8. Logistic Regression Analysis of Frequency of Condom Use with Main and Paying Partners During Past 30 Days (Vaginal Sex)

Variable	Main Partner (n = 271)			Paying Partners (n = 108)		
	% Used Condom*	Adjusted Odds Ratio	95% C. I.	% Used Condom	Adjusted Odds Ratio	95% C. I.
Site						
Long Beach	14.1	reference		61.6	reference	
East Harlem	30.3	2.24 (p = .020)	1.14-4.42	61.1	0.99 (p = .982)	0.40-2.46
Race/Ethnicity						
African Amer.	26.6	reference		54.4	reference	
White	12.3	0.52 (p = .150)	0.21-1.27	72.0	2.36 (p = .128)	0.78-7.17
Latina	16.2	0.42 (p = .035)	0.19-0.94	66.7	1.63 (p = .327)	0.61-4.34
Current Crack Use						
Yes	21.7	reference		61.4	reference	
No	15.7	0.93 (p = .873)	0.38-2.26	62.5	1.34 (p = .720)	0.27-6.60
Prior HIV Result						
Positive	56.3	reference		60.0	reference	
Negative	18.5	0.26 (p = .020)	0.08-0.81	61.6	0.91 (p = .929)	0.13-6.59
Never Tested/DK	18.2	0.23 (p = .018)	0.07-0.77	60.0	1.03 (p = .978)	0.13-7.87
Sex Exchange Status						
No Exchange	20.5	reference				
Exchange	21.4	1.24 (p = .590)	0.57-2.68			

*Percentages represent univariate frequencies based on the median split.

DISCUSSION

Demographic Differences by Site

Comparison of demographic variables shows that the two samples are quite different. Women in East Harlem reported lower levels of education and employment, although both samples represent women who are economically disadvantaged. The rates of unemployment and homelessness for both groups were extremely high. The fact that there was a sizeable difference between the percentage of women who considered themselves homeless and those who reported actually living on the streets suggests that living arrangements for many of these women may be extremely unstable. While the majority of women recruited from both sites had used crack cocaine during the past 30 days, the pattern of injection drug use differed by site, with more injectors recruited from Long Beach. The ethnic composition at the two sites was also markedly different.

Recruitment Site as a Predictor

Recruitment site was a significant predictor for several of the variables examined, for both main and paying partners. Women recruited in East Harlem were more likely than those recruited in Long Beach to believe that using condoms for vaginal sex with main partners would harm their relationship. It may be that in East Harlem, where HIV seroprevalence among drug users is greater, having a monogamous relationship is viewed as an important method of risk reduction. Women may fear that by initiating condom use, they may be notifying their partner that they themselves are not safe sex partners, and may consequently jeopardize their relationship. Recruitment site also predicted the belief that using condoms for vaginal sex with main partners would provide disease protection, with women in East Harlem being more likely than those in Long Beach to hold this belief. Women recruited in East Harlem also reported greater condom use with their main partner during the prior 30 days than did those recruited in Long Beach. These findings are probably related to the fact that the rates of HIV infection among drug-using women in East Harlem are greater than among those in Long Beach. However, with regard to paying partners, women who exchanged sex for money and/or drugs in Long Beach were more likely to believe that using condoms would provide disease protection, and also reported greater intentions to use condoms for vaginal sex with their paying sex partners. Previous prevention efforts in Long Beach (e.g., Corby et al., 1993) had specifically targeted women

who exchange sex, and this may account for the differences in beliefs and intentions. More research is needed to determine why the differences in condom beliefs and intentions were observed, especially since there were no significant differences between women from the two sites in reported use of condoms with paying partners.

Race/Ethnicity

Race/ethnicity was a significant predictor for all four of the variables examined, but only for main sex partners, with African American women expressing more positive cognitions and greater frequency of condom use. African American women were less likely than White women to believe that using condoms for vaginal sex with main partners would harm their relationship, were more likely than White women to believe that using condoms with their main partner would provide disease protection, and reported greater levels of self-efficacy for using condoms with such men. They also reported greater intention to use condoms for vaginal sex with main partners than did both White and Latina women, and reported greater condom use during the prior 30 days than did Latina women. Ethnicity was an important predictor for cognitions and condom use with main, but not paying partners, and this suggests that racial/ethnic differences may be associated with partner type.

Current Crack Use

Current crack use was not a statistically significant predictor for any of the condom use cognition or behavior variables. This finding suggests that the use of crack is not one of the primary mediators of condom use among this population of crack and/or injection-drug using women.

Prior HIV Test Result

Prior HIV test result was a significant predictor of three of the four variables examined, but only for main partners. Women who had received a positive HIV test result were less likely to believe that using condoms with main sex partners would harm their relationship than were women who had received negative results, and those who had never been tested or who had never received their results. Women who had tested positive also had greater intentions to use condoms for vaginal sex than were women who had tested negative and those who were unaware of their serostatus. Likewise, positive women were more likely to report using condoms for

vaginal sex with their main partner than were negative women, and those who were sero-unaware. These findings suggest that although women who have tested HIV-positive may be more likely than other women to use condoms with their main sex partners, this may not be true for sex with paying partners.

The Exchange of Sex for Money or Drugs

Current sex exchange status did not predict beliefs about condom use, self-efficacy for condom use, or intention to use condoms for vaginal sex with main partners, nor did it predict actual condom use with such men. Women who had exchanged sex for money and/or drugs during the past 30 days were somewhat more likely to believe that using condoms for vaginal sex with main partners may provide protection from diseases. However, these differences were not statistically significant ($p = .088$). This suggests that the use of condoms for vaginal sex with main partners and cognitions associated with such behaviors may not be related to sex exchange status.

CONCLUSIONS

These findings support previous research and suggest that the factors which successfully predict condom beliefs, self-efficacy, intention, and behaviors are different for main versus paying partners. Results also suggest that among drug-using women, attitudes about condoms, intentions to use them, and actual usage may differ significantly from one community to another. One probable explanation for such differences appears to be local community seroprevalence. The availability of HIV-related and other social services in the local community may also be a factor. Interventions designed to increase condom use must recognize that cognitive factors associated with condom use may vary by partner type, ethnicity, and recruitment site, particularly when important contextual variables, such as local seroprevalence, vary. Furthermore, the beliefs of African American women regarding the use of condoms, including self-efficacy, are clearly different from those of White and Latina women. It may be that their reasons for using condoms are different, and in some cases may be dependent on their partners' reactions to this behavior.

One important limitation of this study is the fact that in East Harlem, "Latina" translated to "Puerto Rican," while in Long Beach, "Latina" generally meant "Mexican American." Previous research suggests that there are some differences among Latina sub-groups with regard to behav-

iors and beliefs concerning HIV (Deren et al., in press). Although Puerto Rican women are at elevated risk of HIV infection, Latina women in California (Mexican Americans) appear to engage in fewer risk behaviors than White women (Kegeles, Catania, Coates, Pollack, & Lo, 1990; Rapkin & Erikson, 1990). Additional research is needed to further understand these and other ethnic-based differences in perception of sexual HIV risk, and associated behaviors and beliefs regarding condom use. Such differences should be examined specifically with subpopulations of Latina women, and future research should examine these ethnic sub-groups separately.

Another limitation is the fact that the number of women who had engaged in vaginal sex with paying partners during the past 30 days was relatively small. A larger sample size for this group could result in additional predictor variables of condom behaviors and cognitions showing statistical significance with regard to paying sex partners.

One other important issue that was not addressed by the present study is the fact that the decision to use condoms is not directly controllable by women. This behavior occurs within the context of a particular sexual relationship, and an individual woman's intention to use condoms is always dependent on the willingness of the man to do so. In relationships where men are unwilling to use condoms, a woman's intention to use condoms may be of limited utility in predicting condom use. While this study has explored some of the cognitive variables associated with women's reports of condom use within main and paying partnerships, these issues must also be studied with samples of men, as well as within dyadic relationships.

REFERENCES

Booth, R. E., Watters, J. K., & Chitwood, D. D. (1993). HIV risk-related sex behaviors among injection drug users, crack smokers, and injection drug users who smoke crack. *American Journal of Public Health, 83,* 1144-1148.

Centers for Disease Control and Prevention (1995). U. S. HIV and AIDS cases reported through December 1995. *HIV/AIDS surveillance report, 7(2),* 12.

Corby, N. H., Jamner, M. S., & Wolitski, R. J. (1996). Using the theory of planned behavior to predict intention to use condoms among male and female injecting drug users. *Journal of Applied Social Psychology, 26,* 52-75.

Corby, N., & Wolitski, R. (in press). Condom use among main and other partners among high-risk women: Intervention outcomes and correlates of reduced risk. *Drugs & Society.*

Corby, N., & Wolitski, R. (1992, July). Relationship between street sex workers' attitudes and condom use by type of partner. Presented at the 7th International Conference on AIDS, Amsterdam, The Netherlands.

Corby, N., Wolitski, R., Rhodes, F., O'Reilly, K., & CDC Demonstration Projects (1993, June). Evaluation of a theory-based intervention to increase condom use among commercial sex workers. Presented at the 9th International Conference on AIDS, Berlin, Germany.

Corby, N., Wolitski, R., Thornton-Johnson, S., & Tanner, W. (1991). AIDS knowledge, perception of risk, and behaviors among female sex partners of injection drug users. *AIDS Education and Prevention, 3,* 353-366.

Deren S., Shedlin, M., Beardsley, M., Moore, J., Davis, W. R., & Sanchez, J. (in press). HIV-Related concerns and behaviors among Hispanic women. *AIDS Education and Prevention.*

Dorfman, L. E., Derish, P. A., & Cohen, J. B. (1992). Hey girlfriend: An evaluation of AIDS prevention among women in the sex industry. *Health Education Quarterly, 19,* 35-40.

Edlin, B. R., Irwin, K. L., Faruque, S., McCoy, C. B., Word, C., Serrano, Y., Inciardi, J. A., Bowser, B. P., Schilling, R. F., Holmberg, S. D., & Multicenter Crack Cocaine HIV Infection Study Team (1994). Intersecting epidemics—crack cocaine use and HIV infection among inner-city adults. *The New England Journal of Medicine, 331,* 1422-1427.

Farmer, P., Lindenbaum, S., & Good, M. D. (Eds.). (1993). Women, poverty, and AIDS [Special issue]. *Culture, Medicine, and Psychology, 16.*

Friedman, S. R., Jose, B., Neaigus, A., Goldstein, M., Curtis, R., Ildefonso, G., Mota, P., & Des Jarlais, D. C. (1994). Consistent condom use in relationships between seropositive injecting drug users and sex partners who do not inject drugs. *AIDS, 8,* 357-361.

Gomez, C., & Marin, B. (1993, June). Can women demand condom use? Gender and power in safer sex. Presented at the meeting of the 9th International Conference on AIDS, Berlin.

Inciardi, J. A. (1993). Kingrats, chicken heads, slow necks, freaks, and blood suckers: A glimpse at the Miami sex-for-crack market. In M. S. Ratner (Ed.), *Crack pipe as pimp: An ethnographic investigation of sex-for-crack exchanges* (pp. 37-68). New York: Lexington Books.

Institute of Medicine (1994). *AIDS and behavior: An integrated approach* (J. D. Auerback, C. Wypijewska, H. Keith, & H. Brodie, Eds.). Washington, DC: National Academy Press.

Jemmott, L. S., & Jemmott, J. B., III. (1991). Applying the theory of reasoned action to AIDS risk behavior: Condom use among black women. *Nursing Research, 40,* 228-234.

Johnson, E. H., Jackson, L. A., Hinkle, Y., Gilbert, D., Hoopwood, T., Lollis, C. M., Willis, C., & Gant, L. (1994). What is the significance of black-white differences in risky sexual behavior? *Journal of the National Medical Association, 86,* 745-759.

Kegeles, S. M., Catania, J. A., Coates, T. J., Pollack, L. M., & Lo, B. (1990). Many people who seek anonymous HIV-antibody testing would avoid it under other circumstances. *AIDS, 4(6),* 585-8.

Lindsay, M. K., Peterson, H. B., Boring, J., Gramling, J., Willis, S., & Klein, L. (1992). Crack cocaine: A risk factor for human immunodeficiency virus infection type 1 among inner-city parturients. *Obstetrics & Gynecology, 80,* 981-984.

Longshore, D., Anglin, M. D., Annon, K., & Hsieh, S. (1993). Trends in self-reported HIV risk behavior: Injection drug users in Los Angeles. *Journal of Acquired Immune Deficiency Syndromes, 6,* 82-90.

McCoy, H. V., & Inciardi, J. A. (1993). Women and AIDS: Social determinants of sex-related activities. *Women & Health, 20,* 69-86.

National Institute on Drug Abuse (1994). Outreach/risk reduction strategies for changing HIV-related behaviors among injection drug users: The National AIDS Demonstration Research (NADR) Project [NIH Pub. No. 94-3726]. Rockville, MD: National Institute on Drug Abuse.

Norris, A. E., & Ford, K. (1994). Association between condom experiences and beliefs, intentions, and use in a sample of urban, low-income, African-American and Latina youth. *AIDS Education and Prevention, 6,* 27-39.

Rapkin, A. J., & Erickson, P. I. (1990). Differences in knowledge of and risk factors for AIDS between Latina and non-Latina women attending an urban family planning clinic. *AIDS, 4,* 889-899.

Ratner, M. S. (1993). Sex, drugs, and public policy: Studying and understanding the sex-for-crack phenomenon. In M. S. Ratner (Ed.), *Crack pipe as pimp: An ethnographic investigation of sex-for-crack exchanges* (pp. 1-36). New York: Lexington Books.

Rhodes, F., Corby, N., Wolitski, R., Tashima, N., Crain, C., Yankovich, D., & Smith, P. (1990). Risk behaviors and perceptions of AIDS among street injection drug users. *Journal of Drug Education, 20,* 271-288.

Rhodes, F., & Malotte, C. K. (in press). Using stages of change to assess intervention readiness and outcome in modifying drug-related and sexual HIV risk behaviors of IDUs and crack users. *Drugs & Society.*

Rhodes, F., & Malotte, C. K. (1996). HIV risk interventions for active drug users: Experience and prospects. In S. Oskamp & S. Thompson (Eds.), *Understanding and preventing HIV risk behavior: Safer sex and drug use* (pp. 271-236). Thousand Oaks, CA: Sage Publications.

Schilling, R. F., El-Bassel, N., Gilbert, L., & Schinke, S. P. (1991). Correlates of drug use, sexual behavior, and attitudes toward safer sex among African-American and Latina women in methadone maintenance. *The Journal of Drug Issues, 21,* 685-698.

Seidlin, M., Vogler, M., Lee, E., Lee, Y. S., & Dubin, N. (1993). Heterosexual transmission of HIV in a cohort of couples in New York City. *AIDS, 7,* 1247-1254.

Sibthorpe, B., Fleming, D., Tesselaar, H., & Gould, J. (1991). Needle use and sexual practices: Differences in perception of personal risk of HIV among intravenous drug users. *The Journal of Drug Issues, 21,* 699-712.

SPSS, SPSS Base System Syntax Reference Guide, Release 5.0 (1992) [Computer program and manual]. Chicago, IL: Statistical Package for the Social Sciences, Inc.

Stephens, R. C., Simpson, D. D., Coyle, S. L., McCoy, C. B., & NARC (1993). Comparative effectiveness of NADR interventions. In B. S. Brown & G. M. Beschner (Eds.), *Handbook on risk of AIDS: Injection drug users and sexual partners* (pp. 519-556). Westport, CT: Greenwood Press.

Wallace, J. I., Steinberg, A., & Weiner, A. (1992, November). Patterns of condom use, crack use, and fellation as risk behaviors for HIV infection among prostitutes. Presented at the annual meeting of the American Public Health Association, Washington, D.C.

Watkins, K. E., Metzger, D., Woody, G., & McLellan, A. T. (1993). Determinants of condom use among intravenous drug users. *AIDS, 7,* 719-723.

Weatherby, N. L., Schultz, J. M., Chitwood, D. D., McCoy, H. V., McCoy, C. B., Ludwig, D. D., & Edlin, B. R. (1992). Crack cocaine use and sexual activity in Miami, Florida. *Journal of Psychoactive Drugs, 24,* 373-380.

Weiss, S., Weston, C., & Quirinale, J. (1993). Safe sex? Misconceptions, gender differences and barriers among injection drug users: A focus group approach. *AIDS Education and Prevention, 5,* 279-293.

Wyatt, G. E. (1994). The sociocultural relevance of sex research: Challenges for the 1900s and beyond. *American Psychologist, 49,* 748-754.

Violence and HIV Sexual Risk Behaviors Among Female Sex Partners of Male Drug Users

Haiou He, MS
H. Virginia McCoy, PhD
Sally J. Stevens, PhD
Michael J. Stark, PhD

SUMMARY. *Objective:* Violence and HIV are emerging as interconnected public health hazards among drug users and their families. The purposes of this study are to (1) determine the prevalence of sexual and physical abuse of non-drug-using female sex partners of male drug users, and (2) ascertain the association between such violence and HIV-related risk behaviors. *Methods:* From 11/93 to 11/95, 208 female sex partners of injection drug or crack users in Collier County, FL, Tucson, AZ, and Portland, OR, were interviewed as part of a NIDA-funded HIV risk reduction project. Their mean age was 30 years (range 18-54); 21% were White, 6% African American, 7% Na-

Haiou He is Senior Research Analyst, Oregon Health Division, 800 NE Oregon Street, #370, Portland, OR 97232. Virginia McCoy is Professor, Florida International University, 3000 NE 145th Street, 8C1-394, North Miami, FL 33181. Sally Stevens is Associate Professor, University of Arizona, 102 Douglass Building, Tucson, AZ 85721. Michael Stark is Director of Program Design and Evaluation Services of Oregon Health Division and Multnomah County Health Department, 800 NE Oregon Street, #370, Portland, OR 97232.

This research is supported by Research Grant 1-U01-DA-07302-02 from the National Institute on Drug Abuse.

[Haworth co-indexing entry note]: "Violence and HIV Sexual Risk Behaviors Among Female Sex Partners of Male Drug Users." He, Haiou et al. Co-published simultaneously in *Women & Health* (The Haworth Medical Press, an imprint of The Haworth Press, Inc.) Vol. 27, No. 1/2, 1998, pp. 161-175; and: *Women, Drug Use, and HIV Infection* (ed: Sally J. Stevens, Stephanie Tortu, and Susan L. Coyle) The Haworth Medical Press, an imprint of The Haworth Press, Inc., 1998, pp. 161-175. Single or multiple copies of this article are available for a fee from The Haworth Document Delivery Service [1-800-342-9678, 9:00 a.m. - 5:00 p.m. (EST). E-mail address: getinfo@haworthpressinc.com].

161

tive American, and 63% Hispanic. *Results:* Of the 208 women, 28% reported being sexually molested and 20% raped before age 13; 41% reported being raped at least once in their lifetime. Forty-two percent of the women were physically assaulted by their sex partners; 36% had been threatened with assault by their sex partners. Those who were raped or threatened with assault were more likely to have multiple sex partners and engage in unprotected anal sex; there was a trend for women who had been physically assaulted to be more likely to engage in unprotected anal sex. *Discussion:* Rape, assault and the threat of assault are commonplace in the histories of female sex partners of male drug users. Experiences of violence and threats of violence are associated with heightened risk for the sexual transmission of HIV. Providers of HIV prevention need to understand the sequelae of violence, and design interventions which empower women to protect themselves from sexual transmission of HIV. *[Article copies available for a fee from The Haworth Document Delivery Service: 1-800-342-9678. E-mail address: getinfo@haworthpressinc.com]*

Women today face an array of adverse conditions and situations that may seriously compromise their health status and well-being. Childhood sexual and physical abuse, domestic abuse and violence, alcohol and drug abuse, unintended pregnancy, and sexually transmitted diseases, including HIV, are among the pressing issues that confront women in modern society.

Some of these mentioned conditions have reached epidemic proportions in the United States. The incidence of HIV transmission and AIDS cases among women is one such epidemic. The Centers for Disease Control (CDC, 1994) reports that women constitute the fastest growing group of individuals contracting AIDS and women now represent 18.1 percent of all reported cases. This figure has steadily increased from 7 percent of total cases in 1985 to 16.2 percent of total cases in 1993 to the current number (CDC, 1994). In 1994, women of color accounted for more than three fourths of all U.S. AIDS cases among women with 57% of infections occurring among African Americans (CDC, 1995).

Transmission of HIV through heterosexual contact is on the rise (CDC, 1995), with particular risks from injection drug using men and men who reported engaging in sex with other men. Unprotected sex provides a route of transmission from drug users to their sexual partners. In the U.S. AIDS cases among women, 53% of the heterosexually transmitted cases were attributed to sex with an IDU (CDC, 1994).

An epidemic of domestic violence also plagues women, with African American more, and Hispanic women less, likely than Whites to report physical violence in their relationship (Sorenson, Upchurch, & Shen, 1996). From 1987-1991 there were over half a million cases of domestic

violence reported by women on average each year (Bureau of Justice Statistics, 1994). The estimated number of battered women in the U.S. is even higher, ranging as high as 1.6 to 12 million a year (American Medical Association, 1991; Helton, McFarlane, & Anderson, 1987). The discrepancy between these two figures is most likely due to the fact that domestic violence is difficult to measure because it most often occurs in a private setting and women may be reluctant to report a crime because of shame, fear, or repercussions by the offender (Bureau of Justice Statistics, 1994). For women who live with violent or alcoholic partners rape is even more prevalent. Although about one out of every seven married women reports being raped by her husband (Heise, 1993), at least 40% of battered women report being raped (Campbell & Alford, 1989). The percentage of batterers who assault their partners while intoxicated has been reported to be as high as 70 to 90 percent (Roberts, 1988).

In addition to domestic violence, women experience a high rate of violence early in life. National estimates are that one in four girls are sexually assaulted before the age of eighteen (Zierler et al., 1991). A study of 535 adolescent mothers found that 55 percent had been sexually molested, 42 percent had been victims of attempted rape, and 44 percent had been raped (Boyer & Fine, 1992). Research has suggested that sexual and physical victimization in childhood may play a role in some of the most intractable problems of our time including teenage pregnancy, STDs, substance abuse, violence, prostitution and HIV (Heise, 1993; Klein & Chao, 1995; Paone & Chavkin, 1993).

The epidemics of HIV, domestic violence, and early physical and sexual abuse are interrelated, especially for women. The National Association of People with AIDS reports a strong link between violence and AIDS. In a recent survey conducted by the association, patients with AIDS ranked the threat of violence as a major concern. Seventeen percent of all women in the survey and 25 percent of Hispanic women reported violence in the home (National Association of People with AIDS, 1992).

A woman may find men reacting with hostility and violence if she indicates a concern regarding AIDS, which also may be perceived as a lack of trust by the male partner (Shayne & Kaplan, 1991). Moreover, many women may engage in sexual risk-taking behavior because of perceived threats to their social as well as economic survival, and lack of power in sexual decision making (Heise, 1993; North & Rothenberg, 1993; Weissman, 1991; Worth, 1989). A woman may be at serious risk of harm from her partner(s) when she informs her partner(s) of her HIV positive status; indeed there have been reported cases of women being

shot, injured and abandoned as a result of partner notification (North & Rothenberg, 1993).

Efforts by intervention programs to promote condom use have encountered increased violence for the most vulnerable women who may already be victims of sexual or physical abuse (Weissman, 1991; Worth, 1989). In some cultures women who suggest using condoms for contraception are degraded, considered to be promiscuous, and beaten as a consequence (Armstrong, 1988). Women do not control condom use in most situations and may face serious repercussions if insisting on condom use.

Histories of sexual and physical abuse are linked to HIV risk behavior. Several studies have associated sexual abuse with a high risk of entering prostitution as well as high frequency of alcohol and drug abuse. It has been found that men and women who had been raped or had been forced to have sex in their childhood or adolescence were four times more likely than non-abused individuals to have entered prostitution (Zieler et al., 1991); they were also twice as likely to have multiple sex partners in any single year and to engage in casual sex with partners they did not know. Another study found that a history of physical abuse, sexual abuse, or rape among adolescents was related to a variety of HIV risk behaviors including engaging in unprotected anal sex, prostitution, non-utilization of contraception, and having multiple sex partners, which continued into young adulthood (Cunningham, Stiffman, Dore, & Earls, 1994; Briere, 1992).

Women who were abused as children are also more likely to use drugs and alcohol, which in turn is associated with failure to protect against HIV infection. Women survivors of childhood sexual abuse were twice as likely to consume heavy amounts of alcohol and nearly three times more likely to become pregnant before the age of eighteen (Zierler et al., 1991). Clinical studies have reported higher rates of incest and sexual abuse among women found in alcohol treatment programs (Rohsenow, Corbet, & Devine, 1988) and women in a New York City methadone treatment center also reported high prevalence of childhood sexual abuse (Worth, 1991). Finally, it has been evidenced that women who use alcohol or drugs are more likely to engage in high-risk sexual activities (Harlow et al., 1993).

The purpose of this research is thus to investigate further the relationship between sexual and/or physical abuse and HIV-related high-risk behaviors among female sexual partners of male drug users. It is hypothesized that among these women, those with a history of physical or sexual abuse will be less likely to protect themselves against HIV infection. It is further hypothesized that women who have been physically assaulted or threatened with assault from their sex partners would also be less likely to engage in protective behaviors.

METHODS

Subjects

Subjects were recruited to participate in a NIDA-sponsored multi-site study of HIV risk behaviors and risk reduction among sex partners of drug users. The subjects for this analysis were 208 non-drug-using female sex partners of male drug users recruited between November, 1993 and November, 1995 in Tucson, Arizona, Collier County, Florida, and Portland, Oregon. Participants were recruited using sampling plans developed by the investigators of the respective study sites, which resulted in some cross-site differences in recruitment and data collection strategies. About one-third of the participants from Tucson and Portland were referred to the study by their male sex partners, who were also enrolled in another NIDA-funded HIV prevention project targeted to out-of-treatment injection drug or crack users. Participants in Collier County were recruited through outreach efforts from networks of men and women who live in migrant camps.

The eligibility criteria for this study include self reports of (1) being 18 years of age or older, (2) having not used injection drugs or crack cocaine in the past 30 days, and (3) having sex with a man who had used injection drugs or crack cocaine in the past 30 days. Informed, written consent was obtained from study participants prior to any data collection.

The subjects were 21% White, 6% African American, 7% Native American, 63% Hispanic, and 4% other. The high percentage of Hispanic in this study sample was due to the recruitment strategy in Collier County, where subjects were almost all Hispanic. The mean age of the subjects was 30 years (range 18-54); 62% had not completed high school education; and 58% lived on welfare. Table 1 summarizes the demographic characteristics of the subjects by study site.

Data Collection

A survey instrument (Women's Supplement) was administered to all participants at the baseline intake prior to counseling and testing.[1] The instrument was designed to collect data on demographics, socioeconomic status, decision making in sexual relationships (empowerment), previous history of physical and sexual abuse, recent sexual activity, medical history, utilization of health services, and HIV test history and results. Self-reported data were collected in private, face-to-face interviews by trained interviewers.

[1]RBA was administered in Collier County.

TABLE 1. Demographic Characteristics by Study Sites

Variables	Tucson % (n = 107)	Portland % (n = 30)	Collier County % (n = 71)
Race/Ethnicity*			
White	22	63	---
African American	5	23	---
Native American	13	3	---
Hispanics	54	3	100
Other	6	7	---
Education*			
< High School	54	37	86
≥ High School	46	63	14
Marital Status*			
Single	55	40	38
Married	13	23	39
Other	32	37	23
Major Source of Income			
Paid job	18	10	20
Welfare	57	60	55
Other	25	30	25

* p < .01

Variables regarding empowerment include: decision making in sexual relationships (who makes decisions as to (1) when or whether to have sex; (2) using a condom when having sex; and (3) what type of sex to have); and whether she asked her sex partner to use a condom in the last year.

Variables reflecting physical and sexual abuse include: ever been physically assaulted by a sex partner ["Since you were 13 years old has a sex partner (including johns) ever physically hurt you (beaten up, slashed with a knife or injured in some way)?"]; ever been threatened with assault by a sex partner ["Since you were 13 years old has a sex partner (including johns) ever threatened to physically hurt you?"]; ever been raped or sexually assaulted; and whether raped or sexually molested during childhood (under the age 13).

Variables measuring sexual risk are based on self-reported sexual behaviors in the 30 days prior to the interview, which include: number of sex partners; involvement in different sexual acts; condom use (always, sometimes, never).

Participants were asked to voluntarily provide a blood sample for HIV

testing. All individuals were counseled using NIDA standard HIV pre-test counseling protocol (Coyle, this volume). Counseling included information on HIV risks associated with drug use and sexual activities, issues related to HIV testing and test results, and methods of risk reduction. Blood samples were analyzed for antibodies to HIV using the ELISA assay and confirmed using the Western Blot assay. All subjects, regardless of whether they volunteered a blood sample, were asked to return for a second, posttest counseling session 2 to 3 weeks after intake.

Analysis

Descriptive and chi-square analyses were employed to examine (1) the history of sexual and physical abuse, (2) current HIV-related risk behaviors, (3) the association between such violence and risk behaviors, and (4) variations in the prevalence of sexual and physical abuse and current risk behaviors among different racial/ethnic groups. Due to the small sample size in each racial/ethnic group, it was not appropriate to employ analytic statistics to test the association between abuse history and current risk behaviors within each group.

RESULTS

Of the 208 women, 28% (59) reported being sexually molested and 20% (41) raped before age 13. Forty-five percent (94) reported being raped at least once in their lifetime. Forty-two percent (88/208) of the women reported having ever been physically assaulted by their sex partners, and 36% (74/208) reported having ever been threatened with assault by their sex partners.

Forty-two percent (88/208) reported having asked their main or steady sex partner to use a condom in the last year. Only 10% reported having always used a condom in the 30 days prior to the interview. Eleven percent (22/208) reported having multiple sex partners in the last 30 days. Ten percent engaged in unprotected anal sex. Sixty-three percent (131/208) had ever tested for HIV. Of those who were tested, 3 were HIV positive prior to the intake.

Association Between Violence and Risk Behavior

Chi-square analyses indicate that those who had experienced sexual and physical abuse were more likely to engage in risk behaviors (Table 2).

TABLE 2. Association Between History of Abuse and Current (30 Days) Risk Behaviors

Variables	Multiple Sex Partner				Engaged in Anal Sex				Consistent Condom Use			
	n	Yes	(%)	p	n	Yes	(%)	p	n	Yes	(%)	p
Raped												
Yes	94	15	(16)	.02	93	15	(16)	.02	92	8	(9)	.46
No	114	7	(6)		107	6	(6)		110	13	(12)	
Raped under age 13												
Yes	41	5	(12)	.71	40	7	(18)	.10	40	3	(8)	.50
No	167	17	(10)		160	14	(9)		162	18	(11)	
Molested under age 13												
Yes	59	11	(19)	<.01	58	9	(16)	.18	58	5	(9)	.61
No	141	9	(6)		135	12	(9)		136	15	(11)	
Threatened with assault by a sex partner												
Yes	74	14	(19)	<.01	73	13	(18)	.01	72	8	(11)	.80
No	134	8	(6)		127	8	(6)		130	13	(10)	
Physically hurt by a sex partner												
Yes	88	12	(14)	.22	87	13	(15)	.07	87	10	(12)	.65
No	120	10	(8)		113	8	(7)		115	11	(10)	

Subjects who had been raped were more likely to have multiple sex partners (16% vs. 6% of those not raped; chi-square = 5.2, df = 1, p = .02) and engage in unprotected anal sex (16% vs. 6%; chi-square = 5.9, df = 1, p = .02). Women who had been threatened with assault by their sex partner were also more likely to have multiple sex partners (19% vs. 6%; chi-square = 8.5, df = 1, p < .01) and engage in unprotected anal sex (18% vs. 6%; chi-square = 6.5, df = 1, p = .01). There was also a trend for women who had been physically assaulted to be more likely to engage in unprotected anal sex (15% vs. 7%; chi-square = 3.2, df = 1, p = .07). No association was found between rape history under age 13 and sexual risk behaviors. However, women who were sexually molested under age 13 were more likely to have multiple sex partners (19% vs. 6% of those not molested; chi-square = 6.9, df = 1, p < .01).

Although a higher percentage of those who had been raped reported having asked their main sex partner to use a condom in the last year (52% vs. 39% not raped; chi-square = 3.7, df = 1, p = .05), there was no difference in actual consistent (always) condom use in the last 30 days (9% vs. 12%, NS). Women who had been threatened with assault were also more likely to report having asked their main sex partner to use a condom in the last year (56% vs. 38%; chi-square = 6.0, df = 1, p = .01), but no more likely to use a condom consistently in the last 30 days (11% vs. 10%, NS).

Violence and Risk Behaviors Among Ethnic Groups

The prevalence of prior sexual and physical abuse and the current HIV risk behaviors vary significantly among different ethnic groups (Table 3 and Table 4). Among Hispanics, there were also significant differences in violence and risk behaviors between those from Tucson (almost all of whom were Mexican American) and those from Collier County (both Mexican American and Puerto Ricans). In this analysis, Hispanics were thus divided into two groups: Tucson Hispanics (or Mexican American) and Collier County Hispanics.

The prevalence of history of sexual and physical abuse among different ethnic groups is summarized in Table 3. Among the ethnic groups, White women reported the highest rate of abuse history, followed by Native American, African American, and Hispanics from Tucson. Hispanics from Collier County reported the lowest rate of abuse. Table 4 summarizes the risk behaviors among the ethnic groups. African Americans tended to be more likely to report always using a condom in the last 30 days (33% African American, 13% Native American, 10% White, 11% Collier County Hispanics; 5% Tucson Hispanics; chi-square = 8.8, df = 4, p =

TABLE 3. History of Sexual and Physical Abuse by Race/Ethnicity

Race/Ethnicity	Raped $\chi^2 = 56^*$		Raped under age 13 $\chi^2 = 22^*$		Molested under age 13 $\chi^2 = 24^*$		Physically Hurt $\chi^2 = 63^*$		Threatened with Assault $\chi^2 = 46^*$	
	Yes	(%)	Yes	(%)	Yes	(%)	Yes	(%)	Yes	(%)
White (n = 43)	34	(79)	15	(35)	21	(50)	31	(72)	26	(61)
African American (n = 12)	6	(50)	2	(17)	3	(27)	8	(67)	7	(58)
Native American (n = 15)	10	(67)	6	(40)	7	(47)	10	(67)	5	(33)
Mexican American (n = 59)	29	(49)	10	(17)	16	(27)	30	(51)	28	(48)
Hispanics from Collier County (n = 71)	8	(11)	3	(4)	6	(9)	4	(6)	4	(6)

*df = 4, p < .01

TABLE 4. Current (Last 30 Days) Risk Behaviors by Race/Ethnicity

Race/Ethnicity	Consistent Condom Use $\chi^2 = 8.8^*$		p = .07	Multiple Sex Partners $\chi^2 = 8.5^*$		p = .07	Unprotected Anal Sex $\chi^2 = 14.6^*$		p < .01
	n	Yes	(%)	n	Yes	(%)	n	Yes	(%)
White	42	4	(10)	43	8	(19)	42	9	(21)
African American	12	4	(33)	12	2	(17)	12	1	(8)
Native American	15	2	(13)	15	—	—	15	3	(20)
Mexican American	59	3	(5)	59	4	(9)	59	7	(12)
Hispanics from Collier County	66	7	(11)	71	4	(6)	64	—	—

*df = 4

171

.07). Higher percentages of Whites and African Americans reported having multiple sex partners (19% White, 17% African American, 9% Tucson Hispanics, 6% Collier County Hispanics, and none of the Native Americans; chi-square = 8.5, df = 4, p = .07). Whites were also more likely to have engaged in unprotected anal sex, followed by Native Americans (21% Whites, 20% Native Americans, 12% Tucson Hispanics, 8% African American, and none of Collier County Hispanics; chi-square = 14.6, df = 4, p < .01).

DISCUSSION

The data presented in this study supports previously published reports that a large number of American women experience violence or the threat of violence sometime during their lifetime. Nearly half of the women in this study had experienced sexual and/or physical violence by their sexual partner. Additionally, this data supports previous research that demonstrates a relationship between abuse and/or the threat of abuse with HIV risk-taking behavior. Women in this study who had been raped or who had been threatened with assault by their sex partner after the age of 13 years, were more likely to have multiple sex partners and engage in unprotected anal sex. Furthermore, women who were sexually molested under the age of 13 were more likely to have multiple sexual partners.

Interestingly, while women who had been raped or who had been threatened with assault had more frequently asked their partner to use a condom, actual condom use by those women was not significantly greater. It appears that women with histories of rape and threat of assault may perceive that they are at risk for HIV, other sexually transmitted diseases (STDs) or unwanted pregnancy, and consequently request that their partner use a condom. However, perhaps because of their previous experience with violence or their current volatile relationship, they are unable to *insist* that a condom be used.

Data from this study indicates that a greater percentage of White women reported being (1) raped at the age of 13 or older, (2) physically hurt, and (3) threatened with assault than any other ethnic group. Only Native Americans evidenced a higher percentage than Whites on one of the reported abuse questions (being raped under the age of 13). This data is in contrast to earlier studies in which Whites reported fewer incidences of domestic violence (Sorenson, Upchurch, & Shen, 1996). One possible explanation for this difference is that women in the current study were all sex partners of drug users while the prior research was done with subjects from the National Survey of Families and Households, representing a wide

range of respondents. Given the rates of violence in the histories of the White female sex partners found in the current study, it is not surprising that they reported higher rates of sex risk behaviors, such as having multiple sexual partners and unprotected anal intercourse, compared to women in the other ethnic groups.

Perhaps the most noteworthy difference in reported abuse is the comparatively low percentages of abuse denoted by Hispanics from Collier County. This finding is consistent with that of Sorenson, Upchurch and Shen (1996) and might be a result of reluctance to report among this population or differences in Hispanic lifestyle and culture which inhibit violence against women. This may be especially true in Collier County, where Hispanic culture combined with the lifestyle of rural migrant farm workers may lend itself to less violence between men and women. The Collier County Hispanic migrant farm workers live in small camps, separated from larger communities and urban areas. Social support comes from the other members who live in the camp. Those who live in the camp help each other and each other's families. Perhaps in this less acculturated smaller camp community, members hold each other more accountable, resulting in reduced levels of violence.

Data from this study indicates that experiences of violence (including rape) and the threat of violence impacts women's sexual HIV risk behavior. While these findings have important implications for the development of effective HIV prevention interventions, additional research is needed. Relatively little is known about the situations in which violence occurs, historic and immediate precipitating factors of violent episodes, and if and how women avoid violent encounters. Moreover, the relationship between violence and HIV risk-taking behavior may be different for different profiles of women such as: (1) female sexual partners of *non*-drug-using men, (2) injection drug-using women, (3) women who use non-injecting drugs, and (4) women who have sex with women. The relationship between violence and HIV risk behavior must also be examined across the lifespan with special attention to issues of motherhood/parenting and economic factors.

A need exists for the development of appropriate and detailed assessment instruments to help both researchers and clinicians understand how violence interacts with physical and psychological health, and related health behaviors. Training on how to facilitate a "violence assessment" is critical as the topic is extremely sensitive and may cause emotional upheaval. Obtaining an accurate history while remaining keenly aware of the emotional needs of the woman is a delicate balance requiring both skill and insight. Finally, the development of effective interventions is desper-

ately needed. Interventions must address past experiences of violence and how those experiences shape current behavior. Effective interventions must include strategies for behavior change. Working with women who are victims of abuse and violence, may, however, not be enough. Part of developing effective interventions for women means addressing the issues of their sexual partners. Simultaneous provision of effective interventions for both the perpetrator and the victim of violence may facilitate a pro-healthy lifestyle that includes HIV preventive behavior.

REFERENCES

American Medical Association (1991). Council on Scientific Affairs, Violence against women. Chicago: American Medical Association.

Armstrong, D. (1988). Management of infectious diseases in patients with the acquired immunodeficiency syndrome. *Kansenshougaku Zasshi,* 62 suppl., 247-86.

Boyer, D., & Fine, D. (1992). Sexual abuse as a factor in adolescent pregnancy and child maltreatment. *Family Planning Perspectives,* 24(1), 4-10.

Briere, J.N. (1992). Child abuse trauma: theory and treatment of the lasting effects. Newbury Park, CA: Sage.

Bureau of Justice Statistics, Bachman, R. (1994). Violence against women: a national crime victimization survey report. US Department of Justice, Office of Justice Programs, Washington, DC.

Campbell, J., & Alford, P. (1989). The dark consequences of marital rape. *American Journal of Nursing,* July, 46-51.

Centers for Disease Control (1994). HIV/AIDS surveillance information 1993-1994. *Morbidity and Mortality Weekly Reports,* December 1994.

Centers for Disease Control (1995). Update AIDS Among Women-US 1994. *Morbidity and Mortality Weekly Reports,* 44(5), 81-85.

Coyle, S.L. (1993). The NIDA Standard Intervention Model for Injection Drug Users Not-in-Treatment. Rockville, MD: National Institute on Drug Abuse.

Cunningham, R.M., Stiffman, A.R., Dore, P, & Earls, F. (1994). The association of physical and sexual abuse with HIV risk behaviors in adolescence and young adulthood: implications for public health. *Child Abuse & Neglect,* 18(3), 233-245.

Harlow, L.L., Quina, K., Mocokoff, P.J., Rose, J.S., & Grimley, D.M. (1993). HIV risk in women: a multifaceted model. *Journal of Applied Biobehavioral Research,* 1, 3-38.

Heise, L.L. (1993). Reproductive freedom and violence against women: where are the intersections? *The Journal of Law, Medicine & Ethics,* 21 (2), Summer, 206-216.

Helton, A.S., McFarlane, J., & Anderson, E.T. (1987). Battered and pregnant: a prevalence study. *American Journal of Public Health,* 77, 1337-1339.

Klein, H., & Chao, B.S. (1995). Sexual abuse during childhood and adolescence as predictors of HIV-related sexual risk during adulthood among female sexual partners of injection drug users. *Violence Against Women*, 1(1), 55-77.

National Association of People with AIDS (1992). HIV in America: a report by the National Association of People with AIDS, Washington, DC.

North, R.L., & Rothenberg, K.H. (1993). Partner notification and the threat of domestic violence against women with HIV infection. *New England Journal of Medicine*, 329(16), 1194-1196.

Paone, D., & Chavkin,W. (1993). From the private family domain to the public health forum: sexual abuse, women, and risk for HIV infection. *SIECUS Report*, 21(4), 13-15.

Roberts, A. (1988). Substance abuse among men who batter their mates: the dangerous mix. *Substance Abuse and Treatment*, 5, 83-87.

Rohsenow, D.J., Corbett, R., & Devine, D. (1988). Molested as children: a hidden contribution to substance abuse? *Journal of Substance Abuse and Treatment*, 5, 1318.

Shayne, V.T., & Kaplan, B.J. (1991). Double victims: poor women and AIDS. *Women & Health*, 17(1), 21-37.

Sorenson, S.B., Upchurch, D.M., & Shen, H. (1996). Violence and injury in marital arguments: risk patterns and gender differences. *American Journal of Public Health*, 86(1), 35-40.

Weissman, G. (1991). AIDS prevention for women at risk: experience from a National Demonstration Research Project. *Journal of Primary Prevention*, 12, 49-52.

Worth, D. (1991). Sexual violence against women and substance abuse. Paper presented to the Domestic Violence Task Force, New York City.

Worth, D. (1989). Sexual decision-making and AIDS: why condom promotion among vulnerable women is likely to fail. *Studies in Family Planning*, 20(6), 297-307.

Zierler, S., Feingold, L., Laufer, D., Velentgas, P., Kantrowitz-Gordon, I., & Mayer, K. (1991). Adult survivors of childhood sexual abuse and subsequent risk of HIV infection. *American Journal of Public Health*, 81(5), 572-574.

GENDER DIFFERENCES IN HIV RISK BEHAVIOR AND HEALTH STATUS OF DRUG USERS

Urban Crack Users: Gender Differences in Drug Use, HIV Risk and Health Status

Stephanie Tortu, PhD
Marjorie Goldstein, PhD
Sherry Deren, PhD
Mark Beardsley, RhD
Rahul Hamid
Kristine Ziek, BA

Stephanie Tortu, Marjorie Goldstein, Sherry Deren, Mark Beardsley, Rahul Hamid, and Kristine Ziek are affiliated with the National Development and Research Institutes, Inc., New York, NY.

This study was supported by a grant from the Community Research Branch of the National Institute on Drug Abuse [UO1 DA 7286].

[Haworth co-indexing entry note]: "Urban Crack Users: Gender Differences in Drug Use, HIV Risk and Health Status." Tortu, Stephanie et al. Co-published simultaneously in *Women & Health* (The Haworth Medical Press, an imprint of The Haworth Press, Inc.) Vol. 27, No. 1/2, 1998, pp. 177-189; and: *Women, Drug Use, and HIV Infection* (ed: Sally J. Stevens, Stephanie Tortu, and Susan L. Coyle) The Haworth Medical Press, an imprint of The Haworth Press, Inc., 1998, pp. 177-189. Single or multiple copies of this article are available for a fee from The Haworth Document Delivery Service [1-800-342-9678, 9:00 a.m. - 5:00 p.m. (EST). E-mail address: getinfo@haworthpressinc.com].

SUMMARY. This study assessed gender differences in drug use, HIV risk, and health status in a sample of urban crack users. Using targeted sampling, 1434 crack users (66% male and primarily African-American and Puerto Rican), were recruited from the streets of East Harlem, New York City. A standardized, structured interview was administered, drug use was validated by urinalysis, and HIV testing was offered. Gender differences were observed on sociodemographic variables and patterns of drug use. Other than welfare, men and women cited different major sources of income. Women reported greater use of crack, and men were more likely to use injection drugs as well as crack. Data on sexual risk indicated that women had more sexual partners than men, but the percentage of unprotected vaginal sex for both men and women was greater for those who did not exchange sex for drugs and/or money. The number of persons already infected with HIV was substantial. Many reported histories of other sexually transmitted diseases which were generally higher among men. Future research should investigate the relationship between gender and other factors (e.g., ethnicity, geographic location) associated with HIV risk. *[Article copies available for a fee from The Haworth Document Delivery Service: 1-800-342-9678. E-mail address: getinfo@ haworthpressinc. com]*

East Harlem, the site of the New York-based Cooperative Agreement study, is an area located in the northeast corner of Manhattan in New York City (NYC). Historically, the community was a residential neighborhood for the working poor. Today, however, as noted in NYC's recent assessment of Community District needs (City of NY, 1993), East Harlem is characterized by poverty, high rates of unemployment, inadequate education, and a large number of single parent households. Today's 110,500 residents are mostly African-Americans and first and second generation Puerto Ricans (City of NY, 1993). In comparison to other residents of NYC, they suffer from ill health, as evidenced by the following. In 1994, the tuberculosis rate was 71.5 per 100,000 (NYC Department of Health Bureau of Tuberculosis Control, 1994). In 1995, there were 338 cases of syphilis, 996 cases of gonnorhea, and 800 cases of chlamydia (personal communication, NYC Department of Health Sexually Transmitted Disease Control, May 21, 1996). Finally, with 15 deaths per thousand, East Harlem has one of the highest infant mortality rates in the city (City of NY, 1993).

Like many other poor, inner-city neighborhoods, East Harlem has an extremely active street "drug scene," with high rates of injection drug use and crack smoking among its residents. Along with other factors, such as poverty and lack of access to health care, heavy, chronic drug use is

associated with ill health. Aspects of drug use which contribute to general poor health include nutritional deficiencies, poly-drug use, stress-related immunomodulation, and withdrawal effects (Donahoe & Falek, 1988; Temoshok, 1988). Chronic drug use is also associated with behaviors that increase the risk of certain diseases such as HIV infection. NYC is one of the epicenters of the AIDS epidemic, and East Harlem, with large numbers of injection drug users, has one of the highest rates of AIDS cases in the city. As of September, 1995 there were 3.071 cases per 100,000 adults (NYC Department of Health Office of AIDS Surveillance, 1995, October). Use of crack/cocaine is also widespread in East Harlem. In NYC, crack use has been linked with untreated sexually transmitted diseases in women (DeHovitz et al., 1994). Crack use has also been associated with high-risk sexual behaviors, including multi-partner sex, and trading sex for drugs and/or money (Booth, Watters & Chitwood, 1993; McCoy, Miles & Inciardi, 1995; Tortu, Beardsley, Deren & Davis, 1994) and researchers have demonstrated a relationship between sexual risk and HIV infection in crack using women (Edlin et al., 1994).

Gender differences have been identified in the biological and psychosocial factors associated with the transmission and progression of HIV infection. For example, there are gender differences in types of opportunistic infections, and survival time after diagnosis is shorter for women compared to men (Ickovics & Rodin, 1992). Levels of perceived control and sources of social support, which influence exposure to HIV risk, may also differ by gender (Ickovics & Rodin, 1992). In the Denver Cooperative Agreement project, a study comparing men and women on HIV-related sex-risk behaviors and other psychosocial factors, indicated that women drug users, as compared to men, were at increased risk for HIV through sex-related risk behaviors. Women in the study also had fewer legitimate employment opportunities, and greater depression and anxiety than men (Booth, Koester & Pinto, 1995). Therefore, in assessing determinants of HIV infection among drug users and in planning interventions to reduce risk, gender is a major variable (Ickovics & Rodin, 1992).

In order to learn more about gender differences in drug use, HIV risk behaviors and health status of urban crack users, we compared men and women on key sociodemographic characteristics and health-related variables using a sample recruited in East Harlem, NYC. We examined gender differences on the following variables: sociodemographic characteristics, drug use, sex-related HIV risk behaviors, selected health status indicators (e.g., history of sexually transmitted diseases, HIV infection) and use of health services (drug treatment and HIV testing).

METHOD

Procedures

As part of the NIDA Cooperative Agreement, crack users were recruited via targeted sampling (Watters & Biernacki, 1989) on the streets of East Harlem. The outreach team, a bilingual man and woman, recruited subjects and escorted them to the research field office where their eligibility was confirmed (see Coyle, this volume). After a 45-minute interview (described below), subjects were offered HIV counseling and testing which was conducted on-site by trained HIV counselors.

Subjects

A total of 1434 crack users participated: 66% were male and 34% were female. Of the women, 55% were African-American, 37% were Puerto Rican, and 8% were White. Of the men, 58% were African-American, 36% were Puerto Rican, and 6% were White. Mean age of the men was 37.9 years, and of the women, 35.3 years (F = 38.8, p < .05).

Data Collection

Trained interviewers administered the Risk Behavior Assessment (RBA), a standardized, structured interview used by all Cooperative Agreement sites participating in the national study. It included the following topics: demographics; drug use (previous 30 days); drug- and sex-related HIV risk behaviors (previous 30 days); HIV testing and drug treatment history; criminal justice history, health status variables (history of hepatitis, gonorrhea, syphilis, and genital herpes; for women only, history of vaginal candidiasis, pregnancy status), and use of health services (drug treatment and HIV testing). Questions regarding medical history were worded as follows: "Have you ever been told by a doctor or a nurse that you had . . . ?" All respondents in the study were offered HIV Testing and Counseling and were paid $15 for their participation in the interview.

Data Analysis

Men and women were compared on each of the following dependent variables: level of education; housing status; major sources of income; criminal justice experience; current drug use; sexual risk behaviors; history of syphilis, gonorrhea and hepatitis; drug treatment experience, and HIV serostatus. Among those who reported any sexual activity in the prior

30 days, women who had exchanged sex for drugs or money were compared to women who had not exchanged sex on sexual risk behaviors, and men who exchanged drugs or money for sex were compared to men who had not exchanged drugs or money for sex on the same sexual risk behaviors. The General Linear Models Procedure (SAS, 6.10) was used to calculate F-tests for continuous variables, and chi-square analyses were used for categorical variables.

RESULTS

In the description of results, if a variable is listed in a Table, statistical values and significance levels are reported in the Table. In other instances, all statistical information is reported in the text. Unless otherwise stated, all reported results were significant at $p < .05$.

Sociodemographic Characteristics

As Table 1 indicates, there were several significant differences between men and women on sociodemographic characteristics. Men were more likely to report graduating from high school (59% vs. 47%); being home-

TABLE 1. Sociodemographic Characteristics by Gender

	Men (n = 948)	Women (n = 486)	X^2
High School Graduate (%)	59.0	47.0	17.6***
Homeless (%)	25.0	12.0	31.1***
Living Alone (%)	39.0	24.0	29.9***
Ever Arrested (%)	83.0	58.0	108.4***
Employed (%)	5.0	2.0	6.6**
Major Sources of Income†			
Welfare, AFDC (%)	57.0	54.0	1.0
Illegal Activity (%)	41.0	21.0	57.0***
Prostitution (%)	2.0	29.0	246.7***
Spouse, Family (%)	16.0	23.0	11.9***
Sell/Trade/Barter (%)	17.0	6.0	29.8***

†More than one response was possible
** $p < .01$ *** $p < .001$

less (25% vs. 12%); and living alone (39% vs. 24%); and to have an arrest history (83% vs. 58%).

While 57% of the men and 54% of the women mentioned welfare as a source of income, other major sources of income varied by gender. For example, 41% of the men, but only 21% of the women reported "illegal activity" (excluding prostitution) as a source of income. Prostitution as a source of income was mentioned by 29% of the women, but only 2% of the men. A higher percentage of women (23%) than men (16%) mentioned spouse or family as income sources, while men (17%) were more likely to report selling or bartering than women (6%).

Drug Use

As seen in Table 2, women reported using crack more days than men in the prior 30 days (23.7 days vs. 21.7 days). Women also reported using crack on more occasions than men in the prior thirty days: (241 times vs. 185 times). However, men reported using the following substances more often than women: alcohol (12.2 days vs. 8.9 days), cocaine (3.8 days vs. 2.9 days), and speedball, a mixture of heroin and cocaine (3.4 vs. 2.4 days). Men were also more likely to report the use of any injection drugs at a higher rate than women (32% vs. 27%).

TABLE 2. Drug Use in Last 30 Days by Gender

	Men (n = 948)	Women (n = 486)	Statistic
Mean days used:[b]			
Crack	21.7	23.7	14.1***
Alcohol	12.2	8.9	24.4**
Cocaine	3.8	2.9	5.3*
Heroin	9.1	9.3	.1
Speedball	3.4	2.4	4.9*
Times used crack (M)[b]	184.9	241.0	38.7****
Any injection (%)[a]	32.0	27.0	4.1*

[a]X^2 [b]F statistic
* p < .05 ** p < .01 *** p < .001 **** p < .0001

Sexual Activity and Sexual Risk Behaviors

Data on sexual activity and sexual risk behaviors are described in Table 3. More women (79.6 %) than men (70.5%) reported any sex in the prior 30 days, and of those who reported having sex, women reported more sex partners than men (mean of 27 vs. 5). Men reported a greater percentage of unprotected vaginal sex acts than women (60% vs. 53%). In the past 30 days, proportionately more women (36.8%) than men (4.6%) reported exchanging sex for drugs or money; and women were also more likely than men to report ever exchanging sex for drugs and/or money (64.2% vs. 18.2%). In contrast, men (28.9%) were more likely than women (1.2%) to report exchanging drugs or money for sex in the prior 30 days, and also more likely than women to report ever engaging in this activity (65.5% vs. 7.8%).

Among those who reported any sexual behavior in the prior 30 days, further analyses of sexual risk and sex exchange were conducted separately for men and women. These analyses are presented in Table 4. Women (n = 179) who exchanged sex for drugs or money were compared to women

TABLE 3. Sex Risk by Gender

	Men (n = 948)	Women (n = 486)	Statistic
In Prior 30 Days			
Any Sexual Activity (%)[a]	70.5	79.6	13.8***
Number of Sex Partners (M)[b]	5.0	27.0	63.5****
Number IDU Sex Partners (M)[b]	0.5	2.0	1.6
Unprotected Vaginal Sex Acts (%)[b]	60.0	53.0	6.7**
Exchanged Sex for Drugs or Money (%)[a]	4.6	36.8	253.5***
Exchanged Drugs or Money for Sex (%)[a]	28.9	1.2	156.5***
Ever Exchanged Sex for Drugs or Money (%)[a]	18.2	64.2	303.0***
Ever Exchanged Drugs or Money for Sex (%)[a]	65.5	7.8	430.5***

[a]X^2 [b]F statistic
** $p < .01$ *** $p < .001$ **** $p < .0001$

TABLE 4. Crack Users' Sexual Risk by Sex Exchange†

	Exchange	No Exchange	F- Statistic
Women: Exchange Sex for Drugs or Money			
Number	179	208	
Number of sex partners (*M*)	57.6	1.3	82.27****
Number of IDU sex partners (*M*)	4.1	0.2	3.0
Vaginal Sex Acts (*M*)	42.3	9.0	35.4****
Unprotected Vaginal Sex Acts (%)	26.8	75.5	130.6****
Men: Exchange Drugs or Money for Sex			
Number	270	398	
Number of sex partners (*M*)	5.8	4.3	0.78
Number of IDU sex partners (*M*)	1.1	0.2	7.9*
Vaginal Sex Acts (*M*)	10.0	12.0	1.32
Unprotected Vaginal Sex Acts (%)	53.0	65.0	11.03***

†Analysis only on those who reported any sexual activity in prior 30 days
* $p < .05$ *** $p < .001$ **** $p < .0001$

who did not exchange sex (n = 208) in the prior 30 days. Women who exchanged reported more sex partners (57.6 vs. 1.3) and more acts of vaginal sex (42.3 vs. 9.0) than women who did not exchange. The percentage of unprotected vaginal sex was significantly higher among non-exchangers (75.5% vs. 26.8% for exchangers). Men who reported giving drugs or money for sex in the prior 30 days (n = 270) were compared to men who did not (n = 398). Men who exchanged drugs or money reported more IDU sex partners than men who did not (1.1 vs. 0.2). The number of vaginal sex acts were similar (10 for exchangers and 12 for non-exchangers), but the percentage of unprotected vaginal sex acts (65% vs. 53%) was higher for men who did not exchange than for those who did exchange.

Health Status and Use of Health Services

As Table 5 indicates, there were several gender differences on health status variables. Men were more likely to report ever having hepatitis (16% vs. 10%) and gonnorhea (39% vs. 26%). Women were slightly more likely to report a history of syphilis (21% vs. 18%), but the difference was

TABLE 5. Health Status and Use of Health Services, by Gender

	Men (n = 948)	Women (n = 486)	X^2
Ever Had (%):			
Hepatitis	16.0	10.0	8.8**
Gonorrhea	39.0	26.0	23.2***
Syphilis	18.0	21.0	2.2
Genital Herpes	4.0	1.0	8.3**
Vaginal Candidiasis	n.a.	59.0	
Pregnant at interview (%)	n.a.	4.0	
HIV Seropositive (%)†	21.0	25.0	1.3
Ever in drug treatment (%)	68.0	62.0	4.7*
Tried but unable to enter treatment in prior year(%)	14.0	15.0	0.4
Ever received AIDS prevention info or materials in last 30 days (%)	76.0	77.0	0.7

†778 were HIV tested
* p < .05 ** p < .01 *** p < .001

not significant. Over half (59%) of the women reported ever having vaginal candidiasis, and 4% were pregnant at the time of the interview. Many in the sample were HIV-infected: 21% of the men and 25% of the women, with no significant difference.

More men than women reported having been in drug treatment (68% vs. 62%). About 14% of the men and 15% of the women reported trying, but were unable, to get into drug treatment in the past year. Regarding HIV prevention information, there were no gender differences: 76% of the men and 77% of the women reported ever receiving such materials.

DISCUSSION

Gender is a critical variable in assessing HIV risk and other aspects of crack use, as indicated by the many differences observed on sociodemographic characteristics, drug use, sexual risk, and various health-related variables. Findings suggest that the social context of crack use is different for men and women, with resulting implications for HIV risk. For example, virtually the entire sample is unemployed (although the unemploy-

ment rate is higher among women than men), indicating the importance of immediate survival needs. More than half of both sexes reported income from welfare and AFDC, but there are gender differences in the other major sources of income. For example, 29% of the women, but only 2% of the men reported income from prostitution, and, after welfare, prostitution was the major source of income for the women. Thus, a major source of income for the crack using women in this sample increases the risk of HIV infection and other sexually transmitted diseases, as demonstrated in the Tortu, McCoy, Beardsley et al. study in this volume.

Other data on sociodemographic characteristics showed that men were more likely than women to report being homeless and living alone and less likely to report spouse, family, or friends as a source of income. This indicates that women have more private (i.e., non-governmental) sources of financial support and may also have more sources of social support than men. How these findings relate to disease risk and psychological functioning in a population of drug users needs further investigation. It is also not clear from these data whether homelessness and the apparent greater social isolation among men were causal factors or effects of serious drug addiction, but the nature of the relationship should be clarified in future research.

Although this study focused on crack users, data on current drug use indicated that there were also high rates of alcohol and injection drug use in this sample, and gender differences were observed on several variables. Women reported heavier use of crack/cocaine than men in the prior 30 days on both measures of use (number of days and number of occasions), and men reported more alcohol use than women. Over 25% of both men and women injected drugs as well as used crack, and more men than women reported the use of injection drugs. These data suggest that a significant number of crack users, especially men, increase their risk for HIV infection by the use of injection drugs. Outreach efforts by local needle exchanges should target neighborhood crack users as many of them may be injecting drugs as well.

A greater percentage of women than men reported some sexual activity in the 30 days prior to interview, suggesting women's greater exposure to sexual risk. Men were more likely to report ever exchanging drugs or money for sex than women, but ever exchanging sex for drugs or money was far more prevalent among women than men.

Additional analyses of sexual risk compared recent risk behaviors among women who exchanged sex for drugs or money and those who had not exchanged sex in the prior 30 days and found several significant differences. Women who exchanged sex reported more sex partners, and

more occasions of vaginal sex. However, the percentage of unprotected vaginal sex was significantly higher among women who did not exchange sex. Previous research has indicated a greater use of condoms with "casual" rather than main partners. More research should be done to investigate the sources of women's sexual risk from both casual and main partners, given the importance of sex exchange among women as a predictor of HIV infection in NYC (see Tortu, McCoy et al., this volume).

Men who exchanged drugs or money for sex reported less unprotected vaginal sex than men who did not exchange, suggesting a greater use of condoms in sex exchange situations. These data complement the women's analyses discussed previously, and suggest that the type of relationship ("main" vs. casual partner) is a major determinant of condom use. This is an issue that sexual risk reduction interventions must consider as it is possible that different negotiation strategies are necessary for main and casual partners (Watkins, Metzger, Woody & McClellan, 1993). In addition, men who exchanged had another source of risk from a greater number of IDU sex partners than those who did not exchange.

Previous research has attributed a recent, rising incidence of STDs in minority, urban populations to the use of crack cocaine (Chirgwin, De Hovitz, Dillon & McCormack, 1991; Greenberg, Singh, Htoo & Schultz, 1991). A review of the health status variables in this study indicated that a significant percentage of respondents reported histories of various sexually transmitted diseases. Men were more likely than women to report a history of all STDs except syphilis. There is reason to believe that reported histories of STD infections may be underestimated in this sample, especially among women. Previous research among women in NYC indicated that the presence of untreated STDs was significantly associated with crack cocaine use (DeHovitz et al., 1994). Furthermore, there may be a higher likelihood of undiagnosed and untreated STDs among women than men because some STDs are asymptomatic in women (Chesney, 1994).

A substantial number of persons in this sample were already HIV-infected. Research efforts need to investigate further the effect of knowledge of one's own HIV infection on drug use and drug and sexual risk behaviors. While women were slightly more likely than men to be HIV-infected, the difference was not statistically significant. Many women reported having had vaginal candidiasis which can be an early manifestation of HIV in women (Rhoads, Wright, Redfield & Burke, 1987). It is important to note that over half the women in this sample reported this condition. Further, women with HIV and recurrent vaginal candidiasis are at serious risk for rapid progression to AIDS (Rhoads et al., 1987), suggesting that many women in this sample should be treated aggressively for other opportunis-

tic infections (Ickovics & Rodin, 1992). Poor, minority women often have limited access to health care and may not be able to obtain this treatment. More research is necessary on drug users' access to health care in minority, urban communities. Finally, this study was concerned primarily with assessing drug use, HIV risk behaviors, and related health conditions among drug users. Evidence suggests that this sample may be at risk for other diseases, such as tuberculosis. More detailed health data is necessary in order to better assess the health care needs of this population.

The data reported here show that a number of intriguing differences exist between men and women crack users. Future research should further investigate the relationship between gender and the economic and psychosocial factors that influence HIV risk and other diseases in crack users from East Harlem and other locations (Deren et al., 1994). Complex interrelationships may exist between gender and other factors associated with HIV risk, such as ethnicity, geographical location, and local HIV prevalence.

REFERENCES

Booth, R. E., Koester, S. K., & Pinto, F. (1995). Gender differences in sex-risk behaviors, economic livelihood, and self-concept among drug injectors and crack smokers. *The American Journal on Addictions, 4*(4), 313-322.

Booth, R. E., Watters, J. K., & Chitwood, D. D. (1993). HIV risk-related sex behaviors among injection drug users, crack smokers, and injection drug users who smoke crack. *American Journal of Public Health, 83*(8), 1144-1148.

Chesney, M. A. (1994). Prevention of HIV and STD Infections. *Preventive Medicine, 23,* 655-660.

Chirgwin, K., DeHovitz, J. A., Dillon, S., & McCormack, W. M. (1991). HIV infection, genital ulcer disease, and crack cocaine use among patients attending a clinic for sexually transmitted diseases. *American Journal of Public Health, 81*(12), 1576-1579.

City of New York. (1993, September). *Community district needs: Fiscal year 1995 Manhattan* (NYC DCP 93-44, pp. 227-257). New York: Author.

DeHovitz, J. A., Kelly, P., Feldman, J., Sierra, M. F., Clarke, L., Bromberg, J., Wan, J. Y., Vermund, S. H., & Landesman, S. (1994). Sexually transmitted diseases, sexual behavior, and cocaine use in inner-city women. *American Journal of Epidemiology, 140*(12), 1125-1134.

Deren, S., Kotranski, L., Beardsley, M., Collier, K., Tortu, S., Mulia, N., & Hamid, R. (1994, October). *Crack users in East Harlem, NY and Philadelphia, PA: HIV related risk behaviors, serostatus, and prevention/treatment needs.* Presented at the American Public Health Association Meeting, Washington, DC.

Donahoe, R., & Falek, A. (1988). Neuroimmunomodulation by opiates and other drugs of abuse: Relationship to HIV infection and AIDS. In T. B. Bridge, A. F.

Mirsky, & F. K. Goodwin (Eds.), *Psychological, neuropsychiatric, and substance abuse aspects of AIDS.* New York, NY: Raven Press.

Edlin, B. R., Irwin, K. L., Faruque, S., McCoy, C. B., Word, C., Serrano, Y., Inciardi, J. A., Bowser, B. P., Schilling, R. F., Holmberg, S. D., & The Multicenter Crack Cocaine and HIV Infection Study Team. (1994). Intersecting epidemics–Crack cocaine use and HIV infection among inner-city youth. *The New England Journal of Medicine, 331*(21), 1422-1427.

Greenberg, M. S., Singh, T., Htoo, M., & Schultz, S. (1991). The association between congenital syphilis and cocaine/crack use in New York City: A case control study. *American Journal of Public Health, 81*(10), 1316-1318.

Ickovics, J. R., & Rodin, J. (1992). Women and AIDS in the United States: Epidemiology, natural history, and mediating mechanisms. *Health Psychology, 11*(1), 1-16.

McCoy, H.V., Miles, C., & Inciardi, J. A. (1995). Survival sex: Inner-city women and crack-cocaine. In J. A. Inciardi & K. McElrath (Eds.), *The American drug scene: An anthology,* Los Angeles, CA: Roxbury Publishing Company.

NYC Department of Health Bureau of Tuberculosis Control (1994). Tuberculosis in New York City, 1994. New York: New York City Department of Health.

NYC Department of Health Office of AIDS Surveillance. (1995, October). *AIDS surveillance update.* New York: Author.

Rhoads, J. L., Wright, D. C., Redfield, R. R., & Burke, D. S. (1987). Chronic vaginal candidiasis in women with human immunodeficiency virus infection. *Journal of the American Medical Association, 257,* 3105-3107.

Temoshok, L. (1988). Psychoimmunology and AIDS. In T. B. Bridge, A. F. Mirsky, & F. K. Goodwin (Eds.), *Psychological, neuropsychiatric, and substance abuse aspects of AIDS.* New York, NY: Raven Press.

Tortu, S., Beardsley, M., Deren, S., & Davis, W. R. (1994). The risk of HIV infection in a national sample of women with injection drug-using partners. *American Journal of Public Health, 84*(8), 1243-1249.

Watkins, K. E., Metzger, D., Woody, G., & McClellan, A. T. (1993). Determinants of condom use among intravenous drug users. *AIDS, 7*(5), 719-723.

Watters, J., & Biernacki, P. (1989). Targeted sampling: Options for the study of hidden populations. *Social Problems, 6*(4), 416-430.

A UNIQUE POPULATION
OF WOMEN AT RISK:
WOMEN WHO TRADE SEX
FOR MONEY AND DRUGS

Predictors of HIV Infection
Among Women Drug Users
in New York and Miami

Stephanie Tortu, PhD
H. Virginia McCoy, PhD
Mark Beardsley, RhD
Sherry Deren, PhD
Clyde B. McCoy, PhD

Stephanie Tortu, Mark Beardsley, and Sherry Deren are affiliated with National Development & Research Institutes, Inc., Institute for AIDS Research, Two World Trade Center, 16th Floor, New York, NY 10048. H. Virginia McCoy is affiliated with Florida International University, 3000 NE 145th Street, ACI394, North Miami, FL 33181. Clyde B. McCoy is affiliated with University of Miami School of Medicine, 1400 NW 10th Avenue, Miami, FL 33136.

This research was supported by grants from the Community Research Branch of the National Institute on Drug Abuse [UO1-DA 7286, UO1-DA 6910].

The authors wish to thank the research staff of the New York and Miami sites for their contributions to this study. We also thank Carmen Ortiz-Priester and Kristine Ziek for their assistance with the preparation of this manuscript.

[Haworth co-indexing entry note]: "Predictors of HIV Infection Among Women Drug Users in New York and Miami." Tortu, Stephanie et al. Co-published simultaneously in *Women & Health* (The Haworth Medical Press, an imprint of The Haworth Press, Inc.) Vol. 27, No. 1/2, 1998, pp. 191-204; and: *Women, Drug Use, and HIV Infection* (ed: Sally J. Stevens, Stephanie Tortu, and Susan L. Coyle) The Haworth Medical Press, an imprint of The Haworth Press, Inc., 1998, pp. 191-204. Single or multiple copies of this article are available for a fee from The Haworth Document Delivery Service [1-800-342-9678, 9:00 a.m. - 5:00 p.m. (EST). E-mail address: getinfo@haworthpressinc.com].

SUMMARY. In the US, the number of women diagnosed with AIDS continues to increase. In this study, women in New York City (East Harlem) and Miami, two sites with high rates of drug use and HIV infection, were first compared on sociodemographic variables and risk behaviors. Logistic regression analyses were used to identify significant, independent predictors of HIV infection in each city. In comparing women from the two cities, several differences in sociodemographic characteristics and drug use were observed. In both cities, ever exchanging sex for drugs and/or money was predictive of HIV infection; and in East Harlem only, other lifetime risk variables independently predicted HIV infection: drug injection, having a sexually transmitted disease, and not having graduated from high school. Results suggest that intervention efforts with women who exchange sex should be intensified in both cities. Also, further comparisons of women drug users in AIDS epicenter cities are necessary to provide information on similarities and differences in sociodemographic characteristics and individual risk behaviors. More research attention should be focused on examining the social context of HIV risk in order to develop innovative intervention strategies which focus on the link between contextual factors and HIV infection. *[Article copies available for a fee from The Haworth Document Delivery Service: 1-800-342-9678. E-mail address: getinfo@haworthpressinc.com]*

In the US, the number of women diagnosed with AIDS continues to increase. As of December, 1995, 71,818 cases of AIDS have been reported among women in the US (Centers for Disease Control, 1995). Those with HIV infection and AIDS are most likely to be young, poor, African-American or Latina women in large cities who have been infected through their own injection drug use or through high-risk sex with an infected man (Ellerbrock, Bush, Chamberland, & Oxtoby, 1991; Burke et al., 1990; Gwinn et al., 1991; St. Louis et al., 1991; Sweeney, Onorato, Allen, Byers, & The Field Services Branch, 1992). Women infected through their own injection drug use account for 47% of the total, and women infected through heterosexual transmission account for another 37% (CDC, 1995). Heterosexual contact with a male injection drug user is the most prevalent transmission route for women infected through a male partner, representing nearly half of those AIDS cases, while sexual contact with an infected male partner of non-specified risk accounts for an additional 40%. The extent to which sexual transmission contributes to HIV infection among injection drug users (IDUs) has been difficult to assess, and studies have produced conflicting results (Battjes, Pickens, Amsel, & Brown, 1990; Tirelli, Vacchev, Carbone, DePaeli, & Monfardini, 1986; Nelson, Vlahov, & Cohn, 1991). Recent data do suggest, however, that among drug users, the associa-

tion of sexual risk and HIV infection is of greater concern to women than men. For example, among IDUs in Baltimore, high levels of exchanging sex for drugs or money among women were independently associated with HIV infection (Astemborski, Vlahov, Warren, Solomon, & Nelson, 1994). Also, a relationship between exchanging sex and HIV infection was observed among women crack users in New York City and Miami who had never injected drugs (Edlin et al., 1994). Evidence indicates that a combination of behaviors and sociocultural factors contributes to HIV infection among crack using women (Booth, Watters, & Chitwood, 1993; Inciardi, Lockwood, & Pottieger, 1991; H. V. McCoy & Inciardi, 1993; Tortu, Beardsley, Deren, & Davis, 1994).

It is important to recognize that women are at higher risk from heterosexual transmission than men for both biological and social reasons. The virus is more concentrated in semen than in vaginal secretions, and heterosexual transmission is more effective from men to women than from women to men (European Study Group, 1992; Padian, Shiboski, & Jewell, 1990). In addition, there is a recognized synergy between HIV and other sexually transmitted diseases (STDs) (Wasserheit, 1991) whereby HIV risk is enhanced by the existence of an underlying STD (Chesney, 1994). Many STDs are asymptomatic in women, and may go untreated, as was observed among crack using women in New York City (DeHovitz et al., 1994). Finally, sexual partnering is not a random event. Relationships are more likely to form among those who share similar social characteristics (Laumann, Gagnon, Michael, & Michaels, 1994). The risk for HIV infection is enhanced if persons have multiple sexual partnerships within social networks, and fail to use condoms consistently (Laumann et al., 1994). Because more men than women are infected with HIV, women have a higher probability of encountering an infected heterosexual partner within their social networks than men, especially in neighborhoods with high numbers of HIV-infected men.

New York City and Miami are two cities with high rates of drug use and HIV infection, particularly in poor, inner-city neighborhoods. As of July 1995, data from participants in the NIDA Cooperative Agreement indicated that 39% of the male IDUs recruited in East Harlem, NYC and 27% of the female IDUs were HIV-infected. In Miami, almost 46% of all male IDUs and 50% of the female IDUs were HIV-infected. Women in each city are at risk through their own injection drug use, and the increased probability of having sex with an infected man. In both cities, women's exposure to sexual risks may be heightened by the widespread use of crack cocaine. The purposes of this study were the following: (1) to compare women drug injectors and crack users in NYC to those in Miami on

selected sociodemographic variables and risk behaviors; (2) to describe and compare the behavioral predictors of HIV infection in women drug injectors and crack users in each city; and (3) to identify variables that are independently associated with HIV infection in each city. Three types of variables were examined: sociodemographic characteristics; HIV-related risk behaviors (drug injection, crack use, and exchanging sex for drugs and/or money); and history of sexually transmitted diseases.

METHOD

Sample

Data for this study were collected from out-of-treatment drug injectors and crack cocaine smokers in East Harlem, New York City and Miami, Florida as part of the NIDA Cooperative Agreement described in this volume (see Coyle et al.). Study participants were recruited using targeted sampling plans developed by investigators in each city (Watters & Biernacki, 1989). Trained and indigenous outreach workers recruited drug users from the targeted geographic areas.

The Miami site specifically targeted African-Americans for participation in culturally sensitive and gender-specific interventions. The East Harlem, New York City site recruited a racial/ethnic mix of participants based on their representation in East Harlem, a densely populated community located in the Northeast corner of Manhattan. Subjects in East Harlem were recruited for participation in group-based intervention focused on specific health skills. Having traded sex for drugs and/or money was not a specific criterion for recruitment. Data were collected in East Harlem from September 1993 through August 1995 and in Miami from October 1993 to September 1994. At the beginning of this study, a question was added to the Cooperative Agreement's standardized interview to determine if subjects who reported non-injection in the prior 30 days had ever injected. The study sample in both sites includes only women recruited after the addition of the injection history question.

In East Harlem, subjects were 194 women, of whom 53.6% were African-American, 33% were Puerto Rican and 10.3% were White. The mean age was 36.1 years. In Miami, subjects were 300 women, of whom 95.3% were African-American and 3% were White. The mean age was 34.5 years.

Data Collection

All data used in the analysis, except HIV serostatus and confirmation of drug use (i.e., urinalysis, track marks), are self-reported. Self-report data

were collected using the Risk Behavior Assessment (RBA) Questionnaire. The RBA was developed for the NIDA-funded multi-site study by participating investigators in collaboration with investigators at the National Institute on Drug Abuse.

The questionnaire collected behavioral information primarily for the 30 days preceding the study interview. Those who reported no injection drug use during that period were asked whether they had ever injected any drugs. Individuals responding that they had injected in either the prior 30 days or "ever" were considered injectors. The questionnaire also included items on recent sexual behavior (prior 30 days) and whether respondents had ever exchanged sex for drugs and/or money.

Study participants were asked to provide a blood sample voluntarily for HIV testing and received HIV pre- and post-test counseling using the protocol described in this volume (see Coyle et al.). Testing was conducted by licensed laboratories under contract to the individual projects. Blood samples were screened for HIV using the ELISA assay and confirmed by Western blot.

Statistical Methods

The East Harlem and Miami samples were first compared on demographic characteristics, current and lifetime drug injection, and incidence of HIV and STDs (syphilis, gonorrhea, and genital herpes), using Chi-Squares or independent t-tests. Second, the same statistics were then used to identify variables associated with seropositivity, separately among the two samples of women. Finally, logistic regression analyses were employed to identify factors related to HIV status in each city. These models included as predictor variables all of the characteristics or behaviors associated with seropositivity (at $p < .05$ or better) in the second step. Because of the difficulty inherent in using current behaviors as indicators of past risk behaviors, analyses were limited to variables measuring past behavior (e.g., "ever injected"; "ever exchanged sex for drugs and/or money"), and not behaviors reported only for the prior 30 days.

RESULTS

Comparisons Between East Harlem and Miami Sample

Unless reported in the text, all statistics and significance levels are listed in the Tables. Also, unless otherwise noted, all differences discussed

in the text were significant at p < .05 or better. As Table 1 indicates, there were a number of significant differences on sociodemographic variables between the women recruited in East Harlem and those in Miami. While most individuals in both cities reported the current use of crack cocaine, women in East Harlem were more likely to report the current use of injected drugs as well. Women in East Harlem were older than those in Miami: 36.1 years vs. 34.5 years. Miami women were predominantly African-American (95.3%), according to recruitment plan. In East Harlem, 53.6% and 33% of the women were African-American and Puerto Rican respectively, reflecting the racial/ethnic mix of the community. The majority of women in both locations have been incarcerated, but the proportion of Miami women was significantly greater (73.3%) than the proportion in East Harlem (55.7%). Few women in either city were employed, but employment was more likely in Miami (20.3%) than in East Harlem (1.6%).

TABLE 1. Description of Sample

	E. Harlem (N = 194)	Miami (N = 300)	Statistic[a]
Current Drug Use (%)			74.72**
Injection Only	17.5	2.3	
Crack Use Only	62.9	93.7	
Injection & Crack Use	19.5	4.0	
Age (M)	36.1	34.5	2.39*
Ethnicity (%)			131.66*
Black	53.6	95.3	
Puerto Rican	33.0	0.7	
White	10.3	3.0	
Other	3.1	1.0	
Homeless (%)	8.3	8.7	.03
Living alone (%)	21.8	15.0	3.69
H.S. Graduate (%)	38.1	44.0	1.66
Ever in prison (%)	55.7	73.3	16.47**
Employed (%)	1.6	20.3	36.87**

[a]All X^2 except for age (t-test)
*p < .05 **p = < .001

As seen in Table 2, ever having injected drugs was more prevalent among East Harlem women (46.4%) than Miami women (23.7%). Women in Miami (69.7%) were more likely than women in East Harlem (57.2%) to report ever exchanging sex. Women in Miami (50%) were also more likely to report ever having an STD than women in East Harlem (40.2%). However, prevalence of HIV infection in East Harlem (28.4%) and Miami (33.6%) was not significantly different.

Comparisons Between Infected and Non-Infected Women by Site

In each city, infected and non-infected women were compared on the sociodemographic and risk variables presented above. Table 3 indicates that, in New York, HIV-infected women were more likely than non-infected women to report they ever exchanged sex for drugs and/or money (81.8% vs. 47.5%); ever injected drugs (67.3% vs. 38.1%); and ever had a sexually transmitted disease (58.2% vs. 33.1%). Educational level was also associated with HIV status: a greater proportion of seronegative women were high school graduates (46.8% vs. 16.4% of seropositives). By contrast, in Miami, only one risk factor was significantly associated with HIV infection. HIV infected women were more likely to report ever exchanging sex for drugs and/or money (78.2%) than those who did not (65.3%).

Predictors of HIV Infection in Each Site

In Table 4, results of logistic regression analyses, reported as Odds Ratios (OR), indicated that the strongest significant predictors of HIV

TABLE 2. Comparisons Between Sites: Lifetime Risk Variables and HIV Serostatus

	E. Harlem (N = 194)	Miami (N = 300)	Statistic X^2
Ever Injected Drugs (%)	46.4	23.7	27.69***
Ever Exchanged Sex for Drugs/ Money (%)	57.2	69.7	8.00**
Ever Had STD (%)	40.2	50.0	4.54*
HIV-Infected (%)	28.4	33.6	1.54

*p < .05 **p < .005 ***p < .001

TABLE 3. Lifetime Educational and HIV Risk Variables by HIV Status

	E. Harlem (N = 194)			Miami (N = 300)		
	HIV+	HIV−	Statistic (X^2)	HIV+	HIV−	Statistic (X^2)
Ever (%)						
Exchanged Sex for Drugs/Money	81.8	47.5	18.9**	78.2	65.3	5.3*
Injected Drugs	67.3	38.1	13.4*	24.8	23.1	.1
Had STD	58.2	33.1	10.3**	52.5	48.7	.3
High School Graduate	16.4	46.8	15.4**	37.6	47.2	2.5

*p < .05 **p < .001

TABLE 4. Predictors of HIV Infection in Women

	Logistic Regression Analysis				
Variable	Parameter Estimate	Wald X^2	Odds Ratio	95% C.I. for O.R. Lower	Upper
E. Harlem (N = 194)					
Ever Exchanged Sex	2.00	16.14**	7.41	2.79	19.70
Ever Injected Drugs	2.15	21.35**	8.58	3.44	21.34
Ever Had STD	1.02	5.70*	2.77	1.20	6.39
High School Graduate	−2.07	17.41**	0.13	0.05	0.33
Miami (N = 300)					
Ever Exchanged Sex	0.65	5.18*	1.91	1.09	3.32

*p < .05 **p < .0001

infection in East Harlem were ever exchanged sex (OR = 7.41) and ever injected (OR = 8.58). In addition, ever having a sexually transmitted disease (OR = 2.77) was also predictive of HIV infection, and being a high school graduate (OR = .13) was negatively associated with HIV infection. In Miami, ever exchanged sex was the only significant predictor of HIV infection (OR = 1.91; p < .05), since no other variables met the p < .05 criterion for inclusion in the logistic model.

Since ever exchanging sex (for drugs and/or money) emerged as a

significant predictor of serostatus in both cities, a separate analysis was conducted to assess the site (New York vs. Miami) by exchange (yes or no) interaction effect (using the CATMOD procedure, Version 6.10 of SAS). Results (chi-square = 3.36; p < .07) suggested that the difference between exchangers and non-exchangers in likelihood of being HIV positive was somewhat greater among New York women than among women in Miami. That is, 40% of New York exchangers were seropositive, while only 12% of the non-exchangers were seropositive, a difference of 28%; whereas 38% of Miami exchangers were positive and 24% of the non-exchangers were seropositive, a difference of 14%. A larger sample may have produced a statistically significant (at p < .05) interaction finding.

DISCUSSION

This study compared women drug users in New York City and Miami on a number of sociodemographic and behavioral risk variables and determined the predictors of HIV infection in each location. Results indicated that there were some differences in sociodemographic characteristics and drug use between women in the two cities. These differences are a result of several factors. First, the goals of the Miami project were to implement and evaluate a gender- and culturally-specific risk reduction intervention, with African-Americans as the target group. Thus, the Miami sample consisted of African-American crack cocaine users almost exclusively. Project goals in East Harlem were compatible with recruiting a sample which represented the racial/ethnic composition of the East Harlem community in New York City. The East Harlem sample consisted of African-American and Puerto Rican women who were predominantly crack users, but included substantially more injectors than Miami. Thus, the results of this study must be interpreted with the understanding that differences in recruitment strategies resulted in samples that differed in racial/ethnic composition.

Differences between the two cities in reported drug use may also indicate a preference for particular drugs in various cities. With the advent of crack cocaine, Miami outreach workers reported that fewer women were injecting. Also, cocaine is more prevalent in Miami, as a port-of-entry site, than in New York, and may account for more crack cocaine users in Miami. In comparison, heroin is more prevalent in New York than Miami, possibly resulting in more injectors. To what extent crack cocaine use is more prevalent among African-American women in Miami, as compared

to other racial/ethnic groups in Miami, cannot be addressed by these data, but should be investigated further.

Differences by site were also observed on lifetime risk variables, specifically, New York's higher proportion of drug injectors and Miami's higher proportions of women who exchange sex and report a history of STDs. These differences may also be attributable to the characteristics of the samples recruited in each city. Crack cocaine use among women, as compared with injection drug use, is more likely to be associated with sex exchange and a higher proportion reporting a history of sexually transmitted diseases. One risk behavior, exchanging sex for drugs and/or money, was significantly associated with HIV infection in both New York and Miami. This finding supports previous research among crack smokers in the two cities which demonstrated the association of sex exchange and HIV infection (Edlin et al., 1994), and suggests that prevention efforts targeting women who exchange sex should be intensified in both cities. It would appear that there are economic, gender-based and psychopharmacological explanations for the association between exchanging sex for drugs/money and HIV seropositivity in both cities. For example, drug users often need to exchange sex to pay for their drugs, because their access to other sources of legal or illegal income is limited (see Auerbach, Wypijewska, & Brodie, 1994 for a discussion). As observed in both samples, less than half the women had graduated from high school, suggesting that they had few marketable skills. Indeed, the overwhelming majority were unemployed, with their addiction to drugs placing an additional financial burden on them. Also, most women have less access to drugs than men, and, thus, may have to rely on men to obtain drugs, particularly crack cocaine (Morningstar & Chitwood, 1995). Among crack cocaine users, psychopharmacological explanations of the association between exchanging sex and HIV infection include crack's high addictive potential and the release of inhibitions related to sexual behavior. This leads to an increase in the frequency of high-risk sexual activity among crack users, often in "crack houses" where cheap, high-risk sex is abundant (H. V. McCoy, Miles, & Inciardi, 1995; C. B. McCoy, Metsch, & Anwyl, 1996).

In the East Harlem sample, three other factors also significantly predicted HIV infection in women: drug injection, having a sexually transmitted disease, and having less than a high school education. Over one third of the women in this sample are current injectors, and in East Harlem, where there are high rates of HIV infection among injectors, unsafe injection practices are particularly risky. Prevention efforts targeting injectors in East Harlem must include education regarding needle hygiene and

referrals to the needle exchange sites that exist in this neighborhood (Tortu, Beardsley, Deren, & Hamid, in press). In addition, given the high rates of infection among male injectors in this community, women injectors may have IDU sex partners who are already infected, thus increasing their risk of infection by sexual means. This aspect of dual risk for women injectors in East Harlem needs further investigation. The link between not graduating from high school and HIV infection is not unexpected, and, although the relationship was not significant among Miami women, there was a trend in the same direction. Women with little education who live in an impoverished community and are addicted to drugs may put themselves at risk by relying on the exchange of sex as a means of survival. Finally, in a sample with large numbers of women who are involved in exchanging sex, it is not surprising that reported STDs are associated with HIV infection. Sex exchange involves multi-partner, risky sex which is a source of syphilis, gonorrhea, and genital herpes, as well as HIV infection. In turn, having an underlying STD infection appears to increase the risk of HIV infection (Wasserheit, 1991). Given the higher proportion of crack using women who exchanged sex and reported STDs in Miami's sample, it is noteworthy that having STDs was not a significant predictor of HIV in that city as well, and this difference between the two sites should be investigated further. Previous research in New York has shown that untreated STDs, some of which are asymptomatic in women, are especially likely among crack smoking women (DeHovitz et al., 1994), and it is possible that reported history of STDs underestimates the actual prevalence in both samples. The prevention, diagnosis and treatment of STDs, especially among crack using women who exchange sex, should be considered as an additional HIV prevention tactic.

Data reported here from two epicenters of the AIDS epidemic suggest that in order to prevent HIV infection among women drug users, strategies must be employed that are sensitive to the social context of risk. That is, it is important to understand how socioeconomic and cultural forces such as poverty, gender inequality and drug addiction drive women's risk behaviors and also serve as barriers to risk reduction. Poor, minority women addicted to drugs and living in impoverished communities have limited choices in their struggle for survival, and many perceive AIDS to be only one of many other threats they must face (Ward, 1993). Within this social context, the exchange of sex is a source of both money and drugs, and it follows that the majority of women in both samples have engaged in this risk behavior. Further research, such as that conducted by Weeks and colleagues (this volume), is needed to understand more fully the psychological, sociological, and cultural dynamics within which exchanges of

sex for drugs and/or money occur. Additional studies are also needed of high-risk locales where sex exchange occurs such as shooting galleries, crack houses, and short-term occupancy/transient hotels. Finally, information from these studies should be used to develop innovative intervention strategies which focus on the link between social context and HIV risk behaviors.

REFERENCES

Astemborski, J., Vlahov, D., Warren, D., Solomon, L., & Nelson, K. E. (1994). The trading of sex for drugs or money and HIV seropositivity among female intravenous drug users. *American Journal of Public Health, 84*(3), 382-387.

Auerbach, J. D., Wypijewska, C., & Brodie, H. K. H. (Eds.). (1994). *AIDS and behavior: An integrated approach.* Washington, DC: National Academy Press.

Battjes, R. J., Pickens, R. W., Amsel, Z., & Brown, Jr., L. S. (1990). Heterosexual transmission of human immunodeficiency virus among intravenous drug users. *The Journal of Infectious Diseases, 162,* 1007-1011.

Booth, R. E., Watters, J. K., & Chitwood, D. D. (1993). HIV risk-related sex behaviors among injection drug users, crack smokers, and injection drug users who smoke crack. *American Journal of Public Health, 83*(8), 1144-1148.

Burke, D. S., Brundage, J. F., Goldenbaum, M., Gardner, L. I., Peterson, M., Visintine, R., Redfield, R. R., & The Walter Reed Retrovirus Research Group. (1990). Human immunodeficiency virus infections in teenagers. *Journal of the American Medical Association, 263,* 2074-2077.

Centers for Disease Control and Prevention (1995). *HIV/AIDS Surveillance Report, 7*(2).

Chesney, M. A. (1994). Prevention of HIV and STD Infections. *Preventive Medicine, 23,* 655-660.

DeHovitz, J. A., Kelly, P., Feldman, J., Sierra, M. F., Clarke, L., Bromberg, J., Wan, J. Y., Vermund, S. H., & Landesman, S. (1994). Sexually transmitted diseases, sexual behavior, and cocaine use in inner-city women. *American Journal of Epidemiology, 140*(12), 1125-1134.

Edlin, B. R., Irwin, K. L., Faruque, S., McCoy, C. B., Word, C., Serrano, Y., Inciardi, J. A., Bowser, B. P., Schilling, R. F., Holmberg, S. D., & The Multicenter Crack Cocaine and HIV Infection Study Team (1994). Intersecting epidemics–Crack cocaine use and HIV infection among inner-city youth. *The New England Journal of Medicine, 331*(21), 1422-1427.

Ellerbrock, T. V., Bush, T. J., Chamberland, M. E., & Oxtoby, M. J. (1991). Epidemiology of women with AIDS in the United States, 1981 through 1990. *Journal of the American Medical Association, 265,* 2971-2975.

European Study Group on Heterosexual Transmission of HIV (1992). Comparison of female to male and male to female transmission of HIV in 563 stable couples. *British Medical Journal, 304,* 809-813.

Gwinn, M., Pappaioanou, M., George, J. R., Hannon, W. H., Wasser, S. C., Redus, M. A., Hoff, R., Grady, G. F., Willoughby, A., Novello, A. C., Petersen, L. R.,

Dondero, T. J., & Curran, J. W. (1991). Prevalence of HIV infection in child-bearing women in the United States. *Journal of the American Medical Association, 265,* 1704-1708.

Inciardi, J. A., Lockwood, D., & Pottieger, A. E. (1991). Crack-dependent women and sexuality: Implications for STD acquisition and transmissions. *Addictions and Recovery, 2,* 25-38.

Laumann, E. O., Gagnon, J. H., Michael, R. T., & Michaels, S. (1994). *The social organization of sexuality: Sexual practices in the United States.* Chicago: The University of Chicago Press.

McCoy, C. B., Metsch, L., & Anwyl, R. (1996). Dual epidemics: Crack cocaine and HIV/AIDS. In D. Chitwood, J. Ribers, & J. A. Inciardi, *The American pipe dream.* Fort Worth: Harcourt Brace and Company.

McCoy, H. V., & Inciardi, J. A. (1993). Women and AIDS: Social determinants of sex-related activities. *Women & Health, 20*(1), 69-86.

McCoy, H. V., Miles, C., & Inciardi J. A. (1995). Survival sex: Inner-city women and crack cocaine. In J. A. Inciardi & K. McElrath, *The American drug scene: An anthology,* Los Angeles: Roxbury Publishing Co.

Morningstar, P. J., & Chitwood, D. D. (1995). How women and men get cocaine: Sex-role stereotypes and acquisition patterns. In J. A. Inciardi and K. McElrath, *The American drug scene: An Anthology.* Los Angeles: Roxbury Publishing Co.

Nelson, K. E., Vlahov, D., & Cohn, S. (1991). Sexually transmitted diseases in a population of intravenous drug users: Association with seropositivity to the human immunodeficiency virus (HIV). *The Journal of Infectious Diseases, 164,* 457-463.

Padian, N. S., Shiboski, S. S., & Jewell, N. (1990, June). *The relative efficiency of female-to-male HIV sexual transmission.* Presented at the 6th International Conference on AIDS, San Francisco, CA.

St. Louis, M. E., Conway, G. A., Hayman, C. R., Miller, C., Petersen, L. R., & Dondero, T. J. (1991). Human immunodeficiency virus infection in disadvantaged adolescents. *Journal of the American Medical Association, 266,* 2387-2391.

Sweeney, P. A., Onorato, I. M., Allen, D. M., Byers, R. H., & The Field Services Branch. (1992). Sentinel surveillance of human immunodeficiency virus infection in women seeking reproductive health service in the United States, 1988-1989. *Obstetrics and Gynecology, 79,* 503-510.

Tirelli, U., Vacchev, E., Carbone, A., DePaeli, P., & Monfardini, S. (1986). Heterosexual contact is not the predominant mode of HTLV-III transmission among drug users [Letter]. *Journal of the American Medical Association, 255,* 2289.

Tortu, S., Beardsley, M., Deren, S., & Davis, W. R. (1994). The risk of HIV infection in a national sample of women with injection drug-using partners. *American Journal of Public Health, 84*(8), 1243-1249.

Tortu, S., Deren, S., Beardsley, M., & Hamid, R. (in press). Factors associated with needle exchange use in East Harlem, NY. *Journal of Drug Issues.*

Ward, M. C. (1993). A different disease: HIV/AIDS and health care for women in poverty. *Culture, Medicine and Psychiatry, 17*(4), 413-430.

Wasserheit, J. (1991). Epidemiology synergy: Interrelationships between HIV infections and other STDs. In L. Chen et al. (Eds.), *AIDS and women's reproductive health,* New York: Plenum.

Watters, J., & Biernacki, P. (1989). Targeted sampling: Options for the study of hidden populations. *Social Problems, 6*(4), 416-430.

Streets, Drugs, and the Economy of Sex in the Age of AIDS

Margaret R. Weeks, PhD
Maryland Grier
Nancy Romero-Daza, PhD
Mary Jo Puglisi-Vasquez
Merrill Singer, PhD

SUMMARY. Drug addicted women whose economic and social base is urban streets face limited options for income generation and multiple dangers of predation, assault, arrest, and illness. Exchanging sex for money or drugs offers one important source of income in this context. Yet the legal, social, and safety risks associated with these exchanges reduce the likelihood of regular safer sex practices during these encounters, thereby increasing the risk of HIV infection. Such conditions lead women engaged in sexual exchanges for money to varied and complex responses influenced by multiple and often contradictory pressures, both personal and contextual. Street-recruited women drug users in an AIDS prevention program in Hart-

Margaret R. Weeks, Maryland Grier, and Mary Jo Puglisi-Vasquez are affiliated with Institute for Community Research, 2 Hartford Square West, Suite 100, Hartford, CT 06106. Nancy Romero-Daza and Merrill Singer are affiliated with the Hispanic Health Council, 175 Main Street, Hartford, CT 06106.

The authors greatly appreciate support for this research through cooperative agreement funding from the National Institute on Drug Abuse, grant #U01 DA07284. We also wish to thank the participants who contributed time and information about personal areas of their lives, without whom this research would not have been possible.

[Haworth co-indexing entry note]: "Streets, Drugs, and the Economy of Sex in the Age of AIDS." Weeks, Margaret R. et al. Co-published simultaneously in *Women & Health* (The Haworth Medical Press, an imprint of The Haworth Press, Inc.) Vol. 27, No. 1/2, 1998, pp. 205-229; and: *Women, Drug Use, and HIV Infection* (ed: Sally J. Stevens, Stephanie Tortu, and Susan L. Coyle) The Haworth Medical Press, an imprint of The Haworth Press, Inc., 1998, pp. 205-229. Single or multiple copies of this article are available for a fee from The Haworth Document Delivery Service [1-800-342-9678, 9:00 a.m. - 5:00 p.m. (EST). E-mail address: getinfo@haworthpressinc.com].

ford, Connecticut reported a range of condom use when engaging in sex for money exchanges. This paper explores their differences by ethnicity, economic resources, and drug use, and analyzes these and other factors that impact on street risks through sexual income generation. Surveys and in-depth interviews with drug-addicted women sex workers describe their various approaches to addressing multiple risks on the streets and suggest significant effort by women in these contexts to avoid the many risks, including HIV infection. *[Article copies available for a fee from The Haworth Document Delivery Service: 1-800-342-9678. E-mail address: getinfo@haworthpressinc.com]*

INTRODUCTION

As the AIDS toll continues to rise in the United States, urban communities, especially in the northeast and south, are increasingly hard hit (Centers for Disease Control and Prevention [CDC], 1995a; Holmberg, 1996). High rates of poverty and resulting unequal access to economic and political resources are associated with poor health, poor education, and substance abuse and set a context which jeopardizes the well-being of the urban unemployed and under-employed (Wallace, 1993). Urban neighborhoods face serious "risks" as a result of changes in the labor market that prompted the loss of jobs and opportunities for financial security and the erosion of an economic base capable of supporting their communities (Singer, 1994; Waterston, 1993). Institutionalized racism and discrimination exacerbate these adversities in urban communities of color (Singer, 1994; Bourgois, 1995). In this context, the spread of AIDS is both a consequence and a cause of the enormous problems of the inner city, and adds to the stigma faced by members of already impoverished urban communities.

From the time the disease was identified, the popular response to HIV has been to blame those infected, both for their own disease when it resulted from socially sanctioned behaviors, and for placing the "innocent" at risk by acting as "vectors" of transmission. More recent attempts to respond to HIV disease with support for the infected and their friends, family, and partners have done little to reduce the personal blame imposed on them, and even have raised the specter of punitive response to them and to those engaging in potentially "risky" behaviors (cf. Levine & Dubler, 1990). Thus, stigma remains high for many who are infected or at high risk of acquiring HIV.

This is clearly the case with women who engage in sexual activity in exchange for money or drugs (Carovano, 1991; Fullilove, Lown, & Fulli-

love, 1992; Lyons & Fahrner, 1990).[1] The issue of female prostitution and HIV has been politicized around the fear of spreading AIDS to the broader heterosexual population. This fear has resulted in various public responses, many with limited success, from AIDS prevention programs targeting sex workers and/or their clients to punitive measures against those involved in the sex for money/drugs exchanges (cf. Rosenberg & Weiner, 1988; Estebanez, Fitch, & Najera, 1993; Plummer & Ngugi, 1990). Many such programs focus attention specifically on the exchange itself, rather than on mitigating factors in HIV transmission, such as social, economic, or personal forces that inhibit condom use in these sexual encounters, physical and biological conditions that predispose an individual to infection (e.g., the presence of another sexually transmitted disease), and HIV-risk behaviors unrelated to the sex-for-money exchanges, such as injection drug use or unprotected sex with a non-paying or primary partner who is infected.

Several recent studies concerned with targeted AIDS prevention have begun to disentangle the complex of factors that determine HIV transmission in sexual exchanges for drugs or money (Estebanez, Fitch, & Najera, 1993; Khabbaz, Darrow, Hartley et al., 1990; Cameron, Simonsen, D'Costa et al., 1989; Fullilove, Lown, & Fullilove, 1992; Woolley, Bowman, & Kinghorn, 1988; Kane, 1990). Included among the factors that generate HIV risk for those engaged in such exchanges are the economic and personal circumstances of the sex worker that induce her or him to accept conditions which increase risk. Street prostitution, as compared to prostitution in established locations such as massage parlors, dance bars, and escort services, presents a particular set of risks, and has been associated with higher infection rates of HTLV-I/II (Khabbaz, Darrow, Hartley et al., 1990) and other sexually transmitted diseases (STDs) (Woolley, Bowman, & Kinghorn, 1988).

After reviewing several issues that influence HIV transmission in sex-for-money exchanges with street sex workers, we will explore the environmental and individual conditions of HIV risk for women involved in a community-based AIDS prevention program for drug users in Hartford, Connecticut. In this study, called Project COPE II, we examined the socioeconomic context, drug use patterns, and sexual risks of street drug using women and men. Included in this study was inquiry into the context of risk for women who exchange sex for drugs or money. Inquiry into the sometimes conflicting needs and desires that pull and tug at women who exchange sex suggests the need for complex intervention aimed at addressing multiple issues, including addiction, lack of job opportunities, culturally constituted gender role identity and relationships, the power of

clients (johns) to force unprotected sexual activity, and the power (or lack of power) of women sex workers to protect themselves from such forced encounters.

HIV RISK IN HETEROSEXUAL SEX-FOR-MONEY/DRUGS EXCHANGES

Heterosexual transmission of HIV has increased dramatically in recent years. At present, it is the fastest growing form of transmission in the United States (CDC, 1994, 1995a, 1995b), though it has long been the most common transmission route internationally. The primary routes of heterosexual transmission in the U.S. are through unprotected sex with an injection drug user (IDU) or with other high-risk partners, particularly with multiple partners (Brown & Beschner, 1993; Sorensen, Wemuth, Gibson, Kyung-Hee, Guydish, & Batki, 1991; Sobo, 1993).

Rates of HIV transmission through sex-for-money/drugs exchanges are difficult to determine because of the potential for transmission from injection drug use or sex with infected partners outside the money-sex exchange. In areas of the world where transmission of HIV through injection drug use is minimal, such as in African countries (Estebanez, Fitch, & Najera, 1993; Nzila, Laga, Thiam et al., 1991), high infection rates are associated with sexual activity with a prostitute, increasing in probability when one or both parties have another STD (Cameron, Simonsen, D'Costa et al., 1989; Plummer & Ngugi, 1990). However, in North America and Europe, where injection drug use plays a major role in HIV transmission, infection rates appear significantly lower among sex workers who are not IDUs, when needle and sexual risks are separated (CDC, 1987; Casabona, Sanchez, Salinas, Lacasa, & Verani, 1990; European Working Group, 1993; Khabbaz, Darrow, Hartley et al., 1990; McKeganey, Barnard, Leyland, Coote, & Follet, 1992). This suggests relatively low rates of transmission through the sexual exchange itself, despite the presence of other STDs (CDC, 1987; Plummer & Ngugi, 1990; Rosenberg & Weiner, 1988). Sex-for-crack exchanges appear to contradict these findings, however, and may prove the exception (Fullilove, Fullilove, Bowser, & Gross, 1990; Longshore & Anglin, 1995). Factors such as the intensity of crack dependence, resulting in the need to procure increasingly more of the drug, heightens the willingness of crack addicts to engage in sexual behaviors with multiple partners that are highly risky for HIV transmission in exchange for the drug. This intensity of craving and need for the drug appear to differentiate the sex-for-crack exchange from other situations in which sex is exchanged for money or other drugs. It suggests the need for HIV

prevention to focus on specific sources of risk and transmission, and specific contexts in which sexual activity or drug use becomes risky for the spread of HIV. It also indicates the need to investigate further the dynamic interaction of addiction and prostitution in these environments.

Several issue areas are identifiable in the literature regarding HIV transmission in North American cities for women who exchange sex for money or drugs. Prevention of transmission for these woman may be affected by their ability to hold significant control over the sexual encounter, and over all other risks in their environment. It is further affected by male complicity in reducing risks, and by the effects of drug use on prevention of HIV transmission. Thus, forces that reduce or enhance these women's personal power and control enhance their risk for infection with HIV (Carovano, 1991; Fullilove, Lown, & Fullilove, 1992; Kane, 1990; Weeks, Schensul, Williams, Singer, & Grier, 1995).

Factors that reduce a woman's personal power may be the same as those that motivated her to initiate prostitution as a means of procuring money or drugs in the first place. These include economic need, addiction, a history of trauma including sexual and physical abuse, and low self-esteem combined with a self-identity as "deviant" from the social norm (Plummer & Ngugi, 1990; Silbert & Pines, 1982; Jackman, O'Toole, & Geis, 1963; James, 1976; Fullilove, Lown, & Fullilove, 1992; Waterston, 1993). These factors are exacerbated by social gender definitions of the ideal woman and women's roles that preclude such sexual behavior, despite economic or other circumstantial forces that lead women to engage in it (Weeks, Singer, Grier, & Schensul, 1996). Sources of power for women that increase their potential control over sexual encounters involving the exchange of sex for money or drugs must come from their own recognition of external forces and internalized conceptions affecting their options, decisions, and behavior (Weissman, 1991). To increase such power requires a combination of individual internal processes (e.g., increased self-esteem, better strategies to avoid risky situations or partners) and external changes (e.g., accessible drug treatment, meaningful job opportunities, political organizations of sex workers) that will reduce potential harm for women in these circumstances.

As suggested above, a mitigating factor influencing women's choices about and control over HIV risks is gender role definition, including women's prescribed roles as mothers and lovers or wives. Related to this is the desire of some women for a significant, intimate relationship with a primary partner, and the implications of such a relationship on decisions to modify sexual behaviors (Carovano, 1991; Dorfman, Derish, & Cohen, 1992; Fullilove, Lown, & Fullilove, 1992; Kane, 1990; Philpot, Harcourt, &

Edwards, 1991; Weeks, Singer, Grier, & Schensul, 1996; Worth, 1989). Pressures on heterosexual women to fulfill their reproductive and mothering roles by supporting their children adequately, and to maintain a sense of intimacy and emotional security with a primary male partner, affect their choices to resort to prostitution as a source of needed income and to limit or reject condom use with their main partners despite potential HIV risks (cf. Kane, 1990).

The delicate balance women attempt to maintain to accommodate these sometimes conflicting role expectations plays significantly into the environment of AIDS risk. Other pieces of this risky environment include, for many, the physical, mental, and financial stresses of drug addiction, grinding poverty, and for women of color, varying manifestations of racial discrimination that affect their opportunities for improved job status and that crush their self-esteem and hope for the future (Amaro, 1995; Shayne & Kaplan, 1991; Sobo, 1995).

Interviews with women addicts in a Hartford-based project depict these and other issues influencing their choices and risks. The following discussion outlines the Project COPE II design and the research methods used in our study of street drug users' exchanges of sex specifically for money. Since virtually all the women in this study who reported having exchanged sex for drugs also reported having done so for money (only eight of the 81 had not), and because the issues surrounding sex-for-drugs exchanges are different and call for additional inquiry, we will focus our discussion in the rest of this paper on women who reported having exchanged sex for money. The following reports on findings from survey and in-depth interviews on processes and risks of sex/money exchanges.

STUDY DESIGN AND METHODS

Project COPE II was a collaborative effort by a community-based consortium of research and service organizations in Hartford.[2] In this project, we conducted street outreach to recruit active injection drug users (IDUs) and crack-cocaine users for AIDS risk assessment, educational intervention, and voluntary HIV antibody testing. Recruitment generally involved walk-up introduction by experienced community outreach workers to people found at known hang-outs of drug users in neighborhoods of high drug activity. A targeted sampling plan was used to identify neighborhoods that had high rates of drug use and sales, drug-related arrests, STD rates, and other indicators of potentially high HIV risk. Additionally, the project targeted the two ethnic groups in Hartford among whom HIV rates

related to drug use are particularly high, African Americans and Puerto Ricans, to provide them with culturally targeted educational interventions.

The intake assessment survey measured sociodemographic characteristics of project participants and reported drug use, needle use and cleaning patterns, sexual behaviors, and general health history and status. These data provide a window into the HIV risk activities and risk reduction practices of high-risk, street drug users in the city. In addition to the quantitative baseline and six-month follow-up instruments used to assess HIV risks in this study population, Project COPE II used qualitative methods in the documentation of drug use, needle cleaning, and reported risky sexual activities among project participants. An ethnographer worked with members of the target population to gain access to street drug use settings and observe needle sharing and cleaning practices. Additionally, ethnographic interviewers conducted structured, in-depth and open-ended interviews with a sample of individuals on special topics, including drug use history and practices, and the context of HIV risks associated with sex-for-money exchanges. The following discussion uses data derived from both survey and ethnographic sources on women in the project. The ethnographic data contextualize the dynamics of drug and sexual HIV risks these women reported in the survey interviews.

PROJECT PARTICIPANTS

During the first three years of intake into Project COPE II (October, 1992 through November, 1995) 1,137 participants entered the study. This included 879 men and 258 women, of whom 38% were African Americans, 54% were Latinos (primarily Puerto Ricans), and 8% were Whites and others. Among these participants, 75% were IDUs and 45% reported using crack cocaine (20% of the sample reported both injection and crack use).

Women and men were comparable regarding low income and education levels, homelessness, and unemployment. Women in the project were almost equally divided between Blacks (40%) and Latinas (49%), and nearly half were between the ages of 18 and 35. Fifty-eight percent of the women had not completed high school, 80% were unemployed, and over 70% relied on welfare for their income. Additionally, one-third perceived themselves to be homeless. Over half (53%) of these women reported less than $500 income in the month prior to entering the project, and another 34% had incomes between $500 and $1,000, though the majority (55%) lived with children under the age of 18. This combination of low education, high unemployment, few resources, and low income reflect the eco-

nomic hardship of most women in the project. It also provides the context for and indicates the complications of drug addiction and prostitution in their lives.

SURVEY RESULTS OF REPORTED RISK BEHAVIORS

Because the project recruited active drug users, all women in the study reported injection or non-injection drug use, or both. Frequent injection of heroin, cocaine, or speedball (heroin and cocaine combined) placed many project participants at potentially high risk for HIV infection (see Table 1). Among women in the project, 52% were actively using injection drugs at the time of intake. The majority of women IDUs (56%) reported injecting more than four times every day. Further, 35% of the injecting women reported having used a needle that had previously been used by another injector. Crack use was also common among these women. Fifty percent of them reported having smoked crack in the thirty days prior to intake.

Risk of HIV infection was increased for many women in the project who reported unprotected sex with an IDU or multiple partners (male or female), and exchanges of sex for money or drugs. Table 1 shows that the majority (61%) of the 193 women who were sexually active reported having had only one sex partner in the thirty days prior to intake. However, 24% reported having between two and five partners, and another 15% said they had had more than five partners during that period. In addition, 38% of all sexually active women reported having an injection drug using sex partner in the thirty days before entering Project COPE II. Despite engaging in sex with potentially risky partners, 54% of the women who had male sex partners reported *never* using condoms and only 21% reported using condoms all of the time.

Women's HIV risk resulting from low rates of condom use and high rates of potentially infected male partners was increased by relatively high reported rates of exchanging sex for drugs or money. Almost half (46%) of the women who entered Project COPE II during the first three years of intake said that at some time in their lives they had exchanged sex for money, and 31% said they had at some point exchanged sex for drugs (see Table 1). Among the women who reported ever having exchanged sex for money, 58% had done so in the thirty days prior to intake.

Women who reported having exchanged sex for money in the prior thirty days were significantly more likely to be African American than Latina (p = .006),[3] homeless (p = .03), not supported by welfare (p = .003), and not living with children under 18 (p = .004). They also tended to be younger, single, living in someone else's home rather than their own, less educated,

TABLE 1. Reported Risk Behavior in Prior 30 Days of Project COPE II Women (N = 258)

	% of Sub-Sample (N)	% of Total Sample (N)
Drug Use		
Injection Drug Use (all drugs)		52% (135)
less than 1 time/day	13% (17)	
1-4 times/day	32% (43)	
4 or more times/day	56% (75)	
Used previously used needles (N = 140)	35% (49)	
Crack Use		50% (129)
less than 15 times/mo.	37% (48)	
16-60 times/mo.	28% (36)	
more than 60 times/mo.	35% (45)	
Sexual Practices (sexually active)		
Number of Sex Partners		75 % (193)
Single sex partner	61% (118)	
2-5 partners	24% (46)	
6 or more partners	15% (29)	
IDU sex partner	38% (74)	
Condom Use (N = 180)		
Never	54% (97)	
Less than 1/2 the time	11% (20)	
1/2 or more, not always	14% (26)	
Always	21% (37)	
Exchanged Sex for Money (Ever)		46% (115)
Not in last 30 days	42% (48)	
In last 30 days	58% (67)	
Exchanged Sex for Drugs (Ever)		31% (81)
Not in last 30 days	47% (38)	
In last 30 days	53% (43)	

and more likely to be unemployed and to inject drugs at higher rates, though these differences were not statistically significant. Additionally, women who had exchanged sex for money in the thirty days prior to entering the project reported significantly higher incomes. Table 2 shows that these women were less likely to have incomes under $500 and more likely to have incomes over $1,000 during that period than either the

TABLE 2. Income and HIV Risk Comparison of Women Exchangers and Non-Exchangers of Sex for Money

| | Exchanged Sex for Money | | |
	Never	Not in Last 30 Days	In Last 30 Days
Income in Last 30 Days (p = .07)	**(N = 139)**	**(N = 48)**	**(N = 67)**
Less than $500	55%	56%	48%
$500 - $1,000	37%	33%	31%
Over $1,000	8%	6%	18%
Monthly Injection Rate (p = .5)	**(N = 67)**	**(N = 31)**	**(N = 34)**
1-30 times/mo.	16%	7%	12%
1-4 times/day	36%	32%	27%
More than 4 times/day	48%	61%	62%
Used previously used needles (p = .07)	33%	36%	41%
Monthly Crack Use Rate (p =.7)	**(N = 57)**	**(N = 23)**	**(N = 48)**
1-15 times/mo.	40%	44%	31%
16-60 times/mo.	25%	30%	29%
More than 60 times/mo.	35%	26%	40%
Condom Use Rates (p < .0001)	**(N = 87)**	**(N = 26)**	**(N = 64)**
Never	74%	58%	27%
Less than 1/2 the time	5%	15%	17%
1/2 or more, not always	5%	4%	33%
Always	17%	23%	23%
HIV Positive (p = .005)			
Tested in project (N = 128 tested)	9%	13%	33%
Tested plus self-report (N = 165)	23%	53%	46%

women who had never exchanged sex for money or those who had not done so in the previous thirty days. These data suggest that exchanging sex for money contributed significantly to the financial resources for the women who had engaged in the practice.

Reported drug use patterns, particularly injection use, suggest differences among those who had recently exchanged sex for money compared to those who had not (see Table 2). No significant difference appeared in daily rates of injection among heroin and cocaine injecting women, regardless of their past or current experience with exchanging sex, though frequent speedball injectors were significantly more likely (p = .02) to

have a history of exchanging sex. Although not statistically significant, women injectors who were currently or had previously exchanged sex for money reported overall higher rates of injection in the thirty days prior to entering the project. Furthermore, rates of using previously used needles were slightly higher (though again not significantly so) among women who had exchanged sex for money within the prior thirty days. Finally, reported crack use also was higher among women who reported exchanging sex for money in the previous thirty day period.

The apparent association between exchanging sex for money and higher injection rates and crack use suggests that the former may be a strategy for women to achieve an income sufficiently high to support an addiction at that level (though whether level of addiction was the motivation to exchange sex or the latter allowed or promoted greater quantities of drug consumption is unclear from these data). These women have elevated HIV risk from at least two sources: increased opportunities for HIV transmission through high rates of needle use, including the use of previously used needles, and the potential opportunity for sexual transmission from multiple sex partners in the sex-for-money exchange. Nevertheless, it is necessary to analyze drug use and sexual activity to untangle sources of potential HIV risk.

Reported condom use varied significantly ($p < .0001$) between those who had never exchanged sex for money and those who had, as well as within the latter group between those who had exchanged sex within the prior thirty days and those who had not (see Table 2). Higher rates of condom use were reported among women who had recently exchanged sex for money, while those who had not (whether never in their lives or not during the prior thirty days) reported similarly low rates of use. For example, 74% of the women who had never exchanged sex for money reported never having used condoms, compared to 58% of women who had exchanged sex but not recently, and 27% of women who had done so in the prior thirty days. These reports are consistent with other studies that indicate more frequent use of condoms in exchanges of sex for money than in sexual encounters between intimate partners (CDC, 1987; Weissman et al., 1991; Worth, 1990). Nevertheless, condom use among all these women is irregular, and for many, infrequent.

The combination of risks from injection drug use and unprotected sex also was associated with a rate of HIV infection among women in the project that is extremely high by national standards. In this sample of women, 128 chose to test for HIV within the project. Of those, 19 (15%) tested HIV positive. An additional 37 women chose not to test in the project because they already knew they were HIV positive.[4] The combina-

tion of self-reported and project tested brought the overall rate of known HIV infection among women in the project to 34%. The rate of HIV (from self-reports and tests combined) was significantly higher ($p = .002$) among women who exchanged sex for money, with a 23% infection rate among those who had never exchanged sex, a 52% infection rate among those who had, but not in the prior thirty days, and a 46% rate among those who reported engaging in the practice within that thirty day period (Table 2) (see also Tortu and McCoy in this volume).

Among HIV-positive women in the project who reported ever having exchanged sex for money, the transmission route of the virus is not clear because of the possible additional exposure through infected injection paraphernalia or through unprotected sex with a primary sex partner. Self reports of higher rates of drug use and drug injection among those who exchanged sex for money, described above, suggest particularly heightened risk of exposure from injecting with infected equipment. Since condom use in sex-for-money encounters is generally reported to be higher than in sexual activities with intimate partners, the multiple potential sources of infection and the dynamics of sexual transmission of HIV in exchanges of sex for money must be further unraveled to identify conditions that result in frequent opportunities for HIV exposure among women exchanging sex for money.

BALANCING RISKS AND CONFLICTING NEEDS: PERSPECTIVES OF WOMEN ADDICTS

The exchange of sex for money provides a context in which HIV risks and other dangers converge. Those engaging in such exchanges make choices about priorities and risks, including the decision to take known risks, out of necessity or by constraint. To begin to explore some of the context and meaning of interactions between the women who exchange sex for money and their clients and the implications of these interactions for HIV risk, we conducted open-ended interviews with 22 female participants in Project COPE II who reported having engaged in sex for money exchanges within the month prior to entering the project. This was a convenience sample drawn from the project study population by asking all women entering the project within a period of several months, who reported having exchanged sex for money in the prior thirty days, if they were willing to participate in the substudy. Interviews with these women increased our understanding and ability to interpret the statistical data reported in the surveys.

The women who agreed to participate in our in-depth interviews all

were single and between the ages of 20 and 37. Ten were Puerto Ricans, ten were African Americans, and two were Whites. While ethnic differences have stood out in many of our project findings (Romero-Daza et al., 1994; Singer, 1991; Singer et al., 1992; Weeks et al., 1995; Weeks et al. [in press]), responses to the open-ended interview questions on contextualizing HIV risks while exchanging sex for money did not particularly vary along ethnic lines among these women addicts. This may be explained by the overriding (and unifying) importance of their experiences with poverty, addiction, and street prostitution as a means to support themselves, rather than differences created by ethnic, cultural, or racial issues.

All of these women had serious addictions to either injected cocaine, heroin, or speedball, or to crack. Their frequency of drug use ranged from several times a week to five or more times a day. None of these women were legally employed, but subsisted on a combination of income from welfare, Aid for Families with Dependent Children (among those with children), disability (primarily for those who were HIV-positive), informal sources, such as loans from friends or credit from a local store for necessities, and prostitution. Few had completed a high school education. All initiated their contacts with johns primarily on the streets. They identified prostitution as the only means available to them to secure the income they needed to support their expensive addictions and to provide for their dependent children.

The open-ended, structured interviews conducted with these women focused on three main issues: (1) their perceived reasons for needing or wanting to exchange sex for money; (2) their perceptions of risks involved in that exchange and their decisions about how to respond to those risks; and (3) their assessment of johns and how they deal with issues of HIV prevention in the exchange of sex for money. The narratives of these women provide a window into the dynamic process, in the context of sex-for-money exchanges, whereby they attempt to minimize multiple risks without jeopardizing the transaction unless they feel the physical threat from the john outweighs the threat of HIV infection.

We asked the women to talk about the needs, desires, or pressures that led them to exchange sex for money during the month prior to the interview. Their responses focused on the need to acquire drugs, particularly when they were feeling sick from the initial stages of withdrawal. Their need for drugs overpowered their ambivalence toward engaging in sex in exchange for money or drugs. When asked what would happen if they decided not to sell sex for money, they replied that withdrawal sickness would force them to seek money through some other means, though most were only able to identify other illegal means. One woman said:

The heroin is the worst. It makes you do things that you thought you never could do. Like I never thought I would sell myself for a bag. And you feel so cheap. But I have to support my habit somehow. [If I didn't sell sex] I would go out in stores and steal. I could be selling drugs, but I don't want to do that.

In describing why she sees the need to sell sex, another woman stated:

If I didn't, I'd be very, very sick from withdrawal. But on them days, I usually end up running into someone. Y'know, you can wait out there for hours, and you're getting sicker and sicker. I don't like waiting 'til I'm sick to go out there. I do it before.

The responses of these women regarding risks integral to commercial sex included the possibility of acquiring a sexually transmitted disease (including HIV), arrest and imprisonment and the resulting loss of custody over their children, losing their money or drugs at the hands of clients or strangers, assault while standing on the streets, rape, and murder. The discussion of risks generally coincided with their discussion of johns, since many of the risks they identified were directly related to the wishes and personalities of their customers. With the general exception of arrest and assault on the streets, the character and behavior of the john directly determined much of the risk these women identified, including risk of HIV infection.

An example of this pattern can be seen in their discussion of condom use. All twenty-two women said they generally insist on condom use with partners in exchanges of sex for money, even if they do not in sexual activity with their main partner. Typical expressions of this demand during sexual exchanges included the following:

I just tell them, "If you don't use the condom, I'm not going to take the risk." I will let them know that I haven't checked myself [for HIV]–even though I have, that I'm not sure of myself, that I want to protect him and myself, just in case. They just look at me and say, "Well, I guess you're not so bad."

I just put it to 'em point blank, "You either gonna use this, or go and find someone else." If they don't use a condom, then I'll just leave.

Whether I do blow jobs or just have sex with a guy, I use a rubber. If they don't use it, I just don't go with them. [I tell them], "Either wear it or forget it." And I leave. I can find someone else.

These assertions indicate their sense that they have the option to seek another customer if the one they are with refuses to use protection. Also,

they are more insistent with customers they perceive as "unclean" upon general examination. The majority reported checking their clients for overt signs of STDs and refusing sex or demanding the use of two condoms when those signs were apparent. Two women described this in the following ways:

> I check the guys out, too, if I have a light. Sometimes they're dirty, smelly. Sometimes the odor is so bad that I say, "Ugh, come on guy, no way. You gotta go clean up." I give them their money back and say, "Just get outta here." Sometimes, too, there's . . . white gunk on the top of his thing and I just tell him to clean up and use a condom.

> You have to look at their privates . . . and see if it's leaking or dripping or something's coming out wet, and you ask them questions . . . and I always say, "Uh-uh. Something ain't right." And I say, "No, that's OK, I don't wanna [have sex]." Or I say, "Wanna put two [condoms] on? Then I'll be safe."

Some of the women also reported that they pay close attention to the way johns put on condoms. A few complained that johns do not leave the necessary space at the tip of the condom, and thus increase the chance of rupture. In these cases, women take it upon themselves to teach clients how to use condoms correctly:

> Some men don't even know how to put rubbers on, and that's what I've found out. They put it all the way onto the thing, and one dude that I be with was arguing. I said, "You don't put it on like that." He said, "Yes, you do." I said, "Let me show you. I know how to do it. . . . Look, who's doing this? Who's gonna be doing this?" I said, "I'm not the one going to be—I ain't got another rubber. This is the last one I got, so let me show you." He said, "Okay." So, I showed him. You have to pull it up some, then roll it. He says, "All the damn time I been doing it wrong."

Strong sentiments toward insisting on condom use were dampened for some women, however, by the demands of their addiction. One woman expressed the need for money at a time when she did not have condoms on hand.

> It's a chance you have to take, the risk of getting infected with the AIDS virus, with any kind of disease, really. Sometimes you are sick, and you just go on the street. And the person comes along and they don't have no way of getting the protection and you don't have

it on you. That's the chance you have to take, because I'm sick and I don't want to stop at no stores, you know what I mean? I just want to get it over with. It's not easy. [I can] either stay sick, or go ahead with it, get it over with and take the chance. And I ain't about to stay sick.

Another woman described the dilemma similarly:

I've had occasions where I've just done it without the condom. It was the only [trick] that night and I needed the bag. After standing out there all night, I just kind of check him out and do it. I do it quickly, try not to have him cum inside me, too. Have him do his thing outside. [I'll] try to get it over with as soon as possible.

As both these women reported, their fear of withdrawal is even stronger than their fear of risking HIV infection. To ease their HIV fears, they try to complete the engagement quickly. They do not indicate a belief that speed reduces HIV risk; it only minimizes the time they spend focused on the fear.

For most of these women, HIV risk was considered secondary to more direct, physical risks with which they felt confronted by some johns. Rape figured prominently on the list of risks presented by some johns, with HIV a potential secondary result since forced sex was assumed to be usually without a condom. One woman said:

Rape [is the biggest risk in selling sex], because I feel if you get raped, nine out of ten times there's not gonna be a condom involved. So there goes the HIV.

Physical assault or murder was also a dominating concern. When asked how they assessed the possible risks of a particular john and what indicated to them that an individual client was a potential risk, their responses generally suggested use of intuitive judgment based on subtle clues communicated by the john. These often took the form of unusual or inappropriate talk. The following accounts describe some of the women's encounters in which they experienced uncomfortable interactions with clients, and to which they responded by protecting themselves from what they perceived as a potentially high-risk situation.

[I turn down johns] when I get that "vibes." The way they talkin' to you, givin' you the run around. . . . Like this one guy told me, "Well how'd I know you not a cop?" You know, "give me a taste," and all

that. And then he started sayin', "You under arrest!" And I just jumped out of the car. [When I feel unsafe] I just walk away or get out the car.

[I sometimes feel unsafe] when I meet someone on the street. You never know . . . it could be a serial killer, or something like that, you know, a person that ain't got good sense. . . . I listen to how a person's talkin', and if they don't wanna do what we supposed to be doin', then I'm ready to go. It only takes about five or ten minutes for me to realize that a person ain't for real. Usually when a person stops and picks me up, they asks me, "Do you date?" And I say, "Yes." They ask you, "Do you have a spot you could go?" I say, "Yes." Then they'll say "How much?" And I'll tell 'em. And then when we get there, if they don't start gettin' busy right away, they start doin' something else, or talkin' about somethin' else, then I'll get out *right then.* . . . A lot of people just be talkin' to you, "Well, why you doin' this?" and, "Why you don't have you a job?" I be sayin' "That's not the issue. We talked about doin' this, so we gonna do this, or we're not." If they get off the subject, or get off what we supposed to been doin', then I don't wanna be bothered with 'em, 'cause that let me know right then that they don't wanna do what they said they wanted to do, even though they approach me and ask me. When they start talkin' like that, it makes me know that they didn't want to do it in the first place. They just either pickin' my nerves, or tryin' to be nosey, or insane, you know. When they start talking about things like that they make me think that they got a complex against women that sell sex. So I just say well, "Hey, I'll see you later."

[I turn down a john] if I could look at them and tell, he looks like he's gonna give me a hard time. I've been doing it for a long time, so I just kinda can tell, you know, this one's gonna work out, or this one won't work. . . . You just know after a while.

Interpretations of the intentions of johns by assessing their words and other behaviors provide these women with a means to judge the degree and kind of risk they are assuming by engaging in an exchange of sex for money with each person.

During the course of their discussions of risk, several women expressed fatalistic attitudes about the dangers associated with exchanging sex for money, and an acceptance that these "come with the territory." Others more actively attempted to place some control over their encounters with johns and their general HIV risk. This included seeking steady customers,

who were generally perceived to be safer. As one woman said, "Every time I go out with them, they always treat me right." However, some attempts to control HIV and other risks indicate misconceptions about effective HIV protection, even while they express self-consideration. One woman described her methods of HIV risk reduction as follows:

> I use condoms. I take showers. And I do douches. I maintain myself clean. And every month, well, like last month, I went for the intravenous test [HIV test], and I came out negative, for now. I don't share my needles; I don't take nobody's needles anyways.

Concepts of general hygiene and condom use during sexual encounters and avoidance of injection needle sharing are blended in this description of techniques to reduce HIV transmission.

Several women also suggested they use oral sex as a risk reduction method, because they felt that, even without a condom, it was less risky. In addition, they suggested that oral sex was less intimate, could be finished quickly, and generally provided the john less access to them. In these ways, limiting the encounter to oral sex reduced these women's vulnerability and general risk. They did not specify whether their clients expressed a preference for oral sex as well, but indicated that they offered it first anticipating that their clients would agree.

While fear of assault is a major threat to these women, several indicated that they are capable of protecting themselves from the physical risks they were likely to confront in sex-for-money encounters initiated on the streets. One woman described her method of protecting herself from possible problems with johns who might be interested in something other than sex.

> I have one of them big padlocks with a string on it. [When he wanted me to go someplace I didn't want to go] I took it and I hit him up side the head with it. This guy wanted to take me to the Connecticut River. And I'm not goin', you know. That's too confined for me, I might not be able to get out of it, you know. [If I don't feel safe with someone in a car] usually I just tell 'em to pull over and let me out. Sometime I might have to fight to get away. I [got] hurt once. I had two broken legs. A guy pushed, he threw me out of a car. I was going to jump anyways. I opened the car door to jump, but he pushed me as I got ready to jump. . . . So far I've been lucky [about being able to get away]. But I done slowed down a whole lot [since getting hurt].

Several women concurred that in a situation that seems unusual, un-

comfortable, or dangerous, they would simply walk away. They indicated that in most circumstances, the john would not try to stop them. But they recognized the possibility that their life situation, including their addiction, need for money, and the unknown dangers of unfamiliar johns who picked them up on the streets, increased their vulnerability to physical abuse, including forced unprotected sex, assault, and murder.

In stark contrast to this discussion, these women clearly differentiated sexual encounters for money from sex with an intimate partner, particularly regarding HIV risk. When having sex with a main partner, like a boyfriend or husband, their insistence on condom use was minimal.

> There's only one person that I would take that risk with [of having unprotected sex], and that's my boyfriend. Most of the time, we use a condom. But sometimes he's a little persistent [about not using it]. We've been together for seven years, so I don't persist in using it [at those times].

> I also have [unprotected] sex with my boyfriend. He's in jail right now. He's low risk 'cause I know he only goes out with me.

Faith in a long-term relationship and in the partner's fidelity played significantly in these women's reasons for allowing unprotected sex with their main partners (cf. Sobo, 1993). Lack of fear and trust in the relationship led to the unquestioned decision to allow unprotected sex. Thus, it would appear, sex with intimate partners is itself a form of protection from the emotional and physical risks of the street. For this reason, use of a condom is in contradiction with some of the needs such a relationship fills.

DISCUSSION

Sorting out the factors that increase the likelihood of HIV transmission among drug addicted women sex workers requires assessment of motivations to sell sex, capricious behavior of johns in the course of the exchange, and sources of risk outside the context of the actual sex-for-money exchange itself. When asked to identify the main pressures they faced that affected their decision to engage in commercial sex, the women we interviewed in depth identified their addiction as the primary force. This is not surprising in the socioeconomic context of illicit drug use in the U.S. The combination of drug market forces, international policing, domestic policies that emphasize criminalization and punitive responses to drug use, and a lack of commitment to provide needed and effective drug treatment

programs create an environment in which addiction forces individuals to seek multiple, and generally illegal, sources of income sufficient to support the cost of expensive, illegal drugs. The association between poverty and addiction exacerbates this situation, forcing impoverished women to seek sources of income that present potential physical risks in order to pay for their addiction and avoid the illness caused by withdrawal.

None of the women interviewed in this study expressed the desire to seek income through prostitution over legal means of earning income (cf. Silbert & Pines, 1982). Rather, they indicated either apathy, or the sense that no other options were available and exchanging sex for money was a very undesirable means to a necessary end. No doubt, the limited possibilities for wage-earning jobs to support them and the ever decreasing options for public support sufficient to cover the cost of living, combined with the expense of their addiction, leave them virtually no alternatives. At the same time, however, these women struggled to maintain a sense of self-worth and took steps to reduce the dangers they identified as arising from the context of exchanging sex for money. The pressure to avoid drug withdrawal led these women occasionally to have unprotected sex during these exchanges. Their comments about doing it quickly to "get it over with" indicate their reluctant acknowledgment that in these circumstances they have no alternative but to put their lives on the line.

Based on the way they conceptualized risk from johns, these women have built options for themselves to reduce risks in a potentially highly dangerous situation. Many of these women take considerable precaution in selecting partners, preferring to stick with regulars they know rather than risk someone they do not. They are careful to read for signs or odd behavior that indicates a john is not what he appears to be. These signs include odd behavior that often is manifest as unusual talk, that is, saying things that appear inappropriate or unrelated to the situation that brought them together. The implication of such behavior is that such a person is a potential threat to the woman's life, in an immediate sense, or secondarily through possible HIV infection after rape without a condom. Several of these women reported carrying, and using, a weapon (e.g., a padlock on a string, knives, metal clubs and mace) in response to johns who were acting in ways unacceptable to them. Others chanced the risks and did what they could to avoid dangerous situations or encounters in which condoms were not used.

These women's attempts to insist on using condoms with all johns, including telling a john to find someone else if he argued against it, gave them the sense that they had addressed the HIV risk and risk of other STDs that they acknowledge exists in association with selling sex for money.

Several said they felt capable of insisting on that protection, and were confident that they could walk away from a john who refused to have sex without a condom.

The women interviewed for this study indicated significant "street savvy" in the ways they looked for cues from johns to assess the kinds and degree of physical and other risks he presented. They relied on a combination of intuitive sense, based on significant experience, and planned preparation, whenever feasible and not impeded by the stresses of addiction, to insure the least risky environment in which to conduct sexual transactions. Such knowledge, intuition, preparation, and steps taken to avoid the dangers of street sex-for-money exchanges do not eliminate risks of HIV, STDs, or physical and emotional traumas. But they undoubtedly reduce the likelihood that the sexual encounters in these contexts will result in transmission of HIV.

The greatest threat to these women's ability to follow their intuition or get out of a dangerous situation is their use of and need for the drug to which they are addicted. The dual dynamic of drug use/addiction and sexual activity requires further study to sort out how each reinforces the other and the ways each of these contributes to potential HIV transmission.

CONCLUSION

Where risks from injection drug use compound those from heterosexual activity, efforts to reduce sexual transmission of HIV during exchanges of sex for money or drugs must focus on the specific conditions that reduce the effectiveness of established risk reduction practices. Significant attention is needed to decrease drug addiction as a foremost step in reducing the spread of AIDS, particularly in U.S. urban centers. Following that, interventions targeting street-based sex workers are likely to be more effective if they build on women's existing methods of self-protection and danger avoidance to enhance and reinforce attempts at HIV risk reduction. Such programs also must seek to target johns and primary partners in order to increase the likelihood that barrier methods will be used for general health maintenance, including protecting from HIV transmission.

HIV prevention programs directed toward individual women sex workers can build on the techniques of planning and intuitive or interpretive self-guidance described by the women in this study in choosing and being with different partners. Programs designed to reach women who exchange sex for money or drugs can include mechanisms to improve their feelings of personal worth and encourage them to take steps to protect themselves,

or to share with each other the knowledge they have gained through experience in order to minimize getting into risky situations. This can potentially empower these women to take greater control of their encounters with johns.

Individually oriented interventions, however, whether directed at the prostitute or the john, must be combined with community action and policy change. Empowerment seldom develops internally without the simultaneous support and strength of others in like circumstances. Organizing women who exchange sex provides such a context and mechanism for extending personal protection through group power. Further, policies are critically needed to increase drug treatment availability to reduce the effects of addiction, and injection drug use harm reduction techniques for those not willing to enter treatment, as well as improved training and economic opportunities for impoverished women that would offer alternative legal means to earn a sufficient living. Only through responses like these can we sever the roots of HIV risk associated with drug addiction and exchanging sex for money.

NOTES

1. This is also true of men who exchange sex for money or drugs (cf. Bloor, McKeganey, Finlay, & Barnard, 1992). Several important factors affect women and men differently in this context, which require separate study. These include gender roles/relationships for women vs. men, issues of homophobia for men who prostitute, and complex variation in sex roles as they play out in sexual activities between same-sex and opposite-sex partners. Our focus in this paper is on women who exchange sex and issues affecting their HIV risks.

2. The Community Outreach Prevention Effort II (Project COPE II) was a five-year (1992-1997), community-based research project funded through the National Institute on Drug Abuse Cooperative Agreement for AIDS Community-Based Outreach/Intervention Research Program (grant # U01 DA07284). Collaborating organizations conducting Project COPE II included the Hispanic Health Council, the Institute for Community Research, the Urban League of Greater Hartford, Latinos/as Contra SIDA, the Hartford Dispensary, and the Hartford Health Department.

3. Ten of the women were white, representing 43% of all white women in the sample. Despite the small number of whites in Project COPE II, these reports suggest an extremely high rate of sex-for-money exchanges in this population and indicate the need to explore levels and types of risk among these women in Hartford.

4. We were not able to confirm self-reported seropositive status among participants who did not test in the project.

REFERENCES

Albert, A.E., Warner, D.L., Hatcher, R.A., Trussell, J., & Bennett, C. (1995). Condom use among female commercial sex workers in Nevada's legal brothels. *American Journal of Public Health, 85*(11):1514-1520.

Amaro, H. (1995). Love, sex, and power: Considering women's realities in HIV prevention. *American Psychologist, 50,* 437-447.

Bloor, M.J., McKeganey, N.P., Finlay, A., & Barnard, M.A. (1992). The inappropriateness of psycho-social models of risk behavior for understanding HIV-related risk practices among Glasgow male prostitutes. *AIDS Care, 4,* 131-137.

Bourgois, P. (1995). *In Search of Respect: Selling Crack in El Barrio.* Cambridge: Cambridge University Press.

Brown, B., & Beschner, G. (1993). *Handbook on Risk of AIDS.* Westport: Greenwood.

Cameron, D.W., Simonsen, J.N., D'Costa, L.J., Ronald, A.R., Maitha, G.M., Gakinya, M.N., Cheang, M., Ndinya-Achola, J.O., Piot, P., Brunham, R.C. et al. (1989). Female to male transmission of human immunodeficiency virus type 1: Risk factors for seroconversion in men. *Lancet, 2,* 403-407.

Carovano, K. (1991). More than mothers and whores: Redefining the AIDS prevention needs of women. *International Journal of Health Services, 21,* 131-142.

Casabona, J., Sanchez, I., Salinas, R., Lacasa, C., & Verani, P. (1990). Seroprevalence and risk factors for HIV transmission among female prostitutes: A community survey. *European Journal of Epidemiology, 6,* 248-252.

Centers for Disease Control. (1987). Antibody to human immunodeficiency virus in female prostitutes. *MMWR, 36,* 157-161.

Centers for Disease Control and Prevention. (1994). Heterosexually acquired AIDS–United States, 1993. *MMWR, 43,* 155-160.

Centers for Disease Control and Prevention. (1995a). Update: Acquired immunodeficiency syndrome: United States, 1994. *MMWR, 44,* 64-67.

Centers for Disease Control and Prevention. (1995b). Update: AIDS among Women–United States, 1994. *MMWR, 44,* 81-84.

Dorfman, L.E., Derish, P.A., & Cohen, J.B. (1992). Hey girlfriend: An evaluation of AIDS prevention among women in the sex industry. *Health Education Quarterly, 19,* 25-40.

Estebanez, P., Fitch, K., & Najera, R. (1993). HIV and female sex workers. *Bulletin of the World Health Organization, 71,* 397-412.

European Working Group on HIV Infection in Female Prostitutes. (1993). HIV infection in European female sex workers: Epidemiological link with use of petroleum-based lubricants. *AIDS, 7,* 401-408.

Fullilove, R.E., Fullilove, M.T., Bowser, B., & Gross, S. (1990). Crack users: The new AIDS risk group? *Cancer Detection and Prevention, 14,* 363-368.

Fullilove, M.T., Lown, E.A., & Fullilove, R.E. (1992). Crack 'hos and skeezers: Traumatic experiences of women crack users. *The Journal of Sex Research, 29,* 275-287.

Haverkos, H.W. (1993). Reported cases of AIDS: An update. *New England Journal of Medicine, 329*(7):511.

Holmberg, S. (1996). The estimated prevalence and incidence of HIV in 96 large U.S. metropolitan areas. *American Journal of Public Health, 86,* 642-654.

Ickovics, J., & Rodin, J. (1992). Women and AIDS in the United States: Epidemiology, natural history and mediating mechanism. *Health Psychology, 11,* 1-16.

Jackman, N.H., O'Toole, R., & Geis, G. (1963). The self-image of the prostitute. *Sociological Quarterly, 4,* 150-161.

James, J. (1976). Motivations for entrance into prostitution. In: L. Crites (Ed.), *The Female Offender.* Lexington, MA: Lexington Books.

Kane, S. (1990). AIDS, addiction, and condom use: Sources of sexual risk for heterosexual women. *The Journal of Sex Research, 27,* 427-444.

Khabbaz, R.F., Darrow, W.W., Hartley, T.M., Witte, J., Cohen, J.B., French, J., Gill, P.S., Potterat, J., Sikes, R.K., Reich, R., Kaplan, J.E., & Lairmore, M.D. (1990). Seroprevalence and risk factors for HTLV-I/II infection among female prostitutes in the United States. *JAMA, 263,* 60-64.

Levine, C., & Dubler, N.N. (1990). HIV and childbearing: Uncertain risks and bitter realities: The reproductive choices of HIV-infected women. *The Milbank Quarterly, 68,* 321-351.

Longshore, D., & Anglin, M.D. (1995). Number of sex partners and crack cocaine use: Is crack an independent marker for HIV risk behavior? *Journal of Drug Issues, 25,* 1-10.

Lyons, C., & Fahrner, R. (1990). HIV in women in the sex industry and/or injection drug users. *Naacogs Clinical Issues in Perinatal & Women's Health Nursing, 1,* 33-40.

McKeganey, N., Barnard, M., Leyland, A., Coote, &. Follet, E. (1992). Female streetworking prostitution and HIV infection in Glasgow. *British Medical Journal, 305,* 801-804.

Nzila, N., Laga, M., Thiam, M.A., Mayimona, K., Edidi, B., Van Dyck, E., Behets, F., Hassig, S., Nelson, A., Mokwa, K. et al. (1991). HIV and other sexually transmitted diseases among female prostitutes in Kinshasa. *AIDS, 5,* 715-721.

Philpot, C.R., Harcourt, C.L., & Edwards, J.M. (1991). A survey of female prostitutes at risk of HIV infection and other sexually transmissible diseases. *Genitourinary Medicine, 67,* 384-388.

Plummer, F.A., & Ngugi, E.N. (1990). Prostitutes and their clients in the epidemiology and control of sexually transmitted diseases. In: K.K. Holmes, P. Mardh, P.F. Sparling, & P.J. Wiesner (Eds.), *Sexually Transmitted Diseases* (2nd ed.) pp. 71-76. New York: McGraw-Hill Information Services Co.

Rojanapithayakorn, W. (1994). *100% Condom-Use Initiative in Thailand: An Update.* Presented at the Ad Hoc Technical Advisory Meeting on HIV Prevention Research. Geneva (May).

Romero-Daza, N., Weeks, M.R., Singer, M., & Himmelgreen, D. (1994). *Self-efficacy and Intimacy as Determinants of Consistent Condom Use Among Drug Users.* Presented at the Second Science Symposium on Drugs, Sex, AIDS: Prevention Research 1995-2000, Flagstaff, AZ (September).

Rosenberg, M.J., & Weiner, J.M. (1988). Prostitutes and AIDS: A health department priority? *American Journal of Public Health, 78,* 418.

Shayne, V.T., & Kaplan, B.J. (1991). Double victims: Poor women and AIDS. *Women & Health, 17,* 21-37.

Silbert, M.H., & Pines, A.M. (1982). Entrance into prostitution. *Youth & Society, 13,* 471-500.

Singer, M. (1991). Confronting the AIDS epidemic among injection drug users: Does ethnic culture matter? *AIDS Education and Prevention, 3,* 258-283.

Singer, M. (1994). AIDS and the health crisis of the urban poor; the perspective of critical medical anthropology. *Social Science and Medicine, 39,* 931-948.

Singer, M., Jia, Z., Schensul, J.J., Weeks, M.R., & Page, J.B. (1992). AIDS and the IV drug user: The local context in prevention efforts. *Medical Anthropology, 14,* 285-306.

Sobo, E.J. (1993). Inner-city women and AIDS: The psycho-social benefits of unsafe sex. *Culture, Medicine & Psychiatry, 17,* 455-485.

Sobo, E.J. (1995). *Choosing Unsafe Sex: AIDS-Risk Denial Among Disadvantaged Women.* Philadelphia: University of Pennsylvania Press.

Sorensen, J.L., Wemuth, L.A., Gibson, D.R., Kyung-Hee, C., Guydish, J.R., & Batki, S.L. (1991). *Preventing AIDS in Drug Users and Their Sexual Partners.* New York: Guilford Press.

Wallace, R. (1993). Social disintegration and the spread of AIDS–II. Meltdown of sociogeographic structure in urban minority neighborhoods. *Social Science and Medicine, 37,* 887-896.

Waterston, A. (1993). *Street Addicts in the Political Economy.* Philadelphia: Temple University Press.

Weeks, M.R., Schensul, J.J., Williams, S.S., Singer, M., & Grier, M. (1995). AIDS prevention for African American and Latina women: Building culturally and gender appropriate intervention. *AIDS Education and Prevention, 7,* 251-264.

Weeks, M.R., Singer, M., Grier, M., & Schensul, J.J. (1996). Gender relations, sexuality, and AIDS risk among African American and Puerto Rican women. In: C. Sargent & C.B. Brettell (Eds.), *Gender and Health: An International Perspective,* pp. 338-370. New Jersey: Prentice-Hall.

Weeks, M.R., Himmelgreen, D.A., Singer, M., Woolley, S., Romero-Daza, N., & Grier, M. (in press). Community-based AIDS prevention: Preliminary outcomes of a program for African American and Latino drug users. *Journal of Drug Issues.*

Weissman, G., Brown, V., & the National AIDS Research Consortium. (1991). Drug use and sexual behavior among sex partners of injecting-drug users–United States, 1980-1990. *MMWR, 40,* 855-860.

Woolley, P.D., Bowman, C.A., & Kinghorn, G.R. (1988). Prostitution in Sheffield: Differences between prostitutes. *Genitourinary Medicine, 64,* 391-393.

Worth, D. (1989). Sexual decision-making and AIDS: Why condom promotion among vulnerable women is likely to fail. *Studies in Family Planning, 20,* 297-307.

Worth, D. (1990). Women at high risk of HIV Infection: Behavioral, prevention, and intervention aspects. In: D.G. Ostrow (Ed.), *Behavioral Aspects of AIDS,* pp. 101-119. New York: Plenum.

Index

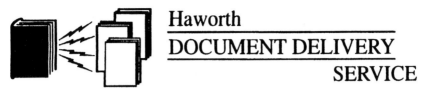

Haworth
DOCUMENT DELIVERY
SERVICE

This valuable service provides a single-article order form for any article from a Haworth journal.

- *Time Saving:* No running around from library to library to find a specific article.
- *Cost Effective:* All costs are kept down to a minimum.
- *Fast Delivery:* Choose from several options, including same-day FAX.
- *No Copyright Hassles:* You will be supplied by the original publisher.
- *Easy Payment:* Choose from several easy payment methods.

Open Accounts Welcome for ...
- Library Interlibrary Loan Departments
- Library Network/Consortia Wishing to Provide Single-Article Services
- Indexing/Abstracting Services with Single Article Provision Services
- Document Provision Brokers and Freelance Information Service Providers

MAIL or *FAX* THIS ENTIRE ORDER FORM TO:

Haworth Document Delivery Service
The Haworth Press, Inc.
10 Alice Street
Binghamton, NY 13904-1580

or FAX: 1-800-895-0582
or CALL: 1-800-342-9678
9am-5pm EST

PLEASE SEND ME PHOTOCOPIES OF THE FOLLOWING SINGLE ARTICLES:

1) Journal Title: _____

 Vol/Issue/Year:_____Starting & Ending Pages:_____

 Article Title:_____

2) Journal Title: _____

 Vol/Issue/Year:_____Starting & Ending Pages:_____

 Article Title:_____

3) Journal Title: _____

 Vol/Issue/Year:_____Starting & Ending Pages:_____

 Article Title:_____

4) Journal Title: _____

 Vol/Issue/Year:_____Starting & Ending Pages:_____

 Article Title:_____

(See other side for Costs and Payment Information)

COSTS: Please figure your cost to order quality copies of an article.

1. Set-up charge per article: $8.00
 ($8.00 × number of separate articles) _____

2. Photocopying charge for each article:

 1-10 pages: $1.00 _____

 11-19 pages: $3.00 _____

 20-29 pages: $5.00 _____

 30+ pages: $2.00/10 pages _____

3. Flexicover (optional): $2.00/article _____

4. Postage & Handling: US: $1.00 for the first article/
 $.50 each additional article _____

 Federal Express: $25.00 _____

 Outside US: $2.00 for first article/
 $.50 each additional article _____

5. Same-day FAX service: $.35 per page _____

 GRAND TOTAL: _____

METHOD OF PAYMENT: (please check one)

❑ Check enclosed ❑ Please ship and bill. PO # _____
(sorry we can ship and bill to bookstores only! All others must pre-pay)

❑ Charge to my credit card: ❑ Visa; ❑ MasterCard; ❑ Discover;
❑ American Express;

Account Number:_____ Expiration date:_____

Signature: ✗_____

Name: _____ Institution: _____

Address: _____

City: _____ State:_____ Zip:_____

Phone Number: _____ FAX Number: _____

MAIL or *FAX* THIS ENTIRE ORDER FORM TO:

Haworth Document Delivery Service	**or FAX:** 1-800-895-0582
The Haworth Press, Inc.	**or CALL:** 1-800-342-9678
10 Alice Street	9am-5pm EST)
Binghamton, NY 13904-1580	